IN THE FOOTPRINTS OF WAINWRIGHT

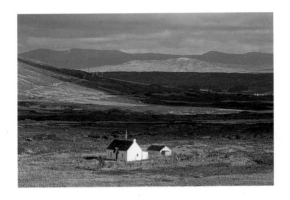

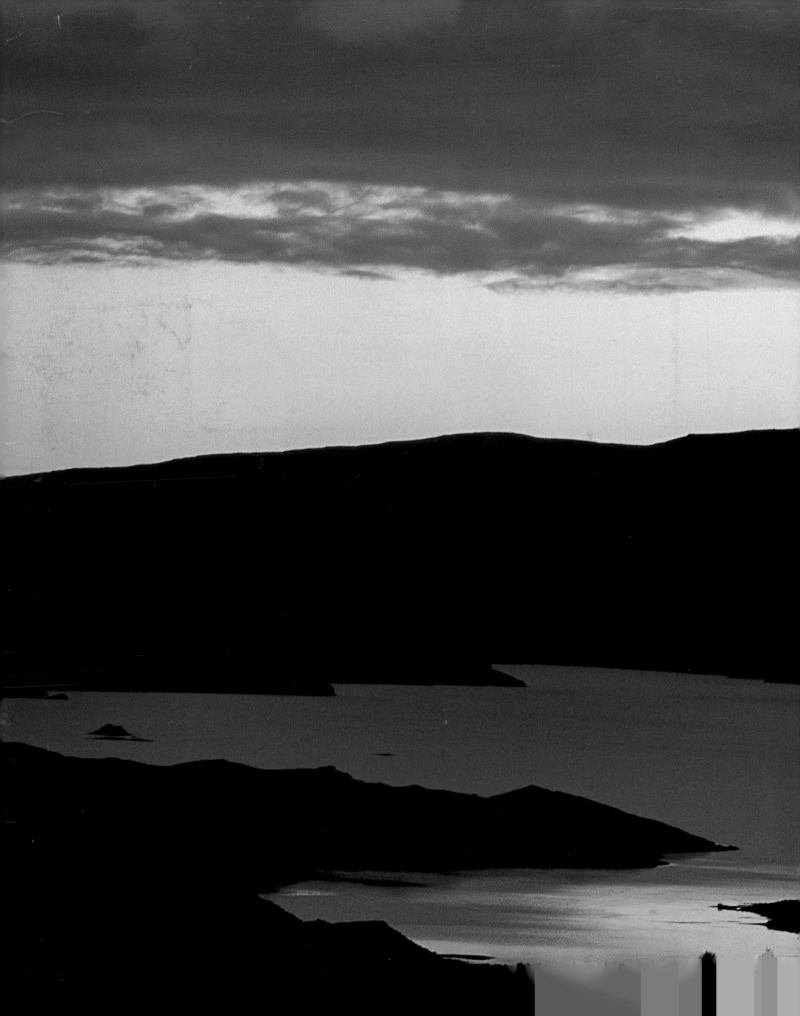

IN THE FOOTPRINTS OF WAINWRIGHT

DERRY BRABBS

FRANCES LINCOLN

Frances Lincoln Limited
4 Torriano Mews
Torriano Avenue
London NW5 2RZ
www.franceslincoln.com

In the Footprints of Wainwright
Copyright © 2005 Frances Lincoln Limited

Text and photographs copyright © 2005 Derry Brabbs
Edited and designed by Jane Havell Associates

First Frances Lincoln edition 2005
First paperback edition 2006

British Library cataloguing-in-publication data
A catalogue record for this book is available from
the British Library

ISBN10: 0-7112-2714-4
ISBN13: 978-0-7112-2714-9

Printed in Singapore

Half-title
The Scottish Mountaineering
Club's hut, Langangarbh, lies
in almost total isolation
between the head of Glencoe
and the watery wastes of
Rannoch Moor. Its dramatic
setting is appreciated by both
climbers and photographers.

Title pages
Stac Pollaidh's distinctive
outline photographed at dusk.
The success of this picture –
in terms of compositional
balance and atmosphere –
relied on the final glimmer of
daylight being captured as it
was reflected on the waters
of Loch Lurgainn.

These pages
River Crake at Greenodd
Sands by moonlight.

CONTENTS

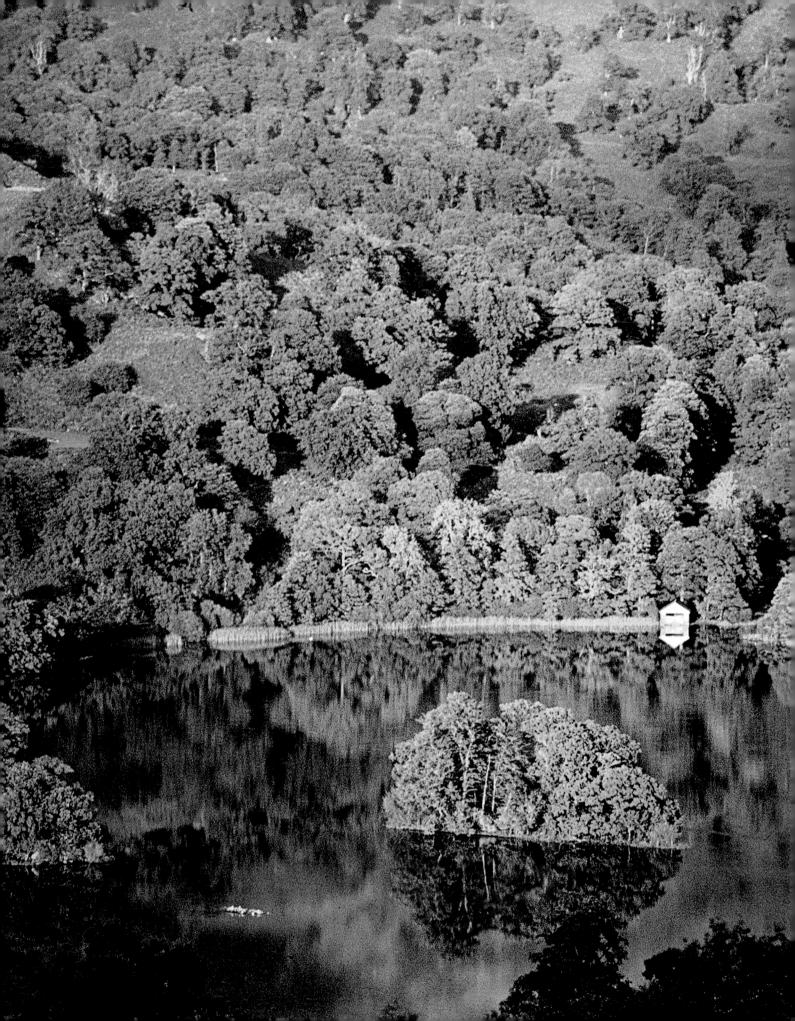

INTRODUCTION

I do not know of any tract of country, in which, in so narrow a compass, may be found an equal variety in the influences of light and shadow upon the sublime and beautiful.

William Wordsworth

It is now over twenty-one years since I embarked upon the first Wainwright/Brabbs collaboration. Although much has been written about AW and his work since he passed away in 1991, I would like to share my own personal experiences during the years I spent working with him.

The opening chapter in fact winds the clock back even further, to the time I first got involved in photography, and then briefly touches upon my early years in television and advertising. Everyone working in the 'arts' strives to achieve a life-transforming lucky break and mine came with the chance to illustrate the subsequent worldwide bestseller, *James Herriot's Yorkshire*. The success of that book enabled me to move on to other publishing projects before eventually being teamed up with AW to produce *Fellwalking with Wainwright*.

However, I do have a serious aversion to heights and consequently never seriously thought that climbing mountains would become an integral part of my working life for several years. It is certainly true that my editorial career had moved in that general direction, but I hoped that my talent for taking landscape photographs would be exploited amidst more benign surroundings than the Cumbrian fells. It was an entirely new and bewildering environment, and I also quickly discovered that the Lake District has its own particularly quirky climate. My photography improved with each of the seven titles we compiled together and, right up until the last picture of the final book, I felt I was still learning about the relationship between light and land.

Alfred Wainwright was definitely a 'one-off'. Few others could ever have had the stamina or single-minded dedication to match his prodigious energy and output. He was certainly not the most gregarious of men, but those who derided him for being unapproachable, grumpy and reclusive were probably unwilling to invest the time and effort required to access the psyche of someone who did not conform to their own outlook on life. It certainly took me a while to get to know AW better, but then ours was a long-term relationship and I was content to accept him at face value until he eventually lowered the drawbridge and allowed me to pass through his outer defensive wall.

Following in Wainwright's footprints was never an easy path to tread, but it was certainly an interesting one.

A telephoto shot of Rydal Water and its familiar boathouse, enhanced by strong patches of sunlight highlighting the foliage of surrounding trees and totally still atmospheric conditions that create almost perfect reflections on the lake's unruffled surface.

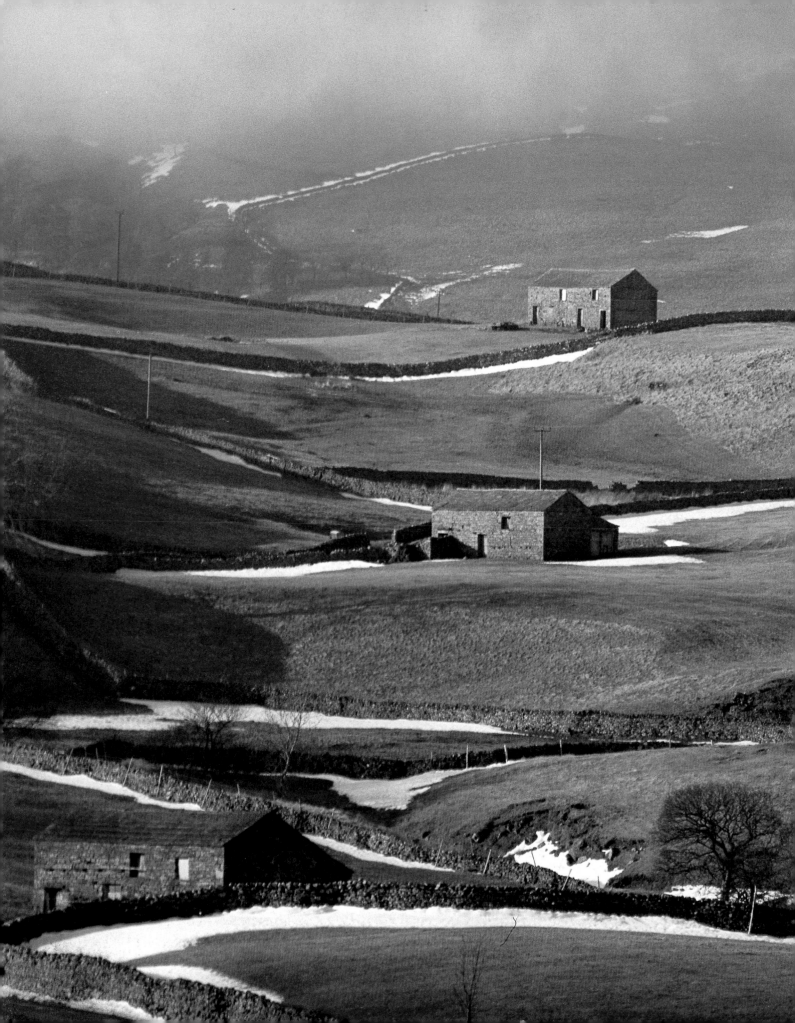

Traditional barns and stone walls above Gayle in Wensleydale laid out in perfect symmetry, a design accentuated by the lines of unmelted snow running beneath the north-facing walls. The desolate, wintry atmosphere is further enhanced by low cloud drifting across the distant hillside.

Chapter One

EN ROUTE TO THE FELLS

'You cannot be serious.' Although phrased as a question, its delivery was more of a statement and the hostile look I received from the school's careers master confirmed that my intention of becoming a photographer was deemed highly inappropriate. As he leaned over to write that apparently blasphemous word against my name, clouds of chalk dust fell from his faded gown. Ten minutes earlier, those white particles had been united on a blackboard to form meaningless statistics about rubber plantation yields in some far-flung corner of the Empire.

Maybe the teaching of geography and the advising of teenage boys which career path to follow were vaguely related, but his reaction left little doubt that mine was not a favoured option for a pupil of Loughborough Grammar School. That ancient, endowed establishment, founded in 1495, was steeped in tradition and more accustomed to despatching school leavers on to university and the 'professions' rather than 'dabbling in the arts'. It was made abundantly clear that taking pictures was not a proper job and, at best, worthy only of pursuing as a weekend hobby.

My life-determining 'road to Damascus' experience took place in the unlikely setting of the local doctor's surgery whose waiting-room table was covered with the customary outdated women's magazines, dog-eared car guides and knitting patterns adorned with couples wearing heavily

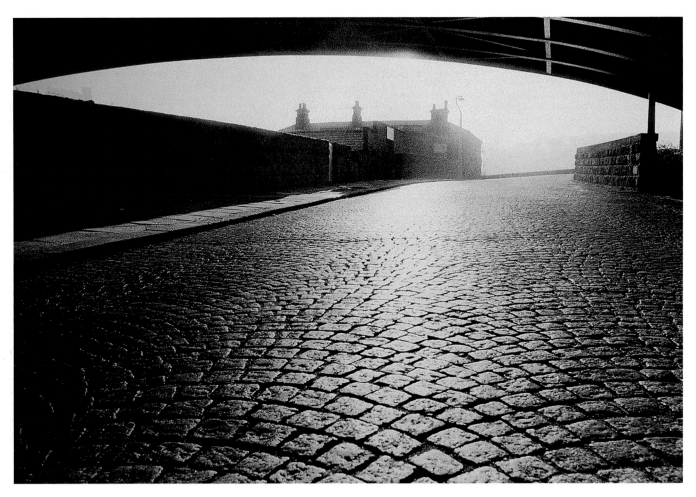

ribbed matching sweaters. Despite being largely obscured, the vibrant yellow border of a *National Geographic Magazine* caught my eye and the ensuing ten minutes provided the spark of inspiration and enthusiasm that had thus far been absent from any decisions about my future. At that time, I was not even a keen amateur photographer but was nevertheless simply spellbound by page after page of stunning colour pictures and knew immediately that I wanted to emulate those who had created them. Until that moment when the magazine's pages transported me to places I had never even heard of, hotel management and catering had appealed as a potentially rewarding and challenging career option. Visions of chef's hats or managerial dark suits were immediately obliterated by thoughts of travelling the world and capturing its stunning natural beauty on film.

My parents were singularly unimpressed by the news. Having made considerable personal sacri-fices to ensure their two sons received an educationally sound start in life, they felt their efforts were on the verge of being wasted. However, to give both them and the careers master their dues, when they realised that I would not be deterred, they took steps to move the process forward. Prospectuses from around the country duly arrived, but my choice was eventually governed more by economics than the respective merits of individual institutions.

Located less than ten miles from our village, Leicester College of Art offered photography as a three-year City & Guilds vocational course. I was persuaded that this was the most realistic option as I could live at home for the duration to avoid the heavy costs of finding accommodation elsewhere.

I duly applied and can only assume that they must have been woefully short of candidates for the 1965 intake, as I was accepted after an interview and submission of a portfolio that comprised

Inspired by a similar image taken by Bill Brandt, one of my early college photographs featured a cobbled street in Halifax, West Yorkshire. The sun's strong back-lighting effect emphasised the texture and design of the stones, and the arched bridge provided a perfect natural framing device.

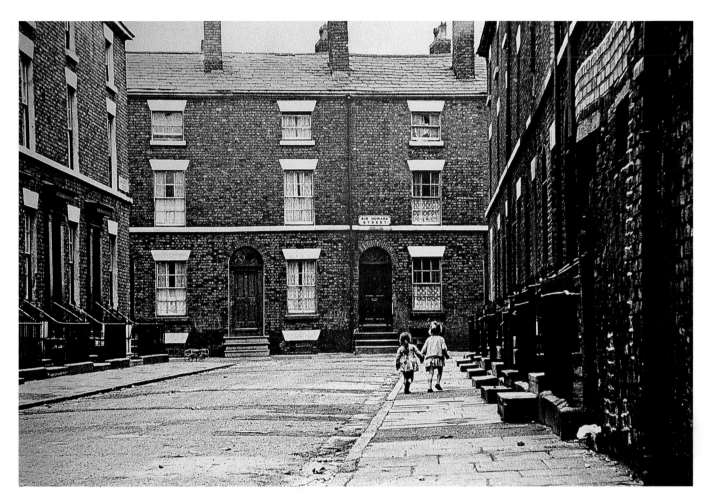

an ordinary A5-size photograph album containing snapshots taken on a Kodak Brownie 127. I had at least captioned the prints using contrasting white ink on the black pages, but it was hardly a state-of-the-art production.

One major impediment to progress was a rule that students had to be eighteen or over to join the course; being only seventeen at the time, that left me with a year to fill. I tried to find a job that would not only fund the purchase of essential photographic equipment, but also help me emerge from a hitherto sheltered childhood and get a taste of what the real world was like. In my case, the 'real' world centred around Lewis's, Leicester's largest department store. Although in reality I could, and indeed should, have been more adventurous, the time I spent there provided an insight into human nature that proved invaluable in later years.

I was initially sent to their furniture delivery warehouse and can still recall the windowless canteen that reeked of stewed tea and coarse Woodbine cigarettes, where football chatter would be interspersed with fanciful tales of sexual encounters with women intent on trying out their newly delivered beds. Everyone knew it was wishful thinking, but nobody dared break the rules by challenging the veracity of somebody else's story. Unfortunately, my tenure there was fairly short-lived, so I never did get to deliver a pocket-sprung divan to a housewife wearing a welcoming smile and very little else.

Phase two of my 'gap year' involved being transferred to the city centre store where I worked for several months as a sales assistant, selling a variety of goods including biscuits, buttons, saucepans, lampshades and even ladies' handbags, before spending a longer period in the men's clothing department. I even had my own tape measure to be used for any part of the anatomy except a gentleman's inside leg, that being the

The rows of terraced houses lining the back streets of Liverpool 8 provided ample scope for budding photo-journalists to emulate the work of the great sixties exponents of the genre, whose photographs were regularly showcased in news magazines such as *Life* and *Paris Match*.

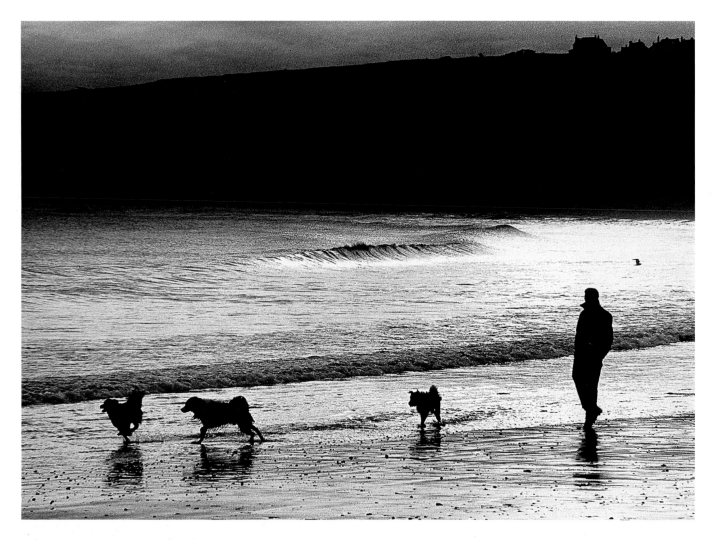

exclusive domain of the senior assistant. A customer only had to utter the word 'trousers' for him to materialise suddenly and any resentment I felt over the loss of commission on a sale was tempered by relief at not having to conduct that embarrassing procedure. Opinions differed as to how high up into the crotch the end of the tape should go to make the correct calculation and, whilst I was content with a conservative estimate, he was painstakingly thorough. It was hilarious to watch the expression on a customer's face turn from mild indifference to grave concern as my colleague busied himself around the waistline and below.

Leicester's art college was housed in a redundant, red-brick hosiery factory and my first few days were a daunting experience, especially once I realised that all my fellow students had consider-able prior knowledge of photography. We novices regarded the final-year students as gods and the quality of their work seemed so far removed from our own initial efforts that we despaired of ever making the grade as fully fledged photographers. I did, however, score a notable triumph by having some of my pictures published on the back sleeve of an album recorded by the famous English blues musician, John Mayall, for which I was paid the princely sum of £10. Although my first professional commission ended up as four tiny thumbnail pictures, I was beside myself with pride and excitement to note that I had actually been credited on the record sleeve for my contribution.

I was just one of several students wanting to specialise in photo-journalism and, although nobody had any intention of making a beeline for south-east Asia, it was impossible to ignore the

A winter morning spent in Scarborough, while I was engaged on a college project about seaside piers, provided the setting for another of my black-and-white *contre jour* experiments. Although the subject material was only a man exercising his dogs, shooting into a low-angled sun helped create an image of interesting shapes, reflections and textures.

impact created by photographs coming out of the Vietnam war. Don McCullin in particular was one of my idols, not only for his stunning images from the front line, but also his atmospheric black-and-white portrayals of industrial England. Both he and Bill Brandt were key figures in shaping how I looked at my surroundings and interpreted them through the camera lens.

Years 2 and 3 were more of a struggle as not only were we relocated to a custom-built tower block to become students at the newly formed Leicester Polytechnic (now revamped again into DeMontfort University), but our new head of department came from the world of advertising and decreed that everybody should train to be still-life photographers, regardless of whether they had any intention of pursuing that speciality as a career. The ensuing revolt from our small reportage faction almost resulted in my ejection from the course but, at the eleventh hour, a deal was brokered whereby we would be allocated free time to pursue our own projects, providing all our set college work was delivered on schedule.

That freedom was well used, with exploratory visits to national newspapers and magazines – we even managed to get an invitation to look around *Vogue*'s photographic studio. There were also many long weekends spent in London, soaking up the heady atmosphere of Chelsea's King's Road, where the 'beautiful people' self-consciously paraded in beads and kaftans, with bemused-looking Afghan hounds at their sides. 'Flower power' had not yet drifted up to Leicester on a sweet-scented cloud of incense and marijuana, so for us it was like entering another world for a few days a week.

But, fun though it all was, the playing ended and after three years the real world of work presented its harsher side in the cold light of an aspirational, but nevertheless unemployed, dawn. I had a well-balanced portfolio of black-and-white prints from both college projects and private work, and set off to join the queues of other ex-photography students outside the offices of London's magazine and newspaper picture editors. No matter how well received my work was, the interviews always had the same 'Catch-22' type outcome: 'Come back and see us when you have more experience.'

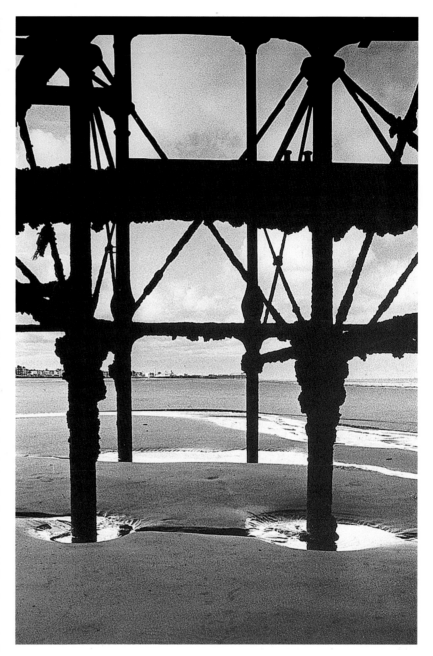

> Don McCullin in
> particular was one
> of my idols

I discovered that the complex support structures of England's piers were often significantly more photogenic than the buildings themselves. Such graphic images are even more effective when printed in monochrome.

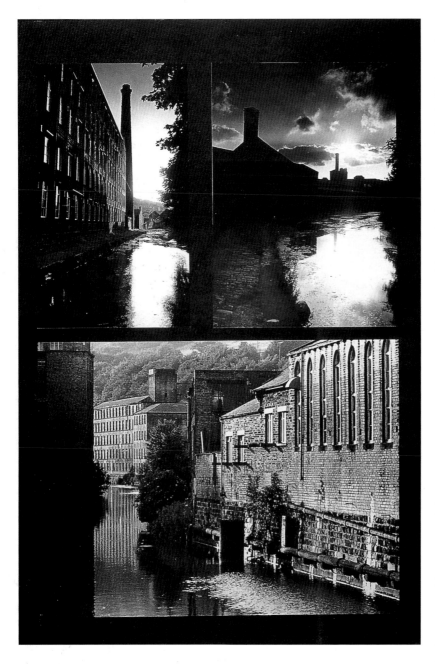

Textile mills and canals shot around Halifax and Hebden Bridge in Calderdale – one of the composite pages taken from my original college portfolio which helped me secure my first job as a professional photographer.

Just when the atmosphere at home was starting to become rather tense and one could sense the 'I told you so' recriminations were about to be aired, I finally got a job based at *TVTimes* magazine's regional office in Manchester. I took my portfolio to their head office in London's Tottenham Court Road and, after an interview with the chief art director, was offered the job there and then for a salary of £1,000 per year – with a non-negotiable starting date of just five days away.

I had been to Manchester once before in my life but had no real concept of its size or layout, and by the time I got back home to Leicester a degree of panic had started to set in. I had to find a place to live and relocate in little more than a couple of days. I borrowed Mother's sturdy Morris Minor, drove to the centre of Manchester where I equipped myself with an *A-Z* street guide and a copy of the *Evening News*, and began sifting through the Accommodation to Let pages, trying desperately to equate the places to rent with street names and areas on the map.

After several hours of driving from one run-down terraced house to another, I was on the verge of despair and resolved to opt for the next place I saw. The only criteria it had to meet were that it should be within walking distance of a bus as I did not yet own a car, and should have a bed that looked as though it might not have a life of its own. I ended up renting a bedsit in a large semi-detached house off the Bury Road. It was the last dwelling in the street and adjacent to the looming presence of an industrial grime-blackened parish church and graveyard.

Finally leaving home was far more traumatic than I had bargained for, and the drive back up to Manchester with my parents on the Sunday afternoon was silent and gloomy. We had had our differences during my three years at college, and I guess it had been hard for them to endure my transformation from demure grammar school boy to rebellious art student. Mother was tongue-bitingly appalled at my new abode but hid her feelings until the moment of parting, when there were tears from her and a stiff-upper-lip farewell and handshake from Father. As they drove away, I was left alone with a suitcase of clothes to distribute among the fusty-smelling drawers and

wardrobe, and just 'Hey Jude' by The Beatles playing on my transistor radio for company.

My boss was a journalist of the 'old school' (hard-drinking, chain-smoking and liberal-swearing) variety, recruited for the newly established post of regional editor from a West Midlands newspaper. Although our main remit was to cover Granada's output in Manchester, we were also expected to generate material relating to the ATV studios in Birmingham and produce illustrated features on the nation's favourite ITV soaps, *Coronation Street* and *Crossroads*. Although I used to indulge in occasional lunchtime beers at college, the drinking culture in Manchester was a quantum leap forward, and in the style of a good commanding officer our boss led from the front. After a couple of mid-morning whiskies in the nearest pub, it would be either back to the office or down to the TV studios but, regardless of the destination, our departure was always accompanied by his favourite battle cry: 'Faint heart never fucked a pig.' Well, who could argue?

I would have benefited from having other photographers to work with, as observing one's peers in action is the best way to learn, but despite that isolation, pictures kept appearing with my name alongside so I must have done something right. However, not having the most straightforward of names did result in some curiously spelt versions that varied from Denny Drabbs to Deeny Drapes with a few more abuses of the English language in between.

One aspect of television production about which I was blissfully unaware was the militancy and power of the industry's trade unions. My ignorance of approved studio protocol almost caused a blackout during live transmission of the popular Sunday afternoon game show, *The Golden Shot*. I had been briefed to get some 'on set' portraits of the show's host, Bob Monkhouse, during the tea break immediately prior to the show being beamed out to an expectant nation. To ensure well-lit pictures, I had taken two large electronic flash units with me and had plugged them in to clearly marked sockets located around the studio walls.

Bob was a few minutes late but, unfortunately, one of the studio electricians had returned to his post early. He took one look at my lighting equip-

ment and promptly disappeared. Within less than thirty seconds the studio's cavernous silence was broken by a large group of angrily gesticulating bodies swarming through the main door. The electricians were apparently protesting that I had actually employed a modicum of common sense to plug in my own lights, and were threatening a retaliatory walk-out. My equipment was turned off and dismantled; I was ejected from the studio and, following a hasty apology from the TV station's management, the electricians elected to go back to work. It was all quite bizarre and could easily have been included in the Peter Sellers film parodying trade unions, *I'm Alright Jack*. I did not get the photographs and consequently received a severe bollocking from the picture editor for my stupidity. That was my first adverse encounter with union power, but by no means the last.

Some eighteen months after starting work in Manchester, I was offered the chance to move to London and work at the magazine's HQ in the heart of the West End, exchanging bedsit land in Manchester for a similar, but more expensive, existence in the London suburb of Ealing. The working brief was very much the same as Manchester, albeit with significantly more driving around involved as there were three major production studios in the London region. Traffic was bad enough back in 1970, but I dread to think what proportion of an equivalent twenty-first century working day would be taken up by the same journeys. What did change significantly with my move south was the opportunity to shoot more in-depth feature work and have my pictures showcased over several pages. During the late sixties and early seventies, the magazine was very much a forerunner of the current crop of glossy weekly 'gossip and celebrity' magazines, and much of my time was spent doing 'at home' articles on well-known actors and actresses.

The format of those domestic sessions seldom varied, as the writers usually insisted on conducting their interviews before any photography took place. There were occasions when that worked in my favour, as the interviewee had become more relaxed and less self-conscious in front of the camera when it was my turn to perform. Getting sufficient material for a full feature was hard work, as one had to shoot at least five different set-ups

Pictures kept appearing with my name alongside so I must have done something right

around the house, and make sure the subject was appropriately dressed for each one and that everybody in the photographs looked happy! Some actors and actresses accepted having to appear in the magazine as part and parcel of their job; others loathed it, and made life intolerable by throwing mid-session tantrums. Numerous lesser lights would suddenly adopt airs and graces commensurate with the upper echelons of Hollywood's 'A' list.

If I did make a complete pig's ear of a session, the option of doing a re-shoot was highly unlikely. To this day, I cannot figure out how I survived an extremely alcoholic morning at the house of the film and television actress, Adrienne Corri. She was an old friend of the feature writer and had champagne on ice ready for our arrival at 10.30 a.m. A couple of glasses would have been OK, but by the time they had chatted about past, current and future projects we had collectively consumed three bottles. I somehow managed to get the pictures in focus, hump heavy lights up and down narrow, twisting staircases without mishap and shot one beautiful portrait that ended up as a magazine front cover. It would have been a salutary and sobering lesson on the pitfalls of drinking on the job had I got it hopelessly wrong, but despite my best efforts to self-destruct I survived to tell the tale.

Trips abroad were jealously viewed as 'perks' by those in other departments, but the reality was that the further one travelled from base, the greater the pressure to get a result. One particular expedition to the Holy Land was memorable for several reasons, not least for being hauled off a fully laden British Airways Trident jet by security guards after we landed at Tel Aviv airport. Two of us had travelled to Israel to do a feature on the Bethlehem School for the Blind choir, scheduled to make an appearance on a pseudo-religious show called *Stars on Sunday*, hosted by Jess Yates. The agents had Uzi sub-machine guns slung over their leather jackets and walked slowly up and down the aisle scrutinising the anxious-looking passengers. On their second inspection, one paused long enough to point in my direction and utter a curt 'You,' gesticulating with his hand towards the plane's front exit. Two hundred relieved pairs of eyes followed my progress and, as I passed the stewardesses at the

door, one of them smiled and disconcertingly said, 'We knew it was you.' I was taken to a waiting army truck where my documents were scrutinised, I was thoroughly frisked and every item of my hand luggage minutely examined. They could not get to grips with the Travel Scrabble set I was carrying and spent some time deliberating suspiciously over the pile of plastic letters. Their command of English was minimal but I managed to persuade them it was nothing more sinister than a game and most definitely not a code encryption kit.

Perhaps my most demanding European trip was the occasion on which I and a staff writer had to be at a remote Alpine hotel for a specified time on a particular day to photograph singing star Shirley Bassey taking her annual winter sports holiday. Matters were complicated by the fact that we had to cover the location filming of another programme *en route*, resulting in a travel schedule that involved a nerve-racking number of tight connections between trains and planes in both Geneva and Milan. One slight hitch would thwart the entire mission – the editor had made it abundantly clear that if we failed to make our appointment there could be no re-scheduling and we should jump off the nearest glacier rather than return without the story and accompanying pictures.

Exhausted but elated, we announced ourselves to the hotel desk clerk with exactly one minute to spare and then waited in the lobby. Five minutes became ten and, despite reassurances that the Basseys were expected, we felt utterly deflated at having kept our side of the bargain but with no reward. Some three hours after our allegedly unbreakable deadline, a helicopter landed in front of the hotel, its rotor blades creating a white-out of driven snow. As Shirley and her husband Sergio paused to collect their key from the concierge, a brief conversation took place, heads were turned in our direction and, immediately, gestures of guilt and remorse emanated from the couple. They could not have been more helpful thereafter and ensured that we got everything we needed to make the feature work, including the loan of a tiny Fiat 500 to drive ourselves halfway up a mountain to rendezvous with their helicopter for a picture session.

We had collectively consumed three bottles. I somehow managed to get the pictures in focus

One of the surprisingly sharp photographs taken for a *TVTimes* feature on Adrienne Corri at her London home after we had all over-indulged on champagne. The patches of out-of-focus foliage were actually intentional, to add a splash of colour to otherwise rather drab brick walls.

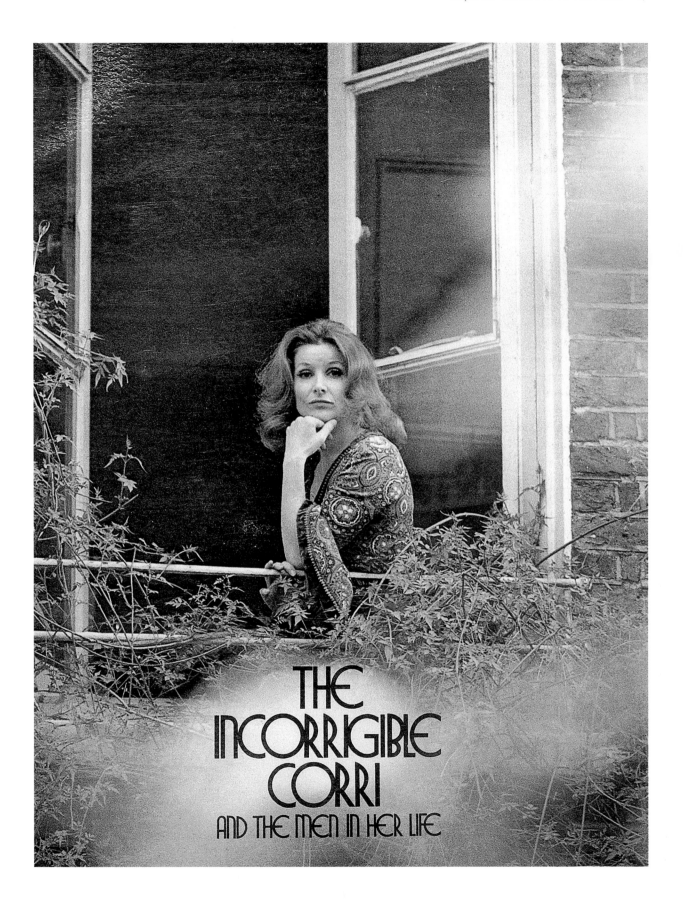

THE INCORRIGIBLE CORRI
AND THE MEN IN HER LIFE

TVTimes had its own photographic studio on the fifth floor of an office block in Tottenham Court Road, used mainly for formal portraits and other sessions requiring more technical facilities. The picture editor had really not thought through one particular job I was given to do up there, but it was not until the shoot was well under way that any problems materialised. I had been asked to photograph the actress Dawn Addams lying on a water-bed – she had apparently just bought one herself and that was deemed a sufficiently valid reason to generate a feature. Assembling and filling the bed was no problem as there was a kitchen next door from which we linked a short pipe. I lit the set using coloured tungsten spotlights and had also acquired blocks of dry ice to create a misty atmosphere. It all looked great and the session was well under way when people started to feel uncomfortably short of breath. With the blackout blinds drawn and the windows closed, I had forgotten that dry ice was actually liquid carbon dioxide and we were all starting to suffocate.

At least that problem was simply resolved by opening a window. But when the session was concluded, the water-bed sat quietly gurgling to itself in the centre of the room: unfortunately, nobody had considered how it would be emptied prior to being dismantled. Hundreds of gallons had be siphoned off, and so I scoured the surrounding streets for a hardware shop that sold garden hoses (not a common amenity in Tottenham Court Road), bought two long ones with appropriate connectors and then set about draining the bed out of the studio window and into the basement car park. It took a great deal of eye-popping suction to get the water flowing and ages for the bed to be eventually drained of its contents. I was obliged to slip the caretaker an amnesia-inducing tenner as executives from other companies began grumbling about having to wade through vast puddles to reach their vehicles in the middle of July.

I had been working at TVTimes for some five years when the appearance of yet another series of 'Stars and their Gardens' on the editorial schedule confirmed a nagging belief that it was time for a change. The catalyst for my eventual move north from London was a chance meeting with the head

For Dawn Addams, staying young at 41 means plenty of restful sleep and enough of her favourite exercise – swimming. In this water bed (vinyl "mattress" holding 150 gallons of heat-controlled water) Dawn finds slumber combines easily with the buoyancy of swimming. "Six hours' sleep at night is right for me if I can get another two hours in the afternoon . . . If I am rehearsing I skip lunch and sleep over the lunch-break. It must be a lying-down sleep. Snatching it in cars and trains won't do," says Dawn, looking lovelier still in Father, Dear Father.

I had forgotten that dry ice was actually liquid carbon dioxide and we were all starting to suffocate

The studio session with actress Dawn Addams posing on a water-bed surrounded by coloured lights and swirling clouds of vapour from blocks of dry ice turned into a logistical nightmare. However, despite having to cope with such problems, I found TVTimes to be the perfect first job: it taught me to be resourceful and, perhaps most importantly, philosophical rather than suicidal when things went wrong!

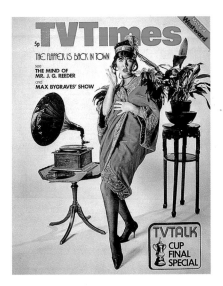

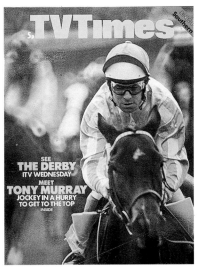

of the stills department at Yorkshire TV in Leeds, who let slip that they needed another photographer on the staff. He was most surprised to get a call from me a few days later, asking if I might be considered for the job. With my proven track record in television, he did not take too much persuading that I was sincere in my desire to leave London and the post was duly mine. I did not let on that I was really contemplating a transfer to the film side of the industry to retrain as a film cameraman; I hoped that already having a job within the company would give me greater leverage when the time came.

Coincidentally, the stills department at YTV was located immediately adjacent to the film crew's office on one side and the *Stars on Sunday* suite on the other. Jess Yates was pleased to see me there, and at least he provided some light relief for what rapidly turned into a nightmare job. I was no longer enjoying taking studio stills, and observed that many of the film crews seemed more interested in the minutiae of overtime sheets and expense claims than the actual programme, leading me to wonder whether I could realistically flourish in such an environment. Trivial though it might appear, I found the childish and almost fraudulent behaviour of some union members abhorrent and knew that if I joined up, but stuck to my principles, I would probably be ostracised as a 'company lackey'.

So I made the decision to sever all ties with television, and opted to work as a freelance in the

Above left: when shooting magazine cover photographs such as the one featuring Amanda Barrie, we were responsible for organising all the necessary props and wardrobe. Fortunately, we were on the doorstep of the West End and theatrical costumiers were just down the road. In those days, antique dealers were quite happy to lend out items when shown a *TVTimes* letterhead.

Above: I had to travel up to Thirsk races in North Yorkshire to capture jockey Tony Murray in action. I used a motor drive on my Nikon and a 500mm mirror lens, and I had to wait until the last race of the meeting before I was finally able to get a clear shot of both horse and rider.

Right: shooting a squash wear catalogue in Tenerife was not exactly high fashion and would have been fairly straightforward had it not been for the girls eating themselves up a dress size and, by the end of the week, being unable to fit into some of the garments.

commercial and advertising sector in Leeds. My lack of experience initially counted against me, but I was fortunate to end up working in a kind of photographic cooperative where I was quickly able to grasp the technical and creative adjustments needed to satisfy the requirements of that particular genre. Due to the varied accounts handled by local agencies, one learnt through necessity to become extremely versatile. One week's work might consist of kids' fashion for a clothing catalogue, machine parts and engine components, nude calendar pictures and Christmas hampers.

Work-related foreign travel became almost non-existent, although I did get a couple of trips abroad to photograph catalogues for a squash wear manufacturer. One of them was shot in Tenerife, based at a smart five-star hotel with a rolling buffet to supplement regular mealtimes. Our two female models had been complaining that the photographer on their last swimwear shoot in the Caribbean had been an absolute bastard, restricting them to little more than lemon juice and water whilst work was in progress. I sympathised with their plight as we queued for yet another plate of

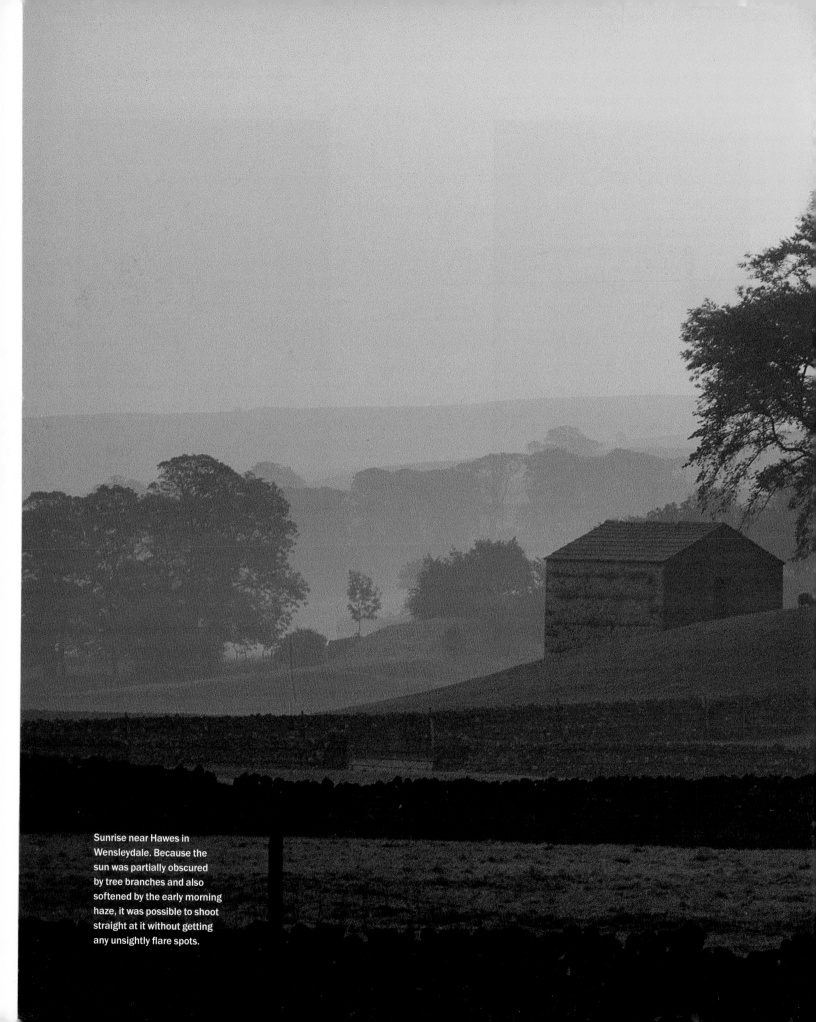

Sunrise near Hawes in Wensleydale. Because the sun was partially obscured by tree branches and also softened by the early morning haze, it was possible to shoot straight at it without getting any unsightly flare spots.

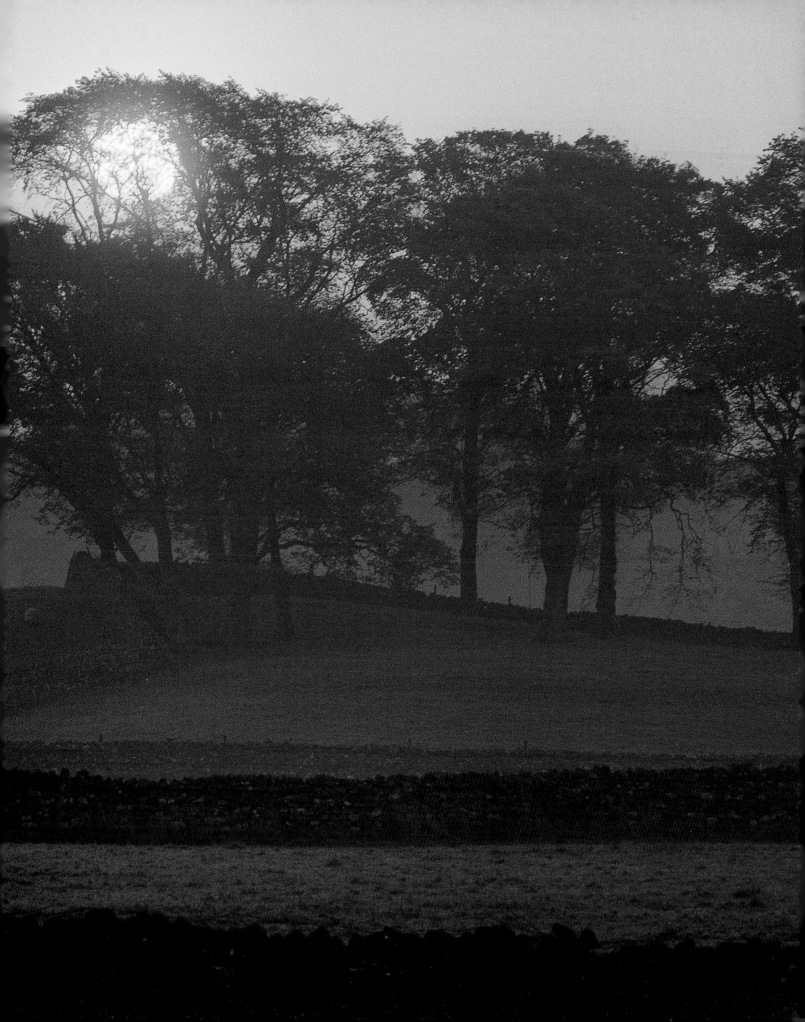

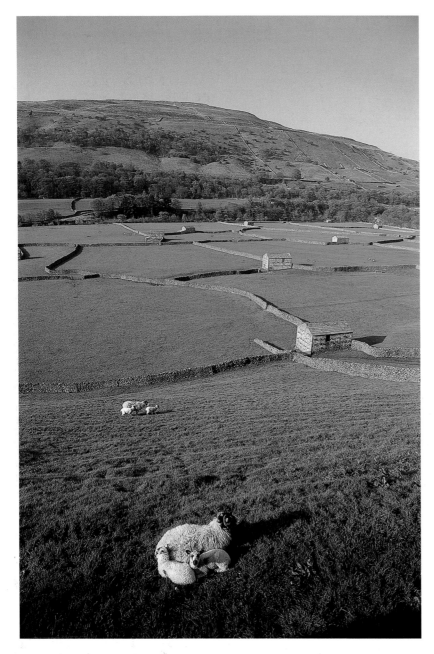

have approximately a year to complete the contract so that all seasons could be represented within the book. Alf began writing almost immediately, forwarding a copy of each chapter to me for reference; although he did not specify precisely what I should photograph, he did assist me by highlighting places deemed most important to the narrative.

Although I was a Yorkshireman by birth, much of my life had been spent outside the county, and apart from occasional day trips the Dales were unfamiliar to me. I was more familiar with the North Yorkshire Moors as we had friends who farmed up near Pickering but, even so, there was much to learn about the two National Parks that formed the essence of the book. The logistics of accomplishing the photography were quite complex, as I was still very much engaged in doing both studio and location work for existing clients in Leeds and Bradford. I learnt over time that there was an inevitability about how my schedule would pan out in terms of weather conditions, the most photogenic days materialising when I was booked to shoot in a dark studio, and inclement ones present in abundance when I was free to work on the book.

Because Alf was busy with his veterinary practice we did not have that much contact on a day-to-day basis, but he was always ready and willing to help with detailed advice on some of the more obscure locations if I experienced difficulty in pinpointing them. We did have occasional forays together so that I could include him in a couple of pertinent photographs, and also one freezing cold session in mid-winter to shoot a specific cover picture but, generally speaking, we worked independently.

Winter was an important season photographically: frost and snow not only added an atmospheric dimension to the landscape, but also emphasised the harshness of the environment in which both farmers and vets had to work. Living in an era when heavy-duty 4×4s seem *de rigueur* for simply transporting children to school on level tarmac roads, it is easy to forget just how arduous it was to cope with adverse conditions back in Herriot's day. One chapter specifically dealt with the problem of snowbound roads, especially those

Above: sheep are obviously an integral part of the Yorkshire Dales landscape at any time of year, but they can also be extremely useful composition aids when one is wanting to fill the void of a vast empty foreground. The ewe with her lambs fulfilled exactly that function near Gunnerside in Swaledale, although she had to be approached with all the stealth of a big game hunter. I could sense that any rapid movement would panic the group and they would immediately take flight.

Opposite: I photographed the bleak Buttertubs Pass linking Wensleydale and Swaledale late one winter's afternoon as the sun was setting. Although the sheep here were not essential, their presence gave an additional sense of scale and balance to the image.

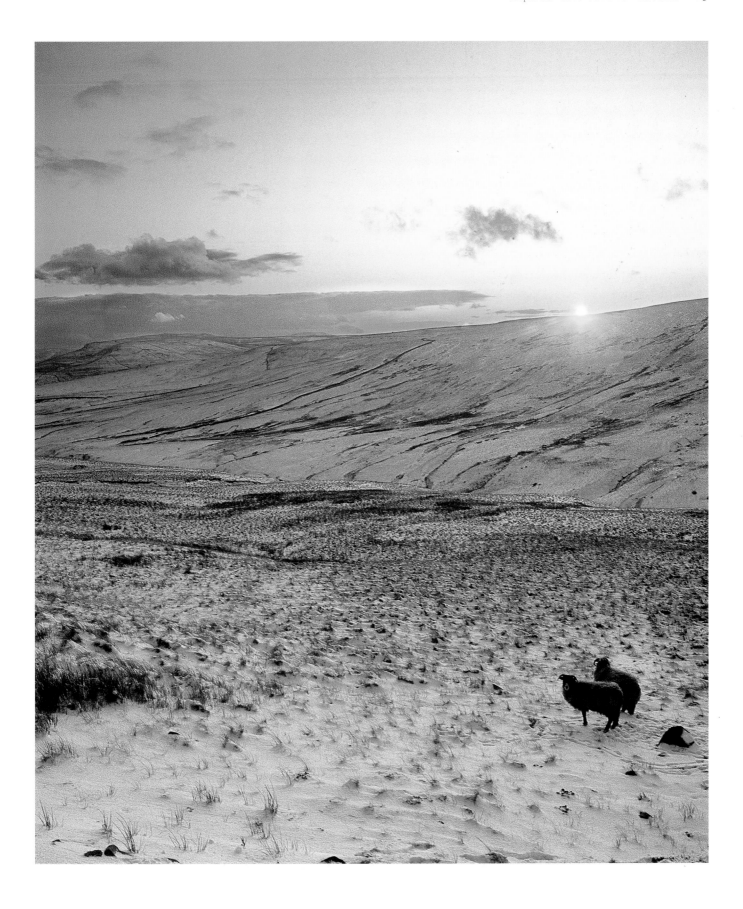

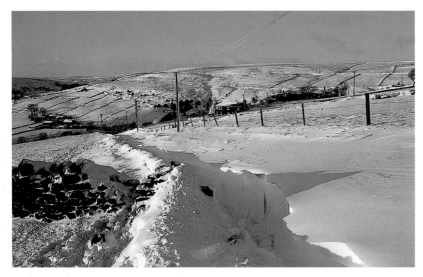

he encountered during the now legendary hard winter of 1947. Nature contrived a reprise for my camera in 1979, and although conditions might not have equalled those of over three decades earlier they made daily life in Yorkshire quite diffi-cult enough.

Simply getting around became problematical, not least because our converted barn high up above Halifax was completely snowed in between January and March of that year. It was extremely fortuitous that when the snowfall first started we had taken the precaution of driving our cars uphill to the nearby village: we had to struggle over fields on foot to get to them thereafter, but at least we had transport to get further afield. My car at that time was a Datsun estate, stable enough but not really endowed with the attributes required for those conditions, and I certainly had more than one or two hair-raising moments out on the wintry roads. I did try to avoid being reckless with my own safety or doing anything that would endanger or incon-venience others, but almost failed on both counts when deciding to explore Bransdale, an exposed part of the North Yorkshire Moors. Access is by a narrow road from Helmsley which, after several miles, plunges steeply down a hill and out on to the open moor. Having survived the descent, I was congratulating myself on finding a superb location when I suddenly met a giant, dark-green snowplough returning from opening up the road for several isolated farms. This was a serious snow-clearing vehicle with a high, lethal-looking,

Above: the road to our Halifax home was snowed under for ages in 1979. It was bad enough having to hump heavy camera bags and tripod through knee-deep snow to our car, but we also had two young daughters, aged two and four, who had to be ferried across the drifts. At least we were lucky enough still to have access to a vehicle, unlike many others who had been forced to abandon theirs in deep snowdrifts. Conditions were atrocious, and many minor roads were blocked for several weeks as priority had to be given to clearing more essential routes.

Opposite: Bransdale, deep in 'Herriot country' up on the North Yorkshire Moors, proved the perfect location for conveying just how harsh rural life could be in deepest mid-winter. Luckily I got a snatched shot of the postman's red Land Rover in the distance – that one dash of colour helped to pinpoint the course of a narrow track carved by the snowplough that I came face to face with a little later.

chevron-shaped blade protruding from the cab in the style of a Canadian Pacific Railroad locomotive.

The path it had cleared through the snowdrifts was as wide as the blade and no more, creating a white single-track road with no passing places. The driver leaned out of his cab, looked down at my patently non-agricultural vehicle and demanded to know what the fucking hell I was doing there. When I sheepishly responded that I was taking photographs, he became quite apoplectic, hurling an even longer torrent of abuse in my direction to the effect that I could effing well take my effing camera, shove it up my effing arse and effing well eff off where I effing well came from. Having got that off his chest, he slammed the cab window shut, revved up the snowplough's engine and started to bear down on me with what would have been described in a court of law as 'malice afore-thought'.

The solid carved banks of snow offered no refuge from the oncoming vehicle and its irra-tionally enraged driver, so my only option was to engage reverse gear and retreat. I could not believe that he would actually run me down but was not prepared to gamble on it and concentrated on steering a straight course. I had not realised that a mile could seem so far, especially as my head and neck were twisted at an unnatural angle as I strove to keep my distance from the pursuing plough. Eventually, I came upon a gap in the snow wall where a tractor had obviously turned earlier and was able to pull in out of harm's way. My tormentor

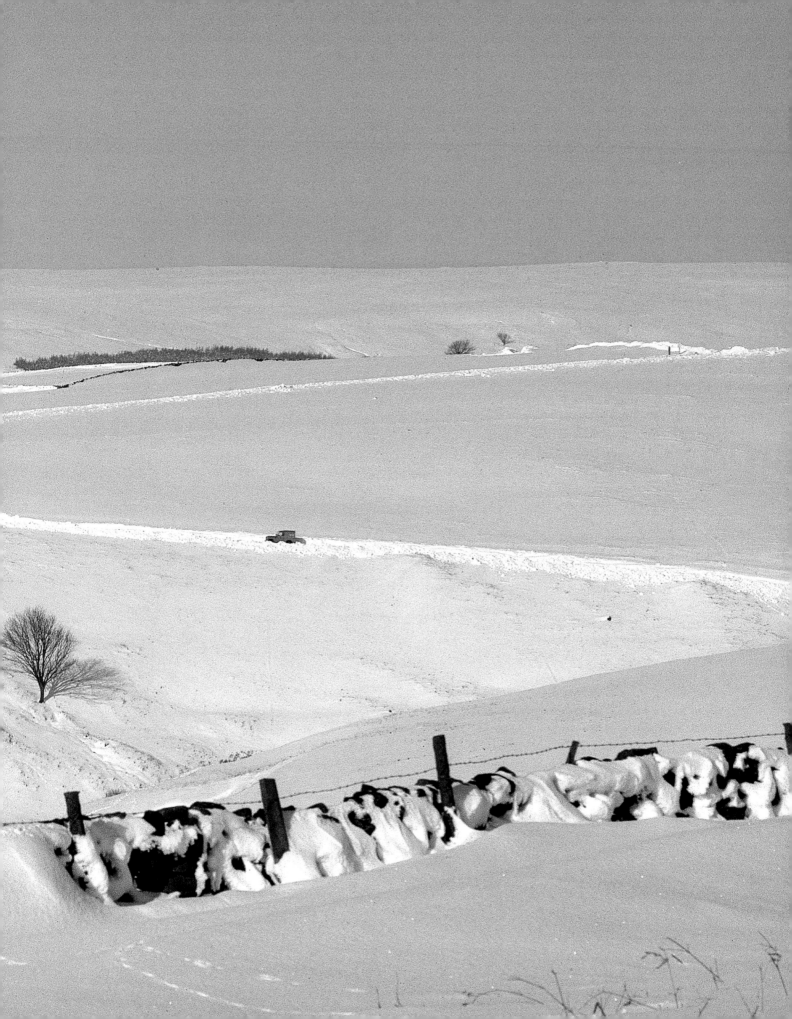

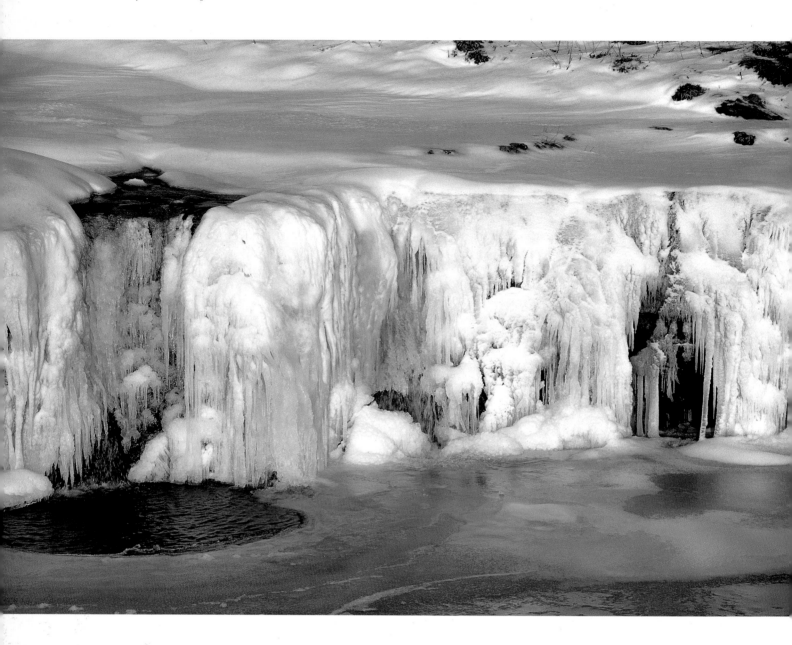

Above: this frozen waterfall on the river Swale near Keld was a visual delight and I opted to maximize its impact by isolating just one section with a telephoto lens. It seems incredible that not so long ago the Yorkshire Dales were able to do a fair impersonation of Siberia. I thought the frozen cascades of water resembled a large candle whose rivulets of molten wax had solidified down its sides.

Opposite: although blanket snow cover can be photogenic, a light dusting can be equally effective. This picture of the river Swale near Reeth is one of my all-time favourites and works particularly well in a vertical format. The barns and curving river bed anchor the bottom of the frame well and the picture then climbs dramatically through the snow line, past a tangled network of stone walls to another cluster of buildings near the top.

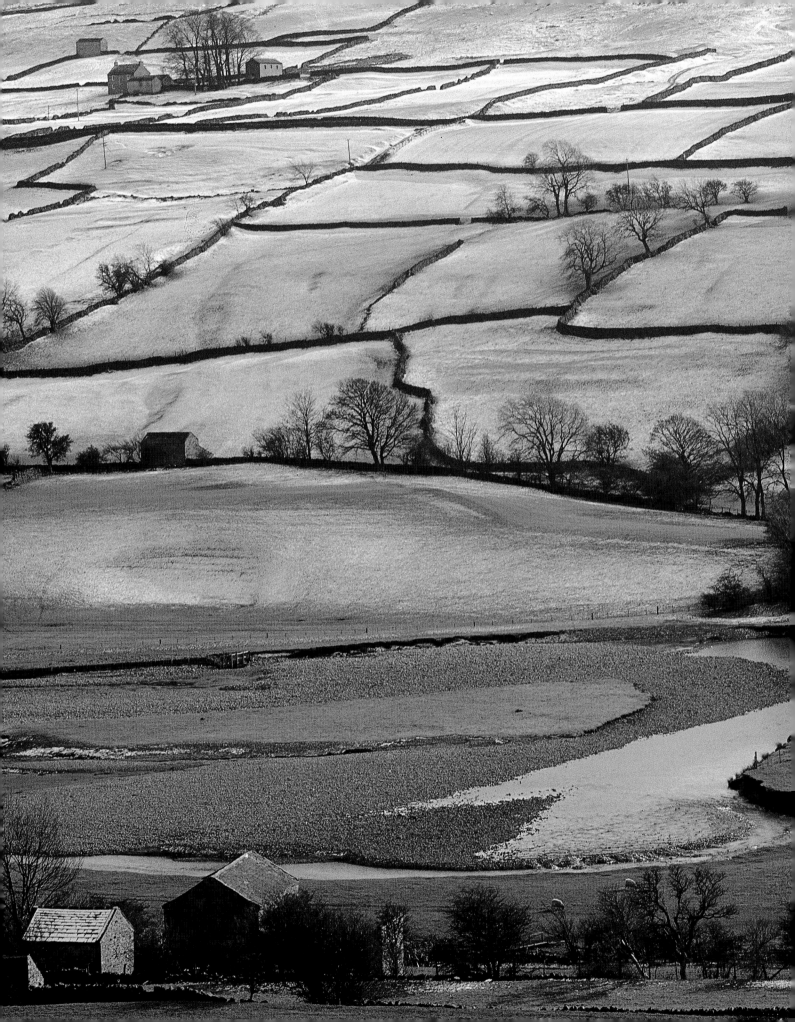

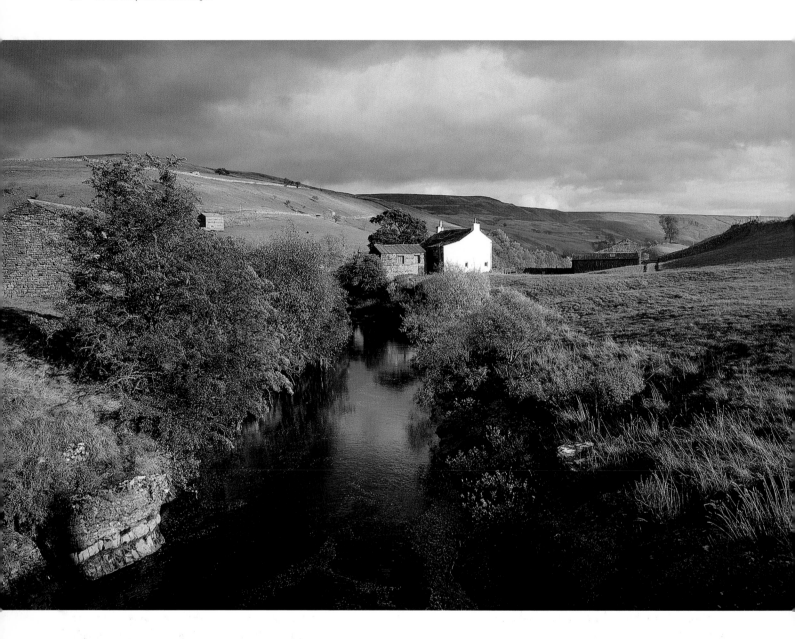

Above: this remote farmhouse on the banks of the river Swale near Keld proves that simple compositions allied with good lighting often make the best photographs. A low sun created rich textures across the landscape and also brightly illuminated the exposed rock in the bottom left corner of the frame, which thereby acted as a visual counterbalance to the searing white facade of the farmhouse.

Opposite: this cover shot for a Silver Cross prams catalogue was significantly easier to execute than some of the inside pages, one of which I was struggling with when I was pleasantly diverted by the arrival of my long-lost snow scenes for 'Herriot's Yorkshire'. A recently fed baby is a quiet and contented one, and I was fortunate that my beautiful model was also the mother – and so tranquillity reigned.

sped on past without even pausing for a farewell obscene gesture.

Having survived that particular incident and other physical ordeals in the snow, I then had to endure weeks of mental torment when the batch of exposed Kodachrome film went missing, either in the postal system or within Kodak itself. I was on the verge of a nervous breakdown, knowing that somewhere there were twelve rolls of film containing priceless images that could simply not be re-shot. Some three weeks later, I was just gaining the upper hand in a battle of wills with a baby who was vociferously expressing a desire not to be photographed in a Silver Cross pram when the postman deposited a parcel of processed film on the office table. Nobody could explain where it had been in the interim, but every single one of my precious snow pictures had been returned intact. I was so moved that I kissed the wailing brat, an act of folly that resulted in an immediate doubling of the pram's decibel output.

Looking back through some of those early landscapes, I readily acknowledge that many could have been better. In mitigation, *James Herriot's Yorkshire* was my first serious attempt at the medium, and my understanding and interpretation of weather conditions and their effect on the prevailing light was to improve. Happily, the world's book-buying public did not share my reservations and bought the book in huge quantities, making it number one in the best-sellers' list for weeks on end. As I was not on a royalty contract, sales figures were irrelevant to me (albeit somewhat galling), but at least my foot was firmly wedged in the publishing door.

That first successful foray into the 'Somebody's Somewhere' formula of the illustrated book market resulted in Michael Joseph inviting me to photograph a similar volume on Wales with Wynford Vaughan Thomas. The regular trips from Yorkshire to cover all parts of the Principality became something of an endurance test, but any inconvenience was readily outweighed by the sense of adventure in exploring somewhere totally new, allied to the sheer pleasure of doing the work I loved and being able to spend so much time in Wynford's company. When I started the project, I had not fully realised how much of a national hero he was, greeted by all

I was so moved that I kissed the wailing brat

and sundry as a long-lost friend. The only problem was that we were mostly travelling around in Welsh-speaking areas so I was instantly excluded and left to wonder what they were chattering about. Listening to the language being used in everyday conversation was quite wonderful as it sounded so lyrical, though I could not comprehend how so many long words contained but a single vowel.

I spent considerably more time with Wynford than any other author I have worked with, and it was a sheer delight to be in the company of such a wonderful raconteur who brought Welsh history to life with a remarkable depth of knowledge and lightness of touch. Apart from occasional paranoia over being talked about in a foreign language, the only other times I experienced a sense of unease were when I was being driven around in his vast Volvo estate car. Wynford propelled it through the rural towns and villages of South Wales as though it were a tank on manoeuvres and the number of battle scars down the vehicle's sides bore testimony to his cavalier attitude to assorted roadside obstacles. It was not that he was a bad driver, merely that he needed at least one hand to conduct a conversation properly and, during more animated sequences, he had to maintain direct eye contact with his listener rather than with the road ahead.

The book was executed in much the same way as *James Herriot's Yorkshire*. I would receive chapters of text and illustrate them in my own time, scheduling trips to Wales in between my other commitments. There were, however, numerous locations that he insisted we visit together as they were so obscure he deemed it unlikely that I would be able to pinpoint them unaided, hence our sorties in the 'blue tank'. Wynford was intensely proud of his homeland and it felt as though he was so intimately acquainted with every square mile that no view ever came as a surprise. He took great delight in chauffeuring me up long, sinuous, tree-lined roads that would abruptly burst out into open countryside with a magnificent panorama spread out below. After leading me to an appropriate vantage point, my guide would extend an arm towards the horizon and utter a phrase that I would become accustomed to hearing over the months: 'There you are, dear boy, now exercise your art.'

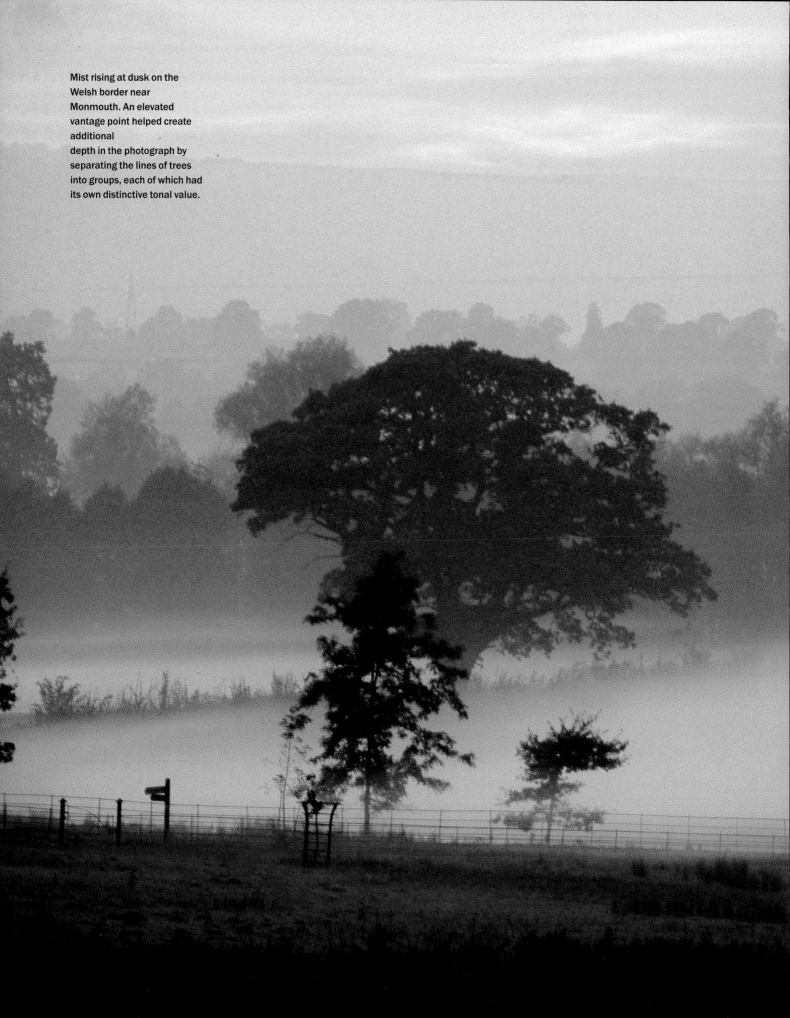

Mist rising at dusk on the Welsh border near Monmouth. An elevated vantage point helped create additional depth in the photograph by separating the lines of trees into groups, each of which had its own distinctive tonal value.

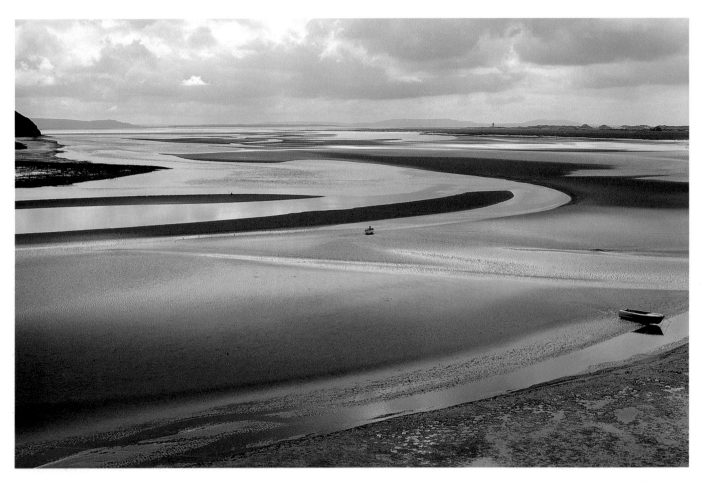

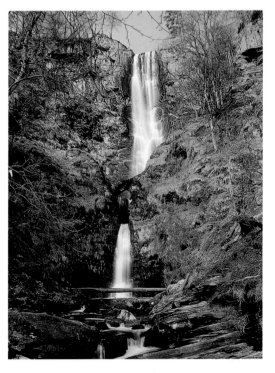

Above: the Laugharne estuary from Dylan Thomas's workroom, enhanced by the interplay of sunlight and shadows across the exposed sand flats. It would have been a much less atmospheric image had I been there at high tide and been confronted by a solid sheet of water.

Left: the greatest waterfall in Wales – Llanrhaeadr-ym-Mochnant – needed a telephoto lens and a careful camera position to capture its drama and majestic setting.

Opposite, above: the 'Green Bridge of Wales' on the rugged Pembrokeshire coast necessitated a nervous crawl on all fours to the cliff edge in order to get a clear shot.

When we were working together, I would either rendezvous with him at a pre-arranged location somewhere in mid Wales, or drive all the way down to Fishguard and stay with him for a few days. I shared many convivial evenings with Wynford and his wife Charlotte, although there were some mornings when I regretted excessive consumption of their most generous liquid hospitality. Hangovers were never helped by Wynford's insistence on cooking omelettes for breakfast, as his technique involved frying a large knob of butter in the pan until it was black and smoking, filling the kitchen with acrid fumes which did little to improve one's fragile state.

In 1981, Wynford took me to Cardiff Arms Park for that greatest of all confrontations, a rugby match between Wales and England. Despite the fact that supporters of the oval ball game tend to be notably less hostile towards visiting supporters than their soccer counterparts, it was impressed upon me that I would be better off transferring my

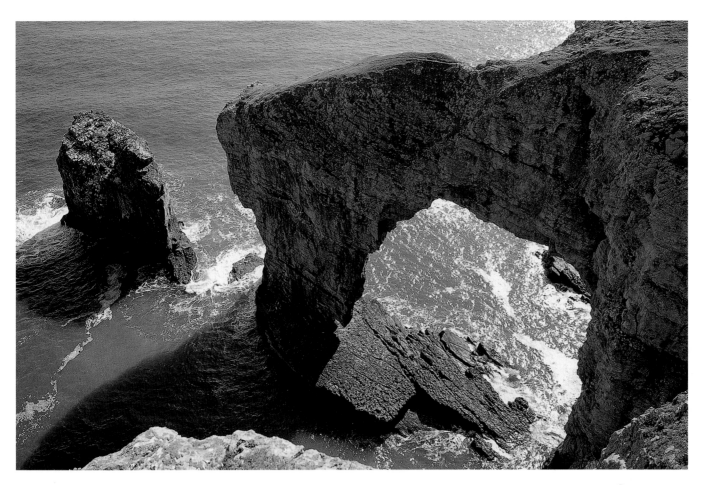

allegiance to the red jerseys for the day. On the obligatory pub crawl around seething city centre bars near the stadium it was patently obvious I was not a native, but as I was with Wynford I was granted temporary political asylum. To be actually inside that legendary stadium when the crowd sang 'Land of my Fathers' was an intensely moving experience. I was happy and proud to be an honorary Welshman for the day and able to rejoice in a notable victory for the home side.

The mountains of Snowdonia featured prominently in the book, but I managed to get away with having to make only two or three serious expeditions on foot. Through judicious use of a decent telephoto lens, I was able to give the author the pictures he needed without too much traumatic rock-climbing. I remember making one valiant effort to get some atmospheric sunrise photographs on Snowdon by setting off in darkness and following the mountain railway's faintly glinting tracks up towards the summit. As dawn broke I

Menu of slate sizes and prices in an abandoned quarry office at Blaenau Ffestiniog. In addition to photographing evidence of the large-scale operations, it was important not to neglect such more intimate details.

thought I had gauged the weather correctly and was about to enjoy perfect conditions – but with almost no warning, swirling banks of cloud and hill fog enveloped the surrounding hills and made a beeline for my position, obliterating everything in sight within seconds. Despite having to cope with that and many similar setbacks, I felt that my landscape photography was improving with experience, although the weather in parts of Wales was significantly more fickle than I had encountered in Yorkshire.

The final book in that 'personality' trilogy took me even further away from home when I collaborated with TV newsreader and presenter Angela Rippon for a book on the West Country. Devon and Cornwall are not exactly adjacent to North Yorkshire, so on two or three occasions we decamped *en famille* for working holidays, during which Madeline and the girls enjoyed days by the sea whilst I dashed around the countryside with my cameras.

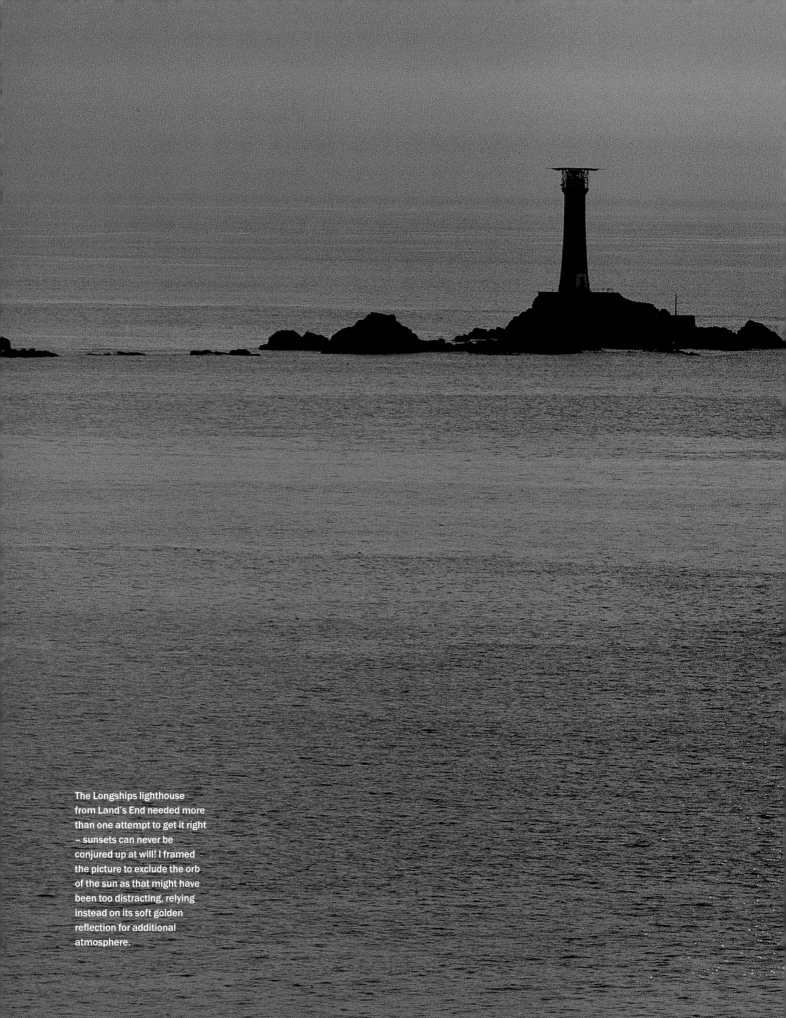

The Longships lighthouse
from Land's End needed more
than one attempt to get it right
– sunsets can never be
conjured up at will! I framed
the picture to exclude the orb
of the sun as that might have
been too distracting, relying
instead on its soft golden
reflection for additional
atmosphere.

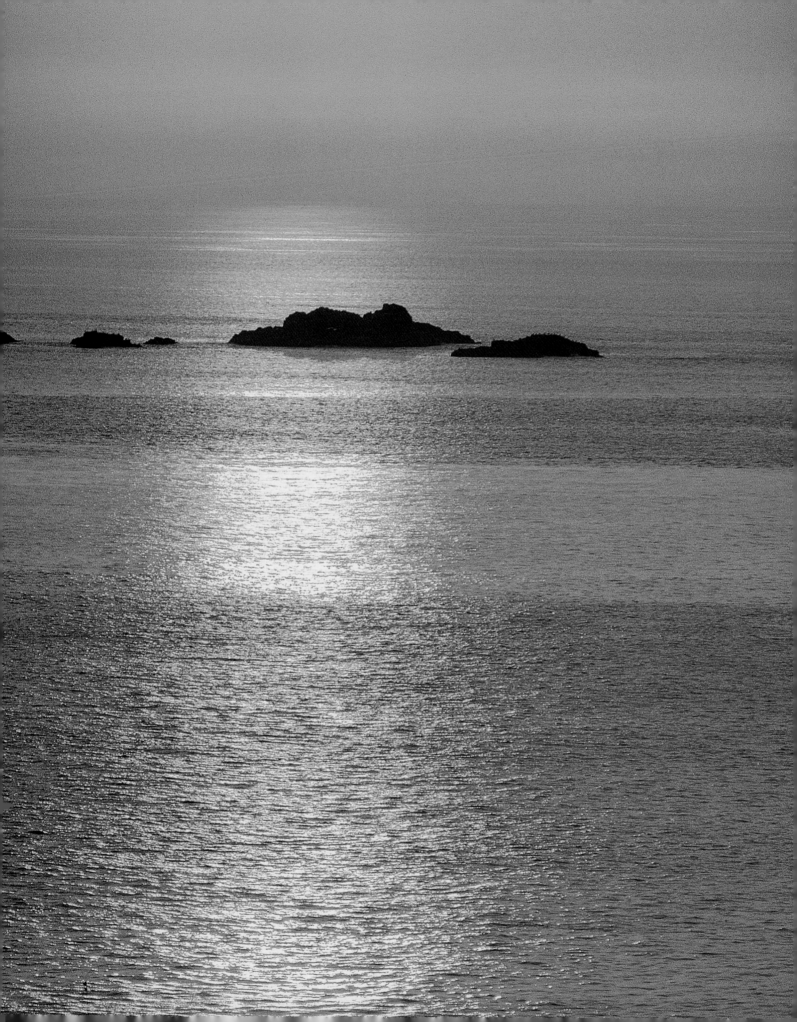

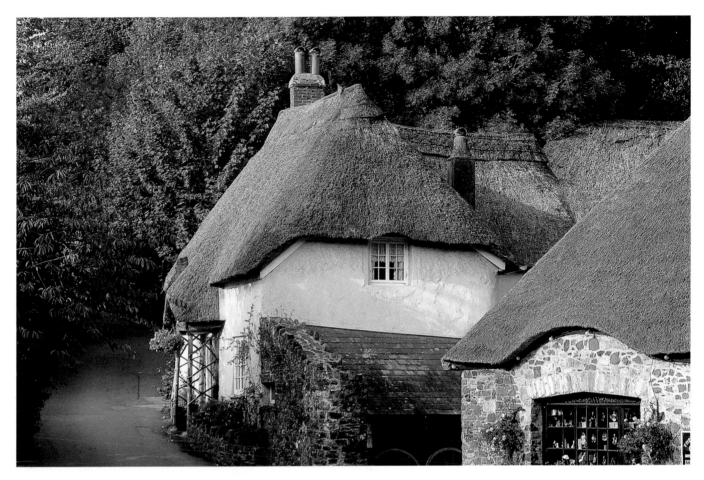

Although the process of commuting to work in Cornwall was tedious in the extreme, the photography was really enjoyable, but it was deeply frustrating to have to undertake 800-mile round trips for little reward when the weather suddenly decided not to cooperate. Long-range forecasting was nowhere near as accurate as it is now, and there was always a huge element of chance attached to any photographic mission. When conditions did fall in my favour, the light was absolutely stunning and of a completely different quality from other parts of England. I could readily understand why so many artists chose to colonise St Ives.

Angela Rippon's West Country may not have been as well received as Wynford's Wales, but it was a catalyst for my future career. I was at that time running a studio in Leeds with another photographer, but my extended absences on editorial projects meant that I was not pulling my weight in the business. In fairness to all concerned, I had to commit myself

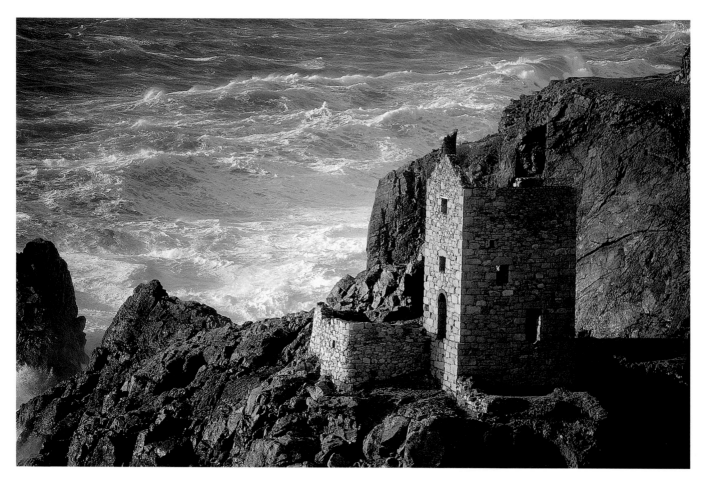

Opposite, above: thatched cottages at Cockington, Torbay, Devon, photographed early in the morning for the best directional lighting on the buildings themselves and also to avoid getting any human clutter in the picture.

Opposite, below: traditional cottages with brightly painted doors in Appledore, Devon. By using a telephoto lens, I was able to create a concertina effect to maximise the impact of the different colours.

Above: a high tide lashing the rocks, and sunlight on the seaward face of the building, gave greater impact to this photograph of the Botallack tin mine engine house on the north-west Cornwall coast.

one way or the other. After much soul-searching, I realised that I had enjoyed the freedom and challenges posed by those three books, and decided that being on the road with a camera and locking horns with the elements was far closer to my original *National Geographic* ideal than hampers, bare breasts and beefburgers.

Severing my ties with the studio and going solo once more was both terrifying and exhilarating. By this time I did at least possess the most valuable commodity a freelance can have – a proven successful track record in the business. All I had to do was find the next project, and I spent many hours browsing in bookshops and libraries, seeking a spark of inspiration to kindle the flame of progress. I came across several guidebooks on the Pennine Way long-distance footpath, all of them fairly practical and generally illustrated only with mediocre-quality black-and-white photographs. Few of the pictures did justice to the landscape, with far too many showing bearded chaps wearing bobble-hats

leaning nonchalantly against assorted stiles and stone walls twixt Edale and the Scottish border.

It was 1983, and I had noted that the date of the official opening of the Pennine Way was 1965. It always helps when making a proposal to have a suitable peg on which to hang the idea – and so 'Happy Twentieth Birthday Pennine Way' it was. I drafted an outline synopsis to Michael Joseph in the hope they would consider extending our already successful association by investing in another illustrated book. My suggestion was that such a landmark anniversary should be celebrated by showing the dramatic, wild countryside that runs up the Pennine backbone of England in full colour. At that initial stage, I had given no thought whatsoever as to who might provide the book's text, my sole concern being to sell the idea and have it adopted as a viable project. If it did find favour, a suitable author would have to be found.

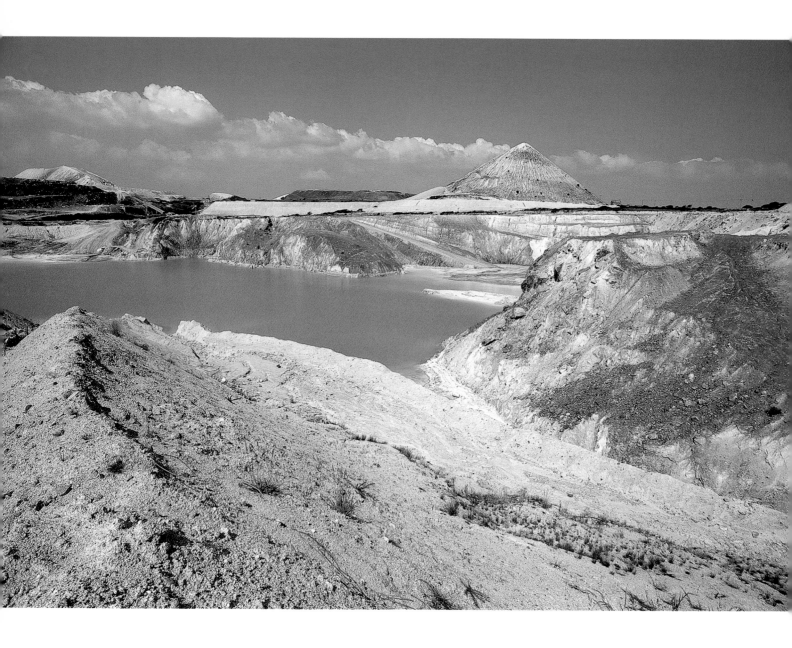

The china clay spoil heaps near St Austell have been called the 'Cornish Alps'; I used a polarising filter to maximise the effect of such a surreal environment. This not only darkened the sky and threw the clouds into sharper relief, but also emphasised the vibrant turquoise colour of the flooded pit.

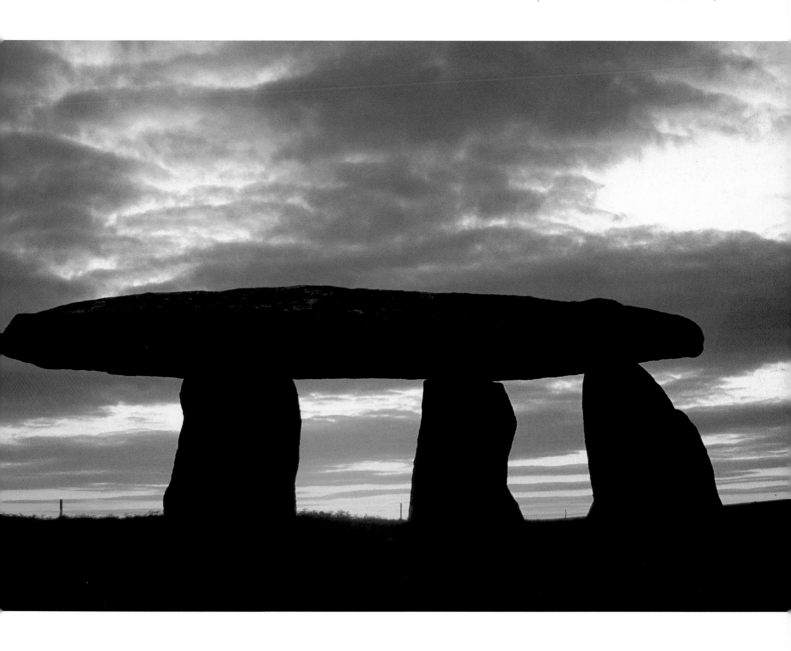

By using a very low viewpoint to throw the subject into clear silhouette, I was able to emphasise the dramatic construction of Lanyon Quoit, a Bronze Age cromlech in west Cornwall. On location well before sunrise in the hope of getting a dramatic sky, I was duly rewarded for my early start – although it could just as easily have rained!

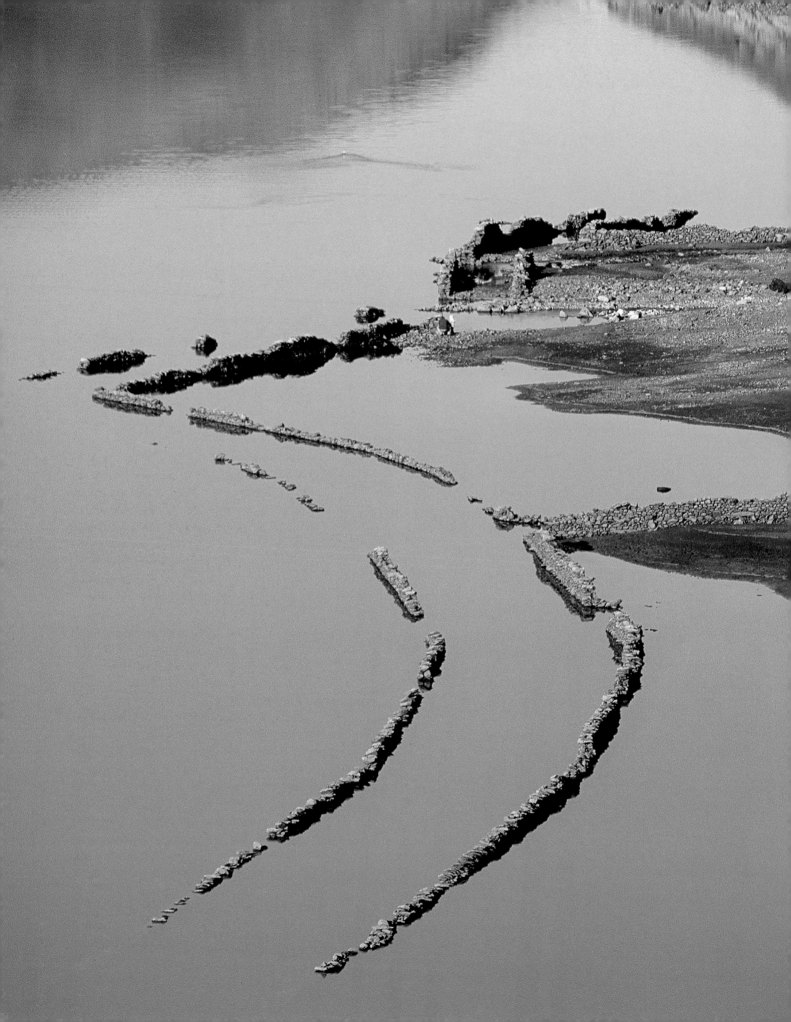

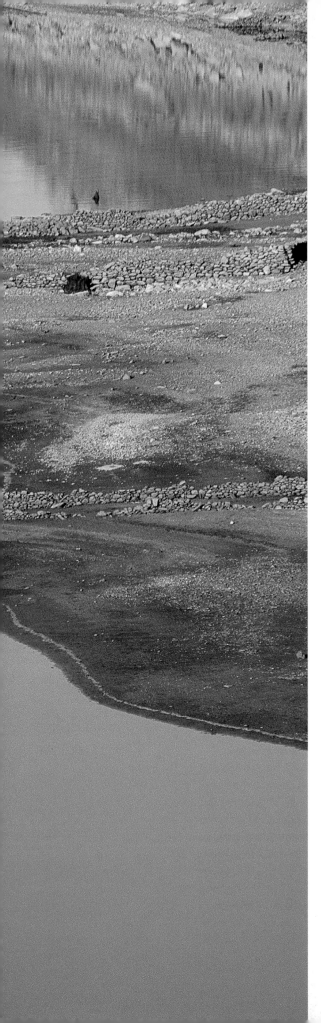

Mardale Green was buried beneath the reservoir of Haweswater, but during periods of drought, when water levels fall dramatically, some surviving sections of wall are poignantly exposed.

Chapter Two

ALFRED WHO?

I was pleasantly surprised to receive a positive response to my Pennine Way proposal from Jenny Dereham, the editorial director at Michael Joseph. She informed me that although it had been enthusiastically discussed at the monthly editorial meeting, nobody had been able to suggest a suitable author. If the book were to continue in the same vein as my previous titles, it would require a well-known personality, writer or broadcaster whose name was synonymous with walking or related outdoor pursuits. Although several prominent northerners were put forward as possible candidates, none was really thought to have the necessary literary credentials. The book's future was in a parlous state.

Extraordinarily, it was my original publishing 'fairy godfather', Victor Morrison, who once again waved his wand in my direction. Having previously taken a gamble by employing an unknown photographer to illustrate *James Herriot's Yorkshire*, he once again came up trumps on my behalf when he suggested that Alfred Wainwright was the only person seriously worth considering as author. Even though he had retired from Michael Joseph, Victor kept in regular touch with Jenny, and during one of their chats she had aired the Pennine Way problem, hoping he might have some helpful suggestions. As a keen walker who had actually tackled the Pennine marathon using AW's original *Pennine Way Companion*

as his guide, he had no doubts that the enigmatic man from Kendal would be the solution, regardless of the fact that AW probably had contractual obligations to the *Westmorland Gazette*, publishers of his *Pictorial Guide* series and other sketchbooks.

At any other time such an approach might have been rebuffed, but it was fortuitous that Jenny's proposal letter coincided with the attempts of AW and his wife Betty to raise funds to secure a permanent home for their animal rescue charity. The initial tentative proposal contained the synopsis of my Pennine Way idea and a copy of *James Herriot's Yorkshire*, not only to highlight my photographic skills, but also to give an example of how a collaboration might look in terms of size and content. We obviously hit the right spot at the right time: a positive response was received almost by return post, summoning us to a face-to-face meeting to discuss matters further. We expected to be invited to the Wainwright stronghold in Kendal, but were instead instructed to meet them at a Buxton hotel in the heart of Derbyshire's Peak District. They were spending a few days there while AW did some work on a new sketchbook for the Gazette, and had considerately reasoned that it would be significantly less distance for Jenny to travel from London.

Not having seriously walked in the Lake District (or anywhere else for that matter), I was unfamiliar with the name of Wainwright. I immediately went off to scour the shelves of local bookshops for examples of his work, eventually locating a couple of *Pictorial Guides* in an outdoors equipment suppliers. The meticulous handwritten pages adorned with perfectly drawn pen-and-ink illustrations captivated my imagination. As none of the books bore a photograph of the author, I wondered what such an artist might be like.

It is now over twenty years since our first meeting in Buxton, and in that time I have done a great deal of travelling over the length and breadth of England: I can now make a fairly accurate prediction about the journey time from Harrogate to just about anywhere. However, back in 1983 I was not quite so conversant with the complexities of our road network: I failed to allow sufficient margin for error, and committed the cardinal sin of being late for our meeting. Punctuality is one of those common courtesies so vital to creating a good impression and I had blown it, leaving Jenny to hold the fort with embarrassing small talk in my absence. I was rapidly to learn that AW did not like chatter for the sake of it; if one had nothing useful to say, silence was always the better option.

Tea-time in the hotel lounge was a hectic affair. I entered the vast room to be confronted by a mass of faces and a wall of sound as the occupants of each table raised their voices to be heard above the conversations of their neighbours. I hurriedly scanned the room and eventually caught sight of Jenny, her facial expression and body language exuding angst in my direction. Although I was not really that late, it was apparently quite late enough and AW had been making disparaging remarks along the lines of how 'people who could not tell the time could not be trusted with anything'. The Wainwrights had their backs to me as I approached the table. Having offered profuse apologies, I sat down next to Jenny and took stock of my companions.

The contrast between them was quite startling. Betty appeared fragile and tiny next to the sprawling bulk of AW, whose outfit that day would vary little in style or content over the ensuing years of our partnership. A quilted jacket covered a woollen jumper whose frontage was randomly pockmarked by small burn holes, the obvious culprit being the pipe that lay with a tobacco tin on the table in front of him, alongside that other Wainwright trademark accessory, a flat cap. From that day onwards, I cannot recollect a single occasion when he was not attired in the same manner, although there must have been times when Betty had to force him into reluctantly wearing formal shirts, ties and jackets for public appearances and business meetings.

The mood around the tea-table lightened as we discussed the possibilities of doing the book. I spoke about my experiences of photographing the Yorkshire Dales for the other Alfred, offering some initial thoughts on how the Pennine Way could be illustrated. Jenny talked about the business aspect of the project and was quizzed by Betty on certain details, with AW taking it all in but saying very little. It was then agreed that a breath of fresh air would be a good idea and we drove over to Edale and the start of the Pennine Way itself. It was a cold,

The meticulous handwritten pages adorned with perfectly drawn pen-and-ink illustrations captivated my imagination

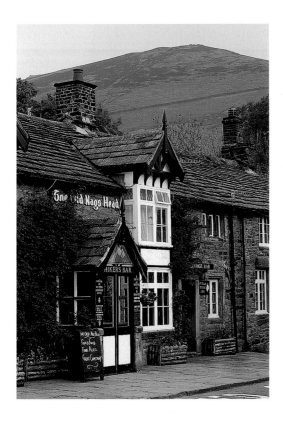

grey, wet and uninspiring day; the car's windows, steamed up by our collective heat, obscured what limited views there were through the murk. We parked near the Nag's Head pub, which marks the official start of the 250-mile marathon, crossed a narrow footbridge and sauntered along the well-worn path that in a couple of miles rises steeply up to the bleak plateau of Kinder Scout.

Our pace regulated by AW's steady lumbering gait, we gently dawdled along, being regularly overtaken by groups of walkers. Some sped by carrying small packs, just big enough for a water-proof, water-bottle and sandwiches. Others passed more slowly, their shoulders hunched against the weight of much heavier rucksacks, with dangling cooking utensils and tightly rolled camping mats indicating that they were destined for considerably more than a picnic lunch and an afternoon stroll. Some of those long-distance walkers seemed burdened by more than heavy equipment, their faces deep set and focused as they prepared to face what might be the most serious physical and mental test they had yet endured.

We spoke about different sections of the walk: some sounded familiar from other projects, but

mostly the names of hills and villages he men-tioned were unknown to me. Upon our return to the hotel, we sat down to confirm formally what had been tacitly agreed earlier, but neither Jenny nor myself was prepared for what AW actually proposed. He revealed that he had been head-hunted by another organisation to do a colour book on the Lake District; he had silently mulled it over during our walk, and had decided to offer us the opportunity of doing it instead. We were just digesting that unexpected bonus when a discon-certing *caveat* was added, namely that as the Pennine Way anniversary was still two years away his own book of walks illustrated with my photographs should be done first. Although it was not actually said out loud, the inference was that we either accepted both books there and then, or would probably drive away empty-handed. Who says blackmailers never flourish!

Jenny thought it was great news, as she could return triumphant with a double deal; but I could see only aggravation and torment by having to cram so much into less than 24 months. The fact

Above: the Nag's Head in Edale, official starting point of the Pennine Way and where many glasses of 'Dutch Courage' have been sunk by those about to embark upon the marathon trek.

Right: as the ancient pack-horse bridge near the Nag's Head lies almost buried beneath trees, I was actually pleased that there was no sunshine on my first visit: any contrast between light and shade would have rendered it virtually unphotographable.

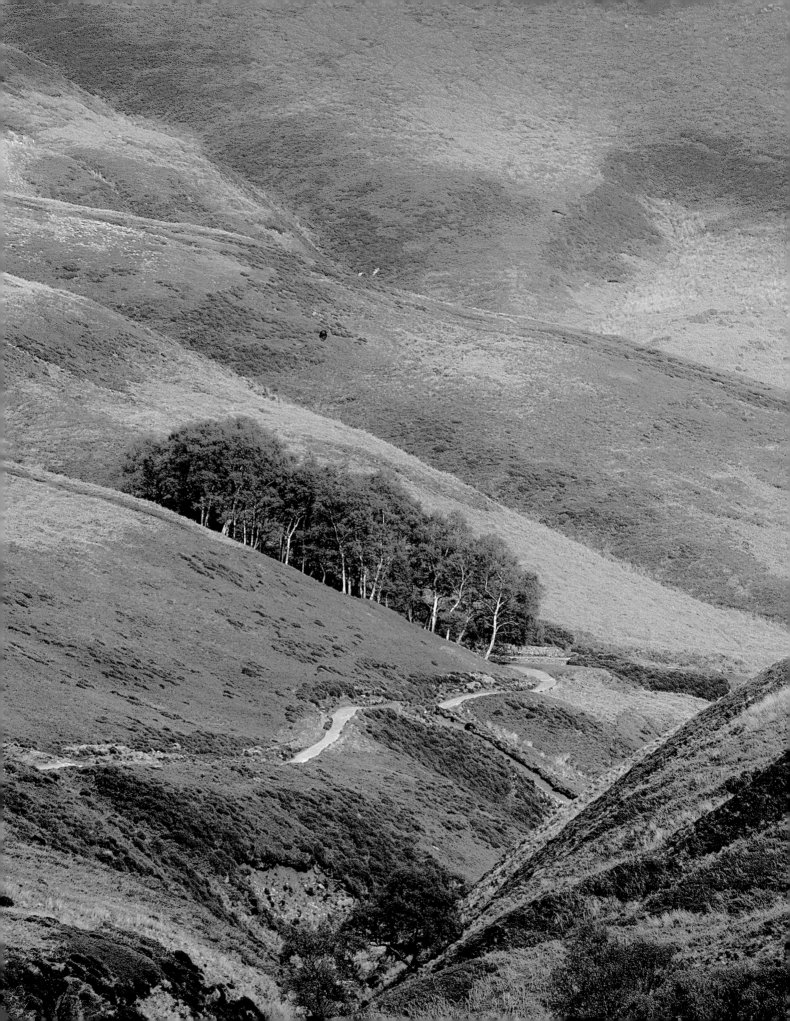

that I had never set foot on the Lakeland Fells, let alone done any serious mountain-climbing, was briefly touched upon but just as rapidly glossed over. When you are self-employed you never look a gift horse in the mouth, even though you know it could inflict a nasty bite. I knew the Pennine Way required a degree of stamina and would certainly involve rough walking and scrambling in places, but leaping around mountain crags and clinging to the edge of precipices in the Lake District had not been part of my plan. I don't do heights! I did not like being too far away from sea level then and nothing has changed since – one just gets used to coping with it. For me, a routine domestic chore that requires the use of a ladder is transformed into a tortuous, rung-by-rung, white-knuckle climb. So the prospects of enjoying a day out on a Cumbrian mountain were comparatively slim.

As I stood in the hotel car park, however, it was the time factor that most concerned me. Obviously I was excited at the prospect of being gainfully employed, but given my experiences of the English climate while shooting the previous landscape books, I was worried about just how much had to be accomplished within a restricted time frame. Although rapid improvements in printing technology meant that even the most complex illustrated books could be got through the design, reproduction and printing process in a matter of months, the immovable feast of the Pennine Way anniversary in June 1985 gave us little in the way of latitude in our schedules. However, the sky did not fall in the following morning; in much the same way that anticipated onslaughts seldom materialise immediately after a declaration of war, there was a tranquil period in which to take stock.

While contracts were being drawn up for what would eventually be published as *Fellwalking with Wainwright*, I decided to familiarise myself with the Lake District. I made several preliminary trips to various parts of the National Park, but restricted myself to superficial orientation rather than serious walking expeditions on any one particular mountain. I also resolved to try to discover more about the remarkable man who had obsessively dedicated his life to producing those incredible books. Wainwright's birth, childhood and upbringing in the Lancashire mill town of Blackburn have been well

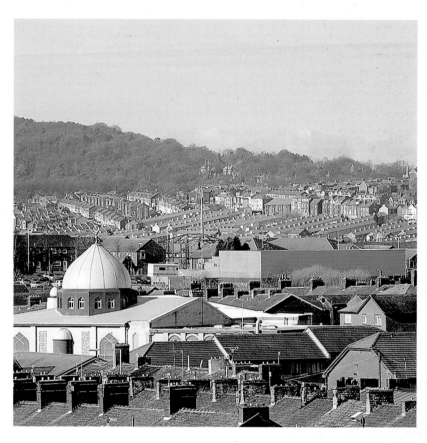

Opposite: a retrospective view of the Pennine Way's initial stages from the Nag's Head, using a telephoto lens to isolate one dramatic section of the steeply rising path. With the sky excluded, the eye remains firmly focused on the central part of the image.

Above: in Blackburn, Lancashire, a brightly coloured mosque stands out amid the old red-brick buildings. It was quite difficult to find a high vantage point from which to put the two contrasting elements into context.

documented elsewhere. I recently paid a visit to Blackburn and wondered whether AW would still recognise today's town if he popped back because, although its setting amid the Pennine hills where he roamed as a child has not changed, the skyline most certainly has. Tall, smoke-blackened factory chimneys are no longer the dominant feature of Blackburn's urban landscape – now it is the domes and minarets of brightly tiled mosques that take the eye, their elegant facades gleaming proudly amidst drab, red-brick surroundings. Ewood Park football ground, home of his beloved Blackburn Rovers, has been transformed into a vast modern stadium in keeping with soccer's elevation from mere sport to multi-million pound entertainment industry. At the time of writing in 2004, his team are actually well below the top flight – and until the manager of Rovers accepts that his team cannot really set the league alight until he buys a centre-forward named Roy, it may continue to under-achieve!

Around Blackburn's inner ring road, industrial and retail parks clutter the sites once occupied by

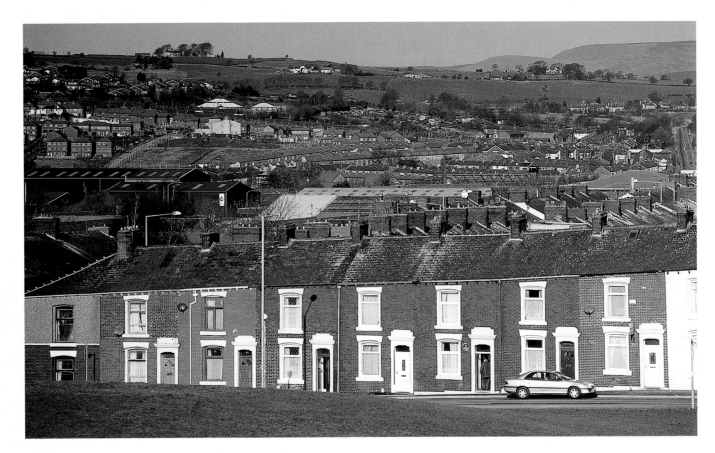

cotton mills. But away from the centre some streets of terraced houses remain, although even they are being gradually replaced by more modern dwellings. Audley Range was AW's road and one wonders how such a naturally self-effacing man would react at seeing a celebratory blue plaque affixed to the wall of number 331, marking it as the place where Alfred Wainwright entered the world on 17 January 1907. Wholesale changes have taken place in its vicinity: the house now looks out over a green landscaped area that was once tightly packed with housing. It might even be the plaque's presence that prevents that particular terrace of houses from being razed. AW would also now have difficulty in tracking down the traditional fish-and-chip shops of his childhood, that particular brand of fast-food outlet being now outnumbered by places offering takeaway pizzas or kebabs.

Having extensively explored his own region on foot, AW made his first journey to the Lake District when he was twenty-three. Every visit thereafter was tantamount to a pilgrimage, as his life became increasingly dedicated to worshipping at one of

nature's most alluring shrines. In this age of the car, we take our ability to move around the countryside at will for granted, but although Blackburn is only some sixty miles from the fells, in those days merely getting to the starting point of any walk would have been an expedition in itself. AW went on a week's holiday in 1930 with a cousin; it was the first break he had ever taken away from home. The bus journey north from Blackburn up the A6 trunk road towards Lancaster and Kendal must have been an exciting experience for the two young men. The chimneys and grime of industrial Lancashire would have gradually been replaced by more pastoral landscapes and the shimmering expanse of Morecambe Bay, beyond which the grey serrated line of the Lakeland Fells assumes an ever more prominent place on the horizon.

AW had researched their expedition meticulously, deciding that Orrest Head, a well-known vantage point near Windermere, should be their first objective when they alighted from the bus in Windermere. For a first-time visitor it is just about the most perfect place from which to get an intro-

Above: Wainwright's birthplace on Audley Range is marked by a blue plaque. Instead of simply doing a close-up shot of the house, I opted for a longer view that gave more visual information about both the immediate surroundings and Blackburn's Pennine setting.

Opposite: Orrest Head above Windermere was Wainwright's first ever view of Lakeland (the information board was not there on his initial visit!). I used a polarising filter both to darken the sky and to enrich the natural colours of the landscape.

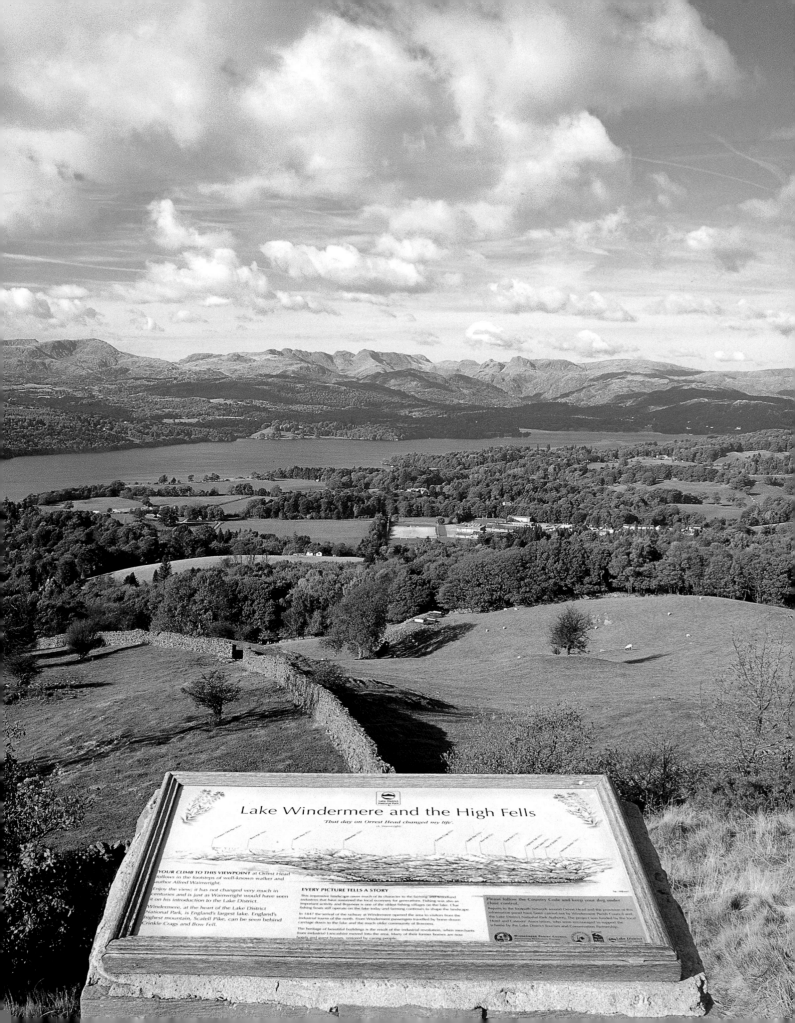

duction to the area, being one of relatively few natural viewing platforms easily accessible to the casual pedestrian. It was not until recently, when I started retracing Wainwright's footsteps, that I made my own belated visit to Orrest Head and was able to appreciate fully why he went into such raptures over the view set out before him.

The great thing about a visit to Orrest Head is the element of surprise. The path from Windermere's main road winds steadily up through a quite densely wooded hillside, giving no warning of the breathtaking panorama that is unveiled when the track finally breaks out into open country. Fields and trees drop away from the rocky outcrop towards the lake's shore, beyond which a jumble of different shaped summits dominate the skyline. AW was able to recognise the distinctive outline of the Langdale Pikes from photographs published in a book, but the other mountains were anonymous on that introductory expedition. It is difficult to comprehend the single-minded resolution that became part of AW's psyche from that first day onwards, transforming him from an over-awed onlooker into a dedicated explorer who would ultimately chart just about every square inch of the Lakeland Fells.

Although I had heard nothing from either Kendal or London in the immediate aftermath of our meeting in Buxton, there had apparently been some fairly heated postal exchanges between AW and Jenny regarding the dimensions, number of pages, design and page layout of *Fellwalking*. Our editor had not fully appreciated the fact that her new author was also a one-man publishing industry and, as far as he was concerned, the only correct way to produce an illustrated book was the Wainwright way. I was eventually drawn into the debate and received copies of the most pertinent pieces of AW's correspondence, some of which exhibited more than a hint of childish petulance.

Publishers generally work on the basis that contracted authors will deliver a manuscript by a specified date and, apart from revisions and other editorial matters, their further involvement in the book's gestation will be minimal. The design, layout and choice and placement of illustrations are usually handled by in-house staff or sent out to specialist freelances. But AW had established a

> *As far as he was concerned, the only correct way to produce an illustrated book was the Wainwright way*

Wainwright sent copies of his chapters to me for photographic reference. When I had finished the book, I passed them on to the publishers, Michael Joseph, with occasional bits of graffiti as extra embellishment.

successful procedure with his own *Pictorial Guides*, and saw no reason to change his tried and tested practices simply because somebody else was publishing his work. Disagreements centred on the copy of *James Herriot's Yorkshire*, which Jenny had originally sent to AW to highlight my work and give him a more tangible idea of how the book might look; unfortunately, AW had assumed the book was a blueprint. Once back home from the Peak District, he had retired to his study and set to work on that basis.

Jenny put up a spirited defence on behalf of her production department, attempting to persuade AW that they had been successfully publishing books for many years and that his work was safe in their hands. Wainwright vociferously begged to differ, brusquely informing her that he knew best what walkers liked to read and exactly how the appropriate illustrations should be presented on each page. The contrite publishers, verbally battered into seeing the error of their ways, duly raised a white flag and acceded to AW's proposals, feeling as if their collective London head had been in a close encounter with a Kendal brick wall. Anyone who owns a copy of both *Fellwalking with Wainwright* and *James Herriot's Yorkshire* will note that they are identical in size and contain exactly the same number of pages!

It was awkward being in the middle of that editorial wrangling, and for the sake of political expediency and a quiet life I diplomatically found favour with arguments from both sides where appropriate. Eventually, all was serene and I received my first batch of text and photographic notes from AW. I had become accustomed to working from an author's manuscript, with any pictorial guidelines scribbled in margins or on additional sheets, but Wainwright's unique method of working was to produce each page as though it were the finished article. The design and layout of each double-page spread was already done, with square or rectangular areas pre-allocated for pictures pertinent to each page's text; wherever AW had decided to use one of his own maps or drawings, a copy was neatly pasted *in situ*.

This method of working was absolutely brilliant from my point of view, as it removed the burden of having to interpret the importance of

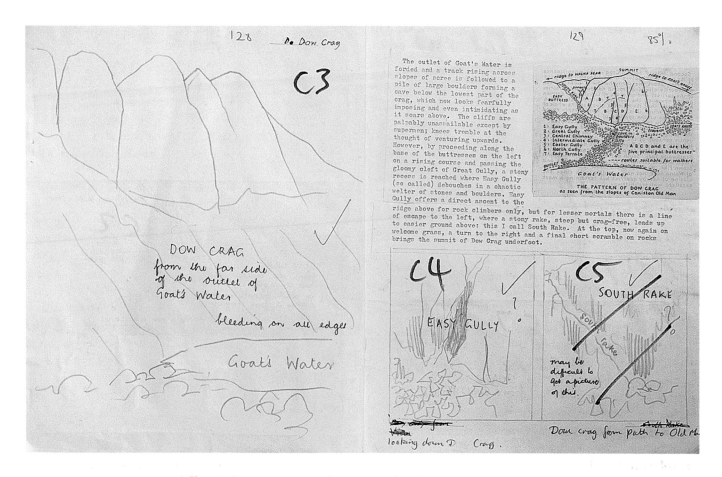

different places or events as they appeared in the writer's narrative. AW even went so far as to draw a skeleton outline of each subject, thereby providing me with a means of instantly recognising a particular rock formation, individual crags or groups of mountains without having to resort to time-consuming orientation and verification via an Ordnance Survey map.

There were, obviously, occasions when his undulating squiggles across the page were open to more than one interpretation but, generally speaking, the system worked extremely well and helped to eliminate costly and time-consuming errors. As I was then a complete novice on the Lakeland fells, I would have had difficulty in capturing the required views had it nor been for AW's guidelines. From day one of the project, it was literally a race against time to complete the photography satisfactorily for *Fellwalking* before being able to begin work on the date-specific Pennine Way book.

For their itinerary on the day following that first tantalising glimpse of the fells from Orrest

Head, AW and his cousin headed up the Troutbeck Valley and on to High Street for a closer encounter with a proper Lake District mountain. Some 53 years later, I too lost my Lakeland fell-walking virginity amid the ghosts of the Roman legionaries who had tramped the road which followed the whale-backed hump of High Street, its curiously urban name derived from that ancient highway. Chapter One of *Fellwalking*, entitled 'High Street and Harter Fell', comprised a seven-mile circular route from the Mardale Head car park at the end of Haweswater. It was the first of eighteen similar walks featured in the book, all of which were six to twelve miles in duration and encompassed some of the most popular Lake District fells and mountains. Each chapter opened with a full-page photograph depicting either an entire ridge walk, or a detail of its most salient feature which, in the case of that first chapter, was the north face of Harter Fell. Unfortunately, I was beginning the photography in mid July, just about the worst possible time of year for atmospheric conditions on the Cumbrian fells,

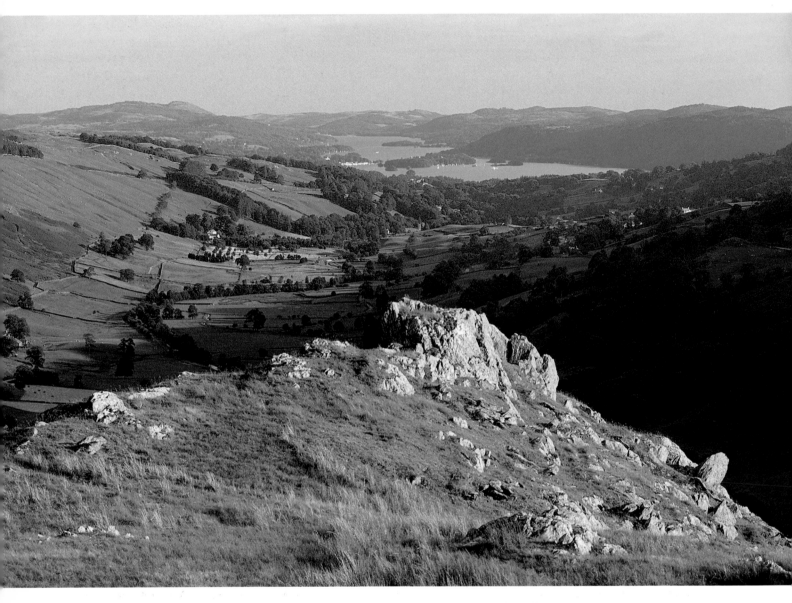

with bland lighting and protracted poor visibility being the norm.

Before setting out on that first expedition I took stock of my outdoor clothing and equipment, some of which was simply not going to be adequate for the task ahead. I did at least have a reasonable pair of boots left over from my days of Herriot's Yorkshire, and a warm, anorak-length jacket that had been standard outdoor filming issue when I was at Yorkshire TV, but apart from those two basic items, my fell-walking and photographic cupboards were just about bare. My camera bag had been emptied by one of those delightful members of society who specialise in breaking into locked vehicles and selling the stolen items on for a fraction of their worth. AW had fairly forthright views on such matters and, while I would not necessarily subscribe to some of his more extreme solutions for dealing with the perpetrators, it does make me very sad that one cannot now park a vehicle anywhere in the countryside without wondering if it will be burgled or vandalised.

I had been devastated by the loss of my precious Nikon outfit which I had been using for years and trusted implicitly, but as I was about to embark upon a completely new type of photography I decided that this might be an appropriate moment to consider other options. Most profes-

A view of the Troutbeck Valley with Lake Windermere in the background almost identical to the one Wainwright and his cousin would have seen on the second day of their expedition. I waited until well into the afternoon for this photograph, so that lengthening shadows would add some depth and contrast to an otherwise predominantly green scene.

sionals have their own favourite make of camera and once they find a system with which they feel comfortable tend to be creatures of habit and not swayed by the tides of fashion. To those who take pictures for a living, cameras are merely the tools of their trade but, even so, each manufacturer's product has idiosyncrasies that have to be mastered over time. Familiarity with a camera's light metering and other settings enables the professional to concentrate solely on the crucial business of composing and capturing an image, so I was mindful that, if I opted for something other than a Nikon, there would have to be a significant period of re-adjustment with my new cameras before operating them became second nature, a mechanical extension to one's eye.

After much research and deliberation I transferred my allegiance to Olympus, whose 35mm cameras were significantly lighter than Nikon's and whose range of lenses were reputed to be among some of the sharpest available. I purchased a new outfit comprising a camera body and three lenses, and was astounded at how compact the equipment was and how little it weighed in total when loaded into my bag. To accommodate cameras and other essentials on expeditions to the fells, I also had to invest in a new rucksack. I eventually found a perfectly designed Karrimor model, divided into three individually accessible compartments instead of the customary single voluminous space, with attached side pockets. The top section carried maps, reference notes, sun cream, rations and water; my small camera bag fitted snugly inside the central section, and the lower segment was reserved for spare clothing. By fixing an elasticated luggage strap to my heavy-duty tripod, I was able to hook it on to the loaded pack, thereby leaving both hands free for safely negotiating my way over rocky terrain.

Day one of Chapter One dawned as bright and clear as promised by the forecast, and I was away from home near Harrogate by 5.30 a.m., headed for Penrith via the A66, arriving at Haweswater's imposing dam some two hours later. I would later come to realise that the working day had to begin significantly earlier than that if I was to make best use of the two hours immediately following sunrise, one of the best parts of the day for photo-

> *The people of Measand and Mardale Green were forced to abandon their homes and farms and relocate elsewhere*

My camera gear has changed little over the years; every picture in this book was taken on an Olympus OM4ti. I use only three lenses: a 24mm wide angle, a 35mm 'shift' lens and a 65–200mm zoom. Polarising filters and a graduated neutral density filter increase cloud and sky effects. The compass is to check exactly where the sun will be rising and setting over a particular scene.

graphy. Although still well before 8 a.m., the sun had already risen high into the sky, neutralising colours and deadening the textures created by low-angled sunlight spilling across the landscape. Hindsight is a wonderful device, but on that particular day I was in no rush to tax my body with a premature assault on High Street.

The reservoir's dam seemed as good a place as any to pull over for a second breakfast of coffee and banana-and-honey sandwiches made with slabs of granary bread. These are a great source of energy but tend not to survive too long into the day, owing to lack of self-control on my part and a tendency on theirs to go soggy if left uneaten for too long.

Because I was not in any way involved in the research and preparation of the book's text, it was not until much later that I fully appreciated the poignant history of the valley prior to Manchester Corporation's commandeering it to ensure the continuity of their city's water supply. Although the remote valley was never heavily populated, the people of Measand and Mardale Green were nevertheless forced to abandon their homes and farms, relocate elsewhere in the district and expected to pick up the threads of their shattered lives. The ethical and practical arguments over the creation of a reservoir by flooding an inhabited valley do tend to polarise opinions sharply. In typical forthright fashion, Wainwright referred to it as the 'rape of Mardale' and in many ways I sympathised with that sentiment; but unless Mancunians were going to be provided with water purification tablets and a piped outlet from the Ship Canal, their water had to come from somewhere. The whole process was probably carefully stage-managed with evicted families receiving financial compensation, but it must have been heartbreaking to sip a final pint in the Dun Bull or attend the last service in the parish church of the Holy Trinity on 18 August 1935. The church was then dismantled and the coffins of past generations exhumed from the graveyard and taken for re-interment at nearby Shap. The pulpit was transferred to St Andrew's in Stonethwaite and, in a cruel twist of irony, some of Holy Trinity's windows were actually placed in the newly built reservoir tower.

When the dam was completed, Haweswater's level eventually rose by some 96 feet, obliterating

An autumnal view across Haweswater towards High Street on a day when sunshine was at a premium. I was fortunate to get just one quick burst of light on the foreground, but that was enough to create an atmospheric photograph. The dark sky and unlit background tend to thrust the illuminated segment forward and create the impression of a more three-dimensional image.

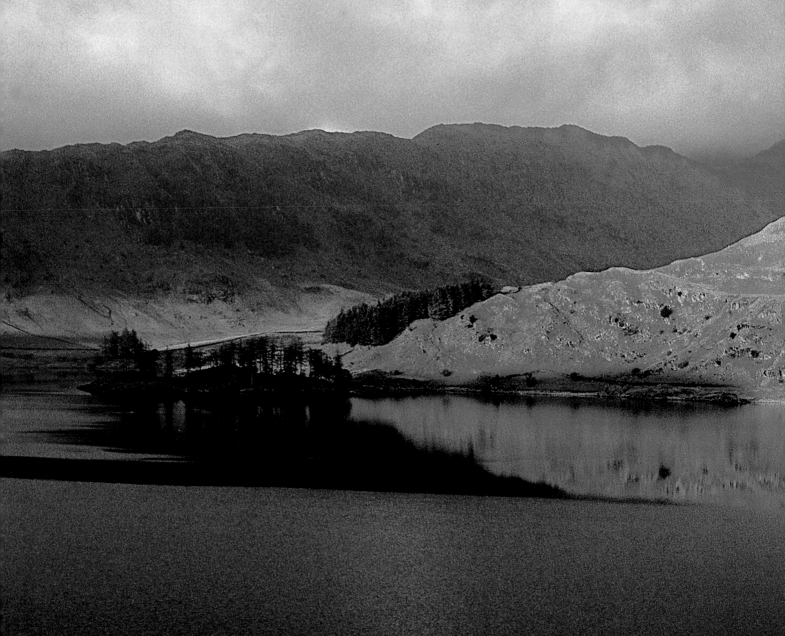

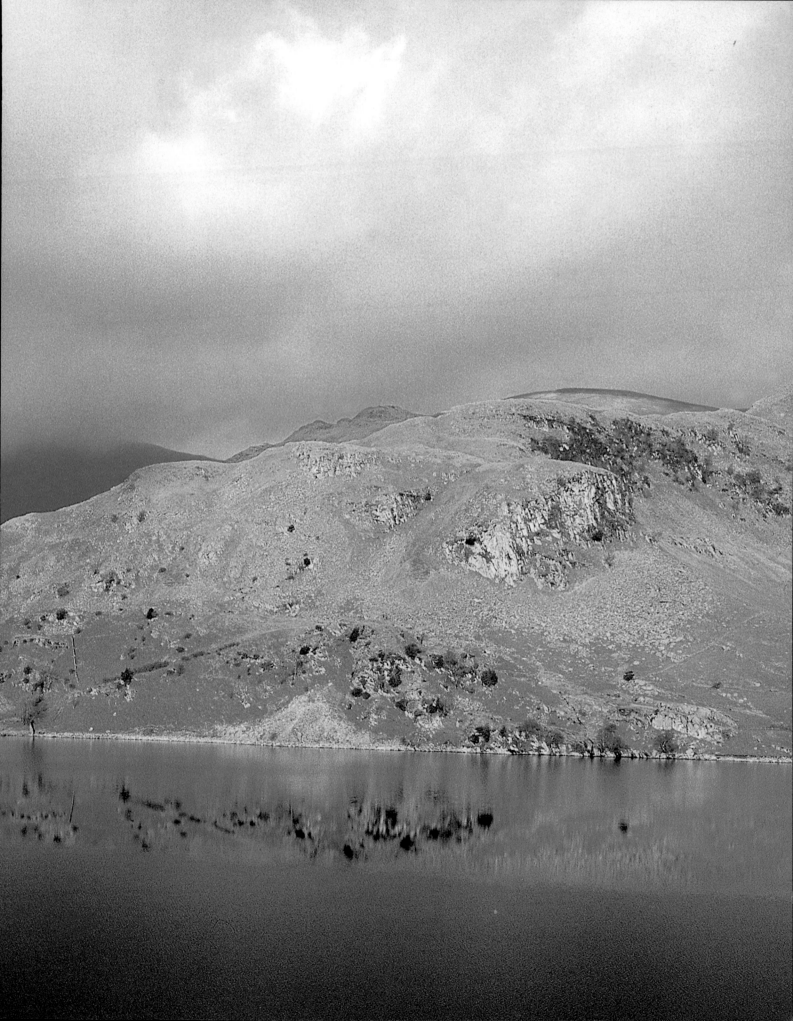

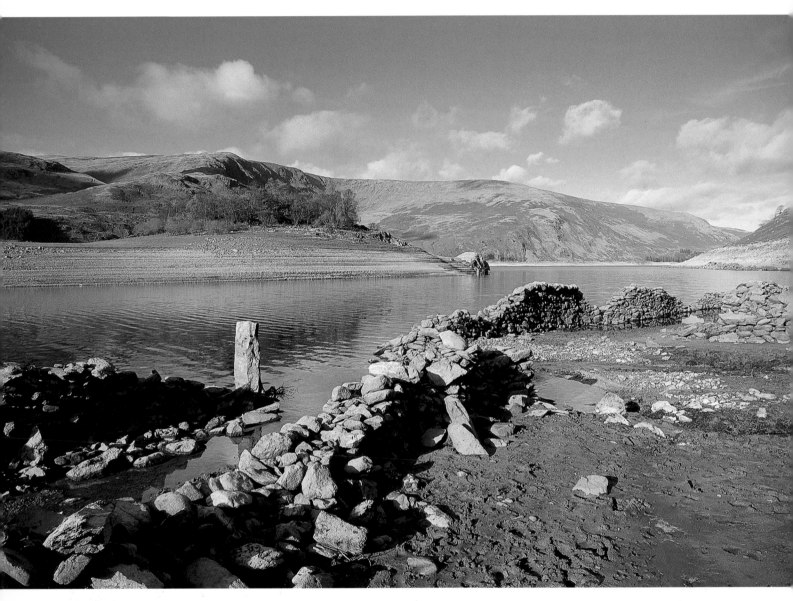

all traces of previous occupation. One of the best times to visit Haweswater is after a protracted period of drought, when the water level falls dramatically to reveal traces of the old village. However, anyone hoping to see the tragic remains of ruined cottages will be disappointed: only piles of stones, lines of walling and the diminutive Chapel Bridge survive intact. Even those scant remains, however, provide a sad, tangible epitaph to a victim of the increasingly voracious demands of twentieth-century society.

I sat by the car and compared AW's notes with my own set of maps, tracing the exact location of the first of the 225 photographs I would need to

illustrate the entire book. The opening shot was a full-page portrait of Harter Fell, which Wainwright decreed should be taken from the old Mardale Corpse Road, clearly discernible on my Ordnance map and easily accessible through a roadside gate. The track twisted and climbed up a series of hairpin bends, designed to moderate the valley side's steep gradient, before levelling out on to a small plateau on which stood the ruined stone barn AW had indicated should occupy the photograph's foreground.

I executed that first picture exactly as instructed – because of the accuracy of AW's sketch, I almost expected to find markings in the turf indicating

The walls of the drowned village of Mardale Green become exposed when Haweswater's level drops significantly during dry summers. In contrast to the image on pp. 42–3, which was shot from above with a telephoto lens to create a more graphic design, this one uses a wide-angle view from the shoreline to set the ruins more into context.

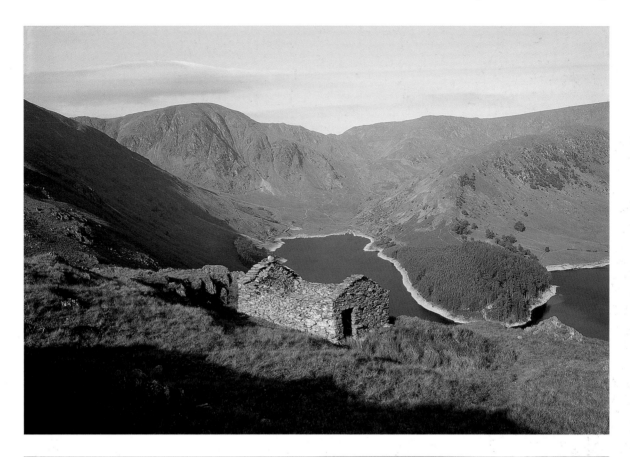

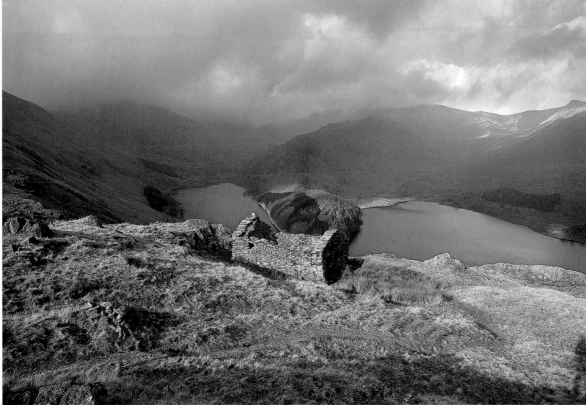

Two contrasting views of Harter Fell and Haweswater show just how different the landscape can appear with seasonal variations and how each have their merits. The predominantly green version is from the original *Fellwalking with Wainwright* sessions and appears rather bland. The autumnal shot was taken more recently and, although perhaps more appealing in terms of its colour and atmosphere, it has lost Harter Fell in low cloud.

exactly where my tripod legs should go, similar to the 'photo-opportunity' signs placed at vantage points around well-known theme parks to aid visitors armed with state-of-the-art cameras but little vision! As I progressed through the chapters, it became increasingly uncanny to realise that AW had probably explored just about every square inch of the fells, as his knowledge appeared encyclopaedic. When used in close conjunction with the walk's narrative, few of those outline drawings were not instantly recognisable from the correct viewpoint; they were invaluable to a novice such as myself, visiting all those places for the first time.

Since I was well ahead of the daily influx of walkers who use Mardale Head as a convenient access point to the eastern fells, the small car park at the end of the reservoir was deserted when I descended from my detour up the Corpse Road. With the car engine and radio off, the silence was broken only by the distant cries of birds wheeling over the water; despite the warmth of that July morning, I felt the chill of the unknown enveloping me. It was pathetic really, but just at that moment, I wondered what I had let myself in for and whether I would be found wanting when it came to having to push myself to limits I had not yet encountered in my working life. The Yorkshire Dales and North Yorkshire Moors had required little more than pleasant country walking; Wales had been marginally more taxing, but I had never really felt out of my depth. Looking back on that day, my anxieties should not have been quite so intense – after all, I was not about to make a solo attempt on the north face of the Eiger, merely a seven-mile circuit up to High Street, round Harter Fell and back to the car.

I loaded up the pristine rucksack and, with temperatures already rising as the sun beat down from a cloudless blue sky, opted for shorts instead of jeans. In the presence of soaring crags and fells, my cream tennis shorts looked quite inappropriate, but I had not yet properly addressed the matter of pukka walking gear. A white-and-blue cheesecloth shirt completed the outfit, its tails gathered up and tied in a bow over my midriff to allow additional ventilation. I may not have qualified for any best-dressed walker awards, but I was at least safely shod in appropriate footwear. I hefted the Karrimor on to my shoulders and, with exposed white legs perfectly complementing my outfit, sallied forth do the master's bidding.

I was initially instructed to follow the Nan Bield Pass for a photograph of the attractive waterfall of Dodderwick Force, before retracing my steps back towards Haweswater and picking up the route that follows the lake's western shore to the sharp promontory named the Rigg. During later expeditions involving visits to Mardale Head, I discovered that Nan Bield was a significantly easier route by which to access High Street but on that occasion I got my first sample of doing things the Wainwright way. The straightforward tourist routes obviously had their merits but, wherever possible, he forsook the easy well-trodden paths in favour of more adventurous options that really gave one an insight into the true character of a particular place. With that aim in mind, he directed my feet towards Rough Crag, a most aptly named route up to the summit.

The initial part of the ascent from the Rigg was not too demanding, but all of a sudden the incline grew noticeably steeper and the pulsating sound of my heartbeat magnified in my ears as I struggled over the rough terrain. Perhaps the worst aspect was having to adjust to the presence of a heavy load on my back, the weight of cameras, lenses and other equipment significantly increased by the 10lb tripod tied on to the rucksack. On some steeper sections it was difficult to maintain balance: whenever I attempted to do my spine a favour by adopting a more vertical walking position I felt gravity mischievously trying to pull me back down to the Rigg. As the day progressed, I became accustomed to compensating for the load but that first hour was very uncomfortable, made even more so by rivulets of salty perspiration cascading down my forehead and causing painful stinging sensations to the eyes.

Having attained the rudimentary cairn marking the interim summit of Rough Crag, I paused to double-check my picture list and get some photographs of the immediate location. To the right of Rough Crag as one ascends is the great natural amphitheatre of Riggindale, terminating in a line of cliffs that run along the High Street ridge. There could not be a more perfect or appropriate location

Wainwright forsook the easy well-trodden paths in favour of more adventurous options

The 'Wainwright way' up High Street via the uninviting terrain of Rough Crag. I elected to photograph it from a distance to show the ridge from a different perspective, but I had to wait ages for a strip of sunlight to illuminate the ridge itself. Without it, the picture would have been flat and featureless.

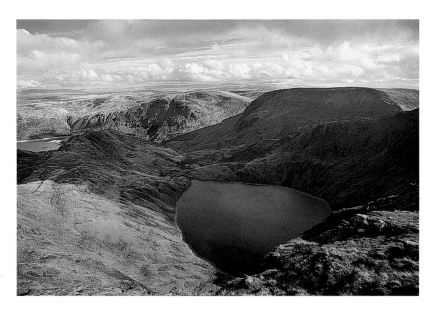

for the golden eagles that have made it their home, although so far they have disappointingly declined to perform aerobatics or pose menacingly on a nearby rock for my camera.

When the first breeding pair appeared after the species had been absent from the region for over a century and a half, the RSPB transformed Riggindale into a natural history version of Fort Knox, determined to ensure the birds were not disturbed by over-enthusiastic ornithologists or their nests raided by egg thieves. I have always been mystified and saddened by the mentality of the secret collector, because the object of their desire, be it a rare bird's egg or a priceless work of art, will most probably have been acquired illegally. Such acquisitions cannot therefore be proudly exhibited or boasted of to one's friends and I simply cannot get my head round what perverted pleasure could ever be derived from gloating over one's treasures in a locked and shuttered room.

With photographs taken, pulse restored to near normal and sweating brow somewhat cooler, I prepared for the next leg of the climb, but baulked at the sight of my next objective. AW encouragingly defined Long Stile as 'a steep rocky spur of intimidating aspect, but with no difficulties in its ascent'. Standing before the near-vertical looking slope confronting me, I thought his first part of the description to be absolutely spot-on, but reserved judgement on the latter segment. I decided the best way to attack that last steep section was never to

I marvelled at just how different everything looked from my new vantage point

Above: the view from High Street looking east towards the Pennines, with Blea Tarn in the foreground.

Opposite: a panorama of the distant western fells from High Street on an uncharacteristically clear autumn day. Although not prominent in the picture, the sheep do add a sense of scale and also help break up what would otherwise have been a large expanse of green foreground.

look up – in that way, I would not keep seeing just how far I still had to go. That system worked well and I was pleasantly surprised when I hit the last few metres of scree that signified my imminent arrival on the blissfully flat expanse of High Street.

If I had not been so knackered, I might have had a sense of elation at the achievement of attaining my first Lakeland summit, but at that precise moment I was berating myself for being so physically and mentally unprepared. I had thought my fitness levels to be above average but realised I had some way to go before being able to scamper up a Lake District mountain without batting an eyelid or scarcely breaking sweat. It was perhaps unfortunate that I had inadvertently chosen one of the hottest days recorded that summer for my initiation. As I gently fried on the exposed expanse of High Street's summit ridge, I wondered how on earth people could derive any real pleasure from such self-inflicted pain.

That question was partially answered when I had recovered sufficiently to stand up and survey my surroundings which, despite an intense heat haze, were truly magnificent. The advantage of height totally changes perspective and I marvelled at just how different everything looked from my new vantage point, not least the route I had just pursued. From a distance, Rough Crag appeared as a gentle slope although Long Stile did sustain its ferocity at closer quarters and I was relieved not to have to descend that way. Despite the poor visibility, I could just make out the distinctive whale-back hump of Cross Fell in the distance, representing the highest point of the Pennine Way; I rued the fact that I still had seventeen and a half chapters of *Fellwalking* to photograph before I could 'exercise my art' on the long-distance path.

Before moving off to the next objectives I rummaged around for some fuel, deciding to put a Mars bar out of its misery before it was transformed into chocolate soup by the heat. As soon as my eyes alighted on the wrapper the advertising jingle 'helps you work, rest and play' sprang to mind, and I wondered whether its consumption back in the car park might have speeded my progress up High Street. Conversely, I was puzzled as to how one could actually enhance the process of resting, since collapsing into a horizontal posi-

tion could readily be achieved without guzzling several hundred calories of a particular brand of chocolate.

Although anxious to progress with the scheduled circuit, I first headed north along the route of the Roman road, constructed originally as a link between the forts at Galava (Ambleside) and Brocavum (Brougham). This was obviously not one of their more major road-building projects but, even so, one cannot help but admire the manner in which a legion's engineers exhibited an almost total disregard for topographical considerations. Unless confronted by insurmountable barriers, they worked on the principle that the quickest route between two points was in a straight line, regardless of obstacles. The path that snakes away from High Street is now no more than a footpath, but it does not require too much imagination to picture the scene nearly two thousand years ago when soldiers tramped that route, hunched against

a biting Cumbrian wind and cursing their luck at having to endure such a posting. At that precise moment, I felt great empathy with their plight – and, who knows, one of them might even have kept a piece of vellum stuffed down his tunic on which to record details and sketches of each mountain he encountered during a tour of duty. Maybe at some fifth-century chariot boot sale on the outskirts of Rome a dog-eared volume entitled *Fellwalking with Tiberius* could have been picked up for a handful of loose change?

As I resumed AW's specified itinerary and headed across to Mardale Ill Bell, it was fascinating to observe the panorama changing with each step and, in particular, how different landmarks gradually arranged themselves into a perfect composition as one's viewpoint altered. On one occasion I had to backtrack, realising that I had actually passed the optimum place for a photograph; despite the wide expanses surrounding me, the

Above: the route of the old Roman road across High Street's broad summit plateau is clearly defined, and I chose a camera position that allowed the track to wind right through the frame. Scenes such as this are far more effective when photographed in winter – the path stands out so much more against the faded yellow grass.

Opposite: a brief glimpse down into Kentmere provided a prelude to the second chapter of *Fellwalking*. On that day, the clouds were strong enough to become an integral part of the photograph.

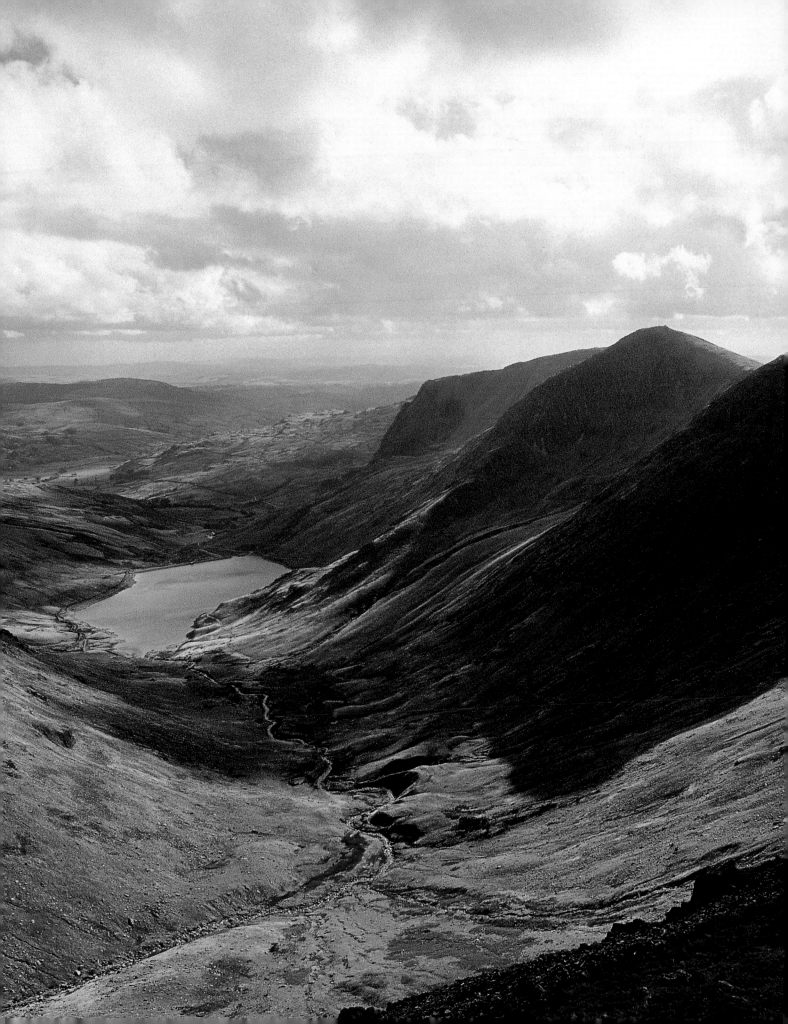

correct framing of a particular image required inch-perfect precision.

The descent from Ill Bell to the top of Nan Bield was not too arduous, but in the early afternoon heat I was definitely starting to wilt and every step down only made the final climb up to Harter Fell appear potentially more taxing. In photographic terms, I was becoming increasingly concerned at just how green everything appeared and, with the sun almost directly overhead, shadows and textures on the landscape were non-existent. For both technical and artistic reasons, it would have been better if I had called a halt to proceedings and returned when lighting conditions were more favourable, but as the easiest way back to the car was via my scheduled route I decided to keep shooting and complete the chapter despite my unease at the likely results.

Harter Fell's summit cairn remains the most curious I have encountered, its customary pile of rocks intertwined with twisted, rusting, iron fenceposts to create an offering that might have drawn favourable comment had it been an exhibit of contemporary sculpture. The view directly down the length of Haweswater from near the summit was quite breathtaking. I actually caught a welcome glimpse of my car far below, although its diminutive size made me realise that despite having just taken the penultimate picture the day was far from over.

Fortunately, the Gatesgarth Pass linking Mardale and Longsleddale was one of many trade routes over the fells and, as such, comprised a long series of zigzags designed to ease the gradient for heavily laden pack-horses and ponies. I was

Top: the view back down to Haweswater past Small Water confirmed my nagging suspicions that the hot July conditions would produce excessively flat green colours on most of the photographs.

Above: The summit of Nan Bield pass, again showing the too blue, too green influence of midsummer.

grateful to be able to follow in their hoofprints as my knees were now transmitting messages of distress and the last half-mile seemed over double that distance. Back in the car park I celebrated with a cup of lukewarm coffee and felt quite pleased with myself as I surveyed the route I had just traversed. I had faithfully promised AW that I would report in after that first expedition, so I headed down towards Kendal instead of taking the more direct road home.

The Wainwrights had been touchingly concerned over my wellbeing and AW had even remarked in one of his letters to Jenny that he certainly expected me to damage myself at some stage, although it would be preferable if any injuries sustained were not fatal as that would jeopardise the book's future! They were most hospitable when a bedraggled, sweat-smeared specimen appeared on their doorstep, still clad in tennis shorts, and I was given one of the most welcome glasses of cold beer ever drunk. AW listened intently to my account of the day's expedition, grunting contentedly from behind his pipe whenever I concurred with his opinions over the merits of a particular view or feature of the walk. It would have been easy to linger in the secluded shade of their garden but as I could feel every joint in my body starting to stiffen, I decided that a hot bath and a kilo of Radox was needed far more than another drink.

As a going-home present, AW handed me another couple of completed chapters, one entitled 'Helvellyn by the Edges' which, he assured me, would really provide an exciting challenge – I must let him know what I thought of Striding Edge.

AW had remarked that he certainly expected me to damage myself at some stage

Harter Fell's bizarre summit cairn resembles either the disastrous aftermath of a school metalwork class or a live candidate for a future Turner Prize.

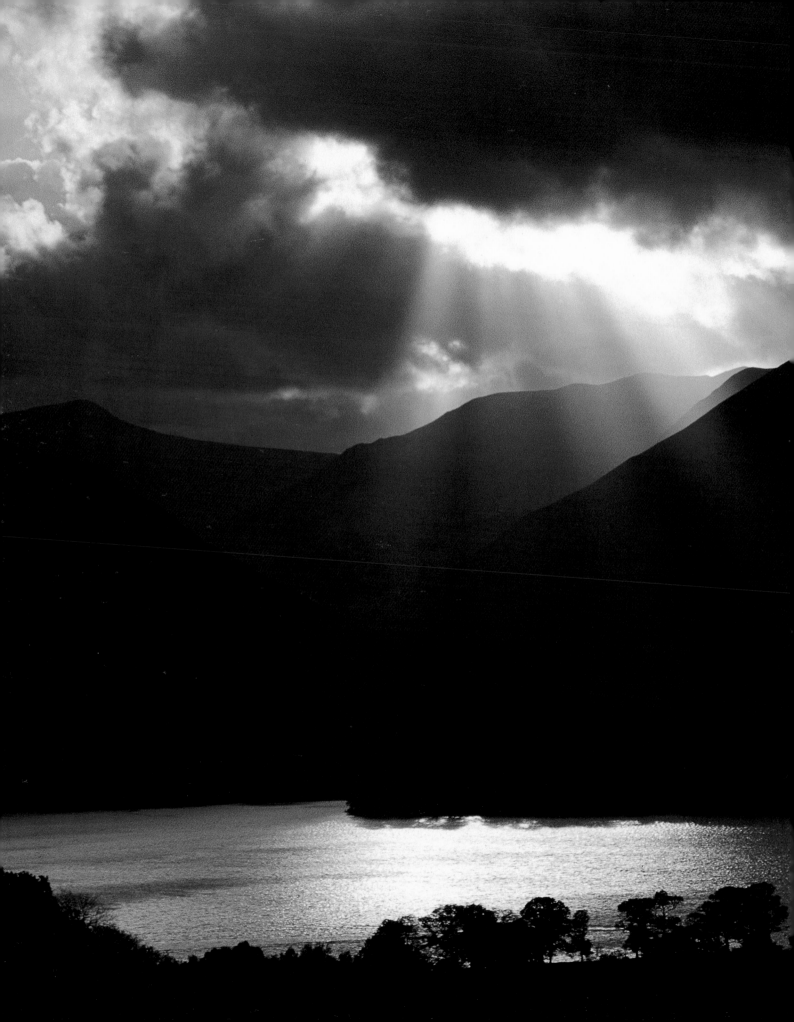

Chapter Three

FELLWALKING AT THE DOUBLE

After cutting my fellwalking teeth on High Street, I began addressing how the rest of the book could be structured in terms of seasonal colours to try to create a harmonious blend as the chapters progressed. Laudable though those initial intentions were, the constraints of time and the Lake District's fickle, and often vindictive, micro-climate resulted in a frustrating struggle to complete the eighteen circular walks on time. AW was really enthused about the project, knew exactly what he wanted to write and how it should all be presented, and the outcome was a rapidly accumulating pile of completed chapters awaiting the attention of my camera.

The processed 35mm Kodachrome slides from Chapter One, 'High Street and Harter Fell', were acceptable up to a point, but far too many of them lacked depth of colour, shadow and texture. I was forced to concede that the combination of high overhead sun and extreme haziness that predominates on the fells during August would not be conducive to landscape photography, so I reluctantly elected to mark time and wait until the light mellowed in September. Fate, unfortunately, had other ideas about the weather for the rest of that year and into the next, but crisp clear periods were scarce and only so much could be achieve in any one day, especially when daylight hours were at a premium.

AW structured the book's contents to progress roughly from east to west, so following the chapters based on Haweswater and Kentmere he concocted circular walks around the more central mountain groups of Fairfield and Helvellyn. Starting and finishing near Ambleside, the Fairfield Horseshoe is one of the most popular walks in the Lake District. It comprises an 11-mile circuit that visits four peaks in excess of 2,500 feet and the same number of lesser altitude. I elected to do the walk in its entirety, but as the start and finish points are some distance from each other I actually began the day from the common denominator of Ambleside, rather than driving closer to the main access point of Sweden Bridge Lane.

The Kirkstone Pass out of Ambleside steepens dramatically the moment it branches off the main Keswick to Windermere road and so, by the time I eventually reached the bridle path leading up to High Sweden Bridge and the walk proper, I was already fairly exhausted. Just prior to the end of the tarmac road, I noticed a newly developed bunga-loidal *cul-de-sac* with ample on-street parking and vowed that if I ever returned to Fairfield that spot would be my launching pad so that I might at least start the day with a fresh pair of legs. One of the other lessons I learned, but only with hindsight, was that attempting to photograph a whole circular walk at one attempt was unlikely to succeed.

Dramatic rays of sunlight pierce the clouds over Derwentwater, Keswick. Such images are impossible to plan for; one can only hope to be in the right place at the right time when such phenomena occur.

Left: I discovered an interesting group of fungi alongside Sweden Bridge Lane and photographed them twice on the same day. It was an interesting exercise as to how the time of day when a picture is taken can affect its colour. The first shot in the morning appears cold and lifeless but, upon my return several hours later, the colour temperature of the light had warmed up and gave a more natural feel to the subject.

Above: Ambleside from Loughrigg Fell. It can be frustrating when clouds persist over the higher fells but for this shot their presence was an advantage, as the dark background diverts the eye back into the heart of the photograph.

Opposite above: the views westwards towards the Langdales from Sweden Bridge Lane *en route* to Fairfield can be spectacular but, even when conditions for long-distance work are unsuitable, studies of the more immediate surroundings can still be rewarding. Stone walls, sheep, trees and rugged fell sides create an interesting grouping of colours and textures.

Opposite, below: Sweden Bridge is one of those locations that is a delight at any time of year, but it can also be far too tempting a place to linger instead of pressing onwards and upwards.

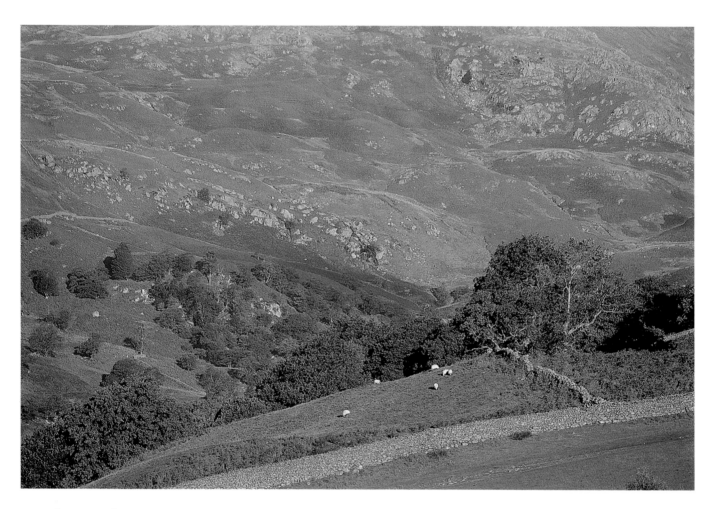

Even if one was fortunate enough to be blessed with good light and weather throughout the expedition, not every subject listed for illustration could necessarily be captured at its best at the time of day one happened to be there.

Sweden Bridge Lane was as delightful a companion as AW had promised, providing spectacular views down into the Vale of Rydal. The ancient single-span bridge from which the lane derives its name proved an ideal place to shed my rucksack and take in the surroundings. My attention must have wavered slightly when resuming the walk as I misread both my map and AW's instructions regarding which path to follow immediately after crossing the bridge. I knew that a stone wall had to be followed all the way up the summits of Low and High Pikes, and straight ahead was a path cutting through waist-high bracken. Although hardly well-trodden it was a track of sorts, and I forged ahead up to a high dry stone wall, whereupon I

discovered there was absolutely no sign of any onward route, only further expanses of aggravatingly tangled bracken. Instead of going for the sensible option of retracing my steps and starting again, I stupidly pressed on regardless along what was patently not the correct wall. Unwilling to admit to myself that I had messed up, I surmised that it would eventually join up with the one I should have followed had I not made that fundamental error of navigation.

My wall terminated abruptly in front of a near-vertical slope which had no perceivable way round, so I was forced to scrabble my way upwards, in places using fingerholds in the rocks in the manner of a hardened Alpine climber. When I eventually heaved myself and my heavily laden rucksack on to level ground, I found myself just a few yards from a wide path running parallel to the wall I should have been accompanying all along. Two energetic springer spaniels came to investigate

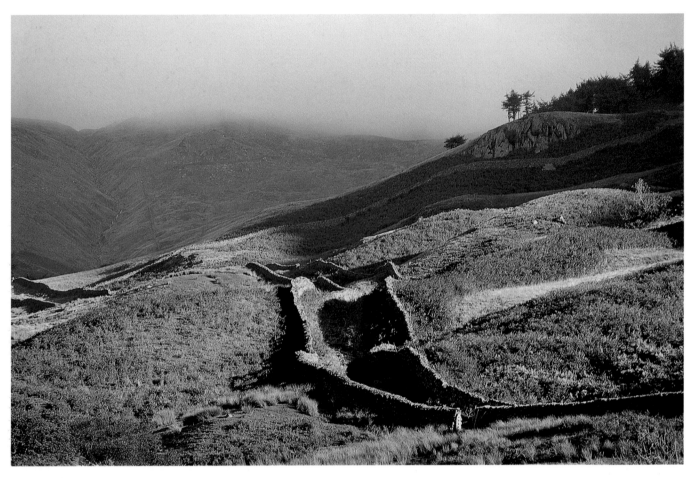

Above: Scandale from the path to Low Pike. This picture illustrates the problems of making an early start, as the low-angled sun is still casting long shadows across much of the scene. However, as a good percentage of the frame was well lit, I allowed it through the quality control net!

Left: the unbroken wall running up towards Low Pike never ceases to amaze me by its complexity. It is a remarkable piece of engineering when studied in close-up, but I think the long shot works better in this instance – it provides the viewer with far more information than a still life of interlinking rocks.

the sudden apparition before being hurriedly called back by their owners, who also seemed curious as to how and from where I had suddenly materialised. Feeling more than a trifle embarrassed by such an unscheduled and foolhardy detour, I attempted an air of nonchalance but I suspect it was betrayed by excessively heavy breathing, a perspiring red face and a state of dishevelment not acquired through gentle walking. I resolved to be doubly careful in future when faced with similarly confusing alternatives – the golden motto from thereon would be 'Check up before cock up.'

I resumed the correct route towards Low Pike, marvelling at the sheer scale and craftsmanship employed in constructing a wall that soared unbroken up and over High Pike. It had long been one of my ambitions to walk at least part of the Great Wall of China; although perhaps not really comparable, the Cumbrian version provided a majestic temporary substitute.

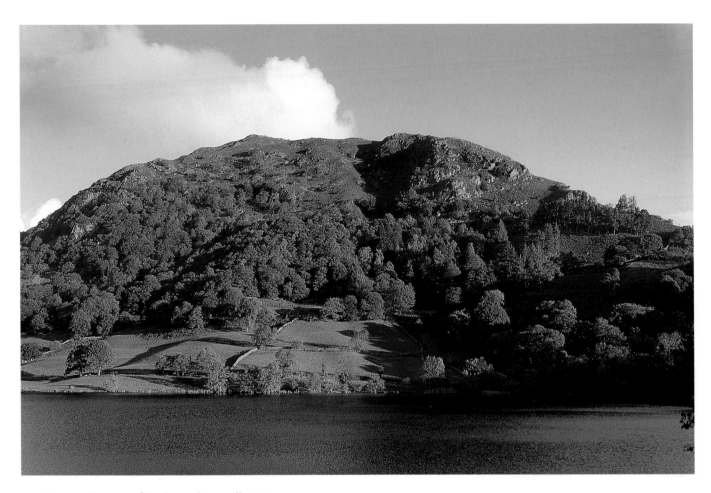

Lying at the apex of the horseshoe walk, Fairfield appeared at first glance to be little more than a bland, elevated hump with scant visual appeal. I was obliged to retract such ungracious thoughts after following AW's recommended 300-yard (no metres in his world) diversion to the summit of Cofa Pike, from where a retrospective view of Fairfield's hidden northern face revealed a dramatic line of cliffs. Unfortunately, by the time I had arrived at that halfway point the sun was well to the south, leaving the cliffs in shadow. As the light would only get worse as the day wore on, I had no alternative but to take the photograph and hope that not too much detail would be lost. My worst fears were justified: the lack of direct illumination caused the cliffs to be reproduced as a dark grey, featureless mass of rock and they certainly deserved better.

I noted from AW's text that Cofa Pike also provided an opportunity to view the 'tremendous bulk of Helvellyn, towering into the sky across the

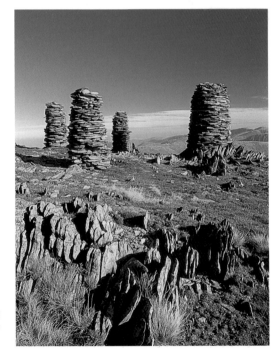

Above: Nab Scar is the route of descent from the Fairfield Horseshoe. If enough energy remains in your legs, it is best appreciated, as here, from the far shore of Rydal Water.

Right: the cairn on High Bakestones near Dove Crag and Fairfield is a monumental construction, built to withstand decades of the foulest weather without shifting an inch.

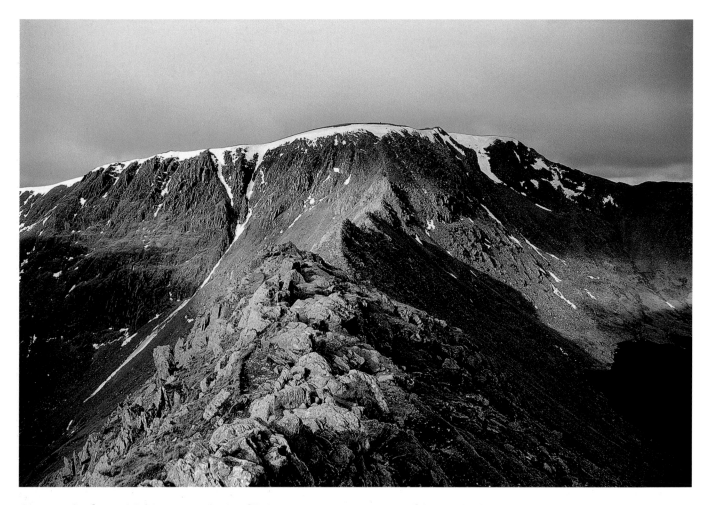

deep trench of Grisedale'. It was a sight that filled me with trepidation rather than anticipation as the chapter immediately following the Fairfield Horseshoe had a significantly more ominous ring, 'Helvellyn by the Edges'. I did not realise until a later reading of AW's memoir *Fellwanderer* that my initiation to the fells was charting a path almost identical to his own first experiences some fifty years earlier. During that week spent in the company of his cousin, he had first trod upon the Roman road of High Street and thereafter come face to face with one of the Lake District's more daunting features, the razor-sharp ridge of Striding Edge. Their expedition was conducted in appalling weather conditions, with low mist and driving rain preventing them from fully appreciating the hazardous nature of Helvellyn's legendary challenge. I was not blessed with similar ignorance as I had seen photographs of it, and although the old adage 'forewarned is forearmed' may hold good in

certain circumstances, I felt completely unarmed by knowing what was in store for me.

The reality of Striding Edge, however, was less daunting than I had feared: a 'wimp's route' runs several feet below the ridge itself, enabling those whose sole ambition is to get safely from one end to the other to do so without too much fear of putting themselves in jeopardy, especially in high winds. There have been several tragic cases of people literally being blown off Striding Edge; when the wind is dangerously high, discretion ought to prevail over bravado. I did have to venture up from the sanctuary of the lower path to take some photographs and found it to be most unnerving, rather like standing on a tightrope with no safety net below. When actually on the apex of the Edge, one's peripheral vision brings in the void on either side, which exacerbated my already strong sensations of vertigo. Even with one eye closed and the other glued to the camera, I still

One of the Lake District's more daunting features, the razor-sharp ridge of Striding Edge

Striding Edge, Helvellyn, looking up towards the mountain. With a line of snow and the dark sky behind, the ridge's natural drama is enhanced.

found extreme difficulty in concentrating on the image in my viewfinder. Probably the most exciting aspect of Striding Edge is the retrospective view, since only from an elevated position can one fully appreciate its real drama. To capture the most effective photograph, you need to be up there fairly early in the morning while the sun is still low in the sky, as the sharpness of the ridge is only accentuated when one side is lit and the other contrastingly dark. Although Helvellyn's broad summit plateau makes an excellent viewing platform, it is a scrappy, unappealing place that is largely devoid of shelter in bad weather.

Helvellyn does, however, boast more than its fair share of quirky memorials to assorted events and personalities. The aviator Bert Hinkler apparently landed a plane there in 1926, a feat that would undoubtedly result in a multiple manslaughter charge if anyone were to attempt a re-enactment – especially on a sunny Sunday afternoon, as what might once have served as a deserted improvised landing strip now frequently resembles a busy urban public park. Helvellyn's most celebrated monument is the Gough memorial stone, erected in 1890, almost a century after Charles Gough fell to his death from Striding Edge. In typically English fashion, the epitaph places greater emphasis on the fidelity of the dog that allegedly guarded his master's body until they were both discovered some three months after the tragedy rather than the demise of poor old Gough himself.

After their sodden excursion on to Helvellyn, Wainwright recounted how he and his cousin made their way on foot to Keswick. Despite resembling drowned scarecrows, they had been taken in by a kindly widow who even rummaged around in her husband's wardrobe to find some dry clothes for them. I discovered fairly early on in the campaign that finding accommodation was far from straightforward, even in major tourist centres such as Keswick or Ambleside. I seldom booked anywhere in advance, preferring to keep my options open and let the weather and my photographic progress determine where I spent the night. On out-of-season weekdays there are vacancies in large numbers of guest houses and bed-and-breakfast establishments, but discrimination

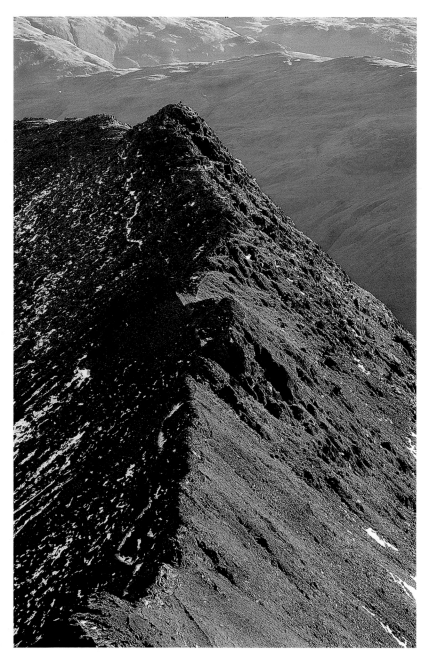

This retrospective view down over Striding Edge is made more effective by the low sun throwing one side into deep shadow, creating the impression of a virtually impassable razor-sharp ridge. I have photographed this view in winter and summer, and it works far more effectively when the predominant colour is brown rather than green.

against single travellers was rife: I lost count of the number of times I was turned away, despite there being several rooms available. Holidaymakers are usually booked in and settled by late afternoon or early evening, but I would frequently be looking for somewhere much later once the light had begun to fade. It became frustrating and annoying to be constantly told 'We don't do singles,' when I patently represented the last chance they would have of selling a room that night. I even received the same answer after volunteering to pay a supplement for single occupancy of a twin-bedded room. Whenever I could find a single room, especially in large converted Victorian or Edwardian terraced houses, it had usually been fashioned out of an upper-floor box room; if described as 'en suite', it might have a shower and toilet in what was once a walk-in cupboard. After a hard day's walking all I wanted to do was get cleaned up, have something to eat and then fall over, not spend up to an hour and a half trying to find somewhere to stay. I seldom had problems finding rooms in hotels, but their daily rates were usually significantly higher, and as I had to fund my own expenses this was a serious consideration.

The Wainwrights had made it clear from the outset that I would be welcome to stay with them in Kendal if I needed a south Lakeland base but sadly I was obliged to restrict myself to visits of just a few hours, rather than overnight, on account of their extended feline family. I have always been an allergy sufferer and cats rank high among things guaranteed to trigger a reaction: within half an hour or so of entering their domain I was a snuffling, sneezing, wheezing, red-eyed wreck. Anti-histamines helped with the worst of my symptoms, but I could never realistically spend a comfortable night there, especially if I needed to be fit and ready to climb a mountain the next day. Betty always booted the cats unceremoniously out of the kitchen door upon my arrival, but their physical absence made no difference to my condition and I always went equipped with a copious quantity of tissues.

One particular female named Totty was never ejected with the rest, but always remained as close to AW as possible – either on his lap, or staring at him intently with saucer-wide eyes from an adja-

The elusive spike of Gladstone's Finger did not work as a dramatic soaring wide-angle shot because it became difficult to isolate it from the main body of rock; a more distant viewpoint was required. By shooting with a telephoto lens, I was able to make it really resemble a pointing finger.

cent chair or settee. She had been taken in by the Wainwrights when just three weeks old and had become utterly devoted to AW, although I was horrified to learn that she nearly always shared his bed: even visualising a cat's head on my pillow would bring on an asthma attack. Despite her size being exaggerated by an extremely hairy and fluffy coat Totty was almost skeletal, and there seemed little room within that frame for the appropriate number of vital organs. It was at least proved that she possessed a pair of lungs, as the poor cat developed a nasty cough from too close a proximity to AW's constantly burning pipe or cigarettes when she sat on his desk and watched him at work. Scientists now know that inhaling somebody's tobacco smoke is harmful to health, and Totty could have been cited as a voluntary victim of passive smoking.

AW was always thrilled when I turned up with a fresh batch of slides. As Betty solicitously fussed around us with sandwiches, tea and biscuits, I would project my most recent efforts on to a white screen for AW's consideration. He loved seeing the images blown up large and I very rarely had to identify a particular view – he was always one step ahead of me in naming the featured fells or crags. But there were occasional mutterings of dissent if circumstances had forced me to compromise and take an alternative photograph to the one he had specified. He had designed the book's layout so precisely that there was little latitude for manoeuvre – each picture had been allocated a specific slot to illustrate a relevant passage of text. If I had failed to deliver the goods and a re-shoot was not possible, we were obliged to use one of AW's original pen-and-ink drawings of the subject, rather than risk misleading readers by the inclusion of an obscure or irrelevant picture.

One of the earliest instances where I had to grovel and request that a drawing be substituted for a photograph was in the Crinkle Crags chapter, a fairly straightforward circuit from Langdale that included Pike o'Blisco, the Crinkles themselves and the Three Tarns immediately beneath Bowfell. On his layout, AW had made provision for a picture of a slender rock pinnacle named Gladstone's Finger, but no matter how hard I tried the damned digit remained embarrassingly elusive. I reasoned that it

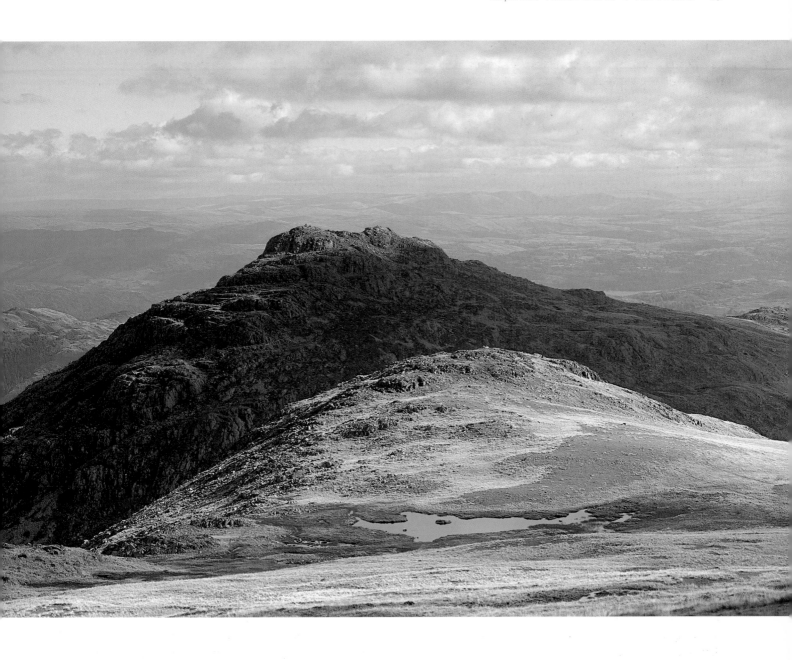

Great Knott and Pike o'Blisco
as seen from the path towards
the first of the Crinkle Crags.
Although the foreground
remained constantly lit for
this shot, I had to wait a
considerable time for any
sunlight to fall on the far peak.
Without that one highlight
on its summit, the great bulk
of Pike o'Blisco would have
been far too dark.

could not be that difficult to find if AW's directions were correctly followed but, having retraced my steps several times and watched as great banks of cloud threatened to curtail that day's photography, I gave two fingers to Gladstone's one and abandoned the search. I have since tracked it down and realised that, on my first attempt, I had been scrabbling around entirely the wrong scree slope in the vicinity of Great Knott. Just a couple of expeditions

after establishing the oft-repeated mantra ('check up before cock up') I had already broken it, and I took a fairly hefty ribbing from the author over my appalling route-finding skills.

On the next page of that same chapter, AW included another drawing (of his own volition) depicting the Bad Step, a hazard comprising two large chock stones barring direct access to the second Crinkle's summit. As there were no other walkers around, I thought little of it at the time and because I was not required to photograph the blocked gully I simply followed AW's diversionary route and continued on my way. During a more recent walk on the Crinkles, I did observe people

Wainwright believed the Bad Step to be the most difficult obstacle on any pedestrian path in the district

Photographing walkers tackling the Bad Step on Crinkle Crags was another instance where I had to take a distant view to put the subject's ingredients into context and provide all the necessary visual information.

overcoming the Step by clambering up a rock face to one side of the sheer-faced stones rather than taking the longer detour path. As I sat and watched a small queue form while others attempted to negotiate the problem, my thoughts drifted to the world's most famous natural step, some 26,000 feet higher than the Lake District's second Crinkle.

The Hillary Step is a 40-foot high spur of snow and ice, the final strength-sapping obstacle to the summit of Everest. It must have been lodged in my subconscious because I had just finished reading an horrific account of a tragedy on the mountain in 1996 that resulted in eight deaths and the mutilation through frostbite of several survivors. Although the Hillary Step is safely negotiable by following a fixed rope, it can only accommodate one climber at a time. During that fateful expedition, several teams attempted the summit at the same time, with queues forming at the base of the Step as daylight, oxygen supplies and lives began to fade. Twenty-three climbers did reach the roof of the world during that prolonged assault, many of whom had paid tens of thousands of dollars to commercial climbing companies to be escorted to the summit; others paid a significantly higher price for the ultimate badge of one-upmanship.

Wainwright believed the Bad Step to be the most difficult obstacle on any pedestrian path in the district but, comparatively speaking, it pales into insignificance when set against other mountain obstacles. That thought made me feel marginally better when addressing my own anxieties but, even so, after taking a closer look at the 10-foot high obstruction, I still took the detour!

There must have been some kind of jinx hanging over Crinkle Crags. Not only did the mountain gremlins conspire to hide an entire rock pinnacle from me, they also made me forget the cardinal rule of mountain walking, so often repeated by Wainwright, 'Always watch where you put your feet.' Instead of following the direct path back down to Oxendale and Langdale, I took AW's recommended route alongside some of the dramatic streams and waterfalls that plunge down off the Crags. For just one fleeting second, I allowed my concentration to lapse as I looked away towards a potential subject for the camera. Some of the rocks running alongside the stream were dark and

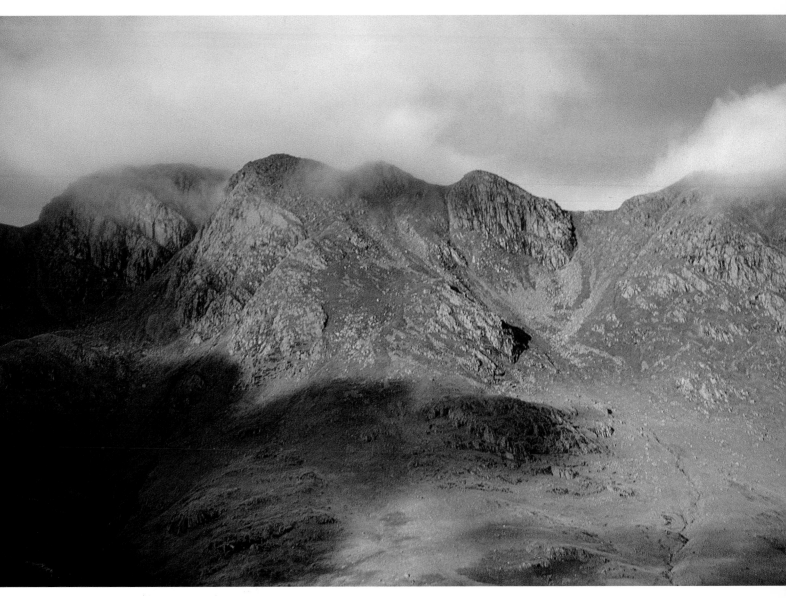

Crinkle Crags from Greater Langdale was an early-morning photograph but, despite the bright sunshine, I despaired of getting a decent shot. The heavy clouds were either obscuring the peaks, or blocking the sun and creating unacceptably heavy shadows.

slimy with algae and, as my unguided foot came into contact with one of those, off I went.

When a fall happens that quickly there is no time for the body's emergency response systems to kick in. The next thing I knew I was several yards further downstream, with one leg submerged and the rest of me sprawled across the stony bank. Having retrieved the sodden limb (thankfully still attached) and levered myself on to dry ground, I inspected the remaining bits to see what damage had been inflicted. Of most concern was the welfare of my tripod but it was of sturdier construction than its owner and had survived the fall unscathed. As the nauseous, light-headed effect

of shock arrived, I had already determined that nothing was broken, although copious quantities of blood flowing from a gashed elbow did little to raise my spirits. There were rips in various bits of clothing and a painful graze on one hip that later turned into a mega rainbow-coloured bruise. Apart from the flap of skin hanging off my arm, everything else appeared intact – luckily, I had escaped serious injury. At the spot where I capsized the gradient was quite steep and the consequences could have been catastrophic. As I limped back down the slope a severe self-bollocking was administered, and although many other resolutions have probably been broken along the way my

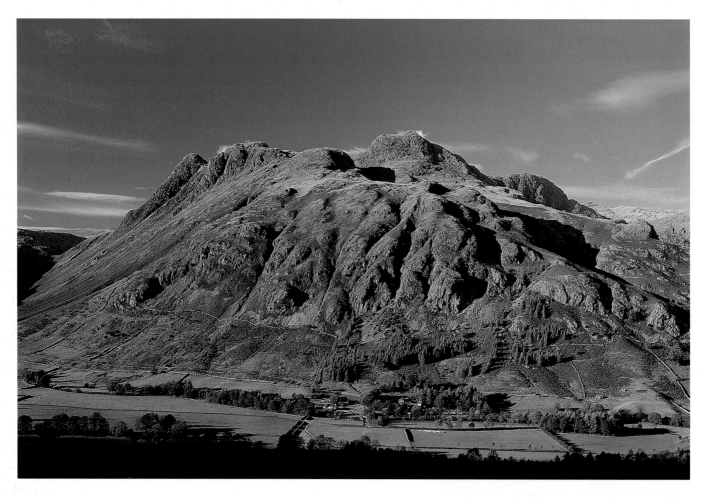

feet are now always stationary before I look around, no matter how stunning the view that suddenly materialises out of nowhere.

As I had photographed Crinkle Crags and the adjacent Langdale Pikes in late summer, the final leg of the Greater Langdale trilogy, Bowfell and Esk Pike, was deferred until winter could transform the landscape. Each chapter began with a full-page illustration depicting the walk's defining feature, and although I attempted to maintain seasonal continuity I was never able to better the predominantly green portrait of Bowfell from Pike o'Blisco that I had taken on an earlier expedition.

The main body of that walk was done under conditions of partial snow, making the photography technically more challenging due to the extremes of contrast between dark grey rocks and brilliant white snow. Although less than halfway through the book, I had become accustomed to the 'Wainwright way' and was not surprised to be

Above: the distinctive outline of the Langdale Pikes makes them photogenic at any time of day but, even so, they are better in the morning, when the ridges and gullies are clearly etched by light and shade. I used a polarising filter to deepen the blue sky and make the summits stand out even more.

Right: Dungeon Ghyll Force is tucked away in a dark recess of the Langdale Pikes, but was not as inaccessible as some falls I have had to track down. Calculating the correct exposure for shots like this can be difficult, as the contrast between dark rocks and white water is substantial.

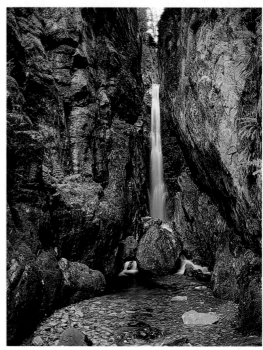

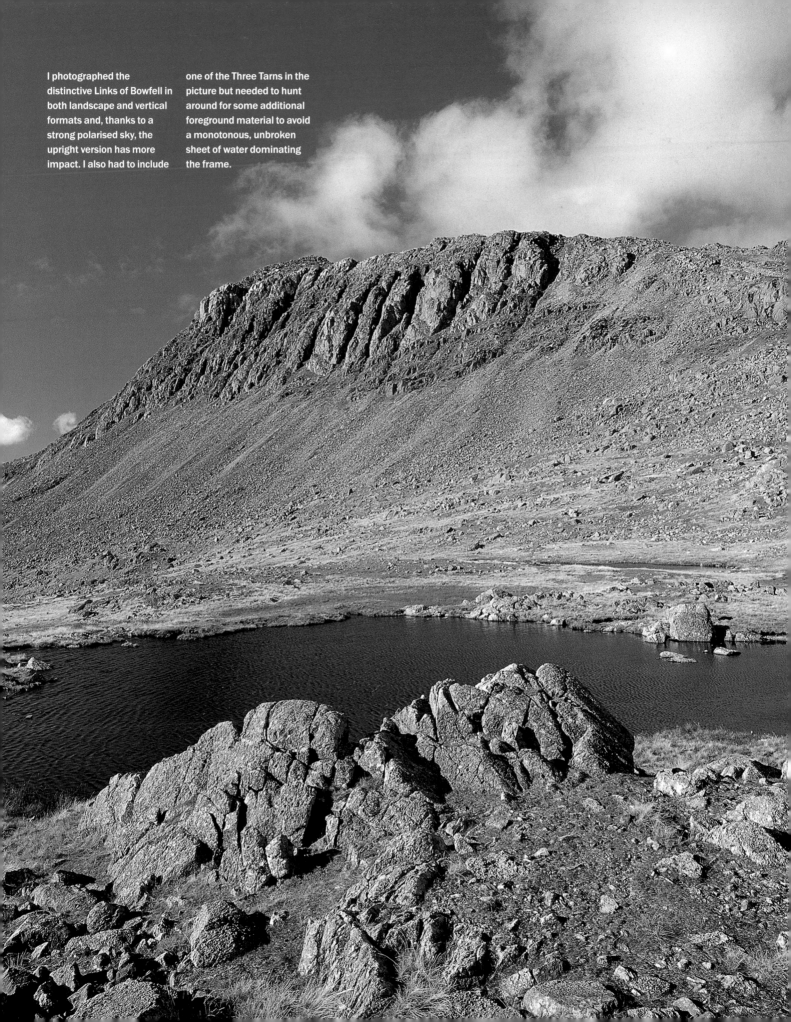

I photographed the distinctive Links of Bowfell in both landscape and vertical formats and, thanks to a strong polarised sky, the upright version has more impact. I also had to include one of the Three Tarns in the picture but needed to hunt around for some additional foreground material to avoid a monotonous, unbroken sheet of water dominating the frame.

directed away from the tourist route to Bowfell's summit and on to a more challenging alternative known as the Climber's Traverse. Wainwright described the path as 'a joy to follow' and the surroundings 'awe inspiring'. I readily concurred with the latter but took issue with the former assertion: the ground underfoot was treacherously slippery and despite the presence of bootprints signifying that other humans had passed that way my mood was as bleak and desolate as the immediate surroundings.

The Climber's Traverse was devised to provide access to Bowfell buttress, a huge triangular chunk of rock whose almost sheer face is a beloved haunt of rock climbers eager to disprove the basic laws of gravity. I was having trouble in that department without even setting foot on the first toe-hold as

the terrain on the access slope fell away steeply from the path where it runs beneath the cliffs of Cambridge Crag. The problem with snow is that it conceals hazards beneath its bland, cotton-wool, soft blanket and I was gingerly picking my way towards the buttress when the ground suddenly moved beneath my feet and I froze to the spot, terrified that I was about to be swept away on a landslip of scree, ice and rock down into Mickleden far below. As in all similar perilous situations, my first response was a spleen-venting string of four-letter words, followed after a period of mature reflection by a more measured response of several more. Having got that off my chest, I had to make some kind of decision: playing statues for the rest of the day on Bowfell was clearly not going to get many more photographs taken. I subtly shifted

Photographing the Great Slab on Bowfell was just one of many problems on a difficult day. Because the sun was above and behind the feature, the dark rock became even darker but at least the semi-backlighting effect did highlight the many lines of footprints crossing the Slab.

my weight as though to take a step backwards off the boulder run, but even that slight movement brought about an even more ominous rumble from below.

I had to have a serious conversation with myself at that point. Although I was probably in no danger, this was my first visit to the place and I had no idea what the terrain was actually like, and despite the other footprints there was nobody around at that precise moment. However, one of the benefits of being a Gemini is that one is never really alone: I can always talk to my other half. This random birth-sign perk probably accounts for all the people who apparently talk to themselves – they are not loopy at all, just conducting a conversation with their alter egos (of course, with the advent of hands-free mobile phones more and more people wander the streets masquerading as Geminis, when they could be Piscean imposters). Anyway, I enquired what we were going to do to get out of this mess and was told in no uncertain terms that it was my fault not his and I would have to sort it. As reversing had seemed to make the scree monster angry, I opted for the best form of defence and took three rapid attacking strides forward, hoping that my sudden momentum would get me across before the stones carried me down to oblivion.

Such incidents can get blown out of all proportion, but as a result of being alone (apart from him, who on that occasion really let the side down) your mind starts off with the worst scenario and works backwards towards cool logic and rationality, and I would probably have frozen to death by the time I reached that point. During a much later visit to Bowfell in midsummer, I made a detour to that same traverse and was relieved to note that the gully really was quite unstable and that, even under normal conditions, it required considerable care to negotiate safely. I felt that my earlier anxieties had been more than justified.

In order to prepare advance publicity material for *Fellwalking with Wainwright*, Michael Joseph asked me to take some portraits of AW, preferably at a location that reflected his life's work among the fells. Although still relatively mobile, AW was not really capable of much walking by this time, so we decided to use a setting close to Kendal that we could access easily by car. On the outskirts of

Kendal, the road to Underbarrow passes close to an area of open ground, in the middle of which lies a huge mound of stones piled up into a cairn. By no stretch of the imagination were we in the heart of the fells but their distinctive profiles were clearly visible in the background, and as AW was the focal point of the photograph it seemed somehow appropriate that they should play a less dominant role.

I monitored the weather forecast for over a week. When we were guaranteed a clear day, I telephoned the Wainwrights to let them know I was on my way across the Pennines to do the session. Thankfully, everything went according to plan. AW was appropriately attired in walking boots and wore the same coat as when we first met in the Peak District. Having settled him comfortably on one side of the cairn, I was able to shoot several rolls of film from different angles without having to give him too much direction. We tried a variety of poses, both with and without the ubiquitous pipe, and as the sun sank ever lower in the cloudless sky he appeared perfectly at peace with the world and oblivious to my clicking camera.

The resulting photographs were most pleasing, and were used as back cover pictures on a couple of our books with the best shot printed up into a delightful poster. On other occasions during our years together I managed to get further photographs of him with mountain backgrounds. AW was never entirely happy being the focus of such attention, but accepted that it formed an essential part of the publishing business. I always endeavoured to make these impromptu roadside sessions as quick and painless as possible.

Whether they were at home or preparing to go out, Betty constantly fussed around AW and as I got to know them better I realised that I had never observed him actually make any form of practical domestic contribution – although I do remember him carrying some cutlery through from the kitchen for a TV-dinner one night. Even before slowing up with age and illness, he seemed perfectly content to be waited on hand and foot by a very willing partner who clearly doted on him. At times when I took AW out for a drive to visit some of the locations he would be writing about, Betty elected not to accompany us. As Wain-

I opted for the best form of defence and took three rapid attacking strides forward

wright was exactly forty years my senior, this was rather like taking one's grandfather out for a Sunday afternoon spin – and just like any other septuagenarian he could be quite naughty and stubborn at times.

He steadfastly refused to fasten his seat-belt, preferring simply to hold it in place over his more than ample midriff for Betty's benefit as she waved us off and in order not to attract the attention of any passing police patrols. I did try to explain that if we were involved in an accident an unsecured belt would do little to prevent his head making violent contact with the car's windscreen; I got so cross with him one day that I stopped the engine and refused to budge until he complied. AW was quite adept at playing the 'butter wouldn't melt in my mouth' trick, and I was unwittingly taken in by it during one of our outings when he suggested we stopped off for tea on the way home. I should have rumbled that he was up to no good, as the roadside diner he insisted we stop at was little more than five minutes' drive away from Kendal and therefore hardly presented the opportunity for a mid-expedition break.

The nationally known name and logo of this establishment represented a vertically challenged cook. Without even referring to the menu, AW ordered gooseberry pancakes with cream. The thick doughy desserts were covered in a green glutinous sauce, topped with copious amounts of whipped cream dispensed at high pressure from an aerosol can. I have seldom seen any dish disappear so fast. What I did not appreciate was that AW had been warned off such indulgences, which would have been strictly off limits had Betty been with us – in fact I doubt that the word pancake would even have been mentioned. His subterfuge was to no avail, since when we got home his face was incapable of hiding the guilty secret. Betty did not have to resort to serious interrogation techniques to ascertain that I had been yet another gullible visitor duped by the old three-pancake trick.

Summer progressed into autumn and conditions became more favourable for photography, but I was also involved in other projects and not able to take advantage of every clear sunny day. Although artistically desirable, spending weeks at a time on *Fellwalking* to the exclusion of all else was simply not a viable option. Apart from attempting to resolve the logistical nightmare of successfully matching my time on the fells with a settled spell of settled weather, I was also technically struggling to cope with the intense shadows created by a sun getting progressively lower in the sky as the year wore on. It was highly beneficial in respect of enhancing the landscape's character, but an all-encompassing view from a high vantage point could be ruined by a large proportion of the image being buried in the jet black shadows cast by surrounding fells.

I was particularly fortunate to have chosen a crisp, bright November day on which to photograph the Newlands Round, a nine-mile walk circumnavigating the beautiful Newlands Valley, which has the solid bulk of Dale Head as its highest point. It seems to take an age for the sun to rise and get going at that time of year, and for some of the earlier shots in the chapter I was perfectly positioned to light the subjects appropriately. But winter days are short, and there is a limit to how much time can be allocated to waiting around for the light to improve on an imperfectly illuminated scene – too much delay would jeopardise those pictures that have yet to be taken further on in the walk.

Dale Head needed to be photographed from the adjacent summit of High Spy but, despite both the foreground and background being perfectly lit, the focal point of the photograph was completely obscured by the deep shadow cast by its eastern face. At that time of year, the sun only gets to a certain height before starting its all too rapid downward slide and it was quite apparent that the face of Dale Head was not going to be the recipient of any sunbeams until the following spring. I had no option but to do the best I could at that particular moment. A retrospective view back to Eel Crags and High Spy from Dale Head worked very well because the sun was almost at right angles to them, creating such detailed textures that one could almost sense the roughness of the rock by simply touching the printed picture. A full-page view looking down the valley and beyond towards Skiddaw worked less well as, by that time, the sun was not only sinking but also positioned directly behind the camera, an angle that gives very flat lighting. Dale Head's own shadow also created an

There is a limit to how much time can be allocated to waiting around for the light to improve

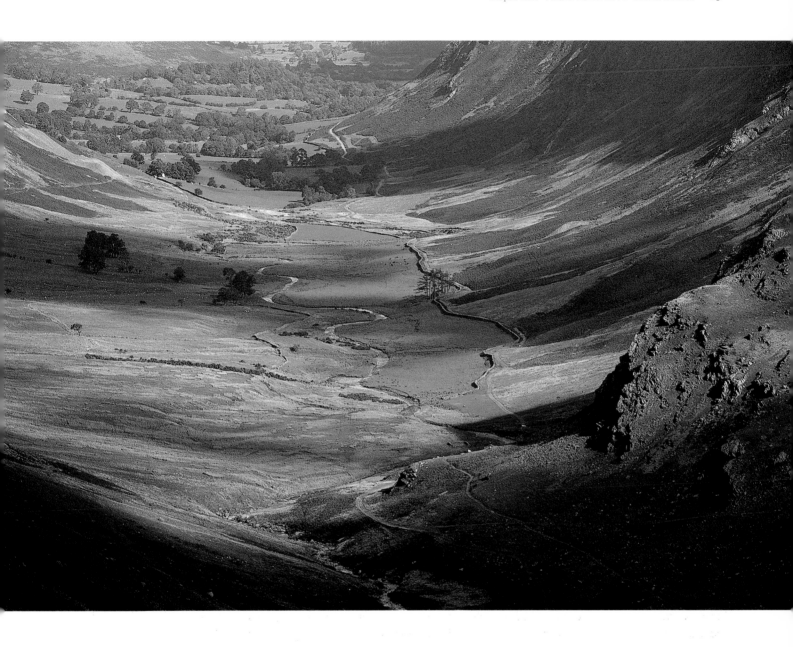

For this sudy of the Newlands
Valley taken from the slopes
of Dale Head, I elected to omit
the sky altogether and use a
zoom lens to focus in on the
essence of the landscape.
Cloud shadows played an
important role in helping break
up the predominantly green
picture, but a great deal of
time and patience was needed
to wait for the right balance of
light and shade.

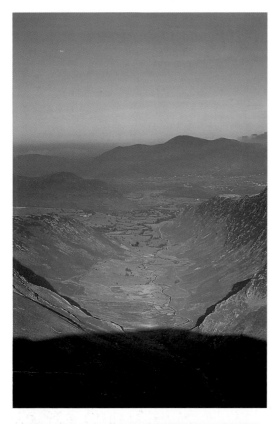

Above left: this view back down Newlands from Dale Head's summit was marred by both poor visibility and a dipping sun that cast an unacceptable dark shadow across the foreground.

Above right: the sun's angle was absolutely perfect for this shot of High Spy, with strong cross-lighting helping to pick out every detail of the serrated line of gullies.

Left: Dale Head has one of the most elegant summit cairns in the Lake District and the wide sweeping views behind it make it particularly photogenic. Because the light was so good that day, I made plenty of use of the sky and clouds to increase the impression of total freedom one has up on the fell tops.

unsightly black arc at the foot of the page, but had to be retained as the image could not be aesthetically cropped to exclude it.

For the purpose of maintaining visual continuity, I felt it was important to try and photograph each walk as a complete entity, exactly as laid out in the narrative. Limited time did mean that some photographs showing details of the terrain from distant points had to be taken separately, and some of those additional images did not match the exact seasonal content within the main body of a chapter. The same applied to the full-page introductory photograph of each walk but, fortunately, those images usually stood alone against a facing body of type and consequently did not create any jarring seasonal contrasts.

I had fully intended to photograph some of the remaining chapters under full winter conditions, when snow completely transforms the appearance of the higher mountains but, unfortunately, it was one of those milder years in which snow was immediately followed by prolonged rain and grey dismal conditions. There never seemed to be a time when temperatures plummeted sufficiently to preserve the snow and leave the Lake District fells glistening white under clear blue skies. If I am honest, there was also more than a hint of reluctance on my part to sally forth into deep snow and ice; I had found the climbing daunting enough under normal conditions, without having to cope with increased nerves and the additional burden of crampons and ice axes.

I allowed self-preservation to override my desire to do the best possible job

These mist-laden valleys photographed from Pike o'Blisco almost appear to have been shot in black and white. By shooting into the light I was able to reduce the scene to a collection of subtle shades of grey, a technique that can be just as effective as flooding the frame with vibrant colour.

As winter subtly gave way to spring there was a reasonable compromise, with sufficient snow lingering on the higher fells to create the illusion of winter without my having to wade knee-deep in the stuff. I was determined that AW's prophecy that I would probably come to serious harm during the project should not be fulfilled, and consequently I allowed self-preservation to override my desire to do the best possible job. It was perhaps unfortunate that the book's contents followed the fells from east to west – this running order left several of the more daunting obstacles until near the end. The Scafells, Great Gable, Pillar and the High Stile range above Buttermere were still all outstanding when the first anxious enquiries began to emanate from Michael Joseph's production department.

I was not being unduly hassled for photographs but they were nevertheless expressing concern that time was marching relentlessly on and the book did need to move into the final stages of production. Declining to reveal the true situation regar-

ding just how much missing material there really was, I made appropriately reassuring noises – owning up at that stage might have caused widespread panic in London. I resolved to clear my diary and concentrate on nothing else but *Fellwalking*, come rain or shine, until the last transparency had been approved by AW and safely delivered to the book's designer.

Most of the remaining walks were accessible from Keswick and Borrowdale, but those featuring Scafell and Pillar were centred on Wasdale Head, the serious walker's and rock climber's mecca where some of the region's most challenging mountains are gathered in a semi-circle around the head of Wastwater. However, one has to pay a hefty price to gain admission to that dramatic natural theatre, as Wasdale is just about the most inaccessible place for motorists within the National Park. It is also one of the cloudiest and wettest. It was a frustratingly long drive round the Cumbrian coast from Harrogate, especially when I had got out of

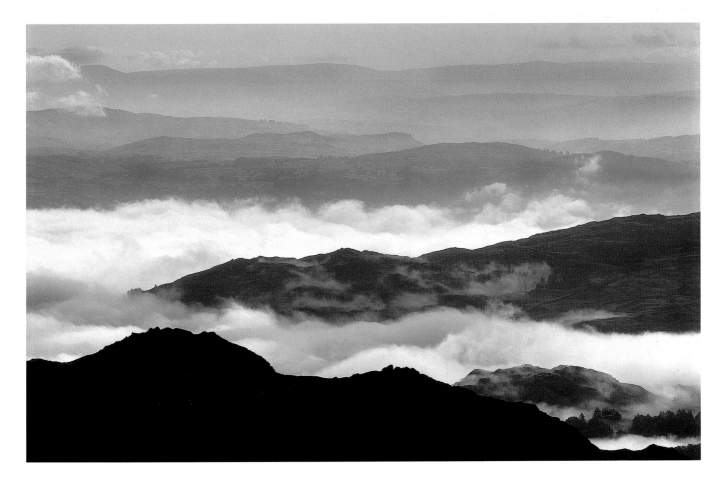

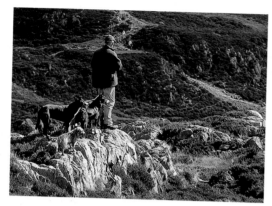

bit interested in the wild, natural beauty that surrounded them, but more concerned with how many pints had been consumed the night before and where a similar quantity might be taken later that day.

On the return leg of that walk I was gently sauntering back down to Eskdale Hause – the path was level and well defined, so I was deep in thought and only half-concentrating on my immediate surroundings – when I was suddenly scared half out of my wits by three noisily panting dogs rushing past. They were not pets who had mischievously slipped their leashes but lean and very muddy working dogs heading for an unsuspecting group of sheep loitering around the base of Esk Pike. As they neared the flock, their headlong forward momentum was arrested by a shouted command. Almost as one, the animals dropped motionless to the ground to await further instructions. The ensuing five minutes were utterly engrossing, as the shepherd strode into view and skilfully manipulated his team around the flock with a voice that could probably have been heard in Keswick Market Square.

That episode brought home to me the fact that the fells are more than a weekend playground. I marvelled at the fitness of the three lads roaming the crags and gullies with their dogs in search of woolly stragglers. I realised then that I had begun to fall under the Lakeland spell. Despite being utterly terrified by some of the tasks I had been asked to perform, I was starting to enjoy being up among the fells and mountains although I also knew that they would probably never, unlike with Wainwright, become my closest friends.

Above left: a shepherd and his dogs take a brief moment's respite while rounding up sheep on the Buttermere fells.

Above: I followed the flock's progress back down to the farm and was able to get an atmospheric picture by shooting almost straight into the late afternoon sun. In order to reduce the risk of flare, I negated its effect slightly by making sure the sun was partially obscured by a tree branch, but the resulting back-lighting still worked wonders in picking out the textures of the fleeces.

Opposite: Ashness Bridge should be one of the most straightforward places to photograph but, due to a combination of factors, it remains one of the most awkward. The worst culprit is a steep hill that ensures the bridge itself remains in shadow until the sun is quite high and the light has flattened out. Once the bridge is illuminated, it then becomes clogged up with visitors and, even if they can be excluded, the light on Skiddaw in the background will have turned bad.

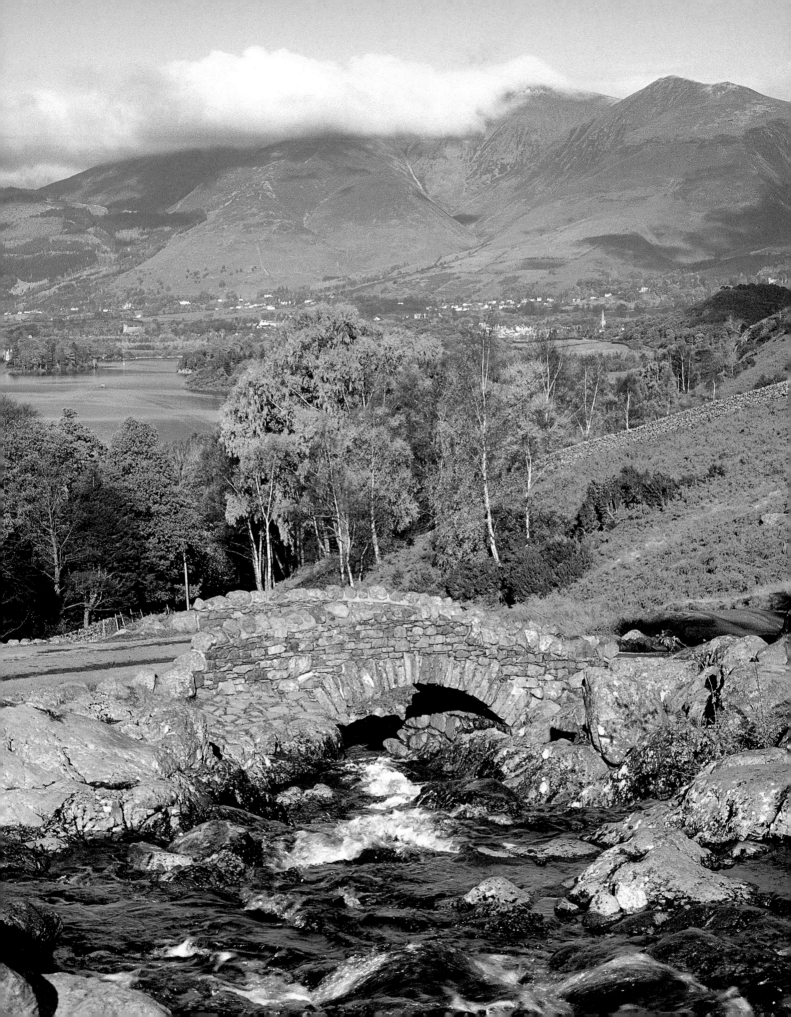

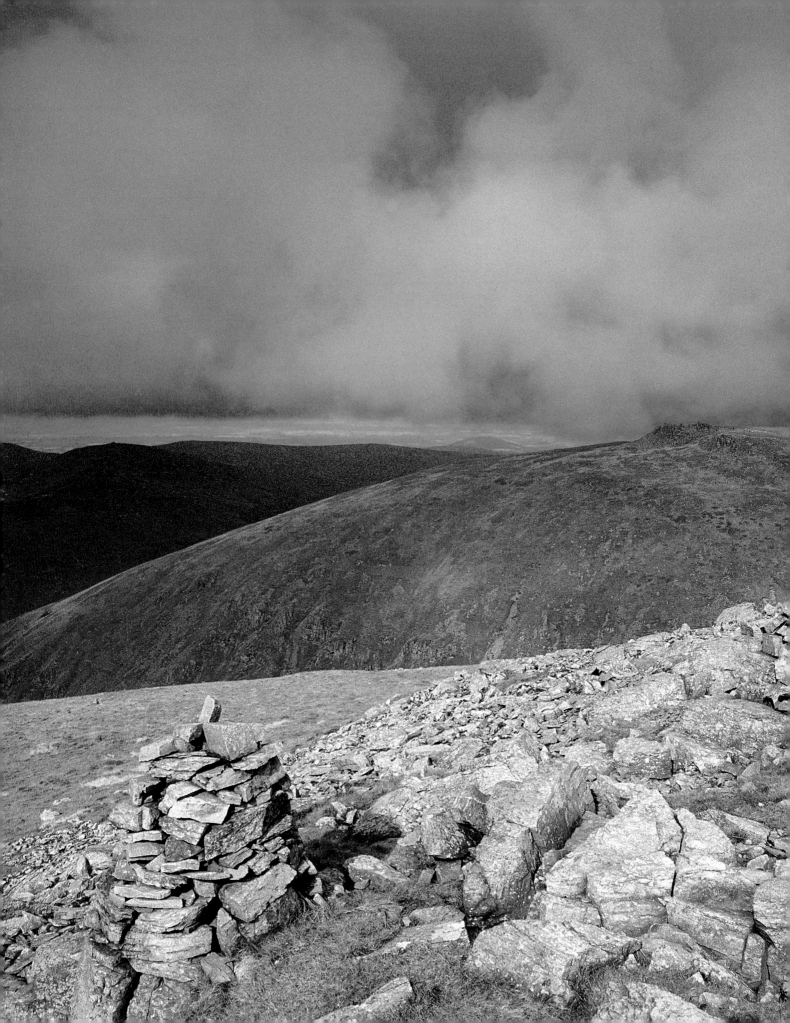

The 'stone men' on the summit of Auchope Cairn were lit just long enough for me to get the photographs I needed. For just a few fleeting moments there was a stark contrast between the sunlit foreground and the glowering black clouds.

Chapter Four

PENNINES, PERSEVERANCE AND PEAT

It was a huge relief to complete the photography for *Fellwalking* and finally be able to concentrate on the Pennine Way book, my proposal for which had been the catalyst for the Wainwright/Brabbs coalition. I thought that once all the Lake District pictures were processed, edited, captioned and delivered to Michael Joseph there would be a clear window of opportunity for me to launch an all-out assault on the long-distance footpath whenever conditions were favourable.

Fellwalking had run well into spring 1984, so I knew the opportunities to show the Pennine Way under wintry conditions would be limited. We were committed to a June 1985 publication date to coincide with the twentieth anniversary, so I would have little leeway in my delivery date. I realised it would be pointless to attempt to chart a seasonal progression from Derbyshire to Scotland, so I concentrated on producing the best possible results for each location, regardless of the time of year, although I did try to avoid too many jarring contrasts of colour within individual chapters.

Because I worked alone, I was frequently restricted in how much I could physically achieve on any given day – the distance I could cover on foot was governed by where I had left the car in the morning. Despite the inconvenience, this often worked in my favour, giving me the opportunity to photograph specified locations in different light, as

the sun would be at totally different angles on the outward and return legs of a walk.

I could have started shooting anywhere along the Pennine Way, but I felt it would be psychologically beneficial to overcome some of the more serious challenges first. So I headed for the peat-sodden wildernesses of Kinder Scout, Featherbed Moss and Bleaklow Head. It was a strange sensation to be back at the Nag's Head, as my previous visit had been in the company of AW on the occasion of our first meeting. It had not taken long to reach the furthest point of our first, and only, walk together: I had not realised then just how rapidly AW's eyesight was failing and that I would never have the pleasure of his company on the fells. He had reluctantly accepted that it was no longer safe for him to walk over rough or rocky terrain; he would certainly have struggled on the latter stages of the approach to Kinder, where Grindsbrook Clough narrows into a steep, boulder-strewn gully before emerging on to a vast, featureless plateau.

I can recall feeling uneasy and confused as I attempted to equate Wainwright's directions with the evidence of my eyes, backed up by the insurance policy of a map and compass. Despite those multiple navigational aids, I still experienced difficulty in deciding which of the many channels through the peat to follow – I felt I was entering nature's ultimate maze. Steep-sided peat walls (known as groughs) towered way above my head: if I chose the wrong option, the wall would either peter out into a *cul-de-sac*, or surreptitiously twist right away from my intended direction. I thought I was being particularly diligent – but, even so, I still retraced my steps several times before picking up the correct route, which followed the River Kinder's sandy bed to its dramatic outlet at Kinder Downfall.

Kinder Scout may not share any physical characteristics with the Kalahari, but during a busy holiday weekend, or when mists descend, the noises emanating from the dark peat have definite similarities with the supposed chant of that famous lost tribe of pygmies: 'We're the Fukawe!' The total Kinder experience has now been deleted from the official Pennine Way route, and permanently replaced by what was originally a bad weather alternative running along the Upper Booth valley

Left: the Pennine Way sign near the Nag's Head pub now sadly points away from the bridge since the re-routing of the official path's initial stages.

and afterwards an easily navigated path along Kinder's western escarpment. The detour was made to prevent further footpath erosion of the moor's fragile environment; obviously, it also reduces the risk of walkers getting into difficulty in adverse weather. The popularity of the route has resulted in a marked increase in the number of walkers during the last decade or so. Agencies responsible for the care and maintenance of the Peak National Park and the Pennine Way have even taken the radical step of paving long sections of peat moor – an innovation that came as a complete shock during my most recent visit. I had driven up the Snake Pass from Sheffield because its summit affords easy access to Featherbed Moss and Bleaklow Head, and I wanted some updated photographs of both locations. After passing through the roadside gate, I was confronted by the sight of a shimmering stone path winding its way into the distance between grass-tufted peat hags. So utterly gobsmacked was I by its alien presence, I half expected a couple of Munchkins to pop up and exhort me to 'follow the yellow brick road'. It was bizarre to be striding out over the paved path, when I remembered how I had floundered in the mire when taking my original pictures for the book.

On closer inspection, I discovered that the great slabs of stone had been salvaged from the floors of redundant local textile mills, and I wondered if the ghosts of the loom operators had accompanied them up on to the silent moors. The Peak District is virtually on the doorstep of the great industrial centres of Sheffield and Manchester; it has always been a haven of unsullied air and tranquillity for weekend refugees from the dark satanic mills. The publicity generated by the mass trespass of ramblers on Kinder Scout in 1932 and the subsequent imprisonment of five of them brought the subject of open access to the forefront of the campaign for the establishment of national parks. The Peak National Park was the first to be officially designated in 1951, but it has taken another fifty years for ramblers finally to be given the right to roam over many other privately owned upland areas. The Countryside and Rights of Way Act of 2000 obliges landowners to provide reasonable pedestrian access to moors and open countryside,

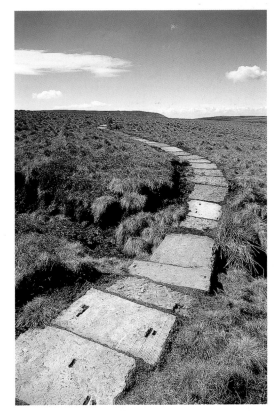

Opposite, above: Edale's narrow pack-horse bridge was a wonderfully evocative starting point for the Pennine Way. To gain sufficient height for this picture I had to fight my way up through tree roots and vindictive nettles.

Above and right: green, slimy and untamed, Featherbed Moss was a nightmare to negotiate when I was doing the original photography, but I could scarcely believe how things had changed when I re-shot it in 2004. An unbroken line of stone slabs now crosses what was once a glutinous morass. It felt for all the world as though I was about to traverse the 'Yellow Brick Road' of Oz.

vast tracts of which had been closed to the public for over a century.

The once notorious quagmire of Bleaklow has similarly been tamed: now there is clear sign-posting, and in places paved sections run parallel to the original route, whose course is still traceable by intermittent stakes poking out of the brown morass. Safe arrival at the distinctive landmark of the Wainstones near Bleaklow's summit is no longer an outcome governed by a combination of skilled map-reading and good fortune. The Wain-stones are also referred to as the Kissing Stones – when viewed at a certain angle, the rocks resemble two human heads in profile with lips puckered and

Right: the Wainstones are a prominent landmark near the summit of Bleaklow. They are also known as the Kissing Stones – for obvious reasons when viewed from one particular angle.

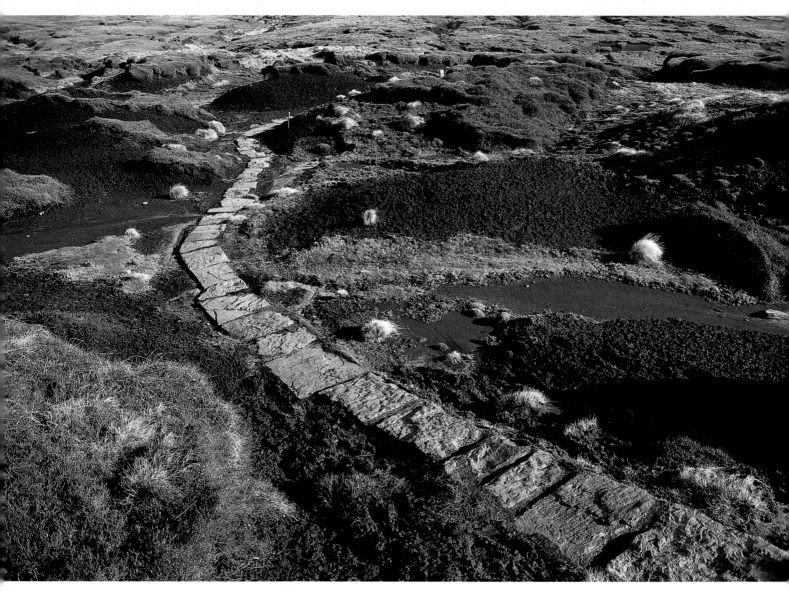

about to get amorous. I was amused to see an abandoned pair of walking boots resting on an adjacent rock and wondered what fate had befallen their owner, but not at the sight of that stone's desecration by graffiti. I include a picture of it here in the hope that it will shame the moron who thought it a clever idea to carve his name there.

Despite feeling a sense of anti-climax at conquering Bleaklow so easily, I reflected that it was preferable to have my clothes unsullied by the glutinous substance that before had caked my trousers up to the waist. I had thought I was walking over a safe section of ground until I promptly disappeared into several feet of gunge, and was extremely fortunate to have been able to prise myself out of the bog unaided by using my tripod for leverage back on to solid ground. Wainwright suffered a similarly life-threatening experience on Black Hill while compiling his *Pennine Way Companion*. He too disappeared into a bog and, despite the best efforts of his companion, remained firmly lodged until additional help fortuitously arrived to pull him out. AW described his extraction as 'being like a cork out of a bottle': since he weighed around 16 stone at the time it must have been at least a jeroboam. The very nature of this featureless terrain meant that walkers always encountered difficulties: I was extremely grateful that I was not called upon to photograph too many more of the assorted mosses before the Way finally establishes itself on the solid gritstone of Blackstone Edge.

Before arriving at that landmark, walkers have to cross the M62 trans-Pennine motorway over an aesthetically pleasing footbridge. It could be argued that this crossing is entirely danger-free, but for those afflicted by an aversion to heights it can be a traumatic experience. The bridge is high above the road, creating the illusion of a tightrope suspended over a deep gorge, with the constant noise of traffic below creating a simulation of rushing water. Having taken the required photograph from Windy Hill, I ventured just a few steps on to the bridge, immediately felt quite nauseous and beat a hasty retreat. Since I was not actually doing the walk, I elected to find an alternative access point to the ancient 'Roman' road on Blackstone Edge.

Above: what grisly fate befell the owner of these abandoned boots, and why do people desecrate nature in this way?

Opposite: a new paved path up through the treacherous peat hags of Bleaklow may offend purists but is proving a great success in combating erosion.

Below: Blackstone Edge and its section of ancient cobbled road, possibly Roman in origin.

Expert opinion is divided over whether the exposed surface of this road is actually Roman; it is now thought likely to be of more recent origin, laid down over the original Roman highway linking Manchester and Ilkley. The surviving section comes into view almost without warning: one is suddenly confronted by a five-metre wide cobbled highway climbing up the hillside at right angles to the Pennine Way. Sadly, further exploration reveals that the impression of great length is illusory: it ends abruptly after climbing about a hundred metres. From the top, however, the view into Lancashire is quite breathtaking.

When I originally encountered Heptonstall and Hebden Bridge, my interest was based solely on their potential as photographic subjects; since completing *The Pennine Way* I have derived great pleasure from visits to these historic textile centres. I have written about the Industrial Revolution and how it shaped the development of such communities. Heptonstall was once a major hand-loom weaving centre, its stone cottages clinging to a moorland ridge, but with the arrival of steam power the 'new town' of Hebden Bridge became established half a mile away on the valley floor. Its mills were supplied with water from the River Calder, and raw materials and finished goods were transported via the Rochdale canal, which was in turn superseded by the rail and road links that run side by side with the waterways.

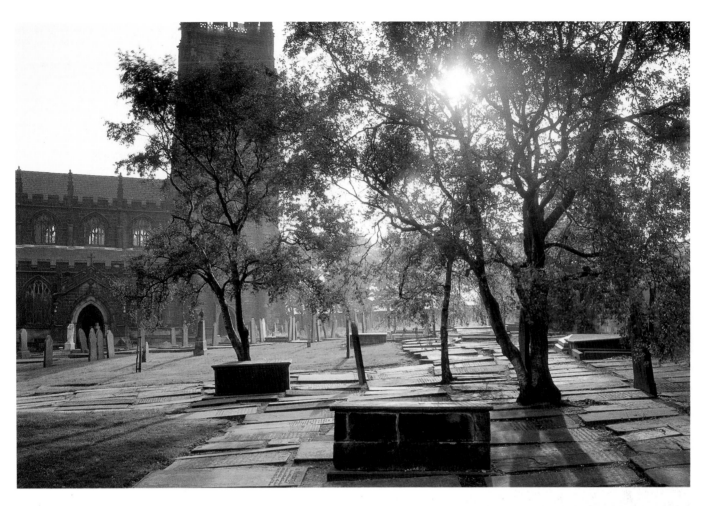

Although most of the mills are now closed, Hebden Bridge's almost claustrophobic setting has acted as a physical barrier to new housing development, allowing it to survive almost intact as a reminder of its industrial past. Tourism is now an important source of income, with the region's strong literary associations playing an important role in attracting visitors intent on savouring an atmosphere that was perhaps pivotal in shaping the output of different generations of writers and poets. Poet laureate Ted Hughes was brought up around Hebden Bridge; his wife, the poet Sylvia Plath, was buried in Heptonstall following her suicide in 1963. As the Pennine Way climbs up out of the valley past the forlorn ruined graveyard of the Mount Olivet Baptist Chapel, it charts a course across open moors that ultimately leads to the famous ruined farmhouse of Top Withens and entry into what is now referred to as 'Bronte country'.

Opposite: Hebden Bridge needed a high vantage point to show clearly its valley bottom setting, surrounded by high moorland, farms and old weavers' cottages. Finding the right vantage point can be time-consuming, but is worth the effort for the right result.

Above: the hillside weaving community of Heptonstall has one of the most beautiful churchyards in Yorkshire. I enhanced its atmosphere by making the sun an integral part of the photograph.

Right: forlorn and abandoned, the ruins of Mount Olivet chapel are on the Pennine Way's stiff climb out of the Calderdale valley.

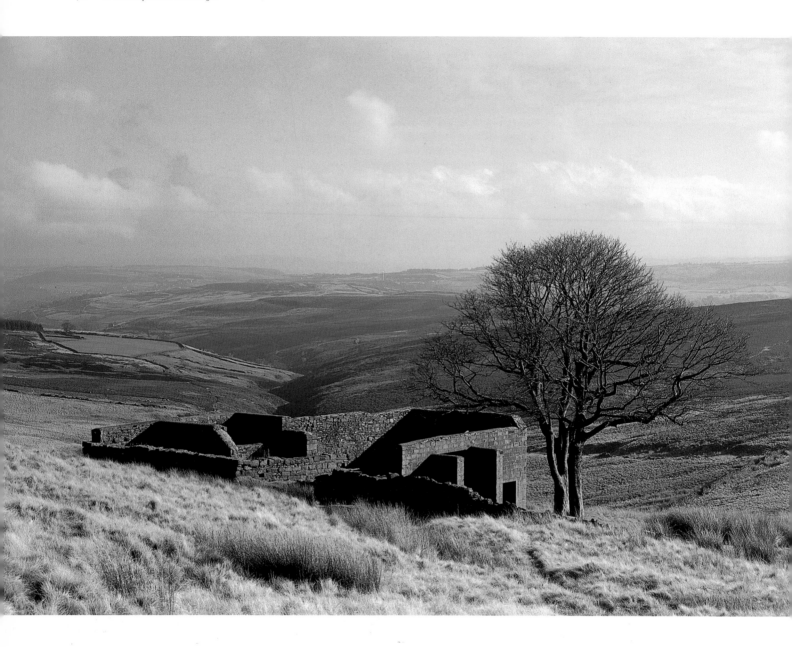

Top Withens may have no factual connection to the Bronte sisters, but for many devotees it will always be Wuthering Heights. Photographing it from above is the only way to convey fully the bleakness of its setting; it is also best shot in winter. Not only does the scene look better with yellowed grass but, once the sheltering tree bursts into leaf, it obscures a significant proportion of the view.

Bronte lovers have always associated Top Withens with the Earnshaw home in Wuthering Heights

Opposite: I nearly abandoned my attempt to photograph Haworth's eerily atmospheric churchyard as early morning cloud and rain showed little sign of abating. However, I was eventually rewarded by soft sunlight that transformed the hitherto dark, featureless tombstones into slabs of glistening gold.

Vandalism and the harsh climate have combined over time to reduce the stature of the gaunt farmhouse significantly, but the decline is now happily arrested by the cement-sealing of some areas of stonework. Bronte lovers have always associated Top Withens with the Earnshaw home in *Wuthering Heights*, despite the Bronte Society's plaque on the building pointing out that 'even when complete, it bore no resemblance to the house she described'. Devotees remain undeterred, and still make the long pilgrimage from the Bronte home in the parsonage at Haworth, intent on imbibing the spirit of Heathcliffe up on the bleak moor.

Although the track is clearly defined and paved over some sections, it is still quite a trek up to the ruined farmhouse. But on any day of the week, one can almost guarantee to meet an eclectic mix of fellow walkers, ranging from trail-hardened Pennine Way veterans to inappropriately clad

Above: the signpost to 'Wuthering Heights' includes a Japanese translation but, curiously, no other foreign languages.

groups of tourists – with billowing dresses and heads bowed against the buffeting wind, the latter give fair impersonations of their Bronte heroines battling against the elements over those very moors. As the path climbs quite steeply over the final few hundred metres to Top Withens, a signpost has been erected where another track branches off towards the equally popular Bronte Waterfalls. I was taken aback to notice that one of the wooden fingers was carved in Japanese characters, a confirmation of the sisters' worldwide appeal.

Brontefication has, thankfully, not overwhelmed Haworth. Giftshops in the village have little impact on the sombre atmosphere that prevails around the churchyard, Black Bull Inn and their cobbled environs. Lines of dark tombstones bearing the poignant epitaphs of those who predeceased the Brontes line the narrow path linking parsonage and parish church; were it not for the

The Leeds–Liverpool canal at Skipton may now be flanked by mills and warehouses converted into shops or apartments, but none of the developments is obtrusive. Large segments of the towpath have probably changed little since the era when narrow-boats carried fuel and cargo instead of holidaymakers.

intrusion of a few modern signs directing visitors to the museum created in their former home, one would feel that corner of Haworth to be forever locked in the mid-nineteenth century.

I have tried hard to empathise with the sisters' works but so far have failed. I have not abandoned them permanently, though, and hope that in the fullness of time their world might welcome me. Perhaps I should imagine *Jane Eyre*, *Wuthering Heights* or *Villette* as my additional book to accompany the Bible and Shakespeare on the BBC's imaginary desert island – that would leave me with no option but to knuckle down and concentrate on unlocking their dark and often troubled world. When he agreed to be a castaway on *Desert Island Discs*, Wainwright provided one of my all-time favourite pieces of radio broadcasting, an opinion possibly not shared by presenter Sue Lawley who had certainly encountered more voluble intervie-wees and must have wondered whether she would be able to extend the show beyond fifteen minutes. I would never have had AW down as a country music fan, but one of his choices was a wonder-fully melodramatic number entitled 'There's an Empty Cot in the Bunkhouse Tonight'. He returned to more predictable territory with 'The Happy Wanderer', a tune I vividly remember as one of my parents' first records – it was always belted out with gusto during long family car journeys. And am I alone in being brave enough to own up that it took me ages to realise there was actually no such song as 'My Knapsack on my Back', despite the Vienna Boys Choir stating quite categorically that they loved to sing it as they went along?

By its very nature, the Pennine Way cannot sustain a constant succession of visual delights, and the route northwards from Haworth certainly fell into the dreary category until it met up with the Leeds–Liverpool canal near the curious two-arched road bridge at East Marton. Unlike the Rochdale canal which exudes redundancy and desolation, the Leeds canal is still vibrant with traffic, although the traditional, brightly painted narrow boats now carry holidaymakers instead of cargo. The nearby market and textile town of Skipton is just a few miles down the towpath; like several other places within range of the official route, it is well worth a detour.

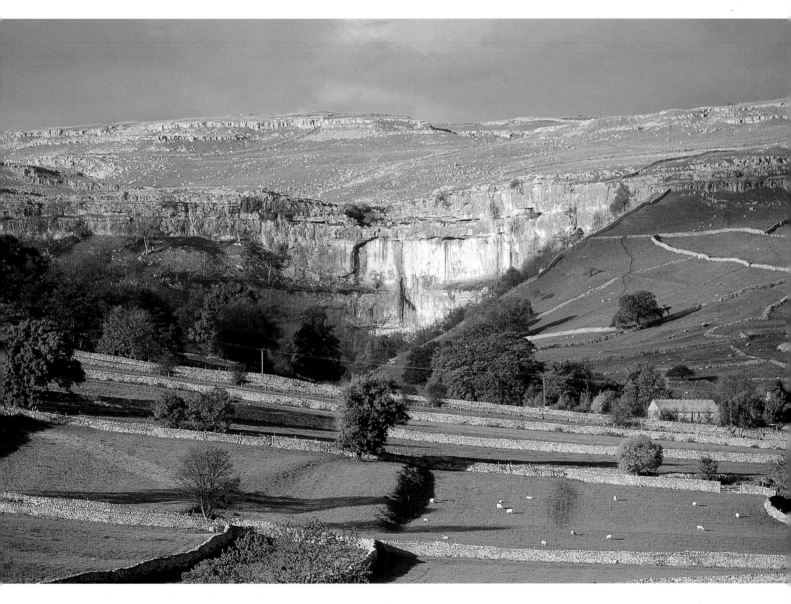

Although Malham Cove is spectacular in close-up, I wanted to put it more into the context of its surroundings. I explored a hillside some distance away and, by using my 200mm lens, was able to fill the frame with much more visual information about that area of limestone.

During the photography for the Pennine book, Skipton was a regular stopping off point for me to stock up with supplies before heading up into the Dales. The town's industrial past is reflected in the mills and warehouses that still line the canal banks, many of them now converted into waterside apartments. During summer months in particular, Skipton's canal basin is a hive of activity as novice bargees take instruction on how to handle their floating mobile homes and navigate them safely through the canal's various locks, the more complex of which can be the setting for the most marvellously entertaining one-act comedy dramas.

I regularly use the A59 from Skipton for Kendal and the southern Lake District, but can never pass the signs for Malham without being tempted to take a quick detour up to the heart of limestone country. I never tire of witnessing the landscape's sudden transformation from green to white. Whether approached by car or on foot, the first sighting of Malham Cove's towering cliff face and surrounding limestone pavement is a memory to savour, perfectly exemplifying as it does the forces that shaped the natural environment. For strict Creationists it is all quite straightforward, the celestial chisel probably sculpting out the gleaming rock formations well before lunch on day three. But there is a more logical explanation involving a

sea teeming with life, the shells and skeletons of which sank to the ocean floor, accumulating over millions of years to form the limestone layer that has gradually been exposed by the combined actions of water, ice and erosion.

The stunning shapes and textures of the limestone dales attract hordes of artists and photographers, but luckily many of them seem averse to rising in the dark and I have frequently been pleasantly surprised to be alone in that unique landscape at sunrise. The low angle of the sun brings out the subtle colours and textures of the rock, effects that are substantially diminished as soon as the morning wears on and the light flattens out.

The component parts of a limestone pavement are clints, the relatively flat-topped blocks, and grikes, the deeply incised fissures that separate them. Never stand on a section of limestone pavement and carelessly remove vital items from your pockets: the 'buttered toast syndrome' will prob-

ably send the car keys plummeting into the most inaccessible crevice with the accuracy of a guided missile. That fate befell my invaluable polarising filter one cold winter's morning as I fumbled with frozen fingers to screw it on to the lens. Wanting to transform a watery blue sky into a deep, rich aquamarine, I scrabbled to retrieve it, but in vain. I could see the little bugger faintly glinting in a dark recess, but repeated applications of a slender twig to try to prise it out just rolled the filter further out of reach every time I touched it.

In a predominantly limestone region, geologists are obliged to turn detective in pursuit of countless disappearing watercourses – the rock's porous nature means that most of the aquatic

Left: clints and grikes, the remarkable components of limestone pavements, make great subjects for abstract still-life pictures. Such photographs really need to be taken in angled sunlight so that the conformation and texture of each grouping registers clearly.

Below: a somewhat bedraggled specimen of the saxifrage that Wainwright assured me was literally dripping from the western cliffs of Pen-y-ghent. I had begun to doubt whether I would locate any at all – fortuitously, this lone plant was at least within camera range.

activity takes place below ground. Pennine Way walkers pass one such example at Water Sinks, where the outflow from the glacial lake of Malham Tarn gurgles happily into a hole in the ground like a permanently emptying bathtub. Although there is no opportunity for underground exploration at that location, numerous other sites provide access to a magical subterranean world of gushing rivers, lakes, stalactites and rock formations so fantastic that even the most creatively gifted artist could not have conceived them. For those that relish the challenge of underground exploration it is the stuff of dreams – in my case, that of terrifying nightmares. I have stood in awe and watched wet-suited cave divers disappear below ground, equipped only with torches, bottles of oxygen and copious amounts of courage in their attempts to push back the boundaries of our knowledge.

The distinctive outline of Pen-y-Ghent renders it one of the most photogenic locations in the limestone region, its character and shape noticeably changing as one circumnavigates the mountain. Perhaps my favourite picture of it so far is one I took for the original book, a telephoto shot featuring its stepped southern edge against a blood-red winter sky. I was driven to the point of distraction trying get one particular photograph AW wanted on Pen-y-Ghent, the purple saxifrage which he asserted was 'rampant along the western escarpment, draped like aubretia on a garden wall'. I was there during the correct month, the sun was shining, but despite tramping backwards and

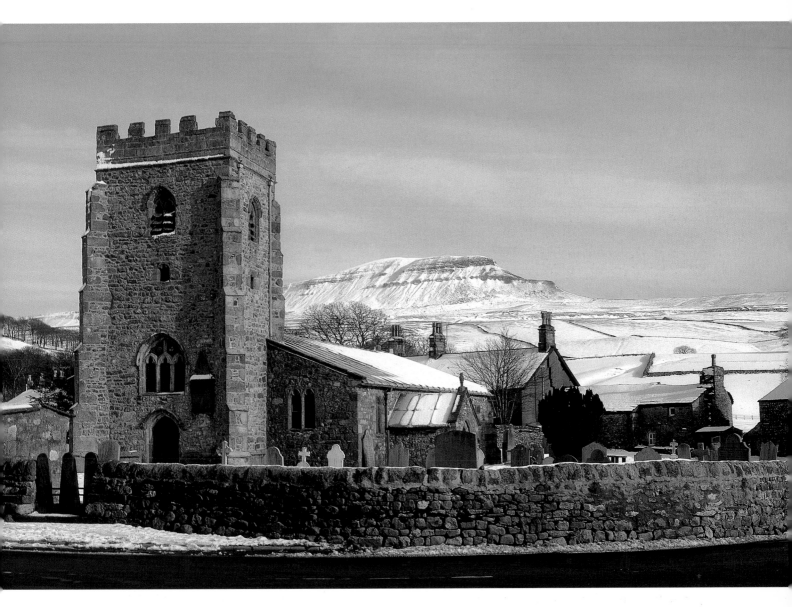

Pen-y-ghent is photogenic from almost any angle, but particularly so from Horton-in-Ribblesdale, where the parish church provides a contrasting foreground. I was able to use my 35mm 'shift' lens and impose a degree of perspective control on the church tower. Without that special piece of kit, I would have had to tilt the camera to get everything in and the building would have appeared to be falling over.

forwards along the base of the cliff I found no evidence of anything even vaguely resembling rampant floral draping. I was on the verge of either hurling myself down the nearest pothole in despair or driving straight to Kendal to throttle the author, when I caught sight of one tiny cluster of pink flowers. Not until a much later visit did AW realise that erosion and rock falls had decimated the saxifrage colony; his instruction had been based on long-past experiences. We tend to think of the landscape as a thing of permanence, unmoving and unchanging over time, but nature is constantly on the move and we ignore or abuse the increasingly fragile environment at our peril.

One of the more effective viewpoints is the village of Horton-in-Ribblesdale, from where Pen-y-Ghent's silhouette dominates the skyline and looks even more impressive than in close-up. Horton is also where the Pennine Way meets yet another of the industrial era's great achievements, the Settle–Carlisle railway. Man's pioneering spirit and determination to impose his will over nature is perfectly illustrated by the tunnels and viaducts that carry the line across the Dales' inhospitable terrain. Armies of navvies laboured in unbelievably torrid conditions; they were housed with their families in filthy trackside shanty towns that shifted with the railway's progress.

Just a few miles to the north of Horton is the Settle–Carlisle's civil engineering showpiece, the stunningly beautiful 24-arched Ribblehead viaduct built to cross the expanse of Batty Moss in the shadow of Whernside. Those elegant arches belie the toil and heartache that must gone into their construction; a nearby church has memorials to the many who died, either through accident or an outbreak of smallpox that swept through the encampments. When strong winds funnel up through the valley and hit the viaduct, there is a screaming noise as the airflow is diverted around the stonework. It must have been quite terrifying to work on that site during ferocious winter storms.

It was a great thrill to be reacquainted with some of the wilder parts of the Yorkshire Dales National Park that I first discovered when photographing *James Herriot's Yorkshire*. Despite living less than two hours' drive away, my attention had been diverted by other commitments to more distant locations during the intervening years. The Pennine Way passes from Wensleydale to Swaledale by

These Swaledale villages photographed at different times of day illustrate how the quality of light can fluctuate. The picture of Thwaite (opposite) was taken well after sunrise and the stone is reproduced in its natural state. The view towards Muker (above) was an evening shot and the setting sun has given it a significantly 'warmer' feel. It was good to see the sundial in Keld still kept good time.

traversing Great Shunner Fell, a bleak, uninspiring lump of peat that I shunned without any qualms, relying on my trusty zoom lens instead of legs to get the necessary images. That approach was something of a compromise but I was anxious to focus my efforts on Keld and the head of Swaledale, where the complex network of stone walls and field barns create such sublime designs upon the landscape that it is virtually impossible not to get good photographs there, especially when the flower meadows are in full bloom.

Having spent so much time amid the dry surroundings of the limestone dales, it was wonderful to be once again in the sight and sound of rushing water, despite its effect of increasing the number of comfort breaks required in the day! A shift in geological structure from predominantly limestone to the younger Yoredale series of rock strata is responsible for the many waterfalls occurring on the rivers of Wensleydale and Swaledale. Although the spectacular Aysgarth falls are way off route, Hardraw Force and a sequence of lesser falls

surrounding the ancient hamlet of Keld provide ample compensation. With a single drop of over 90 feet, Hardraw Force is England's highest fall above ground: a geologist's paradise, where different colours and textures of rock have been exposed by millions of years of cascading water. From a purely photographic point of view, the transformation in the character of the falls between summer and winter is remarkable. In dry weather the stream seems barely able to muster enough water to create a fall, but when snowmelt combines with sustained periods of rain the cascade is truly spectacular. The downside to Hardraw is that access is through the Green Man pub, but the entry fee is money well spent: it is a perfect excuse, if one were needed, to take a restorative glass or three before proceeding on up past Keld.to the next watering hole at England's highest pub, the Tan Hill Inn.

I nearly came to grief when taking a long-distance photograph of the pub to portray its wild

setting. The angle required a viewpoint well away from the well-trodden path and I was concentrating so hard that I forgot about the warnings of exposed coal shafts in the area. I know it is an old cliché: someone having their picture taken on the edge of a cliff with the photographer saying, 'Back a bit, back a bit,' but I very nearly did just that. The hole was almost totally obscured by matted grass which had grown over the flimsy, rotting timbers, towards which I was gradually inching backwards with my eye glued to the viewfinder, oblivious to anything other than the composition. I cannot remember any tangible sound or sensation alerting me to the fact that I was on the verge of extinction, but I suddenly froze and half-glanced behind. Had I made a more extravagant movement, my centre of balance might have shifted the wrong way, and I would have been doomed – it was the middle of the week and the area was deserted. When the heart-pounding adrenalin rush had subsided, I

The Tan Hill Inn is England's highest pub and so I wanted a photograph that reflected its isolation. Because there would be a lot of sky in the frame, I used a graduated filter to darken it down and thereby keep attention focused on the pub. Sadly, I had not realised just how gloomy the clouds immediately overhead were and I think I overdid the darkening filtration.

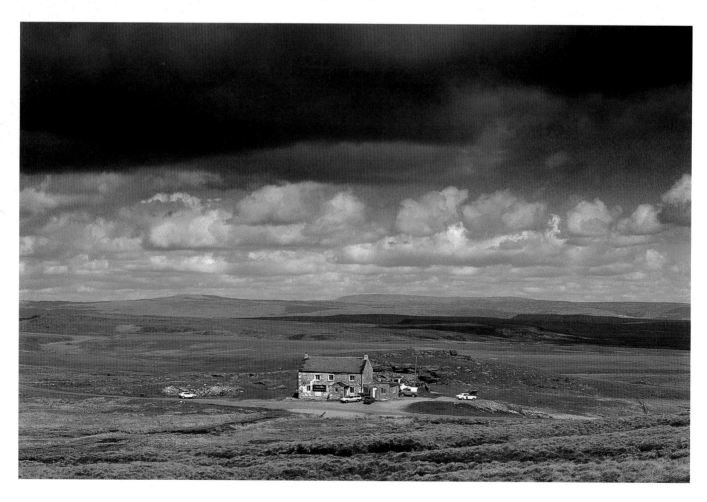

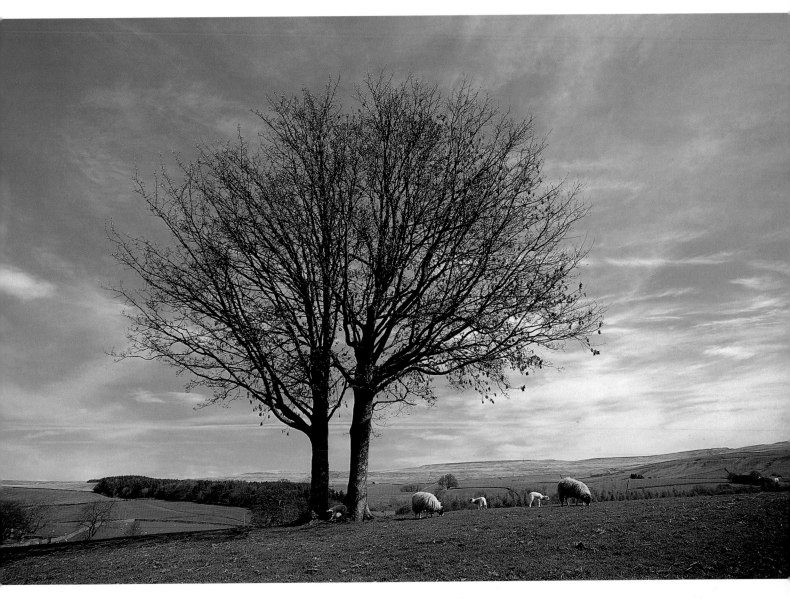

Even though there were no buildings in this shot of Upper Teesdale, I still used my 'shift' lens to maintain the natural stature of the trees, rather than distort them by using a tilted wide angle. The clouds were perfect for polarisation and, as the light was constant, I just had to be patient and wait for the sheep and lambs to graze their way into a more prominent position in the frame.

lobbed a stone into the void: it took quite a while to hit the bottom, and if I had gone down that would have been the end.

After the Way's departure from the Yorkshire Dales, nature seems to have collapsed into a heap, exhausted by its earlier efforts of providing so much stunning scenery. Although there were one or two half-decent spots, my subconscious photographic seismometer did not register again until much further north, in Upper Teesdale. However, there was just one place on the bland sector that was really fascinating – and others must think so too, as the Bowes loop is now an officially approved diversion. The principle attraction is the castle's

ruined Norman keep, but I was more intrigued by the fact that Charles Dickens visited the place in 1838, and subsequently used it as a model for the bleak outpost of Dotheboys Hall in his novel *Nicholas Nickleby*.

Upper Teesdale is a lonely, sparsely populated place whose whitewashed farmhouses stand out starkly from their green surroundings, but despite its remoteness it is an area to be relished at any time of year. In 1988, it was accorded the status of an Area of Outstanding Natural Beauty, one of the largest of the thirty-eight sites around the country protected for their flora, geological and land-scape value. When I originally photographed the

meadows adjacent to the river, they were awash with vibrantly coloured wild flowers; on my latest expedition small gangs of exuberant lambs replaced the floral panorama. Their quietly grazing mothers nonchalantly ignored the lambs' playful antics, until the offspring felt the pangs of hunger and hurled themselves at the food source with such gusto that the poor ewes were knocked sideways in the assault.

The stretch of the Pennine Way that runs in close proximity to the river Tees is one of the most agreeable of its entire length, a succession of smaller waterfalls acting as an overture to the star of the show, the dramatic 70-foot high cascade of High Force. After running unfettered across open moors, the Tees suddenly encounters a hard band of igneous rock, the Whin Sill, which has invaded the limestone and withstood the river's down-cutting effect to create the fall. High Force is impressive in any season but, when the Tees is in full spate, the roar of crashing water can be heard well in advance, a sensation that really heightens one's sense of anticipation. Upper Teesdale is now promoted as a major tourist destination and the path running down to the falls on the opposite side of the bank to the Pennine Way has been significantly upgraded to cater for the casual vehicle-borne visitor. It is a sad indictment of modern society that in such a place of stunning beauty, the authorities are obliged to erect notices telling people not to drop litter or pick the wild flowers and, stating the bleedin' obvious, that standing too close to a sheer drop on wet rocks can be dangerous.

Waterfalls can be difficult to photograph in a way that adequately conveys their impact. There used to be just one vantage point from which a good distant view of High Force could be taken, clearly showing its headlong plunge from top to bottom. Unfortunately, the young trees lining its gorge have grown to such an extent that the expanding network of branches has almost totally obliterated that once perfect view. A few miles upriver, the equally impressive waterfall of Cauldron Snout is impossible to capture in its entirety as it comprises a series of tumbling cataracts hammering over a base of impervious rock, rather than one sheer drop, and one has to be content

The Pennine Way path crosses the elegant Wynch Bridge over the River Tees (above) before arriving at the spectacular waterfall of High Force (opposite). It is quite difficult to photograph from a distance, and the only good view I could get was from amid trees, but several intrusive twigs on the right of the frame could not be avoided. I minimised their impact by using the lens on maximum aperture with no depth of field so that they would appear blurred and almost indiscernible.

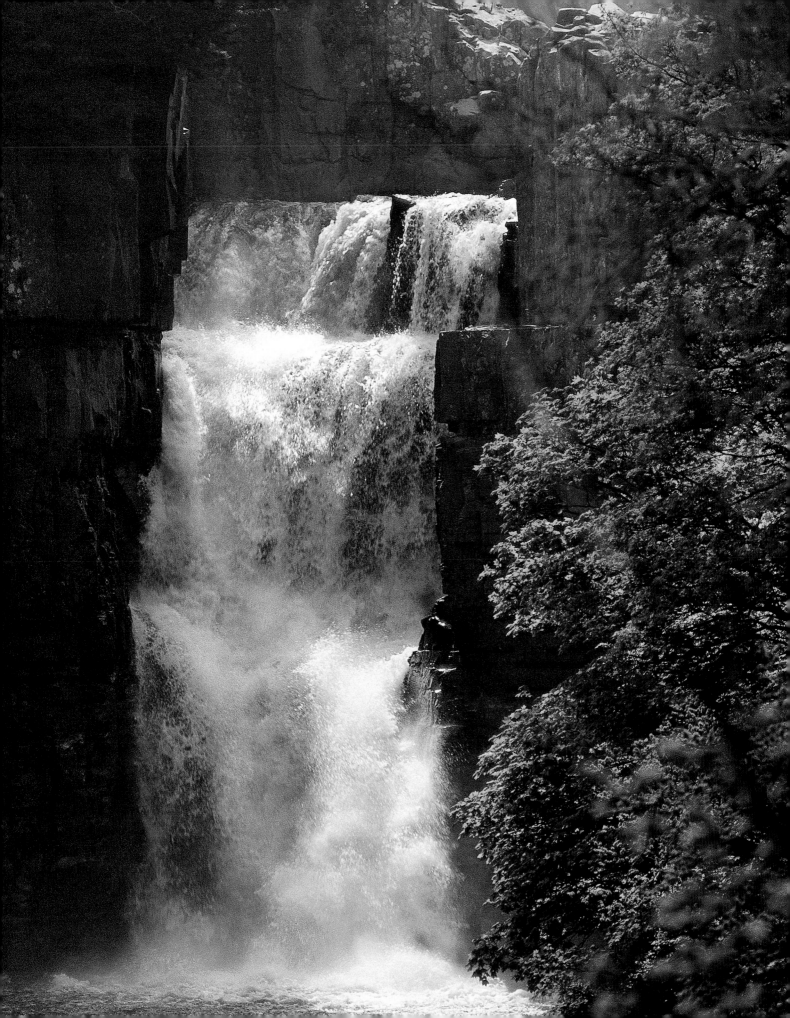

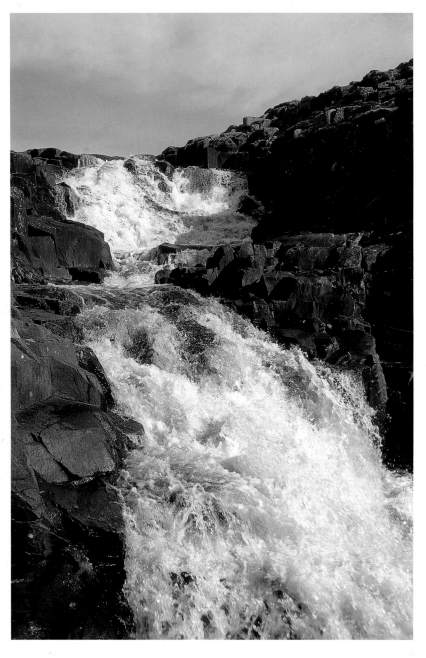

The waterfall of Cauldron Snout, near Cow Green reservoir, is so long that it is impossible to capture its headlong tumble in one shot; one can only isolate a representative section (above). The Cow Green reservoir dam (opposite), whose mesmerising overflow made a wonderfully contrasting image, controls the ferocity of the falls. From an aesthetic point of view, I regretted the narrow gully in the concrete wall, as it spoilt the elegant symmetry of the slithering waves.

with photographing a representative segment.

Cauldron Snout's flow is regulated by the Cow Green reservoir dam, a massive edifice lying less than 200 metres away from the falls, so that even during the wettest of winters, it seldom transforms into the raging torrent one might expect. The dam's construction and the flooding of the valley were highly controversial, given its location in a priceless nature reserve renowned for rare alpine species but, if nothing else, its concrete face provides a wonderful subject for photography. I was captivated by the hypnotic manner in which the water slid down the near vertical slope, appearing to transform itself into a sumptuously draped curtain of the kind one to used to find in front of cinema screens. The only thing missing was the formally attired organist and his Wurlitzer appearing up through a trap door in the riverbed, and usherettes dispensing choc-ices from their trays on either side of the stream.

Walking along a route such as the Pennine Way gives few actual surprises, because each new feature tends to materialise gradually, but one spectacular site genuinely ambushed me: the massive symmetrical bowl of High Cup. I could have accessed it via a shorter walk from the village of Dufton, but as the weather was good I elected instead to continue along the main route from Cauldron Snout alongside Maize Beck amid fairly low-key surroundings. Shortly after a point where the path diverts away from the course of the stream, and without any prior warning, the ground simply drops away in front of one's eyes into a vast natural amphitheatre, flanked by cliffs and pinnacles of rock on either side. The word 'breathtaking' is frequently employed to describe sights that are little more than average in the grand scheme of things, but there can be little dispute from the most pernickety critic in terms of High Cup's effect on a first-time visitor. I was indeed a High Cup virgin and my breath was duly removed.

After taking a selection of pictures as per AW's brief, I was then faced with a long trek all the way back past Cauldron Snout to my car on the Alston to Middleton road in Teesdale. One of the longest walks I had to undertake, it was certainly also one of the most rewarding, although during the last couple of miles my camera-laden rucksack seemed

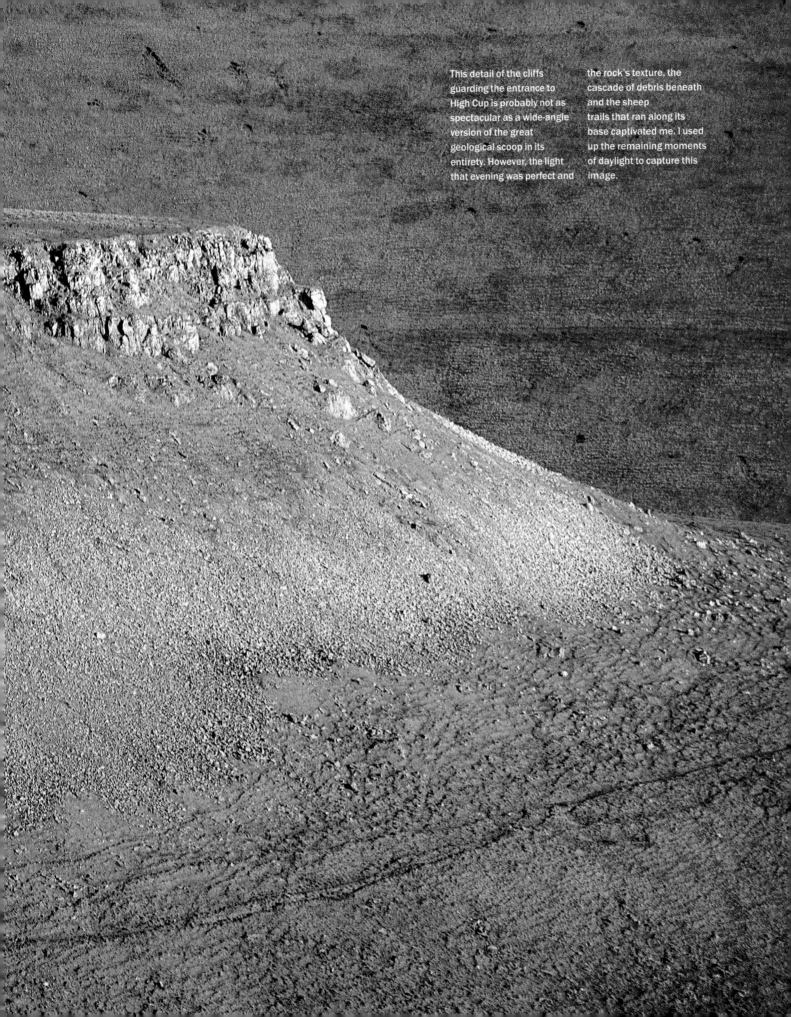

This detail of the cliffs guarding the entrance to High Cup is probably not as spectacular as a wide-angle version of the great geological scoop in its entirety. However, the light that evening was perfect and the rock's texture, the cascade of debris beneath and the sheep trails that ran along its base captivated me. I used up the remaining moments of daylight to capture this image.

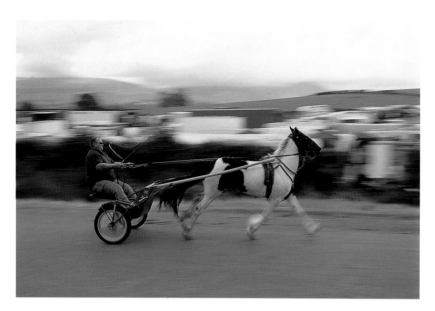

offered for sale, with many of them later put through their paces pulling flimsy lightweight racing buggies at breakneck speeds on a tarmac road adjacent to the site. Police and animal welfare officers from the RSPCA monitor the activities closely but, although there are some accidents involving horses, riders or bystanders, casualties are surprisingly few considering that the smooth road surface is not an ideal medium for metal-shod horses cornering at speed. Some of the young Romany women parade around dressed to the nines, regardless of conditions underfoot, suggesting that Appleby also serves as an annual matchmaking event: some men might leave with more than a strapping piebald gelding.

Hiding amid the diversions of Appleby was pleasant, but the outline of the Pennine Way's highest point, Cross Fell, was a constant visual reminder to me about where I should really be and it was certainly not down among the fillies and mares. AW had made provision for half a dozen shots for that part of the chapter, but I was not looking forward to the task with any great relish, knowing from pictorial research that, despite its elevation, Cross Fell was a drab, uninteresting place whose main photographic value was as a viewpoint. Salvation came in the guise of a narrow tarmac service road leading up to the radar and weather station on neighbouring Great Dun Fell which, on my initial visit, was a mess of skeletal

to increase in weight with every step. Had I been following the Pennine Way from High Cup, I would have descended into the Eden valley and been within range of the historic market town of Appleby.

Appleby is not on the official route, but just has to be visited. If you have a choice of dates, the best time to be there is during the annual New Horse Fair in early June. One amusing prelude is to watch traditional horse-drawn caravans plodding their way slowly along the main A66 trans-Pennine road, impervious to the miles of traffic crawling impatiently in their wake. It brings a smile to my face to observe the barely contained aggression on the faces of drivers in their state-of-the-art cars, rendered impotent by a one-horsepower vehicle. The 'New Fair' is far from that, its title dating back to when it was relocated to the current site on Fair Hill in 1750, a location previously known as Gallows Hill for obvious reasons. Gypsies and travellers from all over the country converge on Appleby to buy and sell horses, compete against each other in harness races or see who can palm the most junk off on to gullible tourists for the most money. But, in fairness, one can also buy exquisite works of lace, wrought iron and saddlery.

A love of horses is in the blood of travelling folk and some of the better-bred nags change hands for substantial amounts of money. The animals are ritually washed in the River Eden prior to being

I had to distil Appleby New Fair down to just three representative images and found a nice group of four horses to fill the otherwise barren foreground of the main picture (opposite). For the trotting horse (above), I used a slow shutter speed while panning the camera to blur the background to convey speed, and the boy washing his horse in the river was perfectly lit by the early sun.

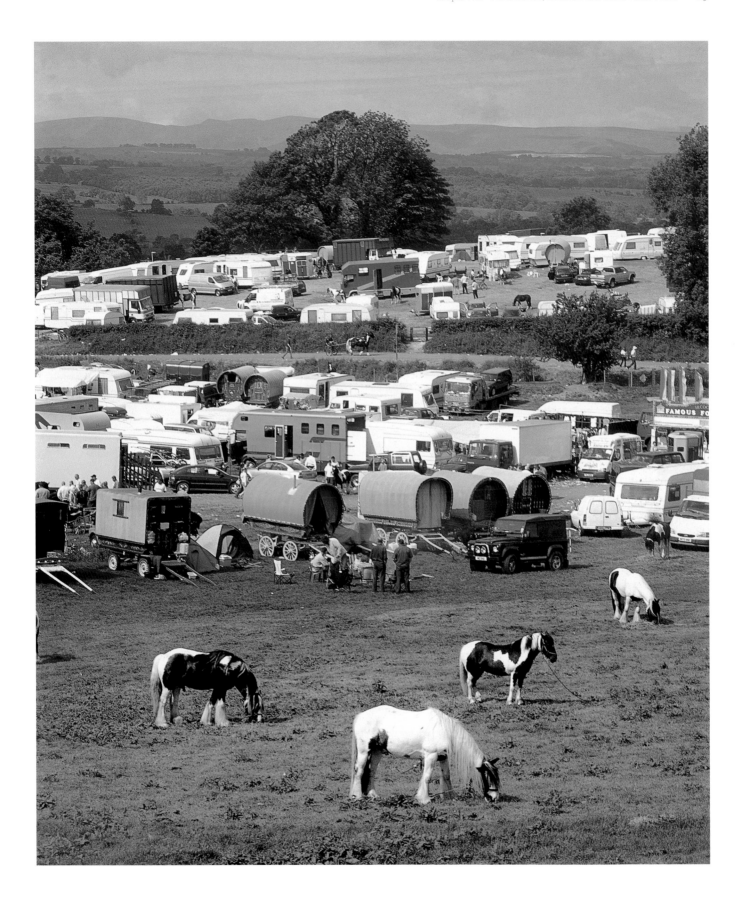

iron structures and rightly decried by Wainwright as a complete disgrace. Fortunately, science has advanced since the 1980s and a hi-tech 'golf ball' now performs the same function as the old masts. It is less obtrusive, although its glaring whiteness can be seen from much further afield than its predecessor – from a distance it really does resemble a golf ball perched on the edge of a fairway, just waiting to be whacked with a hefty seven iron.

The walk up to Cross Fell's summit was as tedious as I had anticipated, made worse by the flattest of light and a thigh-deep excursion into a cunningly disguised hole of liquid peat. I was running fast to try to capture a particular view before the sun disappeared behind clouds and it

was a strange sensation to feel my left leg suddenly disappear and the rest of my body keel over as a result. My forward momentum was sufficiently strong to pull my leg free, but the strain imposed upon my knee ligaments has left its mark – that joint is always the first to complain when the underfoot going gets tough.

I worked my way through the next couple of chapters leading up to Hadrian's Wall, but found little to enthuse over except a visit to Alston, England's highest market town. On the bright, sunny summer's day when I photographed it for the book, posters and banners were everywhere proclaiming the imminence of the town's gala day. I cursed their intrusion into my photographs, but

The outline of Dufton Fell, with the 'golf ball' teed up on its summit, was an image that benefited greatly from having a high proportion of cloud shadow playing across the fell sides. I had to wait until the juxtaposition of light and shade was just right, making sure I had a dark area immediately below the radar and weather station to give it more prominence.

thought nothing more of their significance until reminded of the date some years later. Almost thirty years before Wainwright compiled his *Pennine Way Companion*, he decided to take a break from the looming clouds of war and created his own Pennine marathon by walking northwards along the eastern flank and returning down the west side. He subsequently wrote about his experience, but the manuscript lay untouched and unpublished until discovered by our editor Jenny Dereham after a chance remark made by AW during a routine conversation. She was not only enthralled by its narrative, but also moved by the book's portrayal of a countryside and its inhabitants in that frightening, uncertain time of crisis. AW spent the night in Alston on gala day and his procedure for finding lodgings there was the same as at nearly every other place he stopped at: he simply selected a house or cottage, banged on the door and asked if they had a spare bed for the night! Given that he frequently arrived at these places drenched to the bone, and that his travelling kit comprised just one spare pair of socks and a toothbrush, he must have presented a sorry sight on people's doorsteps and maybe scored highly on the sympathy vote. Speaking of 'scoring', he was convinced he could have done just that in Alston, but was too knackered to take up the implicit invitation of one of the girls living in the house. He was given her room to sleep in, in which silk stockings and other wispy garments had been left hanging on the bedrail as a provocative gesture. His concluding lines were: 'Whoever the owner was, she had put all her cards on the table. I had, of necessity, to play solitaire!'

Despite the fact that I had lived in Yorkshire for over a decade, I had never ventured further north than Swaledale and had no conception of just how spectacular Hadrian's Wall would be. Now designated as a World Heritage Site, the wall stands today as a reminder of the past glories of one of the world's greatest empires. Despite being reduced in stature for much of its 73-mile length, at several locations the natural topography and Roman engineering skills combine to create stunning images. Although most of my photography was conducted during the summer months, Hadrian's Wall is very much a location to be savoured in midwinter, when snow throws the wall, milecastles and ruined forts into sharp relief against the bleak Northumbrian landscape.

Until I delved further into the wall's history, I shared the common misconception that legionaries from Italy, rather than auxiliaries from northern Europe or even Britain, had manned it. When standing upon one of the more exposed sectors on a freezing cold January morning, I thought what a harsh posting it must have been for those accustomed to a benign Mediterranean climate, particularly without the protective clothing we now take for granted. Photographing the highlights of the wall was very much a challenge of being in the right place at the right time, as the angle of the sun on the stonework was critical to getting a good picture. Despite my best efforts in getting weather forecasts and using a compass to plot the sun's trajectory, I became intensely frustrated when repeatedly thwarted by poor weather conditions.

Much of the more dramatic central section of the wall follows the steeply undulating contours of the Whin Sill, a band of the same hard volcanic dolerite rock encountered earlier amid the waterfalls of Teesdale. Although long stretches of the wall are along relatively level ground, in places it plunges almost vertically into a ravine, before soaring up again on to another ridge. Those dramatic changes in elevation contribute greatly to the wall's visual impact, but I discovered through trial and error that there were only one or two vantage points from which to portray the fortifications at their very best.

Hadrian's Wall is in the care of English Heritage and they have done a remarkable job in preserving those stretches that are extant and building up other parts that had crumbled into complete disrepair. It should not be necessary for them to have to request visitors not to walk along the top of the wall, but many people appear to leave their brains at home when venturing into the countryside. I encountered a family of four one day who seemed decent enough people, but I was appalled to see the father and his two young sons clamber up on to the wall and start messing about, completely disregarding a nearby sign that said it was both dangerous and destructive to do so. It would have been easier to ignore their antics but I

Wainwright decided to take a break from the looming clouds of war and created his own Pennine marathon

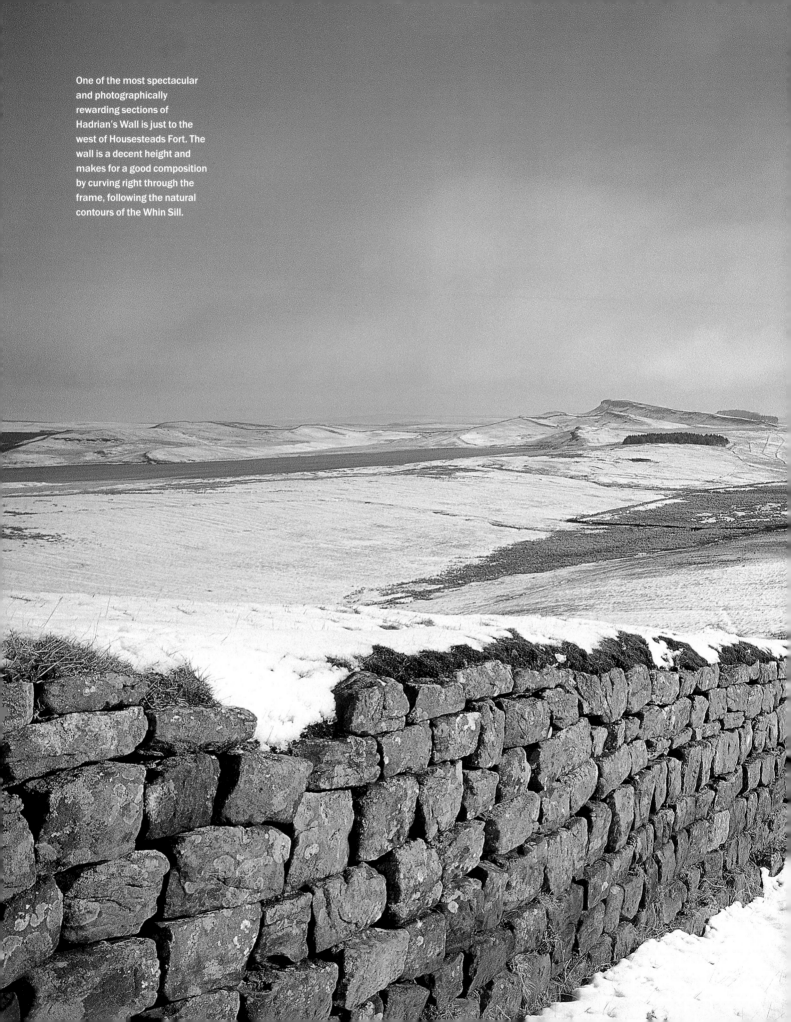

One of the most spectacular and photographically rewarding sections of Hadrian's Wall is just to the west of Housesteads Fort. The wall is a decent height and makes for a good composition by curving right through the frame, following the natural contours of the Whin Sill.

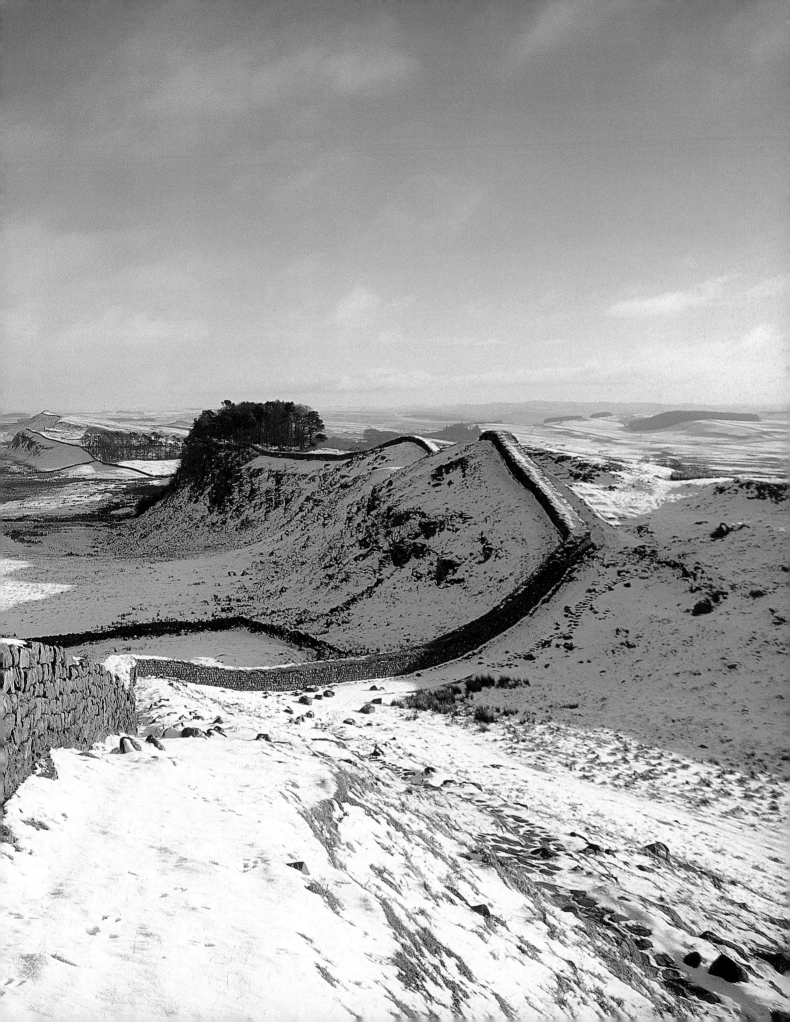

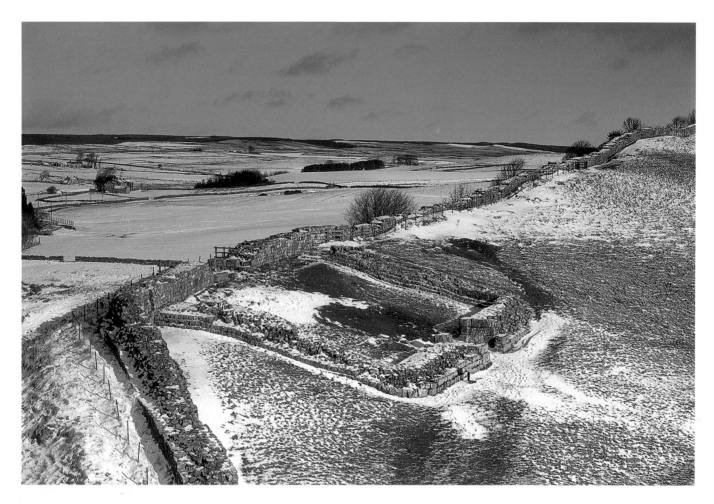

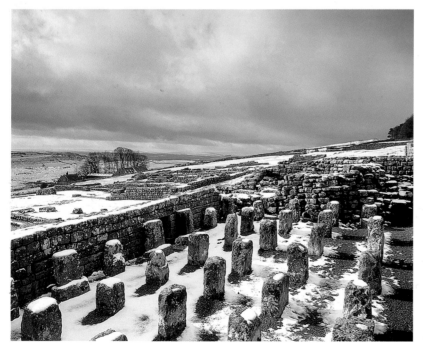

felt moved to say something and I politely drew their attention to the notice, suggesting that it was unfair on those who care for the monument to abuse it in that way. Had I not been carrying a heavy, menacing-looking tripod, I think I would have been head-butted for my trouble; even so, I received a torrent of verbal abuse from the man, disappointingly accompanied by approving nods from his wife and kids. The family from hell then proceeded to upset me further by wandering off in the direction I wanted to shoot, and I had to wait for a full twenty minutes before they disappeared from view.

When you stride along the more elevated sections of the Roman wall, the vast dark conifer plantations of Wark Forest dominate the skyline; as a photographer, I loathe those drab and featureless blots on the landscape. But although from a distance they are a visual blight, they do provide havens of peace and tranquillity when you are

Opposite, above: Milecastle 42 is fortunately overlooked by a sharp incline that provides a great overview to convey what a bleak outpost it must have been, especially during a Northumbrian winter.

Opposite, below: the granary is one of the best preserved parts of Housesteads Fort and the combination of stone against snow beneath a dramatic, filtered grey sky worked really well.

Below: calculating exposures inside the gloom of Wark Forest was quite tricky and I had to beware of extraneous light filtering through the trees and affecting my readings.

walking deep in the heart of them. The silence within the seemingly endless regimented rows of tree trunks is quite eerie, as one's footfall is deadened by thick carpets of fallen pine needles. Even during the windiest of days, the only sound to be heard is a faint whispering of moving branches from somewhere up above; you get the feeling that even birds chirrup in hushed tones, fearful of breaking the silence.

The Pennine Way finishes with a flourish, as the final 29 miles from Byrness to Kirk Yetholm is presented as an uncompromising single leg, with a masochistic option of a peat wallow to the Cheviot Hills thrown in for good measure. Up to that final stage, I had been able to do the various sections largely using my own transport, but for that segment I had to get down to some serious logistical planning. There was no way I could cover that distance in one day, but I did not want to burden myself with camping equipment so had to devise

some method of breaking the journey at roughly half way. After careful study of the maps, I noted that there were two possible routes of escape in the vicinity of Russell's Cairn on Windy Gyle: an ancient track marked as Clennel Street and another unnamed bridle path, both of which ended up at the remote farming outpost of Cocklawfoot. After further trawling through tourist information brochures, I opted to spend the night at a decent-sounding pub in Town Yetholm and when I made the reservation also asked if there was a local taxi service that could collect me from the farmstead. I was obviously not the first walker to have pursued those options, and arrangements were duly agreed.

Back in the era before mobile phones and the internet, all those plans had to be laid well in advance. In the days leading up to my departure I was anxiously scanning the weather forecasts to decide if I might have to abort the mission at the last moment. I left things in place, got myself to

Byrness and tramped off into the Cheviot Hills at the start of a potentially long and uncertain day. I have experienced better light for photography but, equally, I have endured far worse. Gradually I wound my way over the rolling hills and ridges towards Windy Gyle. As the afternoon wore on, a mist descended over the hilltops, reducing visibility to just a few metres; fortunately, I had by then accomplished most of what I needed to do on that first leg. I eventually arrived at the great mound of stones that forms what is thought to be the ancient Bronze Age burial mound of Russell's Cairn, and collapsed in an exhausted heap to gather myself for a last effort down to the valley floor.

The squad of heavily armed and camouflaged soldiers made absolutely no sound as it materialised out of the grey mist. The shock of their sudden, menacing presence almost resulted in the nether regions of my trousers turning the same peat-stained colour as the lower portions. The troops cast disdainful glances in my direction, lit up cigarettes and drank from their water canteens, conversing in sentences containing considerably more f-words than nouns or verbs. One minute they were there and then, without any audible word of command, the troops had vanished back into the murk. I took their departure as my cue to do likewise and set off down to the rendezvous point, noting that I was comfortably ahead of schedule and fervently hoping that my plans would

Top: the vast ancient burial mound of Russell's Cairn may look imposing, but is difficult to photograph as the ground drops away all around and there is no way of gaining a height advantage to provide a clearer view.

Above: a signpost denoting both the Pennine Way and St Cuthbert's Way on the final approach to Kirk Yetholm. A polarising filter darkened the sky and grass, throwing the post into even sharper relief.

slot into place. As I got further down towards Cocklawfoot, the mist briefly lifted to reveal the line of hills I would have to negotiate the following morning – with every step of the descent, they seemed even more forbidding than when I was up among them.

My transport was on time and seldom have I enjoyed a hot bath so much as the one I sank into some thirty minutes later; the steak, chips and giant battered onion rings that I wolfed down after my soak rendered me almost human again. That state of grace survived only until early the following morning when I was collected to be taken back down the narrow lane to begin one final effort. As I toiled up the long incline back to Russell's Cairn, grazing sheep raised their heads and enquired after my wellbeing, or at least I think that's what they said.

I enjoyed better light for that last leg of the journey: although the day was generally cloudy, bursts of sunlight illuminated my subjects to perfection, especially the 'stone men' on Auchope Cairn's summit. Not far from that landmark, I came across a small bothy, a place of refuge supported and maintained by the local mountain rescue team and obviously used by Pennine Wayfarers as a rudimentary overnight bivouac. The walls were covered in scrawled graffiti, a large amount of which obviously related to the nocturnal activities conducted by the hut's temporary residents. It was hard to imagine a more uncomfortable setting in which to indulge in sexual liaisons, but people obviously had and were anxious to tell the world about it

As I began the final approach to Kirk Yetholm, skylarks saluted my progress with one of nature's most beautiful sounds; I looked up into the clouds but found it almost impossible to spot the tiny bodies that were producing those non-stop anthems. The Pennine Way crosses a more recently introduced long-distance path, St Cuthbert's Way, devised in honour of one of Lindisfarne's most venerated bishops, which runs from the great Border abbey of Melrose across country to Holy Island. Just when it seemed that the final knee-torturing work had ended, a cruel blow was delivered in the shape of a thin ribbon of tarmac climbing steeply up out of the Burnhope valley.

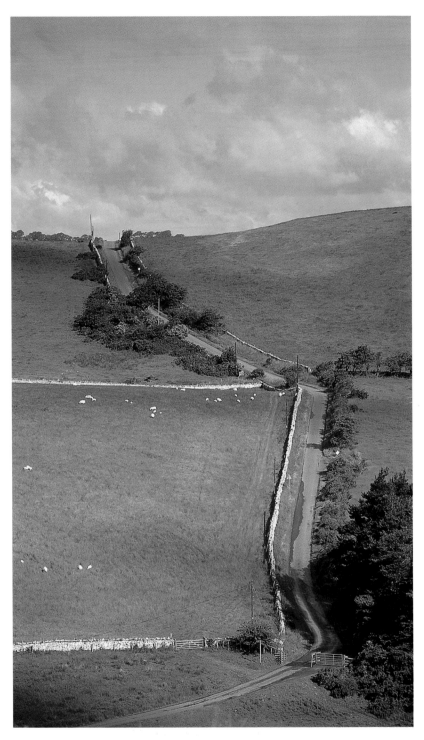

This had to be negotiated before journey's end at the Border Hotel in Kirk Yetholm.

The pub's bar is stuffed with hunting memorabilia and on my latest visit I found a signed and framed portrait of Wainwright on the wall next to the bar. The funds that he left to provide a beer for every walker completing the marathon have long since run out, but the brewery have stepped in to maintain the tradition. In all conscience, I could not look the barmaid in the eye and claim my prize, even though I felt as though I had made the journey several times over. I have promised myself that I will do the Pennine Way non-stop one day, but there are also many other 'must do' items on my list and it will have to wait its turn.

The last heartbreaking sting in the Pennine Way's tail is the tarmac road up towards Kirk Yetholm. I had to photograph it using a 200mm lens from way up on the opposite hillside in order to convey the length and steepness of the road – standing on the tarmac for a photograph would not have properly conveyed that information.

The Border Hotel is not necessarily the most photogenic building but, as the Scottish counterpoint to the Nag's Head in Edale, it had to be done. I have been there three times, but have yet to capture anyone collapsed on the grass outside after just completing the Pennine Way and gratefully drinking their free glass of beer !

The beguiling but treacherous sand banks and channels of Morecambe Bay.

Chapter Five

FROM COAST TO COAST

In the three decades since Wainwright devised his Coast to Coast walk his legions of followers have transformed it into England's most popular long-distance footpath. After the torrid time he endured compiling the *Pennine Way Companion*, it would appear that the Coast to Coast walk was an antidote to the glutinous peat bogs of the southern Pennines and the Cheviot. In his conclusion to *The Coast to Coast Walk*, AW seems to agree, indicating that while he completed his cross-country expedition 'with regret', he finished the walk from Derbyshire to Scotland 'with relief'. He even went so far as to endow both walks with gender-related characteristics: the Pennine Way was entirely masculine, while the Coast to Coast was deemed to possess feminine charms. I have to confess that few of those attributes sprang to mind as I traversed the route: either my attention was concentrated upon light conditions and picture composition, or my imagination was simply on a different plane from Wainwright's.

The Coast to Coast walk may not present as many physical and mental challenges as the Pennine Way, but it is by no means a soft alternative. While some participants might decline AW's suggested high-level options in the Lake District, there are still several demanding stretches of terrain to cover – which, in bad weather, tax even the most experienced walkers. When the wind

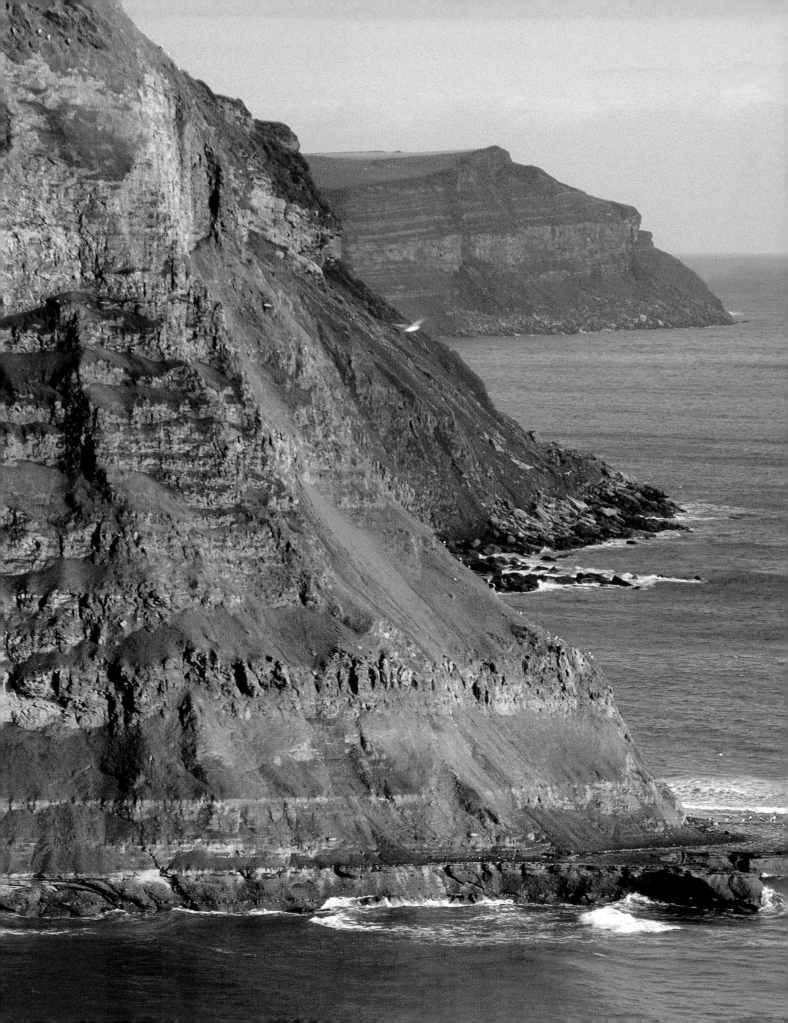

blows hard and rain is driven horizontally across the more exposed tracks of the Yorkshire Dales and Moors, those who have elected to do the walk in reverse, from east to west, will be likely to rue their decision. AW's advice to travel with the prevailing westerly winds at one's back is difficult to oppose – irrespective of arguments about the merits of the landscape at either end of the route and whether they provide a fitting opening or finale to the expedition. Provided rucksacks and clothing are truly waterproof, any amount of water can be thrown at your back with little discomfort, but I have yet to meet anyone who enjoys having a freezing cold jet of water directed straight into his or her face. I totally agree with AW when he extols the virtues of the latter stages of the walk over the Cleveland Hills and North Yorkshire Moors: I think the cliff scenery approaching Robin Hood's Bay is far more impressive than the Cumbrian equivalent at St Bees.

To those who favour the westbound alternative in the belief that the Lakeland mountains form a fitting climax to the expedition, I have but two words: Ennerdale Forest. Despite the pleasures of experiencing almost absolute silence and an atmosphere heady with the scent of resin, the dark regimented lines of trees make poor companions when trudging for mile after mile on hard forestry roads. The combination of Ennerdale and a disappointing last leg to the coast do not make a fitting climax to AW's masterpiece. The hilly outcrop of Dent is coated with still more conifers, and thereafter the drab terraced houses of Cleator do little to raise flagging spirits. There is only one satisfactory way to do the Coast to Coast: Wainwright's way!

Although the Coast to Coast Walk does not explore hitherto unknown areas, it is nevertheless a piece of quintessential Wainwright, crafted from long hours of meticulous and painstaking research. I imagined AW locked away in his study surrounded by Ordnance Survey sheets with a magnifier in one hand, a pen in the other, and a smouldering pipe clenched firmly between his teeth, as he sought out the tell-tale red dotted lines and dashes of the public footpaths and bridleways he used to create the route. In his notes at both the beginning and end of the Coast to Coast Walk, AW

Opposite: this shot of cliff scenery near Robin Hood's Bay was enhanced by the effect of low early morning sun on the foreground and the rest of the frame remaining dark.

Top: a segment of the Coast to Coast path and River Liza in Ennerdale Forest, effectively isolated by a telephoto shot from high up on Pillar.

Above: the interesting colour schemes and new Coast to Coast sign in Cleator village were tightly framed using a 200mm lens to achieve maximum compression of the image.

goes to considerable lengths to emphasise that although he was happy for people to follow his chosen route and share its delights, publication of the guide was also intended as a template, illustrating how easy it could be for people to devise their own adventures. He suggested that, if one had time, a set of Ordnance Survey maps and a little initiative, there was potentially no limit to the number of rewarding expeditions that could be fashioned through the linking together of existing rights of way.

For anyone considering creating their own walks in the future, planning will be considerably easier, courtesy of the Countryside and Rights of Way Act 2000. Once the mapping and consultation processes have been completed, around 1.5 million hectares of common land, moor, heath and mountain will be opened up for public access. Undoubtedly many aficionados have followed AW's advice to branch out on their own but,

equally, countless numbers have indicated their contentment with his choice by voting with their feet, virtually turning the Coast to Coast Walk into a small industry. Specialist companies now offer 'sherpa' and room booking services, transporting bags from one night's stopover to the next, and ferrying walkers to and from their parked cars to either St Bees or Robin Hood's Bay. An ultra secure pocket to hold car keys for two weeks becomes an essential ingredient if the expedition is not to have an inconvenient and embarrassing ending.

If you follow Wainwright's precise itinerary, accommodation is fairly limited on some stages, although I have noticed a gradual increase in farmhouse bed-and-breakfast as enterprising owners have responded to consumer demand. Hill farmers in particular receive scant financial reward for their unyielding year-round labours and diversification into tourist-related activities makes sound economic sense. There is now, for example, more

There was only one angle from which I could clearly show all the stone cairns of Nine Standards Rigg, but that also meant including an excessive amount of drab foreground. At least I had a better than average sky to balance things out and gave it an extra boost by using my graduated filter to darken it still further.

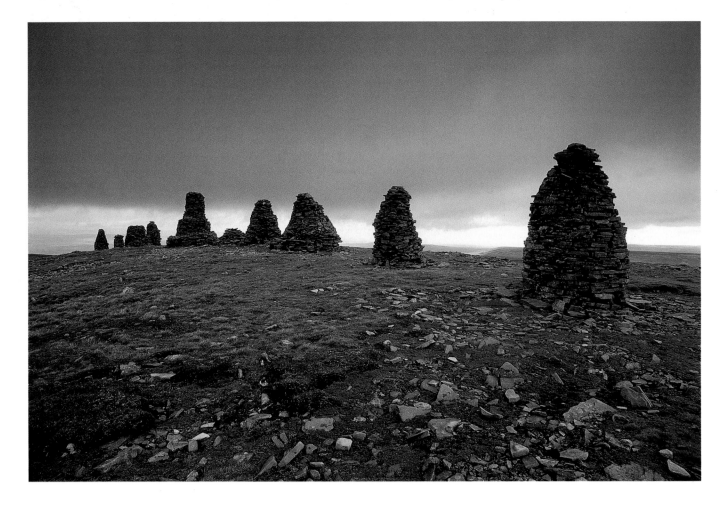

privately run accommodation to augment the Youth Hostel in the vicinity of the isolated Dales community of Keld. Dramatically located at the very head of Swaledale, the hostel overlooks the pedestrian equivalent of 'Spaghetti Junction', where the Coast to Coast and Pennine Way footpaths intersect. There is no congestion, and even during busy weekend periods incidents of 'rucksack rage' remain few and far between.

Additional bed space is now available around the head of Swaledale, but this was not so when I was shooting the book; I vividly recall the end of an arduous day's trek on the Nine Standards Rigg section between Kirkby Stephen and Keld when I came unstuck. I had not planned in advance and was made to rue my lack of foresight. Travelling entirely under my own steam and reliant on public transport at either end, I had foolishly given no thought to where I would spend that night. I reached Keld to find no vacancies, so followed the course of the river Swale down to the larger village of Muker, confident that there would be rooms aplenty there. Once at the door of the village pub, any thought of a good night's sleep was temporarily suspended by the prospect of food and drink. The first pint of lemonade shandy barely touched the sides, and I enjoyed a refill to wash down a giant platter of haddock and chips. When both had been gratefully despatched, I realised it had become quite dark outside and that I should have been making serious attempts to secure a bed for the night.

Logical thought had obviously been neutralised by the combination of tiredness, warmth, food and alcohol; I had mistakenly assumed that the weekday-quiet country pub would be able to put me up. I asked the landlord if a room was available and his response that they did not provide accommodation took a few seconds to register. I had almost digested it when he volunteered the additional information that he knew the only other place in the village was full that night.

The nearest two communities to Muker are Thwaite to the west and Gunnerside to the east. The former is significantly nearer but the latter boasts a school, a pub and a shop so would be more likely have tourist accommodation. Gunnerside is some three miles from Muker and in daylight provides a

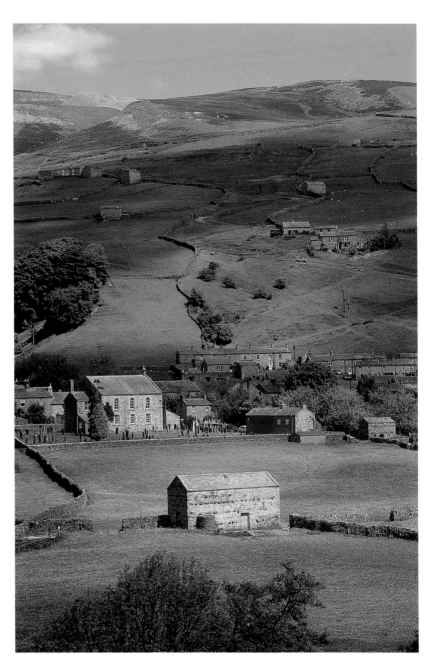

For this photograph of Gunnerside in Swaledale, I would have preferred to exclude the dark distraction of the foreground trees, but could not sidestep them without upsetting the compositional balance of the rest of the frame.

walk of almost unparalleled beauty amid typical Swaledale scenery. But night had fallen quickly, rendering the haphazardly spaced barns and dry stone walls invisible in the darkness. I had neglected to pack a torch, and had to concentrate hard on not straying from the narrow strip of tarmac into a nettle-filled ditch. I got to Gunnerside to find no room at the inn or, indeed, anywhere else. I resolved to carry on walking east towards Richmond on the basis that there must be somewhere I could find to stay before collapsing in a heap and just sleeping where I fell.

The illuminated sign of an isolated roadside guest house about a mile outside the village appeared as a mirage in the darkness. Thankfully, both sign and building were real, and despite the lateness of the hour I was warmly welcomed and given the best double room in the house. That exhausting and embarrassing episode should have taught me to adopt a less cavalier approach in the future, but I usually find the quest for photographic perfection still taking precedence over personal comfort and welfare. Over the years, I seem to have acquired an unerring knack of ending up in a thin-walled room next to the guests from hell. Disturbances usually coincide with pub closing time, when I have just become pleasantly relaxed, my alarm clock set to activate well before sunrise if the forecast sounds promising – because although evenings and sunsets can generate ideal conditions for photography, the clear early morning light is frequently the best of the day. To be out on a perfect morning the hour or so after sunrise is a privilege few seem willing to experience, leaving me entirely alone to savour the magic of another dawn as the sights and sounds of nature's daily ritual get under way.

Although aware that I would probably be seriously inconvenienced, I nevertheless elected to execute some of the Coast to Coast using public transport. Despite the potential for photographic benefits in retracing my steps each day, I had begun to find the constant backtracking to and from my car on the Pennine Way intensely frustrating; I wanted to maintain a more consistent forward momentum. On those occasions when I relied solely on buses and trains, I got a sense of what a time-consuming struggle it must have been for AW

The clear early morning light is frequently the best of the day

Reinstating the original Carnforth railway station clock, immortalised in the classic film *Brief Encounter*, was just one of several initiatives in the recent regeneration scheme.

to get from one isolated location to another, either within the Lake District or further afield, before Betty became his friend, chauffeur and ultimately his beloved wife.

Back in the mid 1980s the national rail network had not been privatised; regardless of any shortcomings in the ageing system, at least all its schedules were contained within one giant tome. I developed an encyclopaedic knowledge of the British Rail timetable, as Harrogate to St Bees is hardly the most straightforward journey. At least the isolated Cumbrian west coast has retained its railway. In its entirety, the West Cumbria route on a map resembles a slightly misshapen letter 'C', with termini at Carlisle in the north and Carnforth at the southern end, both stations accessible via direct trains from Leeds.

From a purely aesthetic perspective, both access routes to St Bees traverse equally magnificent and contrasting scenery. The northern option from Leeds utilises the famous Settle–Carlisle railway, which ploughs a defiant diagonal route up through some of the harshest and most spectacular terrain of the Yorkshire Dales. However, after changing trains in Carlisle, the trip down to St Bees is marred by the dreary coastal industrial sprawl of Workington and Whitehaven. Despite its significantly longer journey time, in rolling stock that had seen better days, the southern approach to St Bees was always my favoured option; any inconvenience was more than compensated for by sustained stretches along the coast. Long, low viaducts carry the line over the deep indentations of Morecambe Bay, and I always hoped to be in transit when the tide was rushing in. The currents in that region are notoriously dangerous and I was mesmerised by the speed at which vast expanses of sand could be obliterated. One disadvantage to this panoramic coastal journey was having to spend time waiting for a connection on Carnforth station.

Carnforth was immortalised when used as a location for the platform scenes in David Lean's classic 1945 film *Brief Encounter*, starring Celia Johnson and Trevor Howard. My own encounters with the dark, drab and run-down Carnforth station of the 1980s were not brief enough, and were in stark contrast to the experiences of present-day rail travellers or dedicated film buffs.

Although it might have been better to have had a train in this photograph of the railway's final approach to St Bees, a two-coach diesel unit in the frame would probably have done little to enhance the portrayal of natural beauty. The fact that I would have had to wait 90 minutes for the next one to pass is beside the point!

Under the auspices of a preservation trust, Carnforth is tenaciously extending its 'fifteen minutes of fame' into another century, courtesy of an expensive facelift. The original clock, which featured prominently in the film, has been tracked down and reinstated, and there are plans to create an exact replica of the refreshment room, although the one actually featured in the film was nothing more than a studio set.

Although *The Coast to Coast Walk* was shot piecemeal over a period of several months, I followed my customary practice of anchoring the book in my psyche by starting work on the opening chapter. It became largely immaterial in which order subsequent sections were photographed, but illustrating those first few pages of text gave me a greater empathy with the author. So, to begin with, I had to get myself to the shores of the Irish Sea.

My arrival on a mid-morning train at St Bees was inauspicious, as torrential rain was being driven ashore by gale-force winds. The village derives its name from St Bega, who allegedly fled her native Ireland to avoid being forced into an arranged marriage with a Norwegian prince. Had she drifted ashore on a day similar to the one which greeted my arrival, she might well have had

second thoughts and opted for the Scandinavian as the lesser of two evils. Her legacy extends to more than a place name: the nunnery she founded in the seventh century was succeeded by a Benedictine priory some five centuries later, part of which survives as the parish church. Despite severe weathering to some of the sandstone capitals flanking the entrance pillars, the typically Norman zigzag decoration over the Romanesque arch is an impressive testament to the skills of the twelfth-century masons.

On that day, as I sheltered beneath the church's deeply recessed arch, my thoughts turned from the glories of medieval architecture to the stark realities of the present. My plan had been to strike out on the initial leg of the walk upon arrival in St Bees, there still being ample daylight to have made it safely to Ennerdale Bridge by nightfall. But as time dragged on with no apparent sign of the weather relenting, I was forced to find overnight accommodation before a single step or photograph had been taken. The guest house room was pleasant enough, but having descended into a deep sulk by mid-

I was able to use a shutter speed just fast enough to freeze the movement of the waves

afternoon I was more or less impervious to my surroundings. Frustrated and tired after an uncomfortably early start to the day, I dozed off, and it was well into the evening before I came to, aware of a warm glow over the bedroom walls.

The earlier storm had abated to leave a perfect evening, but the sun was already dipping towards the horizon. With equal measures of disbelief and panic, I struggled to get my camera gear together and head for the shore. It seemed to take forever to cover those few hundred metres, the light diminishing with every breathless step. I set my tripod up right on the water's edge and managed to get the wonderfully atmospheric shot looking towards South Head which was eventually used as a double-page spread to form the endpapers for our book. It was approaching dusk by the time I took those pictures, but I was able to use a shutter speed just fast enough to freeze the movement of the waves. In the case of that particular image, the sea occupied such a large portion of the frame that a vast and prominent expanse of blurred water would have been unacceptable. After the tiring journey and a long dismal day, that one fleeting moment of magic lifted my mood from depression to elation, and I was able to retire in a more contented frame of mind. It can literally take just a few seconds of extra-special light to transform what might otherwise be an adequate photograph into something memorable.

The worst part about photographic expeditions is not the struggling to overcome bad light or lack of food and sleep, but the nervous wait upon returning home for the films to go through a processing laboratory. The results of days that might have fluctuated between anger, frustration, exhaustion, pain and elation are distilled into several sheets of transparencies, each film of 36 exposures cut into strips of six frames each and slid into semi-opaque sleeves for viewing on a light box. It is impossible to convey the level of stress felt at that moment. Although one can often go back to re-shoot and improve bad or technically flawed pictures, good ones belong to their own moment in time and can never be replicated. I could stand on the same spot at St Bees at the end of every day for months on end without experiencing exactly the same lighting and cloud formations – although

Despite its carved sandstone patterning being partially dissolved and eroded by the harsh Cumbrian climate, the Romanesque arch of St Bees priory church is still an architectural jewel.

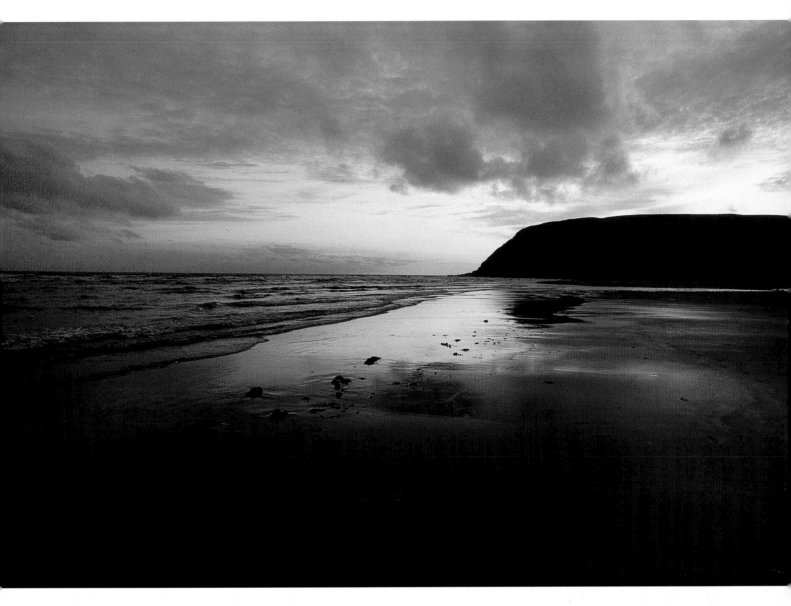

One of the dramatic post-sunset shots I just managed to take on my first mission to St Bees. The foreground may be rather too dark, but the last surviving glimmer of daylight, reflected in the wet sand, has enough power to make the photograph acceptable.

there will be other dramatic sunsets, unless you work somewhere in the world where clouds are the exception rather than the norm, no two days will ever be the same.

Wherever Wainwright offered optional diversions as well as the main route, I always had to photograph both regardless of any personal preference. Although I have not yet walked the Coast to Coast in its entirety, in terms of the sheer distances I covered while producing the pictures I have probably done it at least twice over. One of the best high-level alternatives on the entire walk is the escape from Ennerdale up on to the High Stile range, arguably one of the most rewarding ridge walks in

the Lakes. I still had to endure a return to the miles of gravel road amid acres of dark green landscape desecration, but on that particular day to be high up above Buttermere was an absolute delight.

The uphill slog out of the forest to Red Pike was the worst part, and as the gradient increased so did my pauses for ostensibly taking in the widening views. I was in tortoise mode – everything I needed was on my back and I was proceeding very slowly. Packing for public transport based expeditions became quite an art, especially deciding what could be regarded as non-essential. I did not have a massive rucksack but it had to accommodate camera equipment, fifteen to twenty rolls of film,

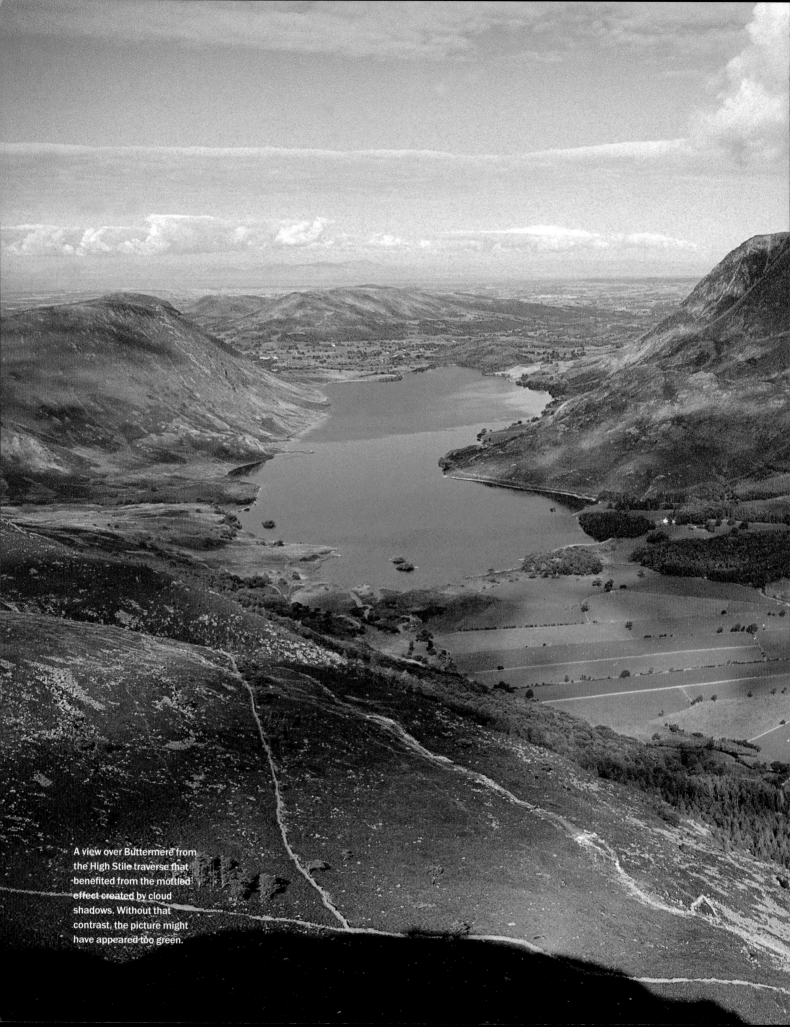

A view over Buttermere from the High Stile traverse that benefited from the mottled effect created by cloud shadows. Without that contrast, the picture might have appeared too green.

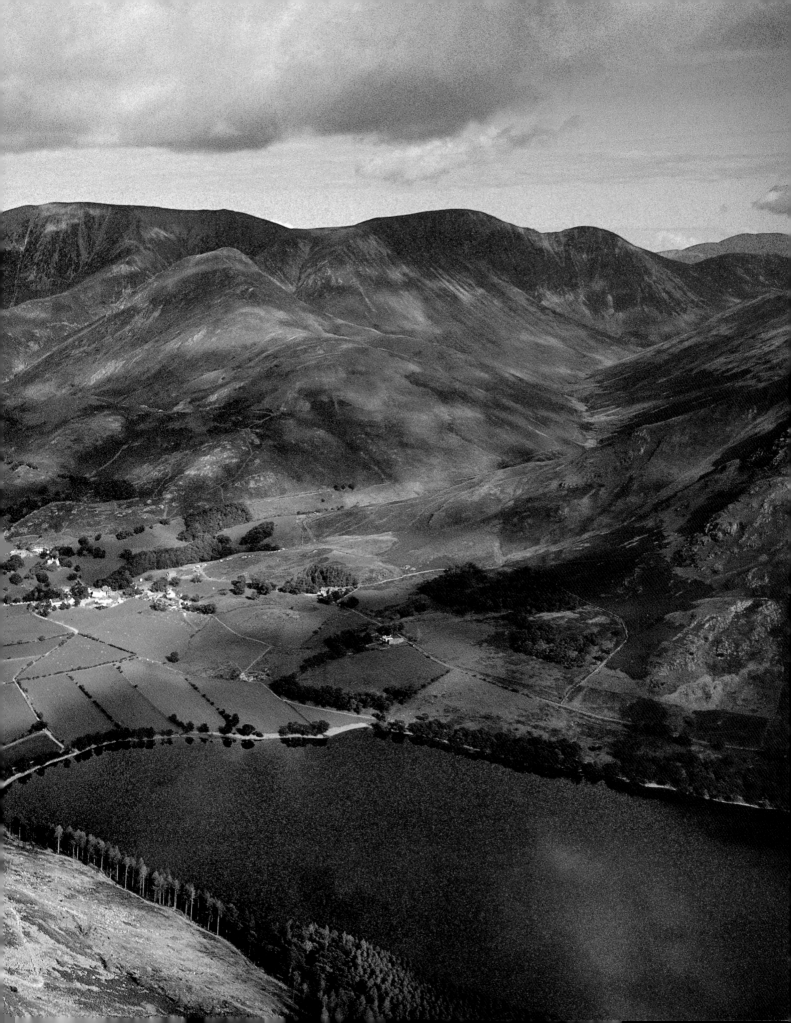

maps, AW's notes, food, thermos, waterproofs, spare socks, toiletries and other essential items of clothing. The tripod was either carried or strapped on to the outside and, when the load was complete, it formed a powerful alliance with the forces of gravity.

Buttermere has become one of the Lake District's most popular destinations for car-borne visitors and a place to avoid during summer peak periods, but even during the busiest weekends the hills above remain relatively tranquil and uncluttered. Unfortunately, on the day I elected to spend up there, the weather was perfect for walking but less than ideal for photography. It was warm with

light breezes, but tracts of clear sky were at a premium as large banks of cloud drifted aimlessly in circles around the sun. Time passes imperceptibly in those situations; I was concentrating more on reading the sky and waiting for sunshine than on clock-watching. Eventually there comes a point in the day when procrastination is no longer an option and I have to make the best of what's on offer. I knew that some locations could be revisited if results were really disappointing, but my schedule could not accommodate too many second attempts.

By the time I had worked my way along the ridge as far as Haystacks, conditions had deterio-

I used a wide-angle lens for this picture of Innominate Tarn in winter to get the maximum effect from a dramatic sky and the tarn's partially frozen surface. Bracketing the exposure either side of the one indicated is crucial under such contrasting conditions, as it is impossible to tell whether a lighter or darker image will ultimately be most successful.

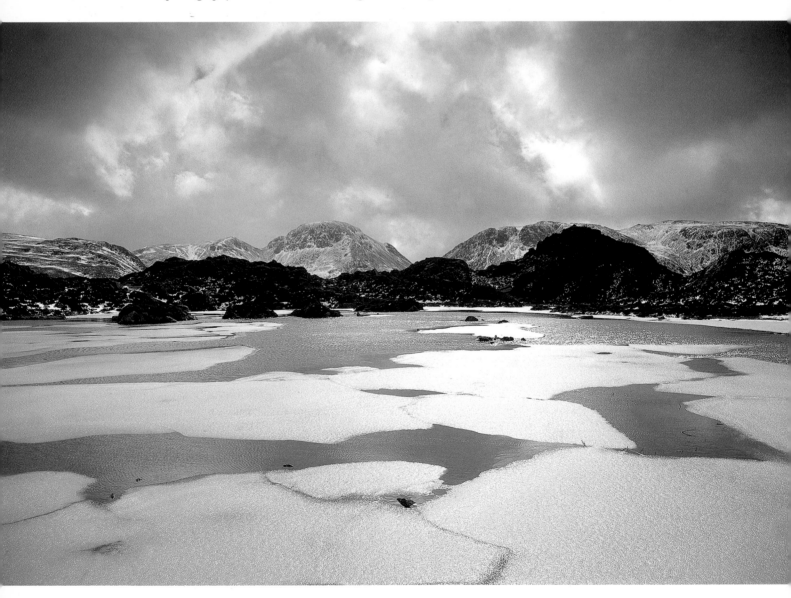

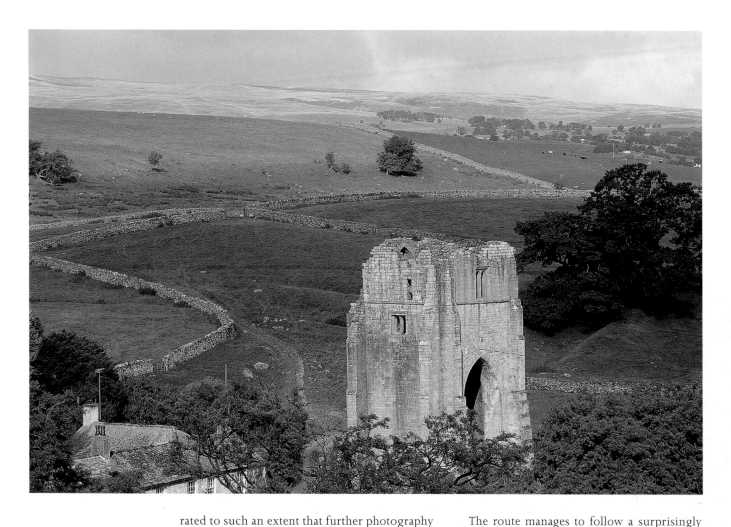

By photographing the church tower of Shap Abbey from above, I was able to incorporate the distant fells into the frame and convey a greater sense of the site's isolation.

rated to such an extent that further photography was impossible. To fill the gaps, I ended up submitting a couple of snowy winter pictures: their presence in the midst of so many midsummer shots was artistically inappropriate but unavoidable. One of those images was of Innominate Tarn, its semi-frozen surface resembling melting Arctic pack ice; I did not know it then, but it was to become Wainwright's final resting place. I cannot shrug off feelings of guilt that in that particular book I portrayed it as cold and inhospitable – somewhere one would perhaps not elect to spend eternity. Anyone undertaking the Coast to Coast should really consider High Stile as an imperative, rather than alternative route, to enable a brief pilgrimage to the 'tarn with no name'. No memorial stone overlooks the pool, and probably only true lovers of the hills will be aware of AW's presence there – to others it may represent nothing more than a scenic picnic spot.

The route manages to follow a surprisingly straight line through the Lake District National Park, eventually crossing its eastern boundary near Shap. One of my favourite locations and a place I never tire of visiting is Shap Abbey, situated on the River Lowther at the foot of a steep hill, a mile from the village. That was my first encounter with the Premonstratensian abbey, built at the end of the twelfth century by a monastic order whose quest for isolated locations surpassed even those sought by their original role models, the Cistercians. The ravages of time and the plundering of stone have sadly reduced most of the abbey ruins to ground level, but at least the site is endowed with a greater sense of scale through the surviving church tower. Shap Abbey eventually suffered the same fate as all other monastic institutions following the Dissolution by Henry VIII in 1536, but the site was well chosen – not until 1540 did the abbot finally surrender to the king's commissioners.

Since the opening of the nearby M6 motorway, Shap has been transformed from a staging post on the main west coast route to Scotland to a quiet backwater whose residents no longer have to put their affairs in order before attempting to cross the road. On any day in summer, through traffic is more than likely to be outnumbered by rucksack-laden walkers heading for the Coast to Coast dedicated footbridge carrying their path across the six-lane motorway.

Some segments on the original route linking Shap with Kirkby Stephen attempted to chart a path over ostensibly 'open' countryside, most notably in the vicinity of the dramatic limestone scenery surrounding the ancient settlement known as Castle Folds. On the relevant pages of those earliest editions, AW chuntered vociferously about lack of access, lamenting that one had to scale a large dry stone wall to make progress towards the prehistoric site. His annoyance was based on the premise that ancient archaeologists would be the only interested visitors, and that some form of stile should be provided to aid their less than agile bodies over the almost insurmountable barrier. Dry stone walls are notoriously difficult to cross safely and, despite their ability to withstand decades of harsh weather without shifting an inch, they can be severely damaged by an inconsiderate and ill-judged human assault. I hate having to climb over those elaborately constructed walls, and tend to err on the side of caution when faced by one with neither stile nor gated access.

Despite his best endeavours during initial field research, AW did in fact direct the route over paths and sections of open land on which no public rights of way existed, and Castle Folds was one of them. He received letters of complaint from the landowner, who took exception to people walking and camping on his land without prior permission and pressed his case through written objections from the Country Landowners Association. He backed this up with a more tangible deterrent: he lodged a bull on the land. In subsequent editions, AW transferred the route to the next landmark of Sunbiggin Tarn on to nearby tarmac roads. He had to take a similar course of action near Kirkby Stephen, following a solicitor's letter from another irate farmer.

Above: the Coast to Coast footbridge over the M6 motorway is less aesthetically pleasing than its Pennine Way counterpart but, by shooting into the sun and creating a silhouette, I did at least manage to make the concrete edifice a bit more dramatic.

Above: a close-up detail showing the intricate construction of dry stone walls.

Opposite, above: this view of Kirkby Stephen really works due to the strong low-angled sun that highlighted the buildings and created shadows and textures across the expansive foreground.

Opposite, below left: the striking facade of Kirkby Stephen's Temperance Hall.

Opposite, below centre: the original Coast to Coast map has thankfully survived the building's change of use and a fresh coat of paint.

Opposite, below right: Sowerby's, the hardware store, from where the priceless snow shovel was purchased

At some time or other, most walkers will unwittingly stray on to private land through navigational errors or simple confusion caused by inadequate directions; few farmers object to such innocent transgressions. Generally speaking, if you appear appropriately confused and contrite, you are politely directed back to the correct path. To date, I have not been set upon by dogs or faced a shotgun brandished in anger by an irate gamekeeper.

But as the Coast to Coast escalated in popularity, the problem of unwitting trespass became more of an issue, and it had to be seriously addressed on a more permanent basis. Michael Joseph worked with the relevant National Park authorities and other organisations to re-route the walk over the nearest official public rights of way or to negotiate continued access with private landowners on a permissive path basis. Our illustrated Coast to Coast book was revised in 1994, and Ordnance Survey Leisure Guide maps of the re-negotiated route also contain the appropriate amendments to Wainwright's original text.

Kirkby Stephen is one of only two towns encountered on this walk. Superficially it appears to have changed very little in the last two decades: there is still the atmosphere of a traditional rural market town with the Temperance Hall standing as a proud reminder of days past. However, closer inspection reveals far more shops and cafés designed to attract casual visitors. What used to be an outdoor clothing store has been transformed into an art gallery, but thankfully the building has retained the original Coast to Coast route map that was displayed on its exterior wall. One establishment that has remained steadfastly traditional is Sowerby's, an Aladdin's cave of hardware and, judging from its window display, just about anything else one could possibly imagine – axes, saws, brass coal buckets and fireplace sets, brooms and mops, pet food and, in winter, sturdy luminous pink-bladed snow shovels. I still have mine kicking around the garden; it is now chipped around the edges and almost translucent through age and mucking out stables, but it serves as a salutary reminder of a time I almost came to grief on an icy road high above the town.

I still squirm with embarrassment at the recollection of that bleak winter's night when I became

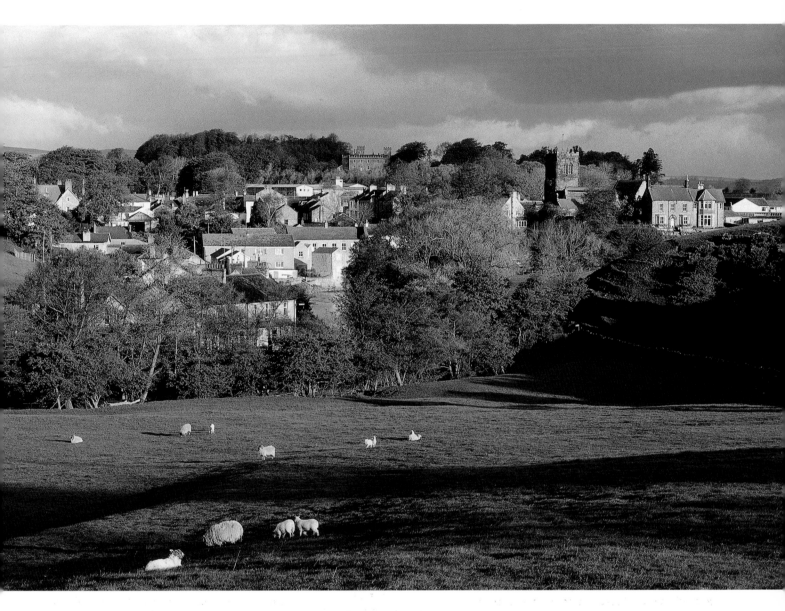

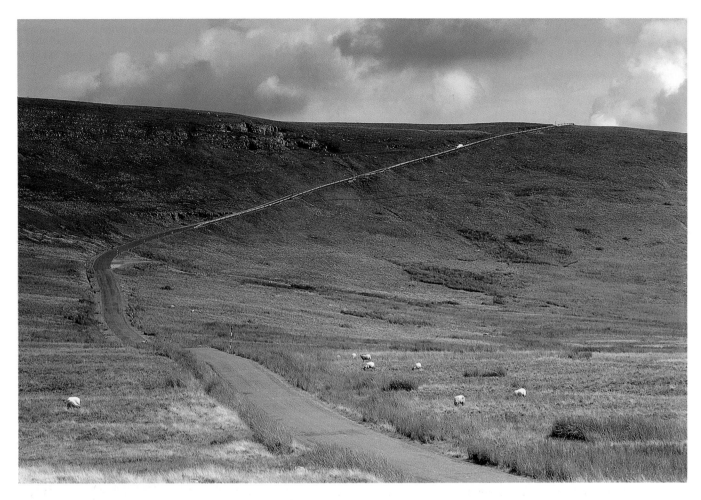

stranded after ploughing into a snowdrift. I was on my way over to Kirkby Stephen; I had driven up through Swaledale past Keld and was at the point where a road branches off to West Stonesdale and Tan Hill when I encountered a large, red 'Road Closed' sign. As there was no hint of adverse weather, I convinced myself its presence was perhaps an oversight by a highway maintenance gang and blithely drove on beneath a rapidly darkening sky. At the end of its long winding course across open moorland, the road executes a sharp right-angled turn and plunges diagonally down the steep escarpment of Tailbridge Hill on to Nateby Common, some four miles from Kirkby Stephen.

The sheer drop is protected by crash barriers and, as I negotiated the bend, I was suddenly engulfed in a maelstrom of swirling white snow and was temporarily blinded by the glistening white crystals reflected in my headlights. I scarcely had time to react before hitting a snowdrift that

had formed in the road, and I shuddered to a halt with a horrible grating noise from beneath the car. Any further progress was out of the question, and I was too tightly wedged into the drift to reverse out, so I was forced to admit that I was completely fucked. I was carrying plenty of protective clothing but had to retrieve it from the boot, and even the simple act of opening a door caused the car's interior to be flooded with white powder.

I packed a small rucksack with spare clothing, locked the car and, armed with a bent and battered ski pole for testing snow depth, lurched on down the hill, scarcely able to keep my eyes open in the driving snow. After two miles of gradual descent conditions eased, and the snow eventually turned to sleet. By the time I had covered the remaining distance into Kirkby Stephen, there was a covering of slush on the roads and pavements, but nothing vaguely resembling the vile conditions up on the fellside.

The view up to Tailbridge Hill where I had to abandon my car in a snowdrift. I was too shell-shocked to record the event when it happened, so have had to be satisfied with this image that shows a vehicle passing the exact spot where I was marooned.

Not a lot happens on wet, winter midweek nights in Kirkby Stephen and when I entered the bar of a market place hotel I felt like the Wild West stranger who has just pushed opened the saloon doors. If there had been a pianist, his fingers would have frozen over the keys. There was a noticeable hush as I self-consciously pinged the bell on the reception desk. The manageress exhibited admirable calm when confronted by the water-proof- and wellie-clad apparition and said, 'You're not doing the Coast to Coast now, are you dear?'

The following morning was absolutely stunning, as though Nature felt remorseful over the previous evening's excesses. I was anxious to make a hasty return and attempt to free my stranded car. The pink blade of the snow shovel displayed on the pavement outside the hardware shop offered a possible solution, so I parted with £7 and began the long, hot walk. The black blob of my vehicle was just visible near the top of the long incline. Having struggled back up through the snow, I was relieved to find it safe and intact, although wedged up to its axles and some distance below the snow line.

Stripping down to my shirtsleeves, I began to dig out parallel lanes of snow equal to the spacing between the wheels, and had been shovelling hard for about half an hour when I heard laughter behind me. Two hikers out enjoying the sun did not even break their stride to offer assistance, merely continuing on their way with a sneering, 'No chance, mate!' I disagreed and finally made it right back to the car, hacked the compressed snow out from under its wheels, started it and reversed out. As I retraced my route back towards Swaledale, the two walkers came into sight on the roadside. I am not a spiteful person by nature, but I have to confess that my wheels were able to make contact with a large roadside puddle and as the freezing water sprayed out in their direction, I gave them a cheery farewell wave.

Serious erosion and incursion on to private land led to the route being diverted after Nine Standards Rigg. I fully understand the need for such action, but I still mourn the loss of the exhilarating sector along Coldbergh Edge to the gritstone outcrops of Millstones. In their midst is a perfectly constructed, circular stone cairn – one of my favourite resting spots on the entire journey. The

Top: a portrait of Millstones, a notable landmark and great backrest but now sadly off the line of the revised and officially approved route.

Above: an eerie silence hangs over the desolate remains of Swinnergill lead mines, high above Keld. Although it was difficult to photograph on a dull day, sunshine would have been an inappropriate intrusion on such a sombre scene.

views over distant ranges of fells and moorland are quite breathtaking; there are no soaring snow-capped peaks along the horizon, yet the sense of height and space is of almost Himalayan proportions. The route now follows the more claustrophobic confines of Whitsundale Beck and it is always a relief to be reunited with Coast to Coast Mark I at the remote farming community of Ravenseat.

Keld marks the head of Swaledale, where tributaries flowing from north, south and west forsake their own identities to join and create the river after which the dale is named. As you trudge up the

cart track to the ruins of Crackpot Hall set high above the hamlet, one of the best river valley views in Yorkshire gradually materialises with each ascending step. Released from the dark confines of Keld gorge and its thundering waterfalls, the Swale scampers happily down towards Muker, creating an elegant shape as it bends around the base of Kisdon Hill. The pastoral tranquillity encompassed within that scene is in direct contrast to the next few miles among the ruins and despoiled land-scape of the region's industrial past.

During the eighteenth and early nineteenth centuries, this was one of the country's most productive and profitable lead-mining areas, with prices peaking sharply during periods of conflict such as the Peninsular Wars of 1810 with their urgent need for extra ammunition. The few surviving mine buildings make dramatic images, but on my first visit to the upper reaches of Gunnerside Gill I was totally unprepared for the scenes of physical upheaval on either side of the valley. Great scars, known as hushes, run down to the valley floor, their creation a result of miners damming a stream and then releasing a devastating surge of water to rip away the topsoil in the search for mineral seams beneath. Gunnerside Gill's appearance today remains much as it was when the industry collapsed in the face of cheap imported Spanish lead. Many redundant miners relocated to the coal mines of Lancashire, while others

The river Swale sweeps around the base of Kisdon Hill in a pleasing arc. The one unlit fell adds welcome weight and balance to the picture, making the barn and flower meadows to the right stand out even more prominently.

remained in the Dale and farmed sheep. Swaledale villages such as Muker, Gunnerside and Reeth have long since adjusted to that exodus, but at the time it must have had a devastating effect on the communities: records show that some parishes lost up to two-thirds of their population. The Old Gang complex is the final and most intact set of buildings, and AW was right when he suggested that at least one of these old sites should be preserved as an industrial museum. Even if it is impracticable to go that far, it ought to be possible at least to stabilise the disintegrating structures and provide some weatherproof information boards. It may be a coincidence, but after walking through the relics and ghosts of an industry that folded largely because of foreign competition, the next man-made landmark on the walk is shown on the map as Surrender Bridge.

As the route along Swaledale passes through Reeth and heads towards Richmond, the landscape mellows into a combination of woods and richer pastures; sheep are replaced by cattle. Although there is a good view view of Richmond on the western approach, the best vantage point to appreciate the town's setting is on the B6271 heading east towards Brompton-on-Swale. This requires a short detour from the Coast to Coast route but is well worth the effort of a stiff climb. Rows of elegant Georgian buildings rise in tiers, surmounted by the castle's dramatic walls and keep, a composition perfectly framed against the backdrop of Swaledale. If you are fortunate enough to be there during the castle's opening hours, the view from the top of the keep is quite stunning. It clearly illustrates how the town evolved outwards from the medieval markets held outside the fortress gate. Richmond occupied a strategically important position and was selected by Alan the Red of Brittany as the site for his great castle on a bluff overlooking the Swale. The dramatic keep was a later addition during the guardianship of the Plantagenet king, Henry II, one of England's most accomplished and prolific castle builders.

As the threat of local hostilities receded, Richmond's town wall was dismantled to provide stone for the construction of some of its oldest buildings. It prospered through the centuries as a major trading centre for Swaledale lead, and established

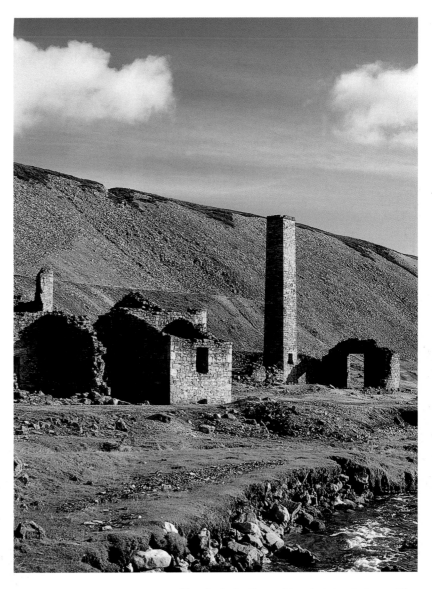

The ruined buildings of the Old Gang Lead mine may stand amid desolate surroundings, but the photograph was definitely enhanced by being sunlit to highlight the stonework and give the image added depth.

itself as the hub of a stocking-knitting industry. The town's affluence during the Georgian era is manifested in its delightful theatre, built in 1788 and restored to its former glory; in addition to staging regular performances, it also hosts a theatrical history museum. Richmond has so much historical and architectural detail to explore it would be a wasted opportunity not to linger for a couple of days.

I note from AW's text in our illustrated version of the walk that once again his thoughts strayed to the opposite sex: he encouraged 'youthful males who are fond of female company and have heard of the lass of Richmond Hill to make themselves presentable as there are still many of them around.'

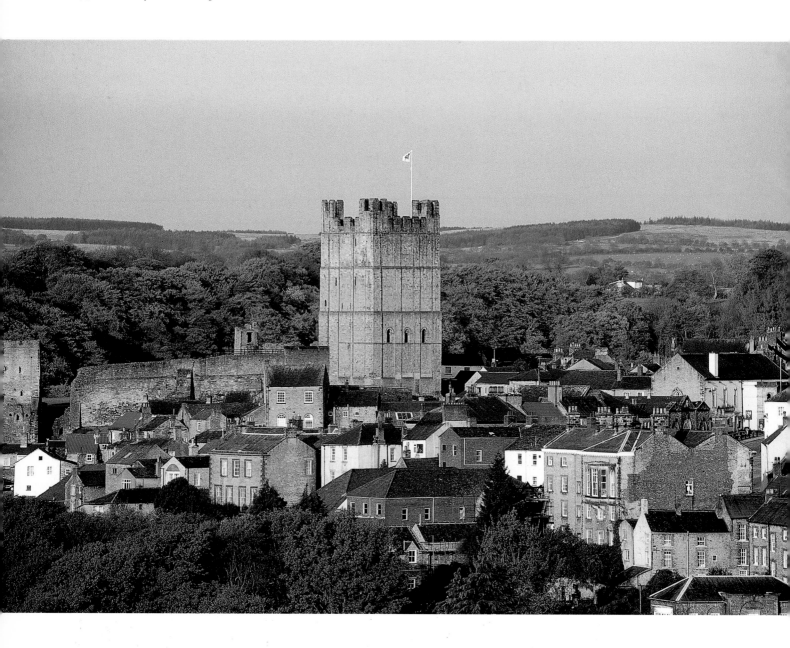

From a photographer's point of view, Richmond is one of the most considerately sited towns in England. Georgian terraces skirt a natural amphitheatre and, at its very heart, the great castle keep soars up against the Dales. An added bonus is that the whole ensemble faces the rising sun and can therefore be photographed in optimum lighting conditions.

Opposite: an aerial view of Richmond market place taken from the castle keep is a good example of when height is the key to making a potentially good photograph even better. I wanted to show how the town developed outwards from the castle walls and that message could not have been effectively conveyed from ground level.

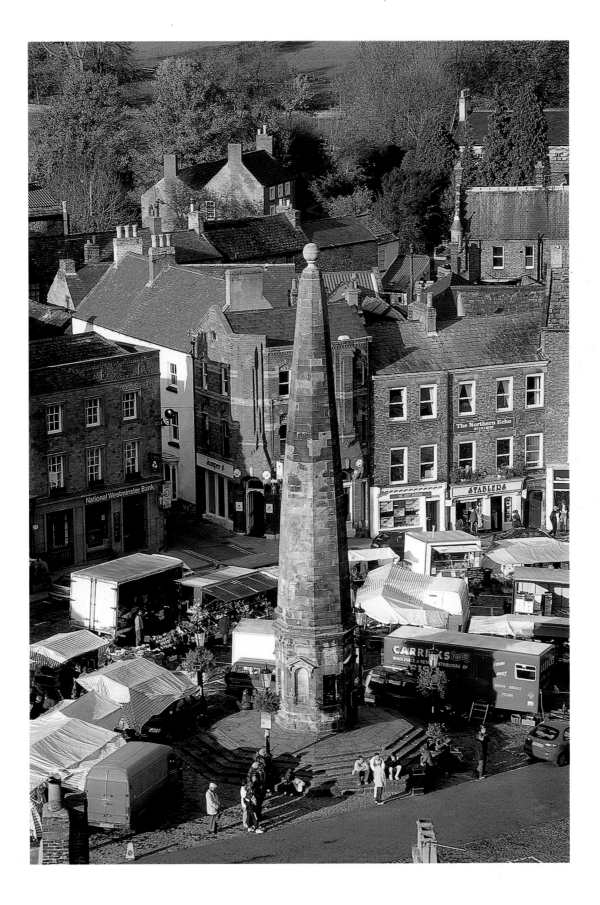

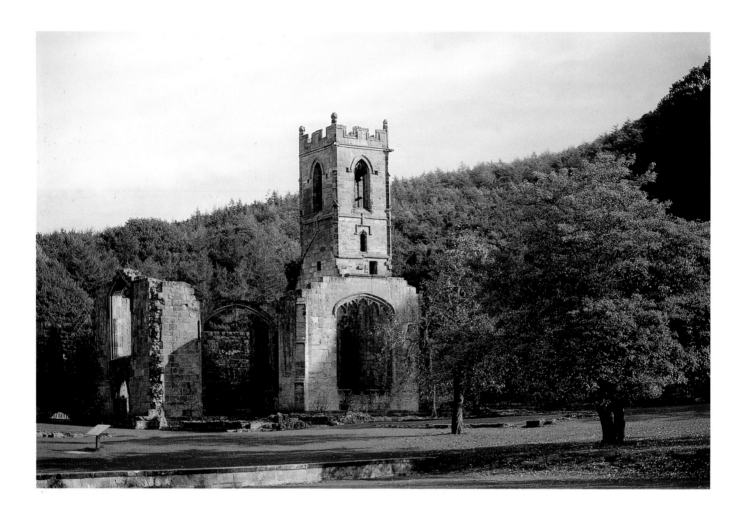

The strongly lit Carthusian monastery of Mount Grace Priory (above) stands out well against the steep wooded slopes leading up to the North Yorkshire Moors. Beyond the church itself, a surviving original wall (left) clearly shows the entrances to the monks' individual cells. Both images were shot with my perspective-control 'shift' lens to ensure that all vertical lines remained as upright as possible.

In an area dominated by sweeping panoramic views, I elected also to focus on one small segment to emphasise the heather's rich colour. The natural contrast between the three ingredients was further exaggerated by the use of a polarising filter.

I thought that traditional song referred to the Richmond near London, not the one in North Yorkshire!

I was grateful to be able to drive to many of the locations over the 20-mile plain separating Richmond from the North Yorkshire Moors. After so long spent amid mountains and moorland that leg is a real anti-climax, but the route does pass through several charming villages to alleviate the tedium. The only real highlight of that sector is reserved for the final half-mile, immediately below the steep bank taking the Coast to Coast path up on to the Cleveland Hills. The Carthusian monastery of Mount Grace Priory was less isolated than Shap Abbey, but both orders were renowned for their austerity, albeit in contrasting ways. The Premonstratensians of Shap placed themselves as far away from secular society as possible, but still engaged in communal monastic life and worship. A Carthusian's regime was based upon personal privation in the belief that poverty of the body increased spiritual wealth. The monks at Mount Grace and other Charterhouses, as their monasteries were called, spent protracted periods alone in their cells, engaged in solitary prayer and meditation.

The cells resembled small self-contained cottages, comprising an upper-floor workroom and a tiny enclosed garden tended by each monk. Communal dining took place only on Sundays and major religious festivals; at all other times, lay brothers left food in a recess by each cell door so that the occupant's devotions were not interrupted. Despite the harshness of Carthusian life there was always a waiting list, and those entering the order were expected to bring a substantial dowry with them upon acceptance.

Certain areas of the countryside are dependent on specific seasonal colours to display their true character, and nowhere is this more true than in the North Yorkshire Moors. The discomfort of midsummer heat in August is more than compensated for by the sheer pleasure of being surrounded by miles of purple heather in full bloom. I was very fortunate to be able to incorporate that period into my photography schedule, and thoroughly enjoyed renewing acquaintance with an area I had come to love during my earlier work on *James Herriot's Yorkshire*.

AW's itinerary also took me to many parts of the Moors with which I was unfamiliar, especially the section skirting the northern fringes of the National Park. On clear days, the view from the summit of Carlton Moor extends right across the Cleveland Plain to the vast chemical plants and

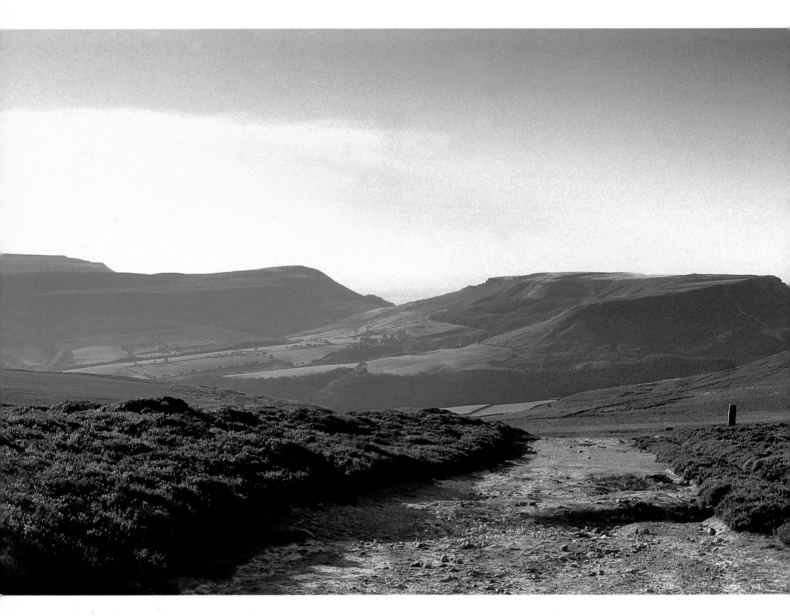

refineries of Teesside. The North Yorkshire Moors are also remarkable for the quantity of visible evidence tracing man's presence back to prehistoric times. Heather-clad burial mounds, truncated medieval crosses and, on the old drove roads, wayside stone pillars inscribed with the phonetically spelt names of the nearest settlements – all bear witness to human occupation. Some of the stones and crosses have inexplicably quirky names such as Old Margery, Fat Betty, Old Ralph and, to complete the family, Young Ralph. Even after exploring old drove roads and other tracks for Wainwright and Alf Wight (James Herriot), I am still finding new examples of graphically etched stone way-markers guarding routes that once echoed to the bellowing of cattle being driven down from Scotland to the more lucrative southern markets.

The Lake District is not the only National Park suffering the effects of too many boots tramping over rapidly deteriorating fragile turf; some parts of the Moors are also bearing the brunt of their popularity. The Coast to Coast route shares some of the same ground as the Cleveland Way (England's second oldest national trail after the Pennine Way), and at one stage is also joined by the Lyke Wake Walk. Devised by the late Bill Cowley in 1955, this is a 40-mile dash against the clock from Osmotherly (near Mount Grace Priory) to Raven-scar (south of Robin Hood's Bay), which has to be completed within 24 hours if you are to qualify for membership of the Lyke Wake Club. The walk's curious name is derived from the 'Cleveland Lyke Wake Dirge' (a lyke is a corpse), which suggests that, after death, the soul will make a journey over the moors. Although the new 'right to roam' access arrangements will help considerably in alleviating erosion on certain over-used footpaths, those who undertake the challenge of the Lyke Wake Walk will still be ploughing their ever-deepening furrow across sensitive sections of open moorland. In direct contrast to the Coast to Coast, which AW intended should use only existing paths, the originators of the Lyke Wake used Bronze Age barrows as way-markers to create their route. Those pioneers waded knee-deep through virgin heather to batter the terrain into submission, an assault from which it has never recovered. Since its incep-

Opposite, above: the view west towards Hasty Bank from the old drove road over Urra Moor was alredy well lit, but I filtered the sky to make that large part of the frame less abrasive to the eye.

Opposite, below: two of the crosses near the route at Blakey. The White Cross (left) is commonly referred to as Fat Betty and the more traditional shaped cross (centre) as Young Ralph.

Opposite, below right: one of the many old phonetically spelt drovers' signposts that abound over the moors.

Above: part of that section of the Coast to Coast that runs over the course of the old Rosedale Ironstone railway.

tion, the Lyke Wake is estimated to have been done by over 160,000 walkers, which translates into double that number of boots carving up the moor. It is hard to imagine anything more of an anathema to Wainwright than this charging obliviously across beautiful open countryside with eyes only for a stopwatch (notwithstanding the fact that many groups do it to raise money for charity).

One section of the Coast to Coast route is virtually indestructible, regardless of how many feet walk on it: for some six miles the route follows the meandering course of the dismantled Rosedale Ironstone Railway. In common with the Dales, the North Yorkshire Moors were the scene of intense mining activity, but of iron rather than lead. The industry can be traced back to prehistoric times, and the medieval Cistercian monks from nearby Rievaulx and Byland abbeys later exploited the rich deposits. The peaceful valley of Rosedale was transformed during the mid-nineteenth century by a mining boom of almost Gold Rush proportions: the local population leapt from 500 to 5,000. Between 1856 and 1885, over three million tons of iron ore were extracted and transported by rail to the iron and steel works of Durham and Teesside. Many of the old workings are now overgrown and have been reclaimed by nature.

Amid the sweeps of heather, shooting boxes and lines of grouse butts provide visible evidence of a more recent moorland industry. Regardless of whether or not one approves of shooting game

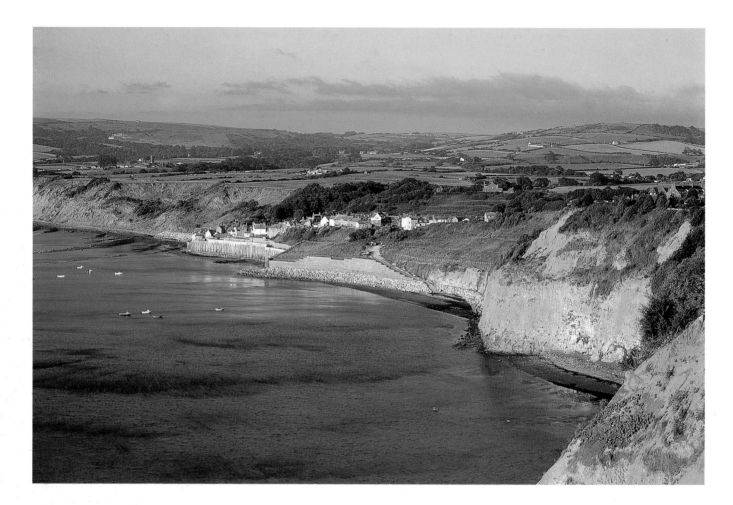

fuel come from? All our coal mines have been exploited to extinction and importing the fuel would probably escalate running costs beyond economic feasibility.

As the Coast to Coast walk enters its final stages, anyone with the temerity to doubt Wainwright's assertion that the North Yorkshire Moors and Robin Hood's Bay provide a fitting climax to his walk should be dining on large slices of humble pie. In a piece of typical AW planning, he diverts the route north of its conclusion to maximise the time spent walking along the majestic cliffs overlooking the North Sea. At that stage the walk is reunited with the Cleveland Way, and as you round the headland of Ness Point the first sighting of Robin Hood's Bay, from a precarious perch on a ledge halfway down the cliffs, is an unforgettable experience.

In the grand scheme of things, it does not really matter whether you complete the Coast to Coast by

tentatively dipping your blistered toes in the water of the Irish or the North Sea – both will probably be freezing cold. The sheer beauty of the three National Parks is undiminished by the order in which they are experienced. However, I steadfastly maintain that AW got it right, and that the awe-inspiring approach to Robin Hood's Bay is infinitely preferable to ending up in a static caravan park at St Bees with the Sellafield nuclear reprocessing plant lurking in the background.

'Anyone remember where we put the car keys?'

The last stretch of the Coast to Coast showing Robin Hood's Bay wedged in its coastal crevice (above) and a view from the top of the village, looking out over the huddled rooftops (opposite).

Left: this view of St Bees shows that an eroded path and a static caravan park do not quite match up to the untainted natural splendour of Robin Hood's Bay.

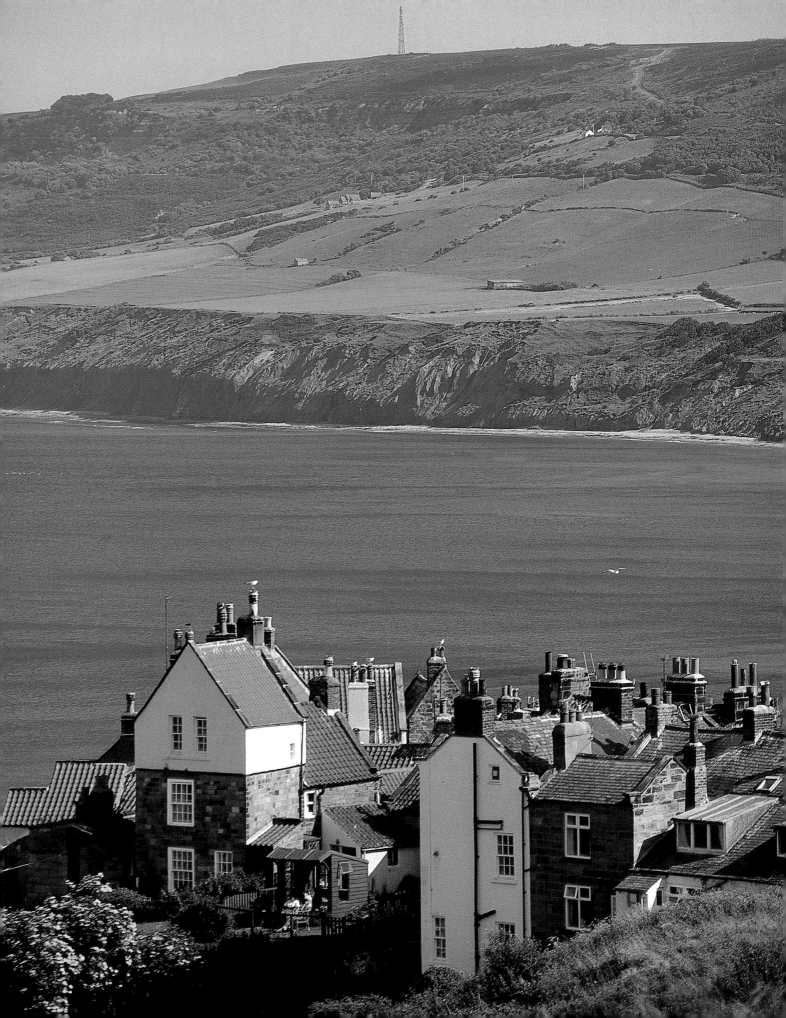

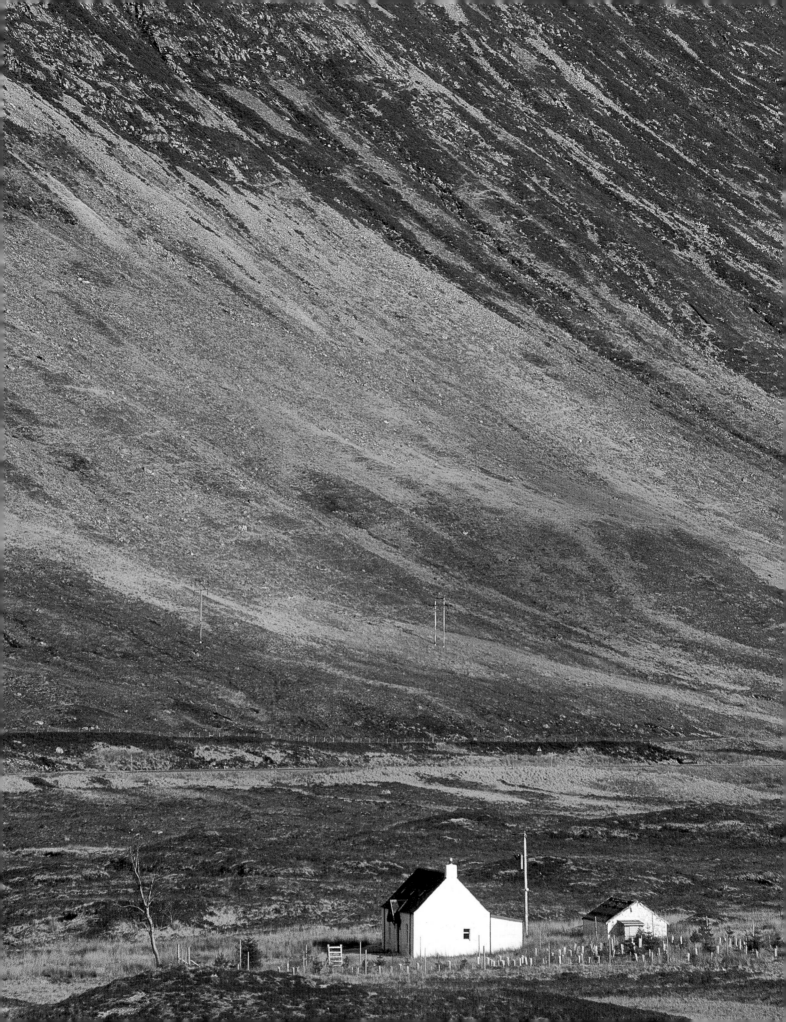

A HIGHLAND ODYSSEY

Above right: a right pair of posers! Alfred Wainwright and Eric Robson on the West Highland Way near White Corries.

Opposite: the Scottish Mountaineering Club's hut, Langangarbh, near the head of Glencoe. The impression of total isolation is maintained by using a 200mm lens to eliminate any sky; the hut is set simply against the soaring slopes of a nearby mountain. For another view see page 1.

Alfred Wainwright unwittingly became one of the more unlikely TV stars of the late twentieth century after being persuaded to participate in a series of programmes for BBC2 in the company of the well-known broadcaster and radio presenter, Eric Robson. It was a triumph for producer Richard Else, who had utilised a clever combination of guile, intrigue and patience to get AW finally to appear in front of a film camera. Who would have thought that the once reclusive fell walker, who allegedly preferred to take refuge behind a rock to avoid having to pass the time of day with fellow ramblers, would succumb to that ultimate exposure?

Wainwright's and Robson's amiable wanderings among the fells and dales of northern England was so well received by viewers nationwide that a further series set in the Highlands of Scotland was scheduled. The BBC decided that it would make good sense to capitalise on the programme's success by publishing an illustrated book to accompany the six programmes. Rather than produce it in-house as was customary, they invited Michael Joseph to join them in a co-publication. Several titles with the author were already best-sellers, so the BBC books department sensibly subscribed to the tried and tested ethos of 'if it ain't broke, don't fix it'.

My commission to photograph Wainwright in Scotland came as a complete surprise, since I had no idea that such a venture had even been mooted. The text, illustrations and layout were to be much the same as in our previous books and, exhibiting his customary zeal, AW was quickly into production at home in his Kendal study and on location in the Highlands. When I received a brief outline of the contents, the sheer scale of the work required took me aback and I was horrified at the restricted time-scale allocated. The contract was issued in spring 1987, and a delivery date stipulated for that September, but with provision for some later winter additions.

Work was always welcome, but the magnitude of the task seemed overwhelming, particularly as the Highlands of Scotland and Harrogate are not exactly adjacent. I could not dash off for a few hours' photography on a whim if a particular day's weather forecast appeared favourable. On a personal level, the assignment could not have arrived at a worse time, since I had just been relieved of my driving licence for being over the alcohol limit. I had been contemplating keeping a low profile and engrossing myself in things that could be executed with a minimal amount of travelling. The remote north-west corner of Scotland most certainly did not fit into that category, and I had to undertake a humiliating search for a temporary driver to ferry me around for the duration of the book's photography.

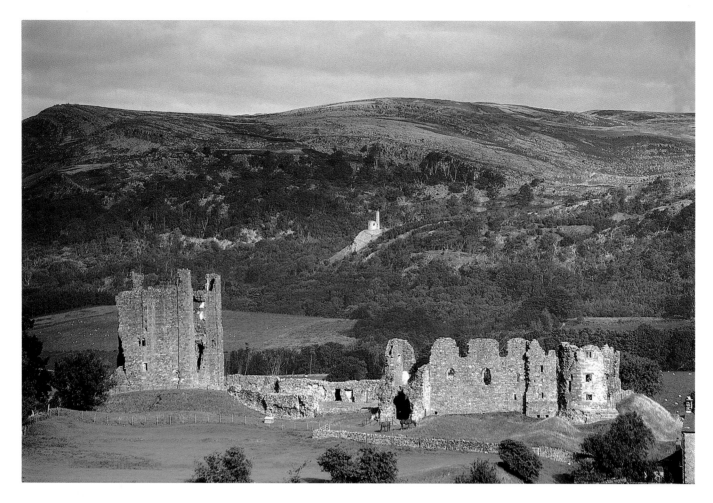

An advertisement in the local press brought a mixed bag of responses and I had the difficult task of compiling a shortlist to interview. If I took their basic ability to handle a car competently for granted, the real determining factor was whether I could endure their close proximity for days on end, week after week. As each trip north would involve staying away for at least three nights, I felt the interests of marital harmony would be best served by eliminating women from the final selection. I eventually opted for a young student about to embark on a photography course who had applied for the job as a practical prelude to his studies. Martin had a pleasant demeanour, was a capable enough driver, and appeared the least likely of the applicants to drive me demented during long months on the road. Our tastes in music were not too dissimilar and I grew to like some of his favourite tapes, while he in turn graciously tolerated most of mine, although he never quite came to

terms with my insistence that a daily visit to Ambridge and the Archers was sacrosanct and not up for negotiation.

The Highlands were several hundred miles away from my home in North Yorkshire, and for the more northerly locations an entire day had to be allocated for travel before a shot could be fired in anger. The east coast route to Edinburgh and beyond has its scenic merits, but in reality the quickest way to Scotland entails traversing the Pennines and taking the M6 and A74 up past Glasgow, Stirling and Perth. Much of that part of the road network has been upgraded since the eighties, with single lanes being expanded into dual carriageways and the Carlisle to Glasgow stretch now a fully fledged motorway, making the journey significantly easier.

Sitting in the passenger seat with Martin at the wheel was a frustrating and depressing experience. I had always travelled alone and, rather like Wain-

Above: the already imposing ruins of Brough Castle appear even more dramatic – I waited until there was no sunlight on the background.

Below: the Countess Pillar near Penrith is easy to miss but, once you have found it, difficult to ignore.

wright, was more than accustomed to solitude while working. The trek north seemed to last forever, its tedium broken only by occasional coffee and toilet breaks and observing notable landscape or architectural features at various stages of the journey. Landmark number one was the Scotch Corner Hotel, an ageing brick-built bastion dominating the intersection of the A1 Great North Road and the A66 trans Pennine route to Penrith. It has no aesthetically redeeming features whatsoever, and harks back to an era when trilby-hatted sales reps plied their trade in shiny black Morris Oxford cars.

Scotch Corner was only 45 minutes from home and so too early in the journey to merit a stop, as was the gaunt ruined outline of Brough Castle, strategically sited to guard the important east–west crossing. Both that stronghold and another nearer Penrith with a similar name, Brougham (pronounced broom), belonged to one of northern England's more powerful dynasties, the Clifford family. Both are in significantly better condition than they might have been due to restoration programmes carried out by Lady Anne Clifford during the seventeenth century. Every time we approached Brougham, I was intrigued by the sight of a curious stone pillar set on an embankment above the road and engraved with sundials and painted heraldic crests. This rather touching monument was erected by Lady Anne in 1656 to mark the spot where she parted from her mother for the last time in 1616.

Our first permitted rest stop was usually the Gretna service station, just a few miles from the famous elopement capital of Britain, but I always resisted the temptation to make a detour as there were far more pressing locations waiting further north. I did finally sample Gretna recently and can confirm that it does not have quite the same atmosphere as Las Vegas, its North American quick marriage counterpart. The hotel at Gretna Green is quite charming but the marriage registration offices are in downtown Gretna, sandwiched between dour, pebble-dash council houses and a line of shops and fast-food outlets. A tenuous gambling link with Vegas is provided by a betting shop and bingo hall located at either end of the parade, but there all similarity ends. On a grey, wet

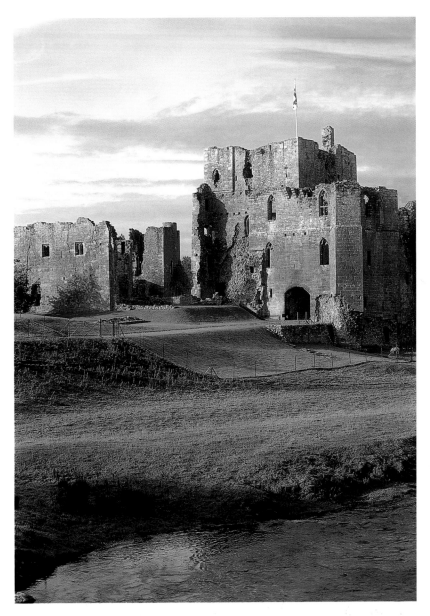

Brougham Castle (above) and the Scotch Corner Hotel (right) are two contrasting buildings from different periods at either end of the A66 trans-Pennine crossing. Both face due east and therefore had to be photographed early in the morning to catch the best light. In the case of the hotel, I was perhaps a trifle premature as there are too many drawn curtains visually defacing the windows.

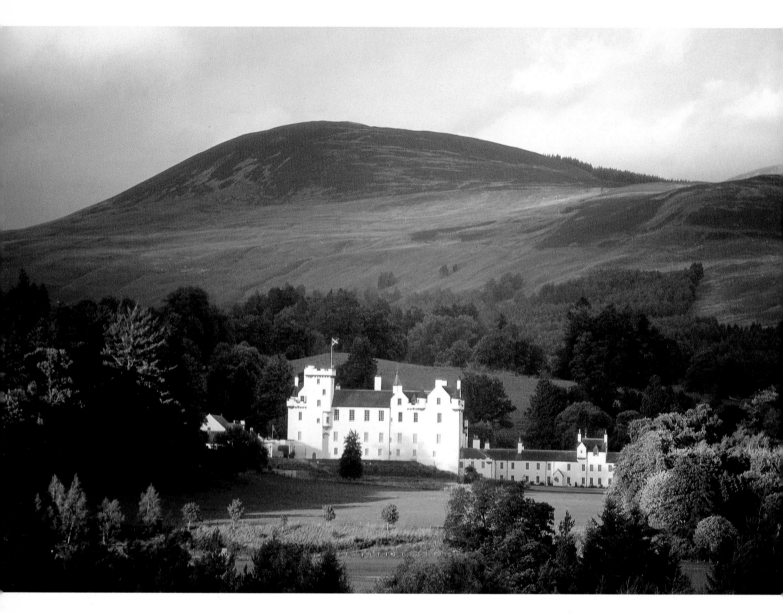

winter Wednesday, it is difficult to detect much of a romantic air.

The next boredom-relieving highlight was nothing more than a road sign, innocuous enough perhaps, except for its place name – Ecclefechan. After our first encounter, Martin dreaded each successive sighting as simply saying the word out loud sent me into raptures, there being so many different ways to enunciate it in a variety of Scottish accents. That unsuspecting village became the setting for a weekly one-man performance of the 'soap of all soaps', *Dr Finlay's Casebook*. For some ridiculous reason, the programme was lodged in my brain; despite the decades that had passed since

its broadcasting, I could still impersonate both the gruff Dr Cameron and the thin, reedy voice of Janet, his housekeeper, though I could never quite manage Finlay himself. Martin had to endure at least ten minutes of demented ramblings once the sign hove into view and episodes covered all manner of topics, including a deadly outbreak of bubonic plague in the village:

'Will you be home for your tea, Dr Cameron?' squeaked Janet. 'Difficult to say, woman,' barked Cameron, 'I'm away up to Ecclefechan where there's something strange going on.' (Janet's voice leaps another octave.) 'Ooooh, Doctor, Mrs Mac-Pherson says there are stories of plague and

Blair Castle may look impressive from the A9, but a white facade makes it a nightmare to photograph in the context of its surroundings. I had to leave it over-exposed and accept some loss of detail on the building because the contrast between the different elements of the picture were just too great to register – even with the incredible scope of Fuji Velvia.

villagers are falling like ninepins, you cannot possibly go there.' (Cameron's face softens at her pleas.) 'I have to go, Janet, it's my duty and if I don't make it safely back, make sure Finlay gets my stethoscope.'

By the time I had run out of dialogue another place name had appeared on the road signs, but back then it was just another small, unremarkable Border town that we drove past without batting an eyelid. Lockerbie has since joined other devastated communities on a worldwide roll-call of places that were simply in the wrong location at the wrong time when the random evil of terrorism came to call.

Even after several hours of driving, I did not really begin to get a sense of being in Scotland until Perth, Pitlochry and the rambling pile of Blair Castle were behind us, as we progressed up the endless miles of the A9 towards Inverness. As the seat of the Dukes of Atholl, Blair represents a curious constitutional anomaly, conferred upon their graces in 1844 by Queen Victoria: she gave them the right to maintain a private army – and the Atholl Highlanders are still in existence today. This conjures up a wonderful scenario worthy of an old Ealing comedy in which a disgruntled duke, plagued by bureaucracy and taxation, raises an army of ageing retainers wielding pikes and muskets rescued from the family's museum and marches on the seat of government to exact retribution.

My downstairs cloakroom wall is still adorned by an improvised hat rack fashioned from a deer's skull with attached antlers that I picked up by the Pass of Drumochter, that most exciting stretch of the A9 where high mountains close in on both sides of the carriageway. After reaching the summit, the road bears north-east and one starts to get long-distance views of the vast bulk of the Cairngorms. AW allocated comparatively little space for that part of Scotland in the book, and although some parts of Deeside and Speyside were quite delightful I never found any real photogenic qualities in the mountain range itself. With hindsight, I think that the time element was a determining factor – there was so little spare time available for lengthy expeditions on foot and the secrets of the Cairngorms cannot readily be discov-

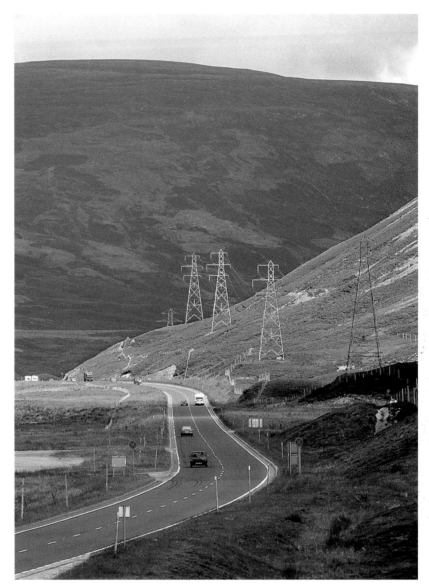

ered on surfaced roads. It was also difficult to find a decent overview of the mountain range that did not include a disfiguring girdle of drab, dark green conifers.

The occasions when we linked up with the BBC film unit and the Wainwrights were few and far between, but I was thrilled to be offered their help in getting one particularly difficult photograph in the heart of the Cairngorms. AW had included the remote Loch Einich on my list but the six-mile long private track had a padlocked gate at one end. Had I not hitched a welcome, but bumpy, ride in the crew's Land Rover, it would have been a 12-mile walk for one picture – though I think I would

The Pass of Drumochter had little visual appeal, but by waiting until the frame was segmented by light and shade I was able to add a little drama to an otherwise bland scene.

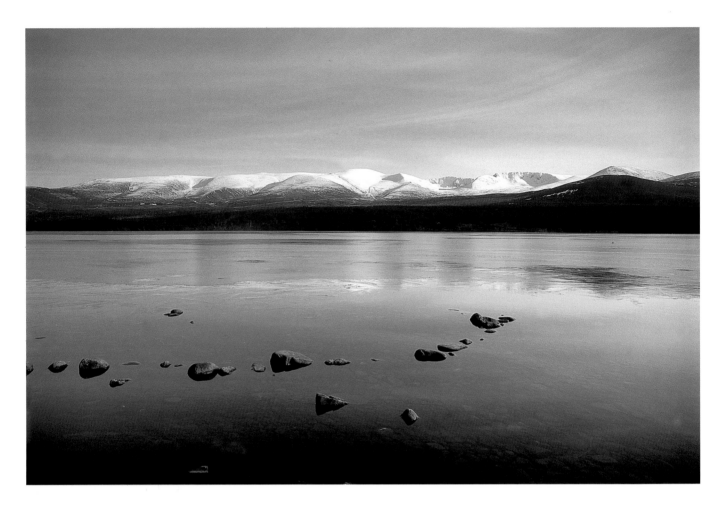

probably have begged AW for a sketch instead. The day allocated for filming was quite foul and fit for nothing in any way connected with the visual arts: conditions were as dull and grey as they could possibly be and to make matters worse it was howling an absolute gale.

When we finally reached the shore of the loch and its dramatic cliff surrounds, the water was being whipped into waves that would not have looked out of place on a rough day in the English Channel. From a picture-taking point of view it was a nightmare, but I had to get what I could. The wind was so strong that unattended equipment was being blown over on the gravel foreshore. The BBC sound recordist was having a torrid time trying to capture the dialogue between AW and Eric as the loud flapping of their anoraks rendered speech virtually inaudible unless they shouted at each other. One part of that area I really did fall in love with was the forest of Rothiemurchus, whose

Above: a long-distance view of the Cairngorms looking across Loch Morlich, for which I wanted to use a wide-angle lens to convey the atmosphere of that freezing cold, clear afternoon. I had to hunt around until I found an appropriate grouping of stones to fill the foreground – without their presence, the picture would have appeared far too fragmented.

Right: Wainwright posing for me in a sheltered spot near the raging fury of Loch Einich.

These ancient pines in the forest of Rothiemurchus were so tightly packed together it was difficult to make a composite shot, but fortunately the dappled sunlight helped create depth and bring out the texture of the trees' bark.

ancient pines were an aromatic and visual treat, providing a perfect prelude to anyone embarking upon one of Scotland's most exciting challenges for serious walkers, the Lairig Ghru. That dramatic 24-mile long pass from Aviemore to Braemar links Strath Spey and Deeside and involves over 2,000 feet of ascent.

As the Cairngorms featured towards the end of the book and AW never deviated from working in correct sequence, I had to begin by following his set itinerary until enough chapters of text had been completed to provide room for manoeuvre. Thus the first few expeditions were the longest and most tiring, as the journey to Inverness alone took some eight hours and there was still further to go after wearily reaching that notable milestone. We would occasionally stop overnight there before pressing on northwards or across to the west, but I was always paranoid about missing out on precious morning light and frequently insisted that Martin

press on closer to wherever the next day's first location might be before we could collapse into bed.

My campaign began in earnest up in the far north-western corner of Scotland amid the terrifyingly high cliffs of that most aptly named savage corner of Britain, Cape Wrath. Conditions were far from ideal on the day we made the trip to that inhospitable corner of the mainland: the light was flat and the sea almost a dead calm. There would be no pictures of waves crashing relentlessly on to the rocks far below and the colours would reproduce as drab and muted. But as getting there involved crossing the Kyle of Durness by passenger ferry and then buying a ride in a minibus to the lighthouse, we had to fit in with the existing schedules and take our chance. We were just two of a motley crew who had elected to make the trip and I became frustrated at the amount of time we wasted kicking our heels waiting for the return bus some two and a half hours later. My pictures had been quickly

accomplished, and on that occasion I had no interest in scouring the headland for sightings of rare seabirds – my only concern was to get to the next location before the light failed.

Sandwood Bay would prove to be one of the atmospheric highlights of the whole book. It was accessible only via a rough four-mile track, the last two miles of which had to be completed on foot. It is one of the most magical places I have ever visited in Britain, and since that first discovery I have made several more pilgrimages to savour its absolute peace and serenity. On one occasion I took a small tent and camped there overnight, but was duly mindful of tales that spoke of Sandwood being haunted by a mermaid. I recall sleeping in snatches that night, alert to every alien sound outside. There was just room enough for me in the tent so the

prospect of being joined by a fishy apparition held little appeal despite her alleged beauty and besides, it would take forever to clean the scales out of my sleeping bag!

The bay is bordered by a barrier of sand dunes, beyond which lies a freshwater loch ensuring that one need never die of thirst, although long-term self-sufficiency could be a bit more tricky. Those willing to experiment with concoctions of sea-weed and shellfish would fare better than visitors who demand more traditional forms of nourish-ment. Sandwood is no longer the closely guarded secret it once was, but the trickle of visitors will never become a flood because of its inaccessibility to motorists unwilling to amble further than the nearest burger or ice cream van. I somehow feel guilty about extolling the virtues of Sandwood to

These two contrasting images of Sandwood Bay complement each other by providing both atmosphere and information. The close-up detail of the beach (above) was a last-gasp effort as the sun disappeared behind a bank of cloud on the horizon, but there was enough light in the sky above to make powerful reflections in the wet sand. The daylight shot looking down on the bay (opposite) shows its conformation and isolated, burger-van-free location.

the uninitiated and can only hope that its devotees will forgive my altruism. It would be churlish not to share the knowledge of such natural beauty.

As Martin drove us away from Sandwood Bay and back down the narrow lochside lane to pick up the main road at Rhiconich, I studied the map and noticed the names of two gleaming white quartzite-topped peaks on the eastern skyline – Arkle and Foinavon. Both these names were given to famous steeplechasers, and never could there have been a more inappropriate juxtaposition. Arkle was a triple Cheltenham Gold Cup winner and for many years the pride of Ireland, but Foinavon's fluke Grand National win at odds of 66–1 came courtesy of a terrible mêlée which decimated the opposition. To add insult to injury, I noted that the map quoted Foinavon as being 128 metres greater in stature than Arkle. Thoroughbred racehorses and their breeding have always fascinated me, but I had never realised that those two horses had been named after Scottish mountains. Place names figure heavily on the bloodstock register, but I admire the creativity exhibited by some owners when combining elements of both the sire's and dam's names. One of the cleverest examples is a horse called 'Wait for the Will', whose father was 'Seeking the Gold' and his mother 'You'd be Surprised'. At least racehorse owners exhibit slightly more wit than some householders – I was amazed to come across a 'Dun Roamin' near Fort William, having thought the name no more than an urban myth. One of my art college friends was an undertaker's daughter and I would dearly have loved their house and adjacent chapel of rest to be renamed 'Dun Breathin'.

Not all Highland mountains have easily pronounceable anglicised names and the complexities of correct spelling in Gaelic certainly exercised Wainwright, especially as some names had been amended by the Ordnance Survey into versions he scarcely recognised. As one might imagine, he put his foot down in defence of some old favourites, but reluctantly accepted that to persist stubbornly with out-of-date spelling could result in confusion. In his first chapter dealing with the Far North, AW wrote about a diminutive mountain he referred to as Stac Polly – far from being shaped in the manner of a pile of parrots, it turned out to

resemble a porcupine when viewed from alongside. Curiously, it also resembled an almost perfect volcanic cone when seen from another angle but, regardless of its appearance, the 2,000-foot summit of Stac Pollaidh made the most perfect vantage point. It was a very steep ascent, but the resulting views out over the surrounding lochs and mountains were simply awesome and I was doubly privileged to have been there on a mellow, clear evening when conditions for photography were perfect. As the sun began the final stages of its plunge towards the Atlantic's horizon, shadows lengthened and the whole colour balance of light on the rocks warmed to rich ochre. To the north, the distinctive twin peaks of Suilven dominated their watery surroundings, those 1,000-million-year-old hulks of ancient Torridon sandstone rearing up from a bed of Lewisian gneiss pre-dating them by a further 1,800 million years. These are the oldest rocks in the British Isles and to watch the light gradually fade over a landscape that bore absolutely no visible trace of man's presence made me feel extremely humble and frail in the presence of nature's handiwork.

I had become accustomed to the vagaries of the Lake District's micro-climate, but the idiosyncrasies of Cumbria paled into insignificance compared to the unpredictable weather I had to cope with in the Highlands. Sometimes it appeared that the world had been bleached of all colour. When moist prevailing westerly winds drifted in from the Atlantic, heavy clouds would swirl relentlessly around the mountains with only periodic glimmers of sunshine penetrating the grey masses. It made life extremely difficult and I never knew whether to move on to a fresh location or patiently wait for the gloom to lift. Anger and frustration finally got the better of me one day in the west coast town of Ullapool, as the promised fair weather had disintegrated into persistent rain of the kind I knew so well from the Lakes. It was all-enveloping and swept in from the sea in solid sheets that showed no sign of relenting – when asked for their opinion, locals stared knowingly at the sky and then sadly shook their heads. A Caledonian MacBrayne ferry was berthed alongside the quay, taking on cars and passengers for its journey to Stornaway on the Hebridean island of

The 2,000-foot summit of Stac Pollaidh made the most perfect vantage point

Opposite: without the assistance of a brightly lit line of fence posts and three surprisingly cooperative sheep, this long shot towards Stac Pollaidh's distinctive outline might have seemed rather bland, lacking in foreground detail and fast-tracked to the bin.

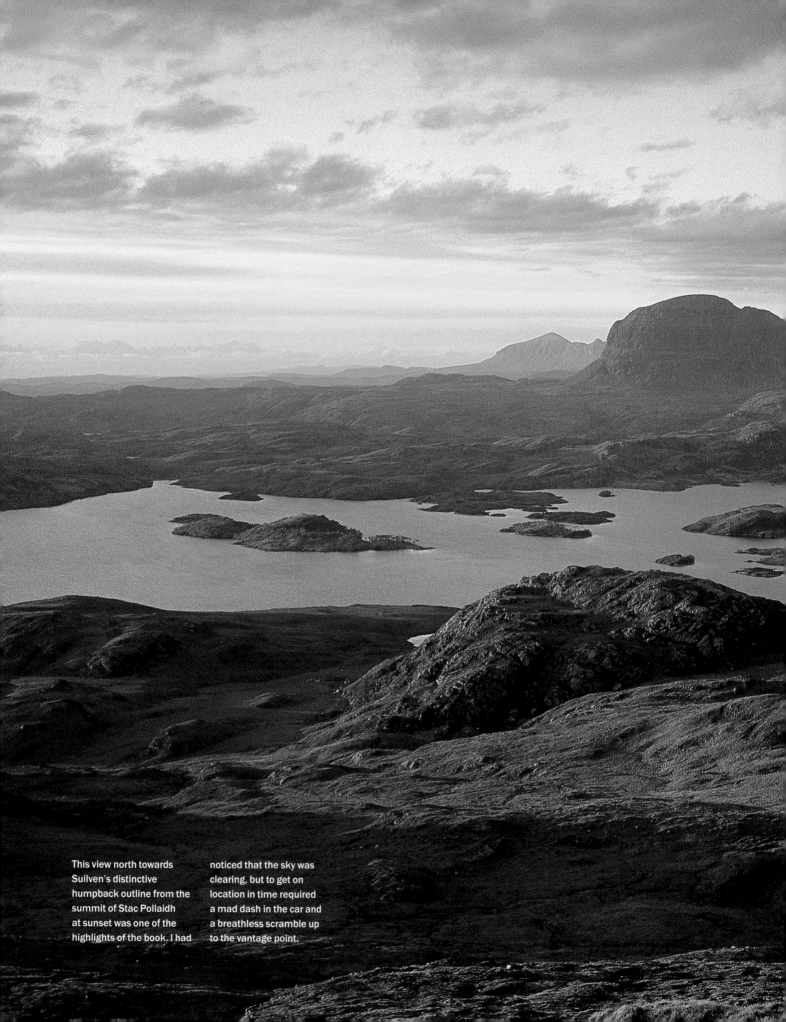

This view north towards Suilven's distinctive humpback outline from the summit of Stac Pollaidh at sunset was one of the highlights of the book. I had noticed that the sky was clearing, but to get on location in time required a mad dash in the car and a breathless scramble up to the vantage point.

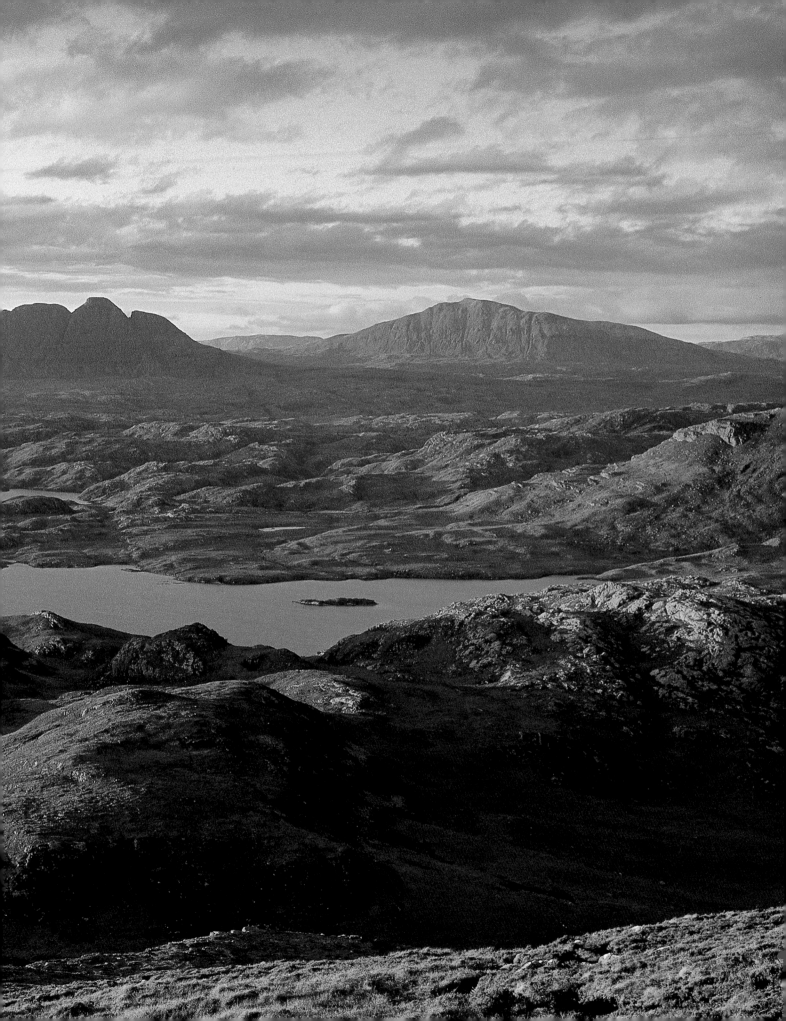

The Callanish stone circle was lit up for just a few precious seconds against a stormy jet-black sky (opposite). Familiarity with one's equipment is crucial on such occasions, as there is no time to dither over what lens or exposure to use when speed is of the essence and a precious opportunity might be lost. Conversely, I had ample time to plan more carefully for the dusk image (above) – although it was by then quite dark, the light remained constant for much longer.

Lewis. I could no longer endure staring impatiently at the blank walls of our cramped guest house bedroom, so went to the ticket office and, on a whim, booked a passage.

As far as the book was concerned it was definitely off piste, but I had always wanted to visit the ancient stone circle of Callanish and at that moment I cared little that it would be in driving rain. We could just make out the silhouettes of the stones against the black sky as we drove up towards the site. We had been parked for no more than half a minute when one searing beam of light appeared to our left and began traversing the hillside towards the stones. Seldom have I moved so fast: I had my camera mounted on its tripod within seconds, unscrewing the legs and scrabbling in my bag for an appropriate lens as I ran. I had just managed to fire off about half a dozen frames when the clouds realised their mistake, quickly regrouped and sealed the illumination leak.

Although the light had deteriorated again, at least the rain had relented and I was able to explore the stones more thoroughly. Believed to be over 4,000 years old, the Callanish site is not as immediately imposing as Stonehenge, but more than matches its Wiltshire counterpart in terms of complexity and atmosphere. I was so engrossed in the stones that I had become oblivious to what was happening with the weather, and was taken aback to see a broad strip of bright blue heading in rapidly from the west. It was as though an unseen hand had started to draw back a window blind: within another ten minutes, the entire site was bathed in golden sunlight. While continuing to take more photographs to capitalise on such unexpected good fortune, I was aware of vehicle noise and turned to see five cars laden with photographers and equipment disgorging their contents in my direction. Apparently there were two photographic holiday courses taking place on the island

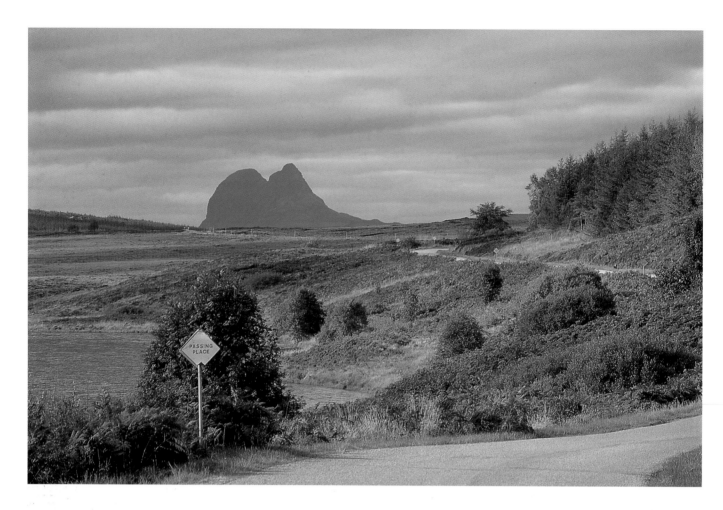

and the ensuing kerfuffle was hilarious to watch, with people swearing and shouting as others inadvertently got in their way. In any group of amateur photographers there is always a bloke (never a woman) who has to take the most creative shot, but getting it involves him fiddling about for an eternity, selfishly impervious to the fact that he is in everybody else's viewfinder. The sun disappeared and, thankfully, so did the snappers, but I stayed on and made a long exposure that gave me the subtly shaded stones illuminated by the dying embers of daylight and a silver moon gleaming against a darkening sky. It was a far happier car that headed back to the mainland.

Torridon was one of AW's most treasured haunts, and although I was gradually becoming attuned to the sheer majesty of the Highlands I was still overwhelmed by its sheer grandeur. The drive from Kinlochewe along Glen Torridon to Shieldaig was a truly exhilarating experience,

although it does require particular attention to be paid to the road as well as to the scenery as there is only a single track with regularly spaced passing places. Those narrow carriageways are an integral part of the road network in the more remote regions and, as one might imagine, the locals have got the technique of negotiating them down to a fine art. If you could observe a section of single-track road from the air, it would be easy to differentiate between residents' vehicles and those driven by visitors. It's a motoring version of musical chairs: an unseen hand periodically turns down the sound, and vehicles have to dive into the nearest passing place – anyone left stranded on the carriageway without a slot gets eliminated! That was how I perceived the game back in 1987; nearly two decades later, it seems that the rules have changed. I recently witnessed some appallingly selfish behaviour on that same section of road. Obviously, one cannot tarnish the reputation of all

Above: the start of the single-track road down to Torridon with the distinctive shape of Suilven on the skyline.

Opposite: I had to overexpose this image of Beinn Eighe deliberately to ensure that the white, crystalline rock was captured accurately. If one takes exposure readings at face value for such shots, there is a probability that the camera will over-compensate for the brightness and consequently produce an unacceptably dark result.

*I ignored the tripod
and used the car roof
to steady myself*

visiting motorists to the Highlands but 'urban four-wheel drive man' has imported the aggression of the daily rat-run to this most serene of environments. Giving way is apparently not a courtesy that applies to some drivers, and it was both embarrassing and sad to witness people actually willing to risk a head-on collision rather than pull over and enjoy the scenery for an extra few seconds. I'm sure that AW would have had a word to say about it all, but I'll grumble on his behalf instead.

One of the most startling aspects of the Torridon group of mountains is their individuality: unlike the Cairngorms or similar groups, none resembles its neighbour. When we first approached from the north after yet another slog up to Inverness, I could not believe the brilliant gleaming whiteness of the extended nine-summit range that forms Ben Eighe, and as the light was good I could not wait to get an establishing shot in

the bag. I was learning from bitter experience that even a crystal clear Highland sky can be transformed into a seething cauldron of cloud before one can say 'sporran'. I got to work immediately. As the light was bright and speed was of the essence, I ignored the tripod and used the car roof to steady myself. Several telephoto shots were followed by some wide-angle versions to set the scene into context then, instead of putting the gear back in the car's boot, I carried it on my lap ready for the next location. Martin sped away and, as we bumped back on to the tarmac, a strange metallic clunking noise seemed to emanate from the roof – as I turned around, I was just in time to see a black cylindrical object bouncing down the road in our wake. My vital zoom lens, left on top of the car, was gaily rolling back towards Ullapool. Fortunately there were no other vehicles behind us and I ran to retrieve the stricken lens, dreading what I might discover. I did not deserve to emerge unscathed

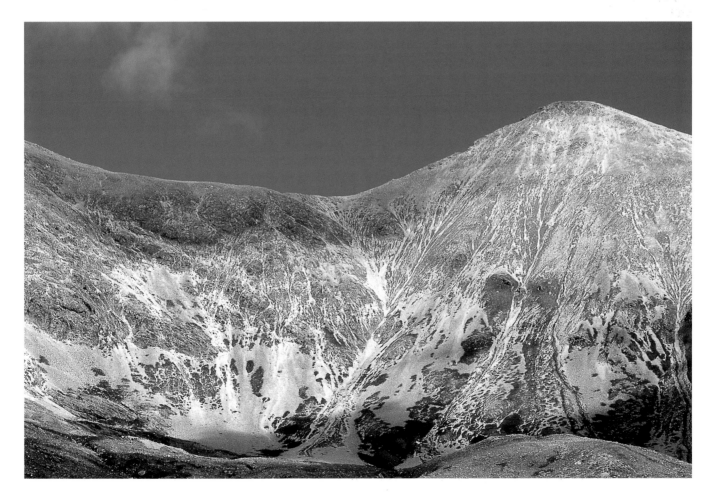

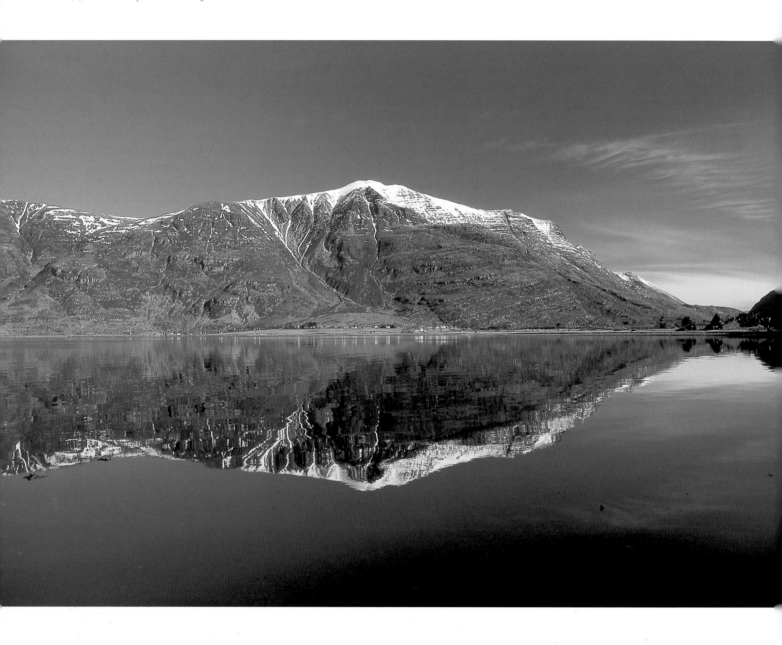

Loch Torridon and Liathach on a perfectly still winter's day. For the wide-angle shot (above) I used a polarising filter to make the mountain stand out against the vivid blue sky and enhance the quality of the reflected image. To emphasise the sheer power of the mountain, I then used a 200mm lens in a vertical framing to isolate the huddle of dwellings (opposite). I left just enough water in the bottom of the shot to carry their reflections, but made sure the bulk of it was taken up by the two dramatic gullies plunging down the mountain's face.

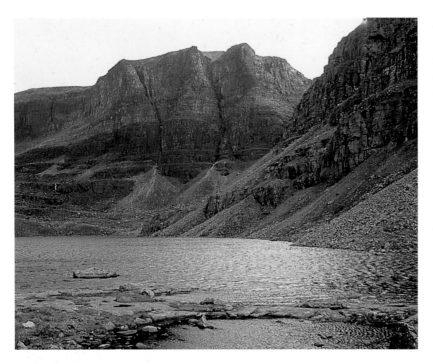

from such an act of carelessness, but the lens was ruggedly constructed – though superficially scratched and a bit dented round the edges, the optics had escaped unscathed and all the moving bits still functioned.

In his original text, AW referred to Liathach, the second of Torridon's three giants, as a monster and I wholeheartedly agreed after my first sighting of its great mass. It was one of those mountains that seemed totally inaccessible to mere mortals bearing tripods but (un)fortunately, AW had pinpointed a means of accessing one of the most dramatic natural features of the group's northern façade, the tongue-twister corrie of Coire Mhic Fhearchair. That wild glacial recess, containing a lake flanked by spectacular soaring buttresses of quartzite, is one of the showpieces of the region. It therefore just had to be photographed – and as there were no technical shortcuts such as the use of a telephoto lens the best part of a day was consumed in the expedition. It turned out to be as awesome as the author described it but, sadly, the light was from completely the wrong direction to do it full justice and the schedule did not allow for another visit at a different time of day. The one photograph of Liathach I am most pleased with does not show the mountain in its entirety, but the

Above: the light falling on Coire Mhic Fhearchair was from completely the wrong direction to portray adequately its grandeur. This was one of those occasions where one had to settle for a less than perfect result.

Opposite, above: the compressing effect of a telephoto lens from the opposite shore made the village of Loch Carron appear as though photographed in front of a painted theatre backdrop.

Opposite, below: the now defunct and much lamented Skye ferry with the Lochalsh hotel in the background.

huddled dwellings of Torridon village totally dwarfed by a network of gullies plunging down from the mountain's summit. An image isolating one such section of a scene can often convey the dominance of nature over mankind more effectively than an all-encompassing wide-angle view.

Torridon and the Applecross peninsula can also be accessed from the south via a road that virtually circumnavigates Loch Carron, with a village bearing the loch's name located midway along its northern shore. Lochcarron has gone on to my shortlist of places in the Highlands that I would love to revisit at leisure – the atmosphere surrounding that elongated waterside community felt so wonderfully soporific, but during those hectic weeks of photography I was only able to pause briefly before dashing on to another site.

By the time we had progressed to Chapter Four, 'The Central Highlands & Skye', Inverness had finally been abandoned in favour of more southerly access points; I did not suffer any withdrawal symptoms following the removal of my weekly A9 fix. However, making progress across country was equally time-consuming and frustrating when having to reach such westerly locations as Mallaig and the Kyle of Lochalsh, the latter being the main access point for the island of Skye. Lochalsh sounds as though it ought to be a more substantial place than it actually is; on the three occasions we stopped there, we always had trouble finding beds for the night. After one particularly long day we arrived physically and mentally unable to travel an inch further, but despite it not even being high season 'No Vacancies' signs were posted outside every guest house and B & B. Our last hope was the Lochalsh Hotel, a smart white building on the water's edge whose room rates were well outside my budget, but had I not found us beds there I might have been faced with driver mutiny. The receptionist pronounced the hotel full with an air of indifference, scarcely raising her head from a pile of paperwork – until I fell to my knees, hands clasped in supplication and implored her to check again. Martin moved away and disowned me, worried glances were exchanged by other guests, and the poor girl could not decide whether to summon the manager, a policeman or an ambulance equipped with a straitjacket. To her eternal

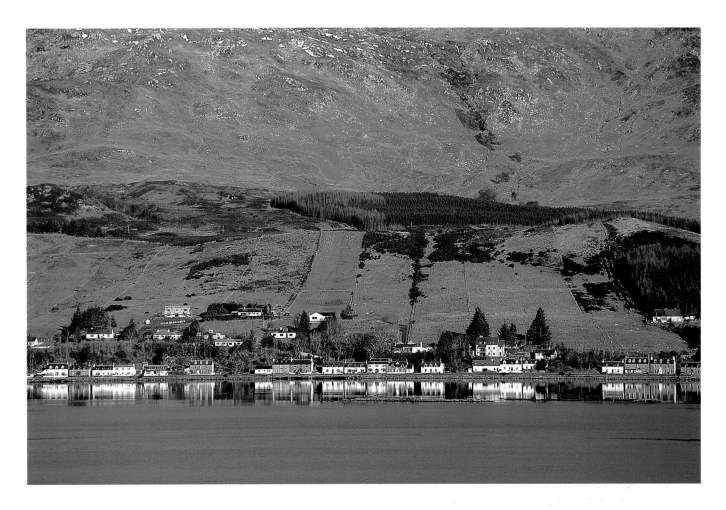

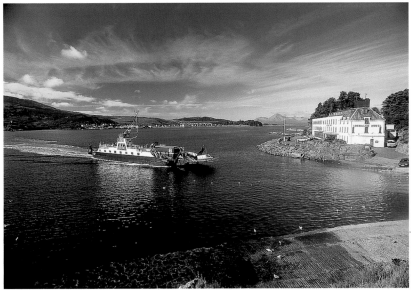

credit and my undying gratitude, she took none of those options and decided we could be accommodated for the then hefty sum of £65 if we were happy to sleep on makeshift beds in what was little more than a box room. We were, and we did.

The hotel was directly next to the Skye ferry, controversially replaced by a toll bridge in 1995, an event that led to many demonstrations and protests at the high tariffs. Even now, the matter is far from settled, although some members of the new Scottish Parliament have vowed to bring about a cessation of charges altogether. (At the time of writing in December 2004, I have heard that tolls are in fact to be abolished.) The new bridge is best seen from the Plock View picnic site, an elevated viewing point at the end of a long tortuous track, accessed through a housing estate on the edge of town. The picnic site actually consists of a series of concrete enclosures set amid dense gorse thickets – it feels more like being in an old Second World War

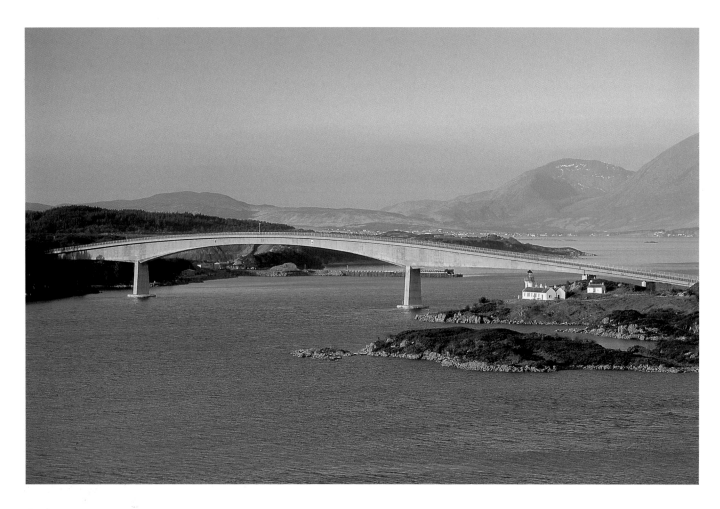

bunker on the Normandy coast than a few hundred yards away from the romantic Isle of Skye.

Wainwright had devoted five pages of his manuscript to the island's renowned collection of weathered volcanic plugs, the Black Cuillin, a mountain range spoken of in reverential tones by even the most experienced walkers, which was a title most certainly not applicable to me. After a nervous breakdown or three contemplating the traumas involved in tackling them, I hit upon the idea of suggesting to AW and Jenny that, as time was pressing and weather conditions less than ideal, the book would be best served by using the author's wonderful line drawings instead of my mediocre photographs. They were both happy enough to accede to my request, knowing full well the true reason for my proposed defection, but they did not rub salt in my wounds of cowardice.

One of Scotland's most photogenic castles is situated just a few miles east of the Kyle, guarding the strategic meeting point of lochs Alsh, Duich and Long. Eilean Donan has probably featured on more tins of biscuits, calendars and greetings cards than any other historic building, as its island setting with arched causeway to the mainland renders it so photogenic. The building that occupies the site today is actually a faithful reconstruction of the original stronghold, made in the twentieth century by the MacRae family; the castle was bombarded into rubble by the English warship HMS *Worcester* in 1719 in the aftermath of the failed Jacobite rebellion four years earlier. We stayed overnight in the vicinity to maximise the potential for photography at both dawn and dusk, ending up sharing a room in a fairly drab-looking hotel just a few miles away.

There was a pool table in the bar and we were having a quiet game after supper when coins were slammed on the corner of the table, indicating a challenge from new players. We had no way of

Above: the aesthetically unappealing concrete edifice of the Skye bridge, photographed from the Plock View picnic site.

Opposite: making a vertical image of Eilean Donan castle maximised the effect of an almost perfect reflection. With no light at all falling on the background, the subject was thrown into even sharper relief.

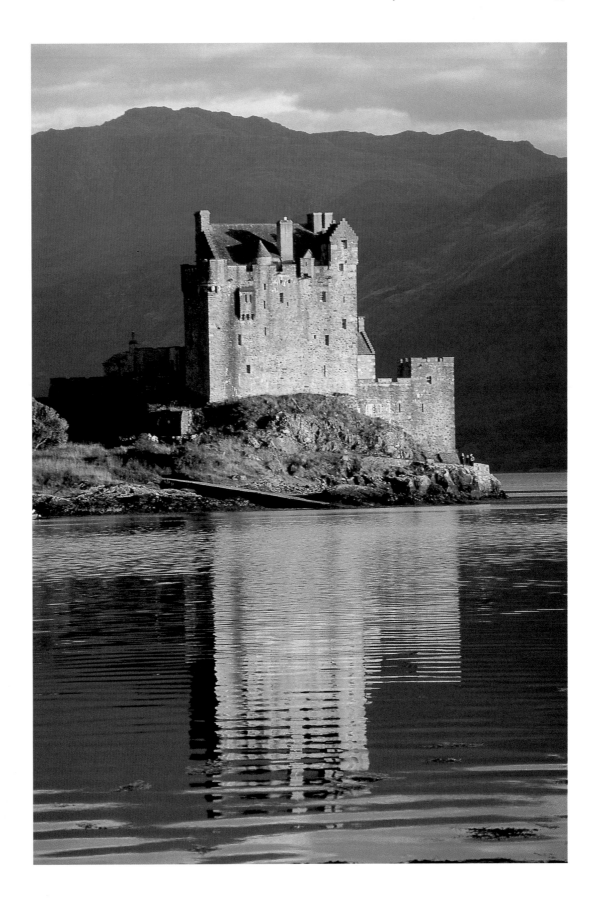

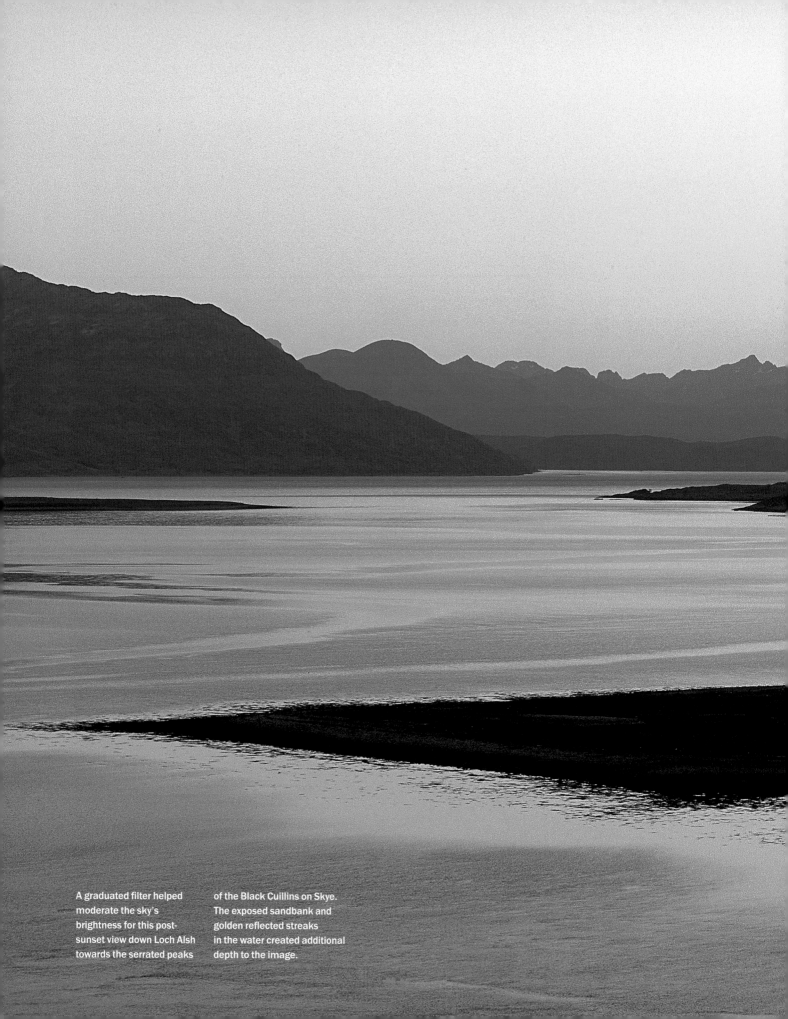

A graduated filter helped
moderate the sky's
brightness for this post-
sunset view down Loch Alsh
towards the serrated peaks
of the Black Cuillins on Skye.
The exposed sandbank and
golden reflected streaks
in the water created additional
depth to the image.

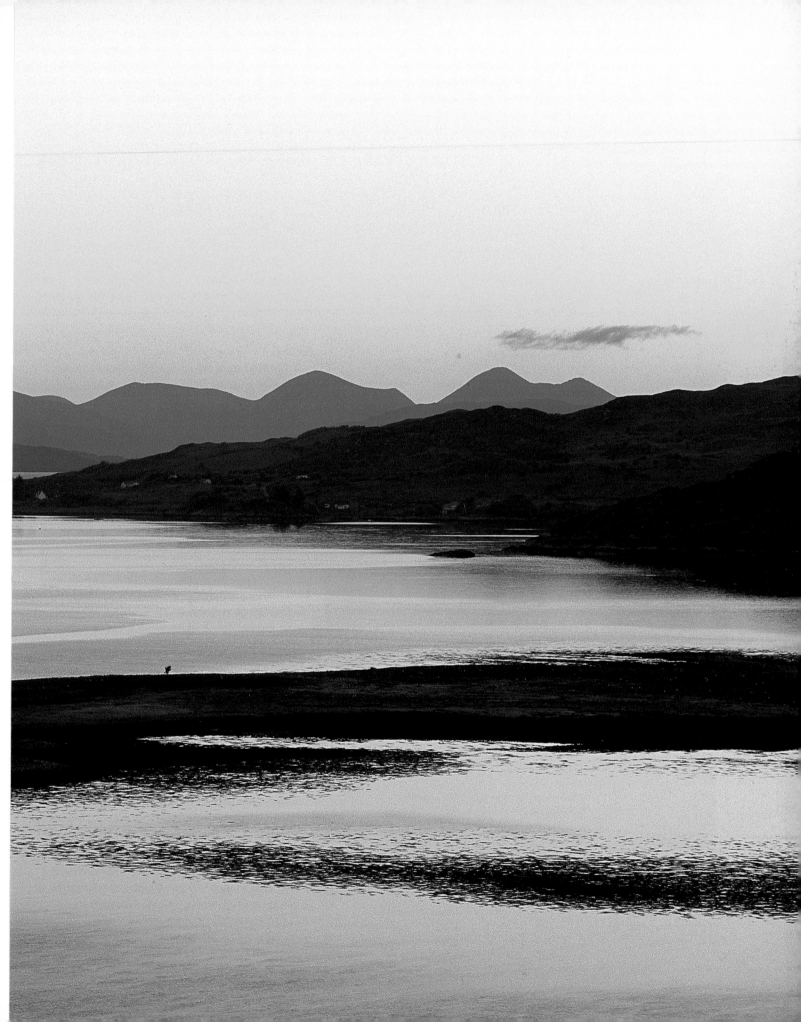

few miles of the approach to Fort William. As they enter the village of Corpach, they pass another remarkable example of nineteenth-century entrepreneurial endeavour, the Caledonian Canal. Built by Thomas Telford, the waterway was intended to provide a link between east and west coasts by utilising the natural rift of the Great Glen between Inverness and Fort William, thereby avoiding a lengthy and potentially hazardous passage around the north coast to reach the Irish Sea. Despite the canal's obvious benefits, the advent of larger steam-powered vessels meant that it never received its anticipated level of patronage and was ultimately a commercial failure.

Corpach was my first introduction to the canal, as its lock basin also happens to provide a stunning view of Ben Nevis, the highest point in the British Isles. Its 4,406 feet did not look too daunting a prospect from that distance, although I was aware that behind its benign western façade lurked more hostile cliffs and gullies that have claimed the lives of many climbers over the years. As ever, AW leapt to the defence of any mountain he deemed to have been unjustly maligned, writing that he considered such fatalities were due to 'human frailty and misjudgements, not to venomous attacks by the Ben'.

I was happy to note that AW also said that the mountain was 'a friendly giant, accepting geriatrics and infants with open arms': since I fell roughly between those two categories, I was reassured that I too would be welcome. With the establishing

Above: the Caledonian Canal at Corpach on an evening when the entire landscape was bathed in a mellow light. I have seldom experienced this, but on this occasion gratefully accepted it.

Opposite: a graduated filter darkens the top of Ben Nevis from Corpach; it was essential to stop the snow from burning out. By using that exposure manipulation aid, I was able to balance the different components of snow, sky, darker mountainside and water.

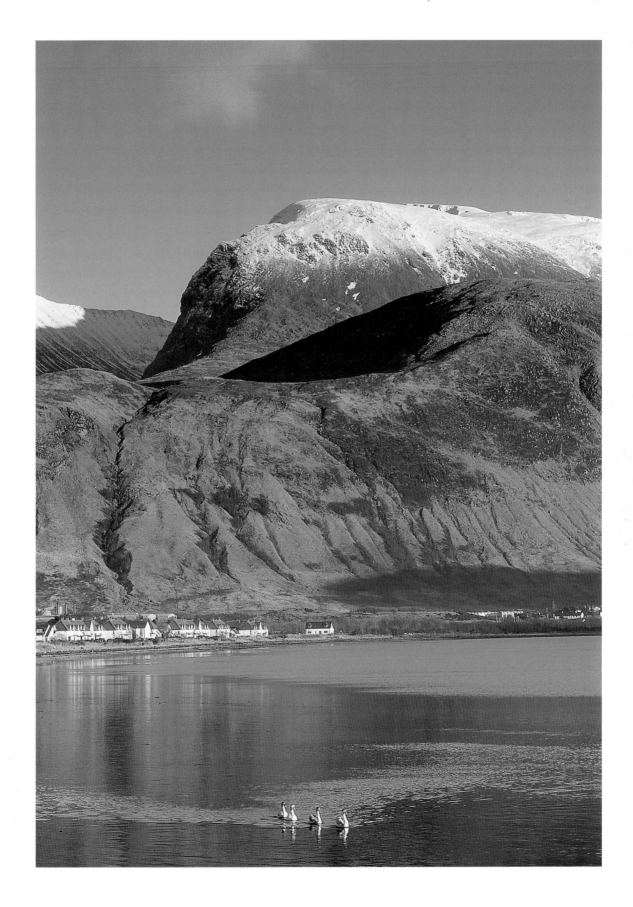

shot taken from Corpach, more pictorial detail around the summit was required, so Martin and I attempted the climb Alpine-style, without oxygen, setting off up the main route on a clear sunny morning. It was an unremittingly tedious, steep climb. Despite being rewarded by ever-expanding views whenever we stopped to recharge our lungs and muscles, I just wanted to get to the top and get the job done while the light and visibility remained so good.

By the time we got close to the summit plateau, we had removed several layers of clothing and were dripping with perspiration. Small groups of walkers were descending and we noticed that they were clad in fleeces, anoraks, gloves and hats – outfits in stark contrast to our thin, sweat-sodden T-shirts. We exchanged smirks and muttered, 'Wimps!' The word had barely had the chance to float away into the atmosphere before we too made it to the summit and got hit by the blast from an open freezer or, as it is known in geographical terms, the Arctic Circle. I wanted to run after the unjustly insulted people and apologise, but was too busy donning fleece, anorak, gloves and hat.

The wind was searingly cold and so strong that I had to suspend a rucksack from my tripod as ballast to prevent it blowing over and use the fastest possible shutter speed to avoid camera shake. When one is being buffeted so violently it is diffi-

Despite the howling gale, I thought the top of Scotland to be a curiously endearing place

The somewhat chaotic summit plateau of Ben Nevis and the ruined observatory.

cult to concentrate and I was relieved that the sun had stayed out and there was consequently no need to hang around longer than necessary. Despite the howling gale, I thought the top of Scotland to be a curiously endearing place, with the remains of the old observatory perched on top of what resembles a rockery under construction, for which the stones have been delivered but nobody has yet decided how they should be arranged.

On our way down, we passed a party of people making the climb, all of them as scantily clad as we had been an hour earlier. The difference was that we had cold weather clothing with us, but they had no spare garments whatsoever and were in for an unpleasant and potentially dangerous shock. The path may be broad, well-trodden and clearly defined all the way, but people forget that conditions on such a mountain can change in minutes. I am sure that the local mountain rescue teams would suggest that even the best-equipped and most careful mountaineers can unwittingly fall victim to quirks of nature, but those who risk their lives to save others must find it hard to be quite so charitable when called out to assist people who left their protective clothing and common sense in the car park. Ben Nevis was indeed a gentle giant on the day we visited, but it could have turned into a very nasty ogre. Although it was hard work, we had been extremely fortunate in our choice of day.

The only other 'Stanley and Livingstone' moment I had with the Wainwright entourage in the Highlands was when we joined up with the crew for a day's filming to get some documentary-style photographs to show how the programmes were made. We agreed to rendezvous for coffee at the Kingshouse Hotel, located midway between the watery wastes of Rannoch Moor and Glencoe, before heading over to the base of the White Corries chairlift where the access road forms part of the West Highland Way long-distance footpath.

AW had already done several programmes, so one would think that he might have become more familiar with the techniques of filming, but it was readily apparent that the director was still having to explain why shots were done out of sequence, or to coax and cajole his subject into providing significantly more than monosyllabic responses to Eric's genial questions. 'Yes' and 'No' are not great im-

Top: on location with the BBC film crew on the West Highland Way. Wainwright and Eric were way down the track, waiting for groups of walkers to clear through the shot.

Above: shooting some close-up footage of Wainwright and Eric deep in conversation at the head of Glencoe. The flat, grey light that day was deemed acceptable for television filming but just about useless for my own photography.

parters of information and make little meaningful contribution to the task of filling a half-hour programme. Stones have been more generous with blood that Wainwright could be with dialogue.

Because AW was not comfortable walking any distance over rough terrain, a Land Rover was used to ferry the 'stars' to their starting mark before disappearing out of sight, creating an illusion that the pair were in the middle of a full day's hike, rather than a 35-metre saunter which, more often than not, would culminate in them leaning on a rock for general scenery assessment and appreciation. Poor Eric had to work very hard to draw conversation out of AW. And there were times when the Wainwright agenda patently did not coincide with the director's script. Richard was obliged to develop the cunning technique of pretending to accede to AW's directorial input and then, almost as an afterthought, casually getting him to try something different that was, in reality, what had been required in the first place.

Those particular sequences were also blighted by constant interference from noisy low-flying jet aircraft rehearsing for the Third World War, or parties of walkers suddenly materialising in the background, causing the director to shout 'Cut!' more times in two hours than a surgeon doing a full day's list in a busy vasectomy clinic. Fortunately for AW, the presence of Eric by his side and a TV crew just a few yards away deterred most passers-by from stopping to address him, but there were many backward glances and nudging of elbows as they realised who they had just seen.

The next designated location was on the remains of the old road at the head of Glencoe, a perfect spot from which to savour the atmosphere of one of Scotland's most dramatic natural features. Any impressions of this place are always coloured by history. In reference to the infamous massacre of 1692, the glen is generally referred to as 'brooding', 'sad' or 'glowering': it is fascinating to contemplate how events perpetrated by human beings on one another endow a particular place with appropriate characteristics. I think one is always aware of such happenings; on all but the sunniest of days, Glencoe's claustrophobic environment certainly seems to exude an air of melancholy, whether by association or otherwise.

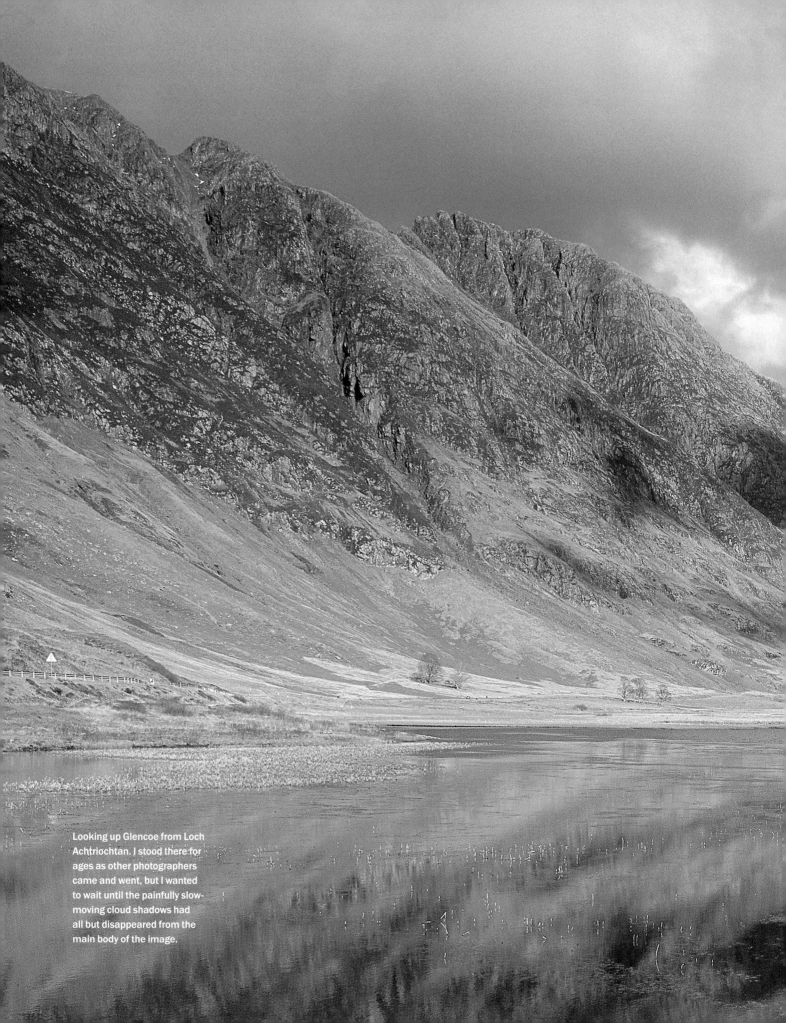

Looking up Glencoe from Loch Achtriochtan. I stood there for ages as other photographers came and went, but I wanted to wait until the painfully slow-moving cloud shadows had all but disappeared from the main body of the image.

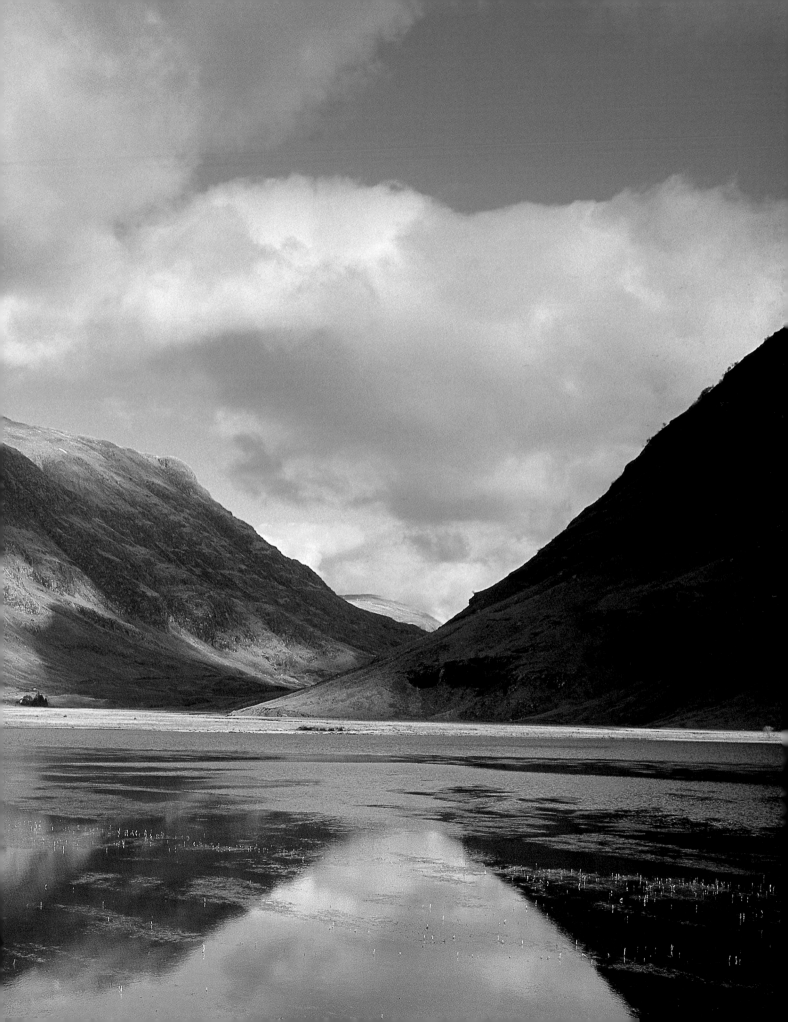

As far as walking goes, Glencoe is absolutely one for the experts. I had done all the pictures of the filming I needed, so was content to sit on a rock with a pair of binoculars, watching the tiny ant-like figures of climbers make their way up some of the few access trails leading to the famous Three Sisters or the facing ridge of Aonach Eagach. As you descend through the glen it is remarkable just how the perspective changes; whenever I pass that way now, I always pull of the road and spend half an hour by the shore of Loch Achtriochtan. I never tire of just watching the interplay of light and shade on the soaring rock faces, their savage lines contrastingly softened and muted when reflected in the water.

After a few hours of independent photography, we met up again with the Wainwrights and the BBC team at an hotel on the nearby shore of Loch Linnhe and dined with them that evening at one large table. I was surprised and a bit disappointed that we were eating so early, but all was revealed when towards the end of the meal AW suddenly did the closest impression of a scalded cat he was able to muster and disappeared from the dining table. I had not fully appreciated just how avidly he followed events in *Coronation Street* and that the entire evening had to be scheduled so that he could be fed, watered and in front of a television by 7.30 p.m. Nobody wanted to contemplate the likely consequences for the following day's filming if AW was in a bad mood through having missed an episode; he was hardly loquacious when in a good one. Although an end-of-term celebratory get-together would have been appropriate, neither the still nor the moving picture factions had completed their respective tasks, and so we checked out the following day to go our separate ways.

The day finally arrived when I thought we had finished, and a tick had been placed against every one of AW's picture requests. But after several lengthy editing sessions on the light box, I decided some images were simply not good enough and would have to be re-shot. There was nothing technically wrong with them, they were just too important in the context of the narrative to be allowed to remain dull or hazy. Martin had retreated after our allegedly final trip to recover from the traumas of the experience. When I rang to explain my dilemma, there was a long silence followed by a heavy sigh at the other end of the telephone. Being a perfectionist can also be a bloody nuisance, as he took time out to tell me repeatedly during the eight-hour drive back up to Inverness.

The afterglow of a spectacular sunset over Loch Linnhe. I did not arrive until after the sun had disappeared, but there was still so much to photograph. I used the concertina effect of a 300mm lens to give the cotton-wool clouds and light-streaked water even greater impact.

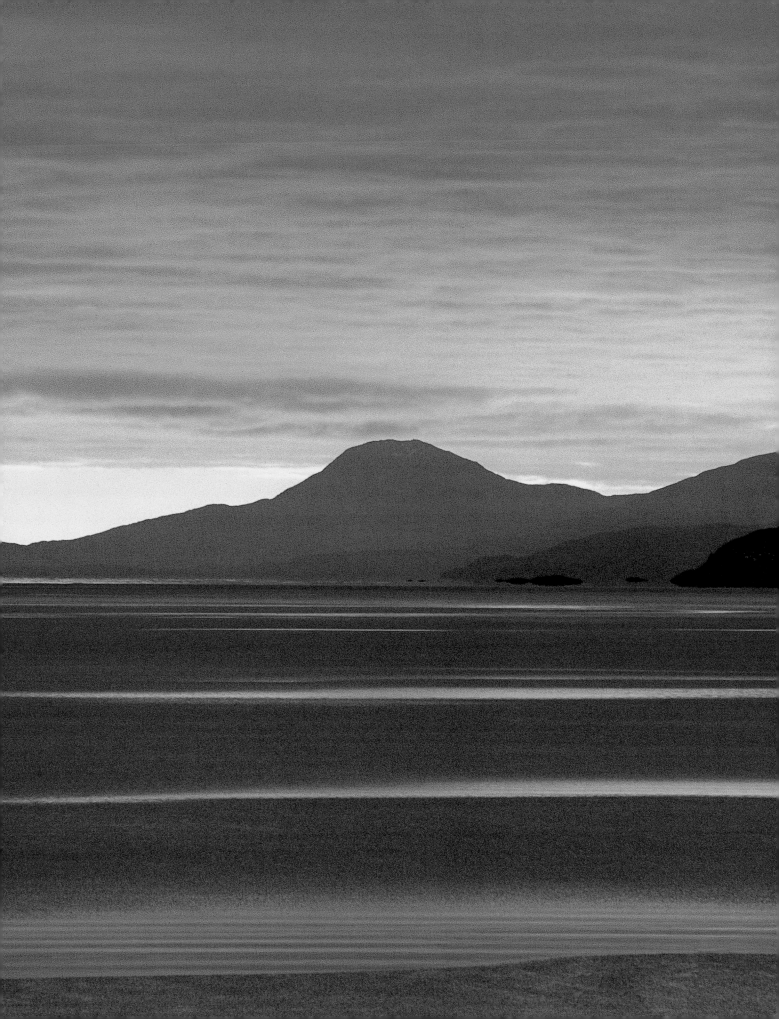

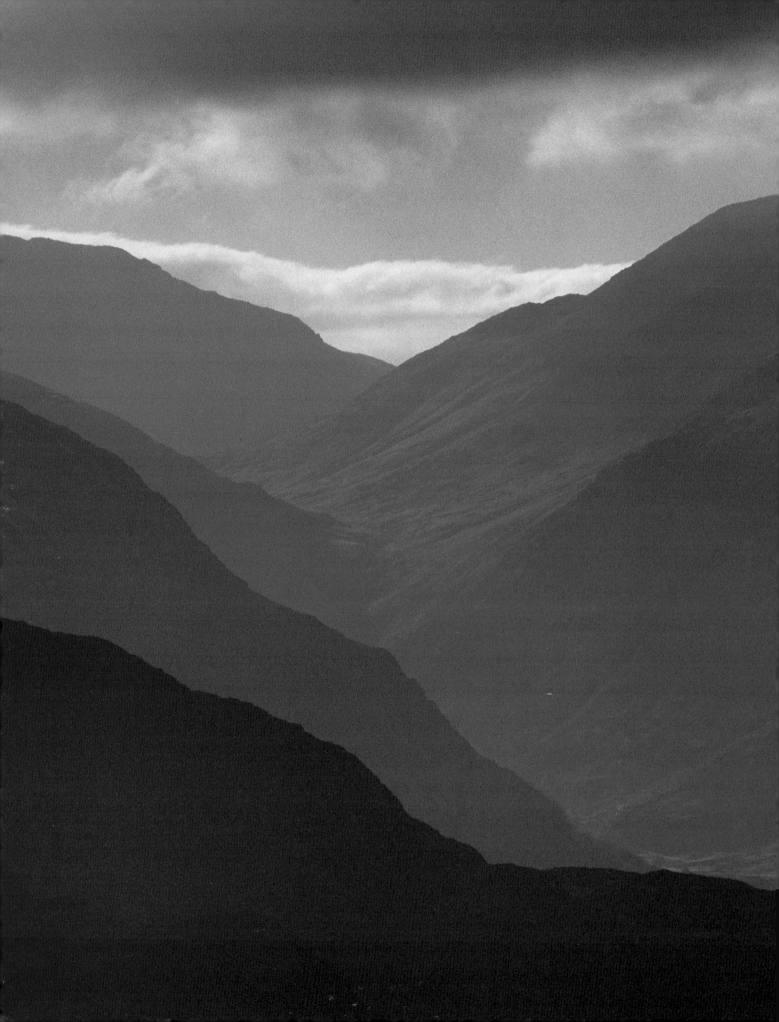

The view over Borrowdale towards Honister Pass. The descending lines of fells were reduced to shades of grey. I filtered the already dark clouds to compress attention back into the frame.

Chapter Seven

OVER THE MOUNTAIN PASSES

No peace for the wicked. There had scarcely been time for the nightmares to abate – being forced to drive up and down Scotland's A9 for eternity – before I was being invited to illustrate yet another Wainwright. It was extraordinary to reflect upon just how much had happened with my publishing career in such a relatively short space of time: not only was I about to embark on my fifth collaboration with AW, I had also been involved in several other contrasting projects related to Britain's architectural heritage. I had written and illustrated books on English churches and pubs, and had also just been commissioned by another publisher to provide photographs for a guide to some of the nation's historic towns and cities.

My only involvement with the Lake District since the completion of *Fellwalking* had been to photograph those parts of the National Park featured in *Wainwright's Coast to Coast Walk*, but in the interim I had not suffered pangs of longing necessitating the donning of boots for a quick Sunday morning sprint up Helvellyn and along Striding Edge. When detailed plans and sample chapters for *Wainwright on the Lakeland Mountain Passes* were received from Kendal, I initially reasoned that those cross-country routes might not be quite so daunting a proposition: by their very nature, after all, passes serve to link high places, not go over them. But I was to discover that my supposition had one basic

flaw – namely, that to show the clearly defined route of a particular pass, one had to be high above it! So it looked as though I would once again be combating my vertiginous anxieties in pursuit of photographic perfection.

I was surprised at just how many passes there were within the Lake District National Park. I had already walked over several of the best-known examples; Wainwright's final list for the book featured forty-nine passes of varying lengths. Each was the subject of a separate chapter, although some of the shorter entries merited just a couple of photographs to accompany AW's narrative and a simple location map outlining the route. Unlike *Fellwalking*, in which each walk had its total mileage clearly stated, the map for each pass merely included a one-mile scale bar, leaving the reader (or photographer) to calculate exactly how far they had to walk. I was amused to note that in his introductory notes, AW made much of the fact that 'all heights were given in English feet and distances in English miles, despite the current regrettable practice of quoting them in foreign metres and kilometres to which the author, a jingoistic Englishman, refuses to comply.' European harmonisation had arrived too late to be readily assimilated into Wainwright's life.

AW had elected to list the passes in alphabetical order instead of organising them in any regional grouping, so it took me ages to cross-reference each path from the contents page and locate it on my newly purchased One-Inch Ordnance Survey map. The routes were all numbered and highlighted with luminous marker pens, and by the time all forty-nine were clearly defined the map resembled the outcome of an uninhibited colouring session at a pre-school play group.

Fortunately, this time the proposed publication date allowed ample time to complete what was likely to be a complex logistical undertaking. By definition, passes start at point A and terminate at point B. I envisaged having to execute the photography in a similar fashion to the *Pennine Way*, by doing approximately half of any given section from one end, returning to the car, and driving round to complete the remainder the following day or whenever the weather was next in a favourable mood. However, I was mindful of the fact that this

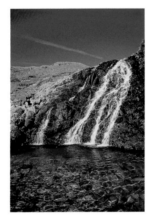

An enchanting waterfall on Sourmilk Gill, near the path to Greenup Edge. By using a polarising filter, I was able both to enrich the sky and totally eliminate reflection on the pool's surface to reveal the pebbled bed beneath.

would probably result in a loss of continuity, a crucial consideration when illustrating significantly shorter chapters. Obviously some passes could be readily accomplished in a round trip from just one departure point but, for the majority, a full day's photography would be required to do them justice.

Unfortunately, the driving ban that had severely hampered my freedom on the Scottish book still had a couple of months to run; unless I used public transport to get across to the Lake District, Martin would have to be dragged out of retirement and persuaded to do a bit more chauffeuring. While not being allowed to drive was a protracted, embarrassing nightmare, for that particular project it enabled me to have someone else behind the wheel to drop me off at one end of a pass and, hopefully, be waiting at the finishing line several hours later. The plan worked extremely well for some of the longer, more time-consuming routes; so much so that even when my licence was restored I frequently enlisted Martin's help. As I neared the end of an exhausting day's walk and that particular pass eventually levelled out on to a bridleway or tarmac road, I did occasionally wonder whether the car would be there to meet me as arranged, or parked somewhere else by mistake.

I made sure we had a duplicate set of maps, with each pass clearly numbered and its route marked out, so that having ejected me Martin would know precisely where he had to be waiting several hours later. The system worked almost flawlessly, though on a few occasions I arrived at the pick-up point to find it not occupied by a car containing a driver with emergency supplies of hot coffee, sandwiches and biscuits. Sometimes it was down to poor timekeeping: he might have been sidetracked during the day and unaware of just how long it would take to reach a particular destination. It was frustrating to be left hanging around, but it was not usually too long before I was picked up.

Happily, communication breakdowns were infrequent, but one did happen at the end of a day that had turned particularly foul after a promising start, and I was left waiting in the pouring rain for an hour and a half, while Martin sat cosily listening

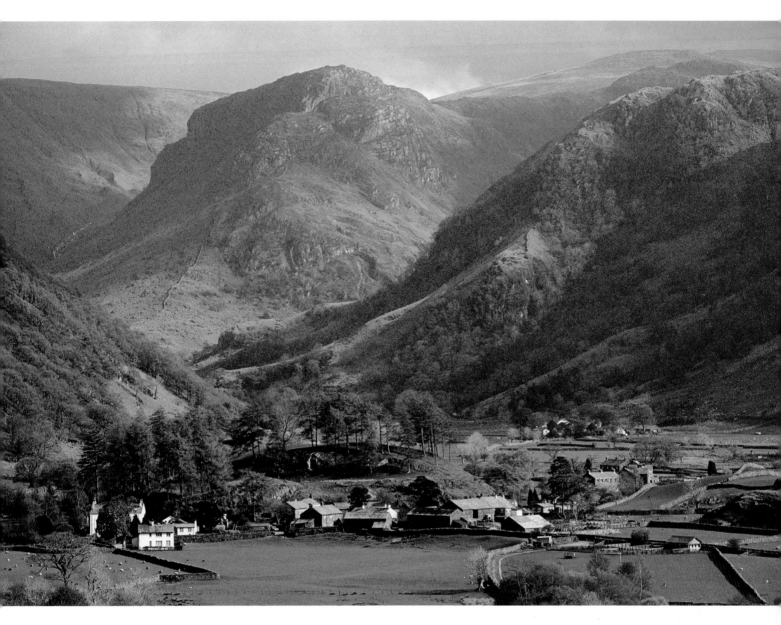

Rosthwaite and Upper Borrowdale, overshadowed by Eagle Crag and with Greenup Edge filling the skyline to the left of the frame.

to rock music tapes in completely the wrong place. I think he had enjoyed an overindulgent late night and when he dropped me off was still not quite firing on all cylinders; he misinterpreted exactly which of Borrowdale's 'thwaites' I was heading for. The pass I was hoping to complete that day linked Grasmere with Borrowdale by following Far Ease-dale up to Greenup Edge before descending to the walk's finish at the enchanting hamlet of Stone-thwaite.

I allocated myself plenty of time to do the walking and programmed extra leeway into the schedule for any delays caused by problems with the light, and instructed Martin to collect me towards the end of the afternoon. Everything was going according to plan and I had taken six of the ten specified photographs, when the sun disap-peared to be replaced by threatening clouds that rapidly thickened and lowered, transforming the landscape into a drab, khaki smudge. Further photography was out of the question; conditions deteriorated with no apparent sign of any respite. So I reluctantly packed away my gear and, having delivered an assortment of vitriolic oaths at the sky, trudged on down to Stonethwaite. Borrowdale's own special brand of relentless, penetrating rain

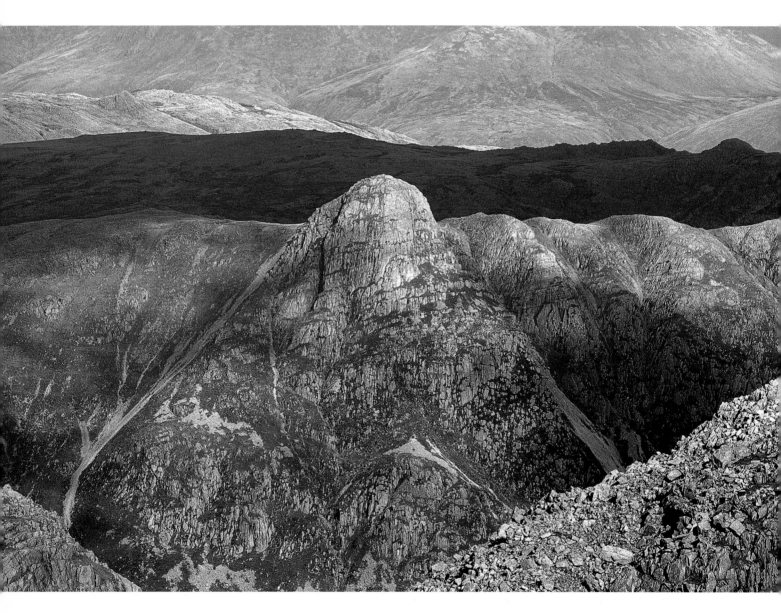

ensured those last couple of miles were distinctly unpleasant. Because I had aborted the mission early, I suspected I might have to endure a soggy wait for the car to arrive, and just hoped against hope that Martin too might be early.

What I had not envisaged was the possibility that he would not turn up at all. As our rendezvous time came and went, I felt a combination of anger, frustration and worry over his absence. While I dripped under a tree at Stonethwaite, Martin sat in the car three miles further up Borrowdale at Seathwaite, wondering where the bloody hell I had got to. Fortunately, he eventually decided to drive around to see if he could spot me anywhere on the

road and we were reunited. Not a lot was said for about half an hour as the car's de-mister struggled to cope with the clouds of steam generated from one very soggy passenger. But although I was exceedingly angry, I largely blamed myself for not double-checking that he was crystal clear about where we were due to meet. Once again, the mantra had been ignored with predictably unfortunate consequences and I resolved that it was absolutely, definitely, positively the last time that I would not 'check up before cock up'.

I was fascinated by the thought that although many of the passes featured in the book were created by those seeking to explore the fells and

The distinctive pointed dome of Pike o'Stickle, site of a prehistoric axe factory. Because the peak had the same tonal values as its immediate surroundings, I waited until a band of shadow touched the fellside immediately behind to make it stand out better.

mountains for pleasure, man had been living and working in the Lake District for thousands of years before tourism was invented. Tangible evidence of that presence is still visible in many areas; some of the routes used by today's motorists and pedestrians evolved from trading routes and farming tracks established by the earliest settlers.

The distinctive pointed dome of Pike o' Stickle that towers over Mickleden *en route* to the Rossett Pass at the head of Great Langdale was the site of a Neolithic 'axe factory' from where pieces of fine-grained, hard volcanic rock were retrieved for fashioning and polishing into axe heads. Examples of those utensils have been discovered by archaeologists in other parts of England, Scotland and Ireland – because of their unique geological structure, they could only have originated in Langdale or similar sites on the slopes of Glaramara and Scafell. Those axe heads were almost certainly the region's first exports, and even in those times basic routes of communication within the Lake District and links to further afield were already being created.

Although a few burial mounds or stone circles, such as the famous example at Castlerigg near Keswick, highlight continuity of settlement through the later Stone and Bronze Ages, those eras left few marks upon the landscape. Not until the Roman occupation were routes forged through some of the wilder recesses, including some sections of the daunting Hardknott Pass, created to link the forts of Ravenglass and Ambleside. The steepest parts of the metalled road on either side of the 1,291-foot summit are a more recent innovation, as even the Legion's normally indomitable engineers decided that conquering the 1-in-3 gradient was beyond their capabilities. One can imagine the surveyors shrugging their shoulders and uttering the Latin equivalent of 'sod that for a lark,' before following a detour around lower contours to the Duddon valley then soaring up again over the marginally less fearsome Wrynose Pass

The Romans did not build the Cumbrian roads for commercial reasons, but primarily to link a network of forts established to counter the threat posed by hostile Brigante tribes on the Empire's northerly frontiers. Any doubts that the road had a military purpose are quickly dispelled by the

remains of Hardknott Fort, built between AD 122 and 138, during the reign of Emperor Hadrian. This is one of England's most spectacularly located ancient monuments. Although it is fascinating to walk round the surviving low, outline walls, it is far better to view it from a distance to put it into a wider visual context. I used to feel sorry for the Roman troops once garrisoned on Hadrian's Wall but, after my first encounter with Hardknott, I rapidly transferred my sympathy to the legionaries and auxiliaries posted to that exposed ledge at the top of Eskdale.

Wainwright made the Hardknott and Whinlatter passes the subjects of separate chapters, but motorists traversing the fells from east to west invariably tackle both as one extended white-

The ruins of Hardknott Fort may be reduced to one or two courses of stone, but that is still sufficient to convey the size and complexity of the Roman site.

knuckle ride. On the first of numerous journeys over the passes, I approached them via the tortuous narrow road leading out of Langdale and past Blea Tarn. From this well-known beauty spot you can take wonderful retrospective views of the Langdale Pikes, whose distinctive summits create interesting reflections on those rare days when no wind ruffles the water's surface. The road is narrow all the way, and a driver's eyes need to be constantly focused on the road rather than the surroundings, something easier said than done when the views become even more spectacular as the road ascends higher. Wrynose does not represent too stern a test for drivers, but certainly sharpens the senses in

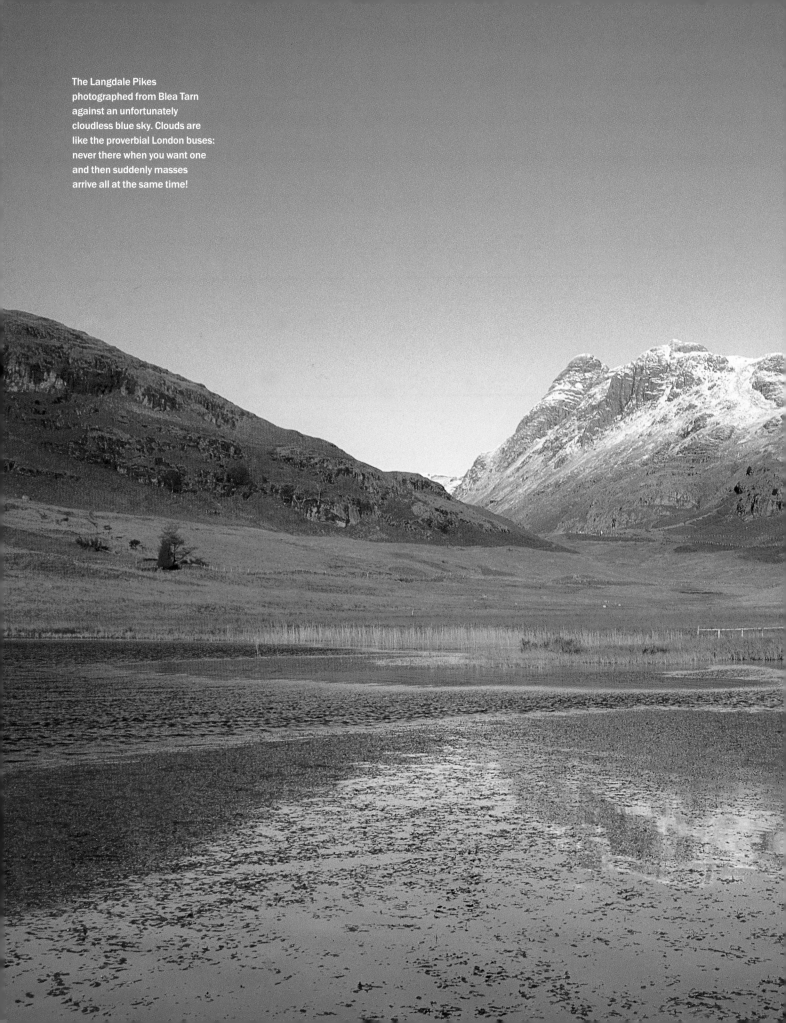

The Langdale Pikes photographed from Blea Tarn against an unfortunately cloudless blue sky. Clouds are like the proverbial London buses: never there when you want one and then suddenly masses arrive all at the same time!

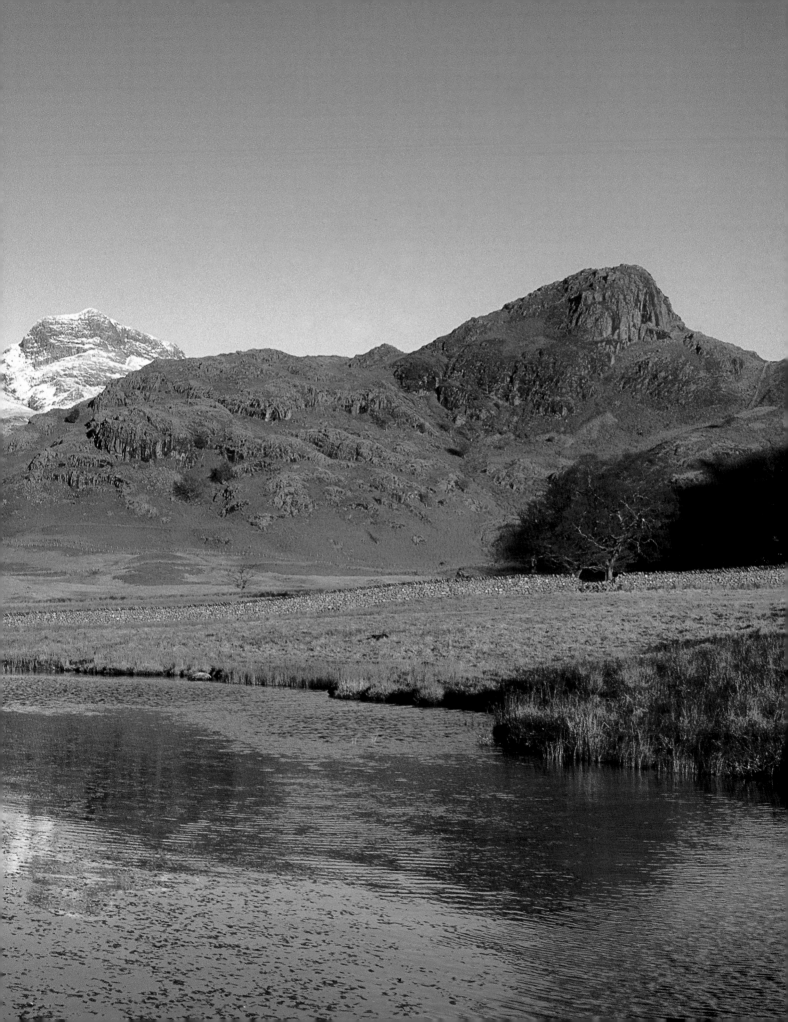

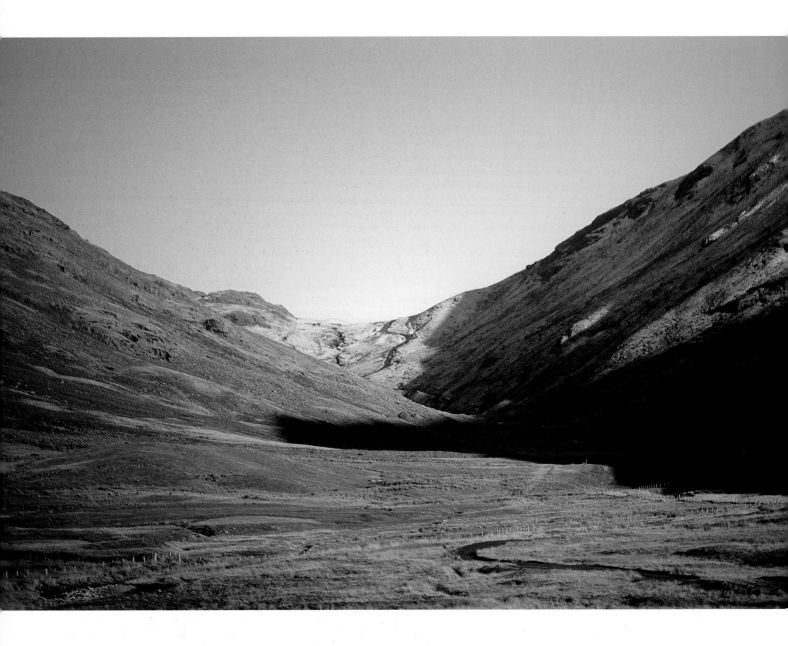

Wrynose Pass photographed at different times of day and in opposite directions. The wide-angle view looking up the pass in mellow late afternoon sunshine makes it appear positively benign (above). In direct contrast, the dark, gloomy version looking down the icy hairpin bends, taken early in the morning, portrays the place as somewhere to avoid (opposite).

preparation for the considerably trickier gradients and hairpin bends of Hardknott.

Hardknott watching during the height of summer is quite a good spectator sport, especially from two-thirds up, where the gradient really kicks in and driving becomes increasingly difficult. Unlike some similar Alpine roads, where the hairpins are separated by longer straights, Hardknott relentlessly twists and turns without respite, calling for perfect control of engine revs and gear selection. Automatics, easier to drive, were not so prevalent when I was working on the book; on one busy Sunday afternoon, I lost count of how many vehicles ground to a halt and stalled at a crucial point of the climb, resulting in flustered drivers and passengers sitting rigidly bolt upright, wide-eyed in fear, as traffic careered downhill towards their stationary car. Hardknott is not the place to discover that one's handbrake cable or hill-starting techniques are deficient!

Numerous signs warning of the road's potential impassability under winter conditions are posted on the approaches to both Wrynose and Hardknott; when conditions are icy the passes can become lethal. I drove up Wrynose early on a freezing morning after a protracted period of rain; by the time I reached the summit, I was aware just how difficult driving conditions were. Flooded watercourses spilling out on to the road had iced over during the night: at frequent intervals I lost traction completely and had to rely on the car's forward momentum to get to the next section of dry tarmac. I parked at the summit and walked some way on to assess the prospects for a safe descent, but it did not augur well: I could see a succession of bends below that were patently not negotiable. I felt rather like a kitten stranded on top of a tree: climbing up had been a piece of cake, but getting down might be somewhat trickier.

I then noticed that piles of gritting salt had been deposited on the roadside at the apex of each bend, and realised that I could make my passage safer by spreading grit around the worst-affected places on six consecutive hairpins. The sheet ice

When conditions are icy the passes can become lethal

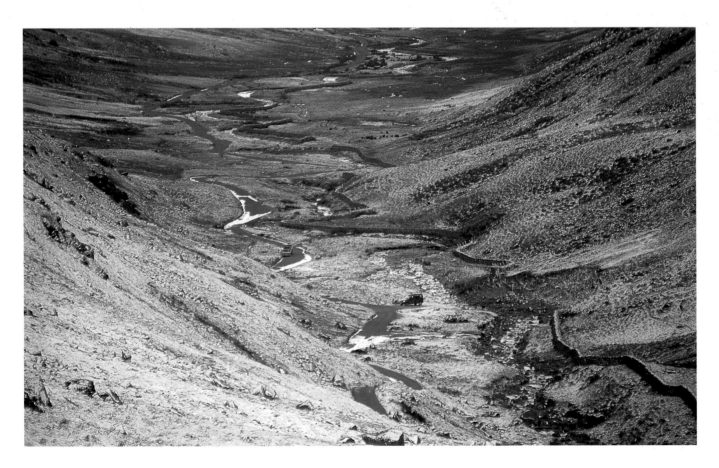

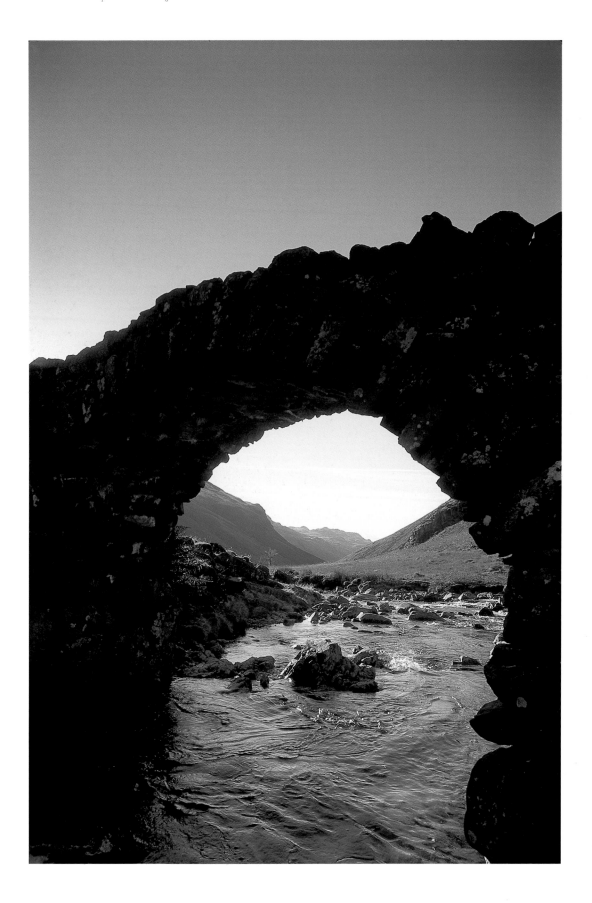

crackled in protest as the salt got to work, and I hoped that by the time I had walked back up to the car, poured a coffee from my flask and rested for fifteen minutes, the road might have become more stable. A first-gear crawl did get me down in one piece but I knew that a similar attempt on Hardknott would be foolhardy and dangerous, so a carefully planned itinerary had to be drastically curtailed. My plan had been to drive down into Eskdale as far as Brotherikeld Farm, the starting point for three passes heading from Eskdale to Wasdale, Langdale and Borrowdale, the latter being one of my particular favourites.

The Esk Hause route from Brotherikeld to Seathwaite in Borrowdale is one of the highest mountain passes in the Lake District. Ultimately it joins up with more popular trails, but in its early, less peopled, stages it gives access to some of the National Park's most awesome scenery. I took the photographs for that particular chapter in early summer, but undoubtedly the best time to be there is on a crisp winter's morning when the first high-altitude snowfall makes the Scafells appear as though dusted with icing sugar.

After leaving the farm buildings at Brotherikeld, the path runs alongside the river Esk for a couple of miles, crossing over at the ancient single arch of Lincove Bridge, surely one of the most evocative of all the Lake District's pack-horse bridges and confirmation that the pass to Borrowdale was an important trade route. Even in its comparative infancy the Esk is not to be trifled with: it hurtles over a succession of rocky waterfalls and the opportunities for fording it at sufficiently narrow and shallow places are few and far between. One of the great joys of the Esk Hause route is the way that the entire Scafell range suddenly springs into view as one climbs up from Lincove Bridge and approaches the flat expanse of Great Moss. For one of the best views of that spectacular mountain presentation, I always scramble up the hillside away from the soggy stalls of the Moss and up to the dry comfort of the dress circle on Gait Crags. Not only is it a perfectly sited vantage point from which to photograph the Scafells, but also a place just to sit in Wainwright-approved total silence, admiring the quality of nature's performance on that distant stage.

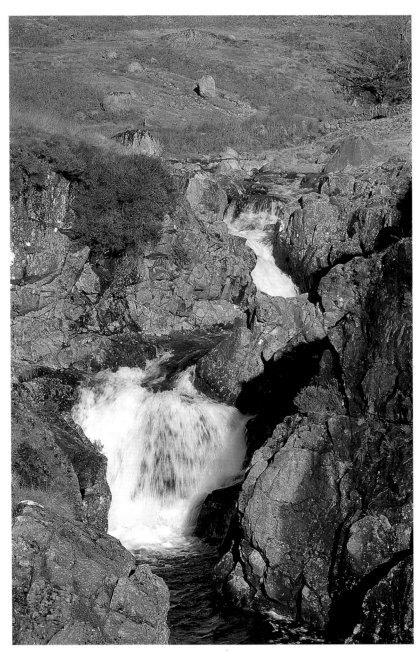

Lincove Bridge is arguably the most photogenic of the Lake District's pack-horse bridges. For the silhouetted version (opposite), I opted to use a wide-angle from low down to emphasise the arch and the bridge's rough-hewn, rugged construction. Although Lincove Beck can be clearly seen beneath the bridge, I photographed an alternative view (above) to convey the impassability of the beck for fully laden pack animals without the bridge.

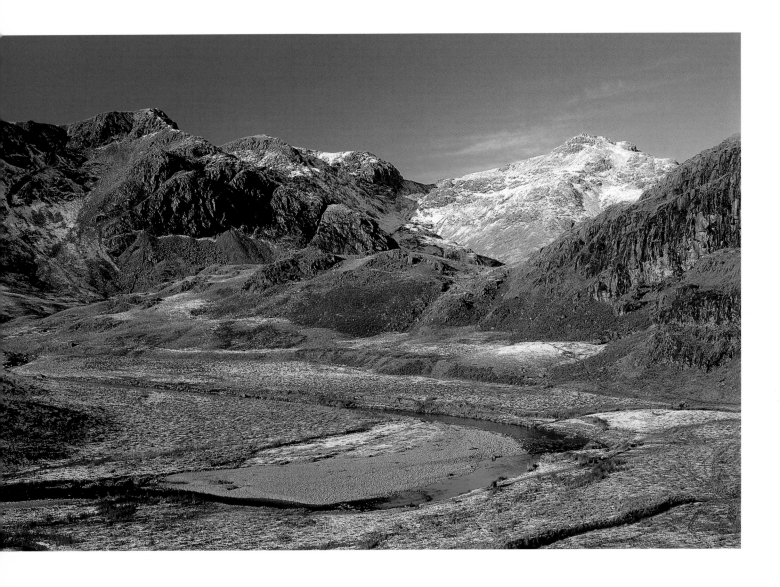

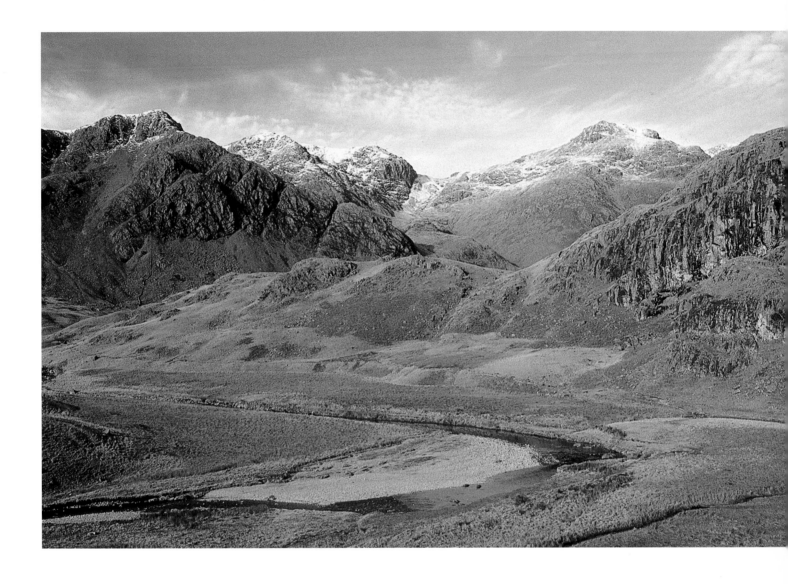

These two almost identical versions of the classic view of the Scafells, with the River Esk looping through the foreground, clearly show how even subtle changes in light and weather can transform a photograph's appearance. The image opposite was taken under more wintry conditions; even a relatively light dusting of snow affects film's colour balance. This manifested itself in a slight blue bias, an effect further exacerbated by a cloudless sky. The version above appears significantly warmer in tone; although there is snow on the mountain summits, this is predominantly a study in shades of brown and ochre.

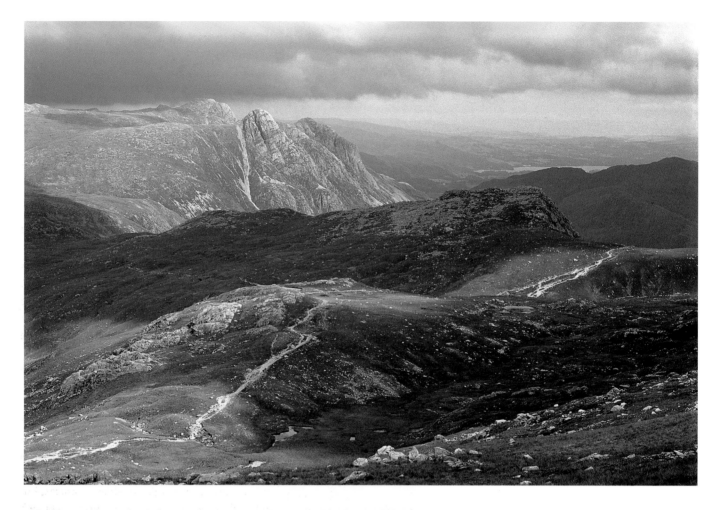

An establishing shot of the Rossett Pass from Langdale to Borrowdale (above), shown running diagonally across the frame from the bottom left-hand corner. By mixing light and shade, I was able to show its route over the fells more clearly. Having put the pass into its wider context, I did some detailed photographs of one section of the path (left) to illustrate how countless boots were destroying the landscape.

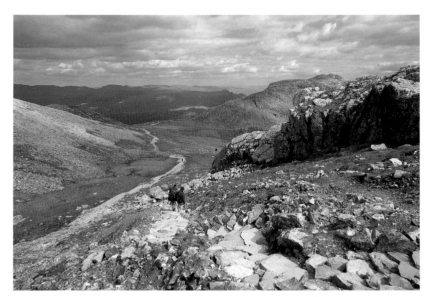

When the pass eventually reaches Esk Hause it can be a shock to the system after such prolonged tranquillity to emerge suddenly into pedestrian commuter territory. As the slope gradually falls away to reveal distant views down into Borrowdale, the unsightly wide scar of the Rossett Pass connecting Langdale with the high Borrowdale fells disfigures the pleasant grassy plateau. The combination of adverse weather and pounding by countless boots has resulted in serious erosion of the mountain passes and other popular routes throughout the National Park. Fortunately, those problems are now being addressed and the damage rectified through a series of restoration programmes designed to arrest footpath erosion and protect the upland network for the enjoyment of future generations. I think Wainwright would have been staggered by recent statistics indicating that some 12 million people a year visit the Lake District, 87 per cent (approximately 10 million) of whom actually forsake their cars and go walking. Those astounding figures mean that somewhere in the region of 20 million boots are pounding the rocks, scree slopes and turf into submission, so it is hardly surprising that the region's natural infrastructure is feeling the strain.

The Upland Path Landscape Restoration Project was launched in 2002 as a ten-year scheme to focus time, effort and money on redressing the terrible damage inflicted on some of our most visited upland areas, with the Heritage Lottery

Newly formed 'steps' on the badly eroded footpath from Esk Hause (top) show how erosion is being rectified by the authorities. Wherever sections of path are under repair, warning or diversion notices are posted at regular intervals (above).

Fund providing up to two-thirds of the funding during the first half of the project. Within that umbrella organisation, a group called Fix the Fells was created specifically to deal with the Lake District, working in partnership with the National Trust, English Nature and the Lake District National Park Authority. There are currently five National Trust Upland Path Teams engaged upon footpath repair and conservation, using a variety of techniques to ensure a restored path is not only durable but also works aesthetically by blending harmoniously with its immediate surroundings.

Two of the main processes are pitching and soil inversion, their deployment dependent on the nature of the terrain to be repaired. Pitching is probably the most noticeable style as it uses large stones dug into the ground to form a hard-wearing path which on steeper ground can be structured almost like a flight of steps. Guidelines on the implementation of such schemes specifically reject steps, but it is difficult to see how else an incline can be effectively structured. I recently encountered the newly re-laid section of the Esk Hause path up to Broad Crag, and you really have to concentrate very hard on where you put your feet on the descent because of the varying width and depth of each segment. Purists will no doubt rail against such seemingly alien measures, but although there is ample scope for people to branch off on their own once the higher fells have been reached, the main passes leading up from the valleys are always going to be heavily used.

The other practice being effectively employed on paths running across grassy, shallower slopes is soil inversion, a process that does exactly what the name suggests. Mechanical diggers are used to scoop out the affected ground, bringing harder subsoil to the surface which is then compacted to create a durable, walker-friendly surface. One of the primary causes of broad, unsightly scars being gouged out across the fells is people's natural gravitation towards the springy turf on either side of an eroded path in preference to an uneven mess of stones and gravel. A well-made soil-inverted track provides an inviting surface to walk on, and the system has had notable successes on some of the most blighted routes.

In July 2003, a three-ton digger was disman-

tled and airlifted in sections to deal with a badly eroded part of the Wythburn route to Helvellyn, where the track had been blazed to almost eight metres wide and, in places, up to a metre deep. Once re-assembled, the machine made short work of restoring the exposed area and creating a new path capable of withstanding future wear and tear on the flanks of the National Park's second highest mountain. Helicopters play an essential role in the restoration programme, despite being expensive to operate, as they are able to deliver stone and other raw materials directly on to the site under repair. I was up on Great End one day recently and watched an air drop of stone on the Wasdale side of the Styhead Pass – for a couple of hours, the machines flew in and out of the valley, with huge bags of rocks suspended beneath them. The pilots exhibited great skill in executing the difficult task: when I wandered down later after flying operations had ceased, I was amazed to see the pinpoint accuracy with which each container had been deposited alongside the existing path.

Styhead is one of the most frequented of all the Lakeland passes, although the Wasdale side experiences significantly less traffic than the Borrowdale end beginning at Seathwaite Farm. A long, semi-metalled track runs from the farm to the ancient pack-horse crossing point of Stockley Bridge, built to provide safe passage over the tumbling waters of Grains Gill; for many casual walkers, that picturesque beauty spot represents the extent of their perambulations. Because the path is easily negotiated, especially now it has received substantial renovation, large numbers do make the trip up to Styhead Tarn and the pass's summit to experience some of the true flavour of the higher fells.

Sadly, many of those who saunter up into the shadow of Great Gable and Great End are inappropriately clad and ill-equipped to cope with adverse conditions. What starts out as a gentle stroll and a picnic lunch in the sunshine after a drive down from Keswick can readily turn into an unpleasant and hazardous trial if weather conditions deteriorate. It is so easy to forget just how rapidly things can change above the valley floor. From a photographic point of view, there is nothing more depressing than observing fields far below bathed in light while one is a couple of thousand feet

Right: bags of large stones dropped by helicopter directly on to an eroded section of Styhead pass.

Below: Taylorgill Force on Styhead Beck adjacent to Styhead Pass, photographed using a slow shutter speed to make the water appear almost ghostlike.

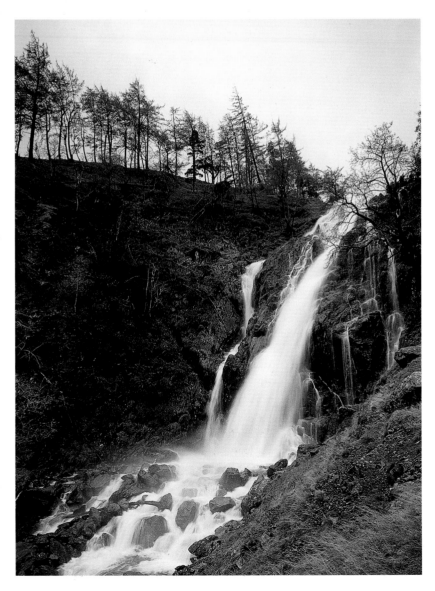

Stockley Bridge is another perfect example of the Lake District's early transport infrastructure. As the main access point to Styhead from Borrowdale, it probably carries more traffic now than in its heyday.

higher up, completely swathed in cloud and mist. I try to avoid working in the Lakes at weekends unless absolutely necessary, as I prefer to keep human presence in my pictures to a minimum, but after a run of bad luck I did venture out one Sunday as I was slipping behind schedule and the forecast was favourable. I needed some extra material from the Sty Head and Sprinkling Tarn sectors and was up there shooting away before it got too crowded.

As the morning wore on, more and more people starting arriving by Styhead Tarn's shore and I climbed away towards Sprinkling Tarn and Great End to escape the T-shirt and trainers brigade. A breeze appeared from nowhere, ruffling the tarn's surface and instantly erasing the atmospheric reflections I was about to capture on film. I was loading my equipment back into the rucksack before trying my luck with another shot when I became aware that a thick swirling bank of cloud was scooting up the pass and enveloping every-

thing in its path. Within ten minutes, there was an almost total whiteout and, for just a brief period, a shocked silence descended over the area as though the mist had sucked the breath out of every living creature enveloped in its grasp.

The spell was broken by vocal pandemonium, but the fog's disorienting effect made it sound like a bizarre ventriloquist's show, with voices being thrown from all directions. Visibility was down to a couple of metres, and so even small groups of people that had briefly split up just to potter around started to call out to each other. A cacophony of name-calling began to reverberate around the top of the pass and, amid the 'Brians' and 'Janets', several dog owners became embarrassingly aware that the idiosyncratic names of their pets did not sound quite so good when publicly shouted out loud. It did not require too much power of deduction to link the confused-looking Dalmatian galloping past me with the

repeated plaintive cries of 'Inkspot!' – I thought the magnificent-looking animal probably deserved better.

Two lads in football shirts and casual shoes stopped me to ask, in thick Birmingham accents, if I knew where they were; even after I put them straight they still appeared confused, and wanted to know how to get to Borrowdale as they confessed to 'not 'avin' an effing clue, mate'. It was all quite amusing at the time but later, when I considered just how many people had been caught unawares by the freak weather conditions, I felt even greater admiration for the work carried out by the various mountain rescue teams. The Wasdale

Rescue Team's website lists the details and circumstances of their call-outs; although a majority deal with genuine emergencies caused through falls and injuries, far too many are caused by carelessness and lack of respect for the mountains. Despite my ambivalence towards mobile telephones, I readily acknowledge their vital role in enabling walkers to summon help from the site of an accident; lives have probably been saved, or potentially serious situations nullified, by those in trouble being able to speak directly to mountain rescue teams or medical advisers. In several cases, people who simply get lost can be talked down off the fells to safety without the rescue teams having to go out

Styhead is one of the busiest junctions on the fells, but it needed a shot from above to convey the well-worn paths that form the crossroads of the pass itself and the Breast Route up to Great Gable.

and locate them. However, it is quite disturbing to read just how unaware some callers are about their alleged position; in some cases, after describing notable landmarks in their immediate vicinity, they were informed by the rescue co-ordinator that they were actually on a completely different mountain from the one they had intended to climb!

Mobile phones may be fine for summoning help but I deplore their selfish use amid the tranquillity of nature; their current popularity has raised noise pollution on some passes and fells to an unacceptable level. As we are about to be protected from the dangers attributed to passive smoking, could there not be another parliamentary bill banning banal, bellowed conversations in public places? Instead of 'It's me, I'm on the train,' walkers are now subjected to the outdoors equivalent of 'I'm on a big rock, where are you?' Mobile phone reception within the National Park is not always crystal clear so very few conversations are private. I recall one day on the Rossett Pass a dozen or so people wending their way up, and probably most of Great Langdale, were treated to a very loud and extremely pedantic step-by-step guide on how to plumb in an automatic washing machine.

Just five predominantly road-based passes are featured in the book, and of them Honister most perfectly exemplifies the region's industrial heritage and the important role in centuries past of a complex network of trade routes. Approaching the pass from Borrowdale, the cottages of Seatoller village at its base, mostly built to house workers from nearby quarries, stand as a reminder of the importance of slate quarrying to the local economy. Westmorland green slate has always been a much sought-after roofing material, prized not only for its distinctive colour, but also its fine grain and durability. Mining on a large scale at Honister got under way in the mid-eighteenth century, with major expansion into underground mines from 1833.

I always much preferred the drive up to Honister from Gatesgarth and Buttermere, especially the final steep drag beneath the soaring face of Honister Crag and the remains of the old tramways and aerial ropeways used to move the quarried slate away for processing at the factory

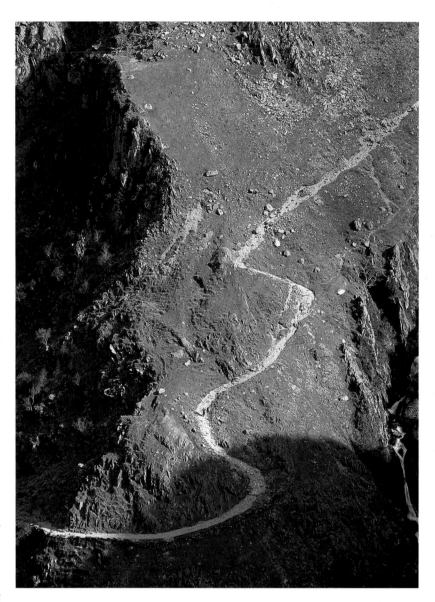

established on top of the pass. There are numerous vantage points from which to look back to Gatesgarth and appreciate the majesty of that classic U-shaped glacial valley. I was constantly having to chide myself for lingering too long on those old tracks, wondering what it must have been like in the quarry's heyday, when there were far more pressing matters demanding my attention, such as photography.

Slate originates from compressed volcanic ash, laid down in water over 40 million years ago and compressed over time into the veins of rock exposed by glaciation. The use of slate for roofing can be traced back to Roman times and there is

The winding track leading from Gatesgarth in Buttermere up to the slate quarries of Honister can also be used to gain access to Haystacks. I was happy with the shadow content of the left of frame, but would have preferred the track at the bottom of the picture not to have been obscured.

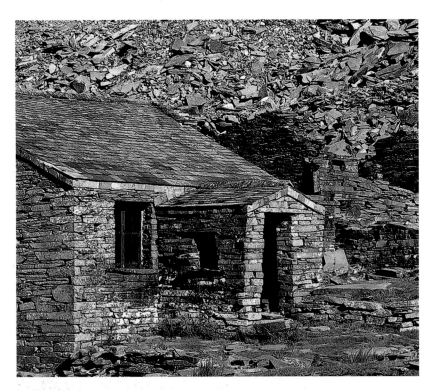

archaeological evidence that the forts at Ambleside and Hardknott had at least some buildings covered in that material. It would have been a relatively easy matter to take slate from the many exposed outcrops, but Honister's most productive and high-quality seams were located underground. As with so many of the nation's other extraction industries, slate fell prey to cheaper or man-made alternatives and gradually went into decline. In his narrative for the Honister Pass chapter, AW wrote that the centuries-old workings had been closed and that all was silent around Honister Crag; indeed, whenever I parked near the huddle of sheds when photographing *Passes* and subsequent books, a noticeable air of desolation enveloped the site. Happily, circumstances have recently changed; the Honister Slate Mine is once more a viable business, combining the production of slate with a thriving tourism enterprise. Guided tours along the miles of subterranean tunnels enable people to sample what life at the rock face was like a century ago.

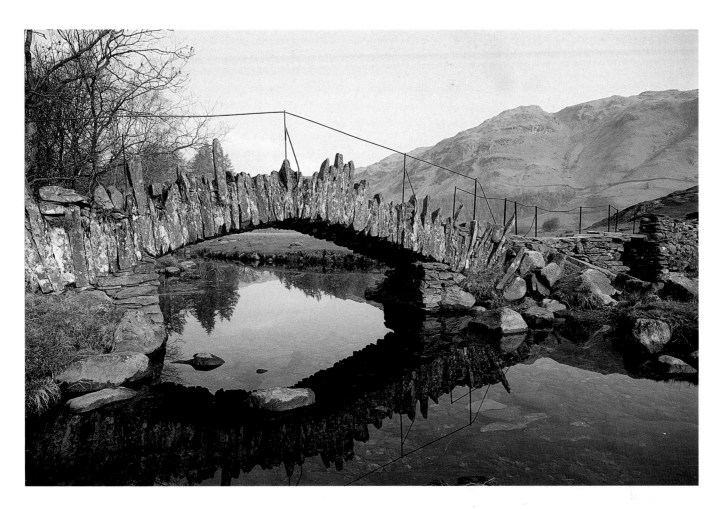

Tangible evidence of the Lake District's thriving slate industry exists throughout the National Park. A worker's hut near Honister now makes a useful shelter for walkers (opposite, above). Exposed veins in flooded quarries clearly show the subtle variations in the rock's colour (opposite) and Slater's Bridge in Little Langdale was probably used by several generations of quarrymen to access their work (above).

An archive document from 1910, outlining the original Buttermere Green Slate Company's operation, detailed how carrier pigeons were used to take orders from the head office in Keswick direct to the workshops at Honister. It mentioned that the same efficient method could not be used to contact the quarries at Coniston, due to the threat from predatory hawks *en route*. It all seems a long way from sending an email with the click of mouse; I suppose the birds of prey were the early twentieth-century equivalent of a computer virus.

Seldom on a day's walk anywhere within the central fells would you fail to encounter traces of slate extraction, albeit on a smaller scale than the Honister and Coniston operations. It is fascinating to wander around the different sites and note how the rock's colour subtly changes at each quarry, a variation reflected in the different hues of green on the slate roofs of farmhouses and other buildings throughout the district. One of my most treasured

discoveries was near Little Langdale, a village that originally housed the slate workers from the nearby Tilberthwaite fells whose slopes are still pockmarked with abandoned quarries of varying sizes. The delightful single-arched Slater's Bridge over the River Brathay was built to provide quarrymen with a direct link between their homes and place of work. Constructed entirely of irregular chunks of slate, the bridge's surface stones have been worn smooth by constant use; it is not particularly high and has an iron handrail, but crossing it is a curiously unnerving experience due to its narrow width.

Slaters, miners and agricultural workers all shared the same eventual appointment: for those living in Cumbria's isolated rural communities, the ritual formalities of death were more complex than in towns or larger villages. Although many had access to chapels of ease for regular worship, such places were not always consecrated for burial – so

that, for some, the journey to their final resting place involved an arduous cross-country trek over the fells to the mother church of the parish in which they lived. The routes specifically established to transport coffins became known as 'corpse roads' and Wainwright featured two such examples in *Lakeland Mountain Passes*.

I had already encountered one during the opening chapter of my first book with AW, and very much enjoyed returning to the Mardale Corpse Road which led from Haweswater over to Shap, some eight miles away. When I first climbed part of that track, I took little heed of its origin; I was using it solely as a vantage point from which to photograph Harter Fell and the head of Mardale. The corpse roads and other passes used for commercial purposes are still characterised by zigzag bends introduced on the steepest sections to alleviate the effects of the gradient and ease the task of pack animals struggling with heavy burdens.

Despite those measures, it must still have been a struggle for the horses. Even an average-weight man, borne in the flimsiest of wicker coffins, must have been quite a load, especially as the pass's initial gradient up out of the valley is quite severe. It does not require much imagination to picture the desperate scenes that must have been repeated through successive generations, particularly when doctors or antibiotics were nonexistent and the prevalence of winter deaths much greater, with vulnerable people succumbing to even the mildest infections. Standing by one of the sharp bends, I could almost see and hear the cortège fighting its way up through driving snow; the horses' hooves scrabbling for grip on the icy surface and a small group of mourners following on behind, heads bowed against the elements and praying that they would not stray from the track and perish in the blizzard. Such a scene is not pure Hollywood: there are several recorded instances of burial parties being lost in snowstorms and coffins being washed away down swollen rivers.

The Burnmoor Corpse Road performed a similar function for the residents of Wasdale Head, creating a link between that settlement and the parish church of Boot in Eskdale. But apart from an initial retrospective view past Wastwater, I found that pass to be far less photogenic than its eastern counterpart as it ploughs across large tracts of featureless, barren landscape. Boot's seventeenth-century church of St Catherine is hardly an architectural gem, an unostentatious low building designed to withstand harsh weather and serve small congregations. But one particular memorial stone in the graveyard makes a visit more than worthwhile. Tommy Dobson, once Master of the Eskdale Foxhounds, is celebrated by an ornate headstone decorated with an odd combination of angels and hunting horns. By the time this book is published, his sport might have been obliterated from the countryside through the actions of a well-intentioned but ill-informed minority who appear to place the welfare of vermin above that of their fellow human beings. One of Tommy's Cumbrian contemporaries, John Peel, is featured in a well-known traditional song; it is perhaps as well that he got there first, as 'D'ye ken Tommy Dobson?' does not have quite the same ring.

It was not until midway through the *Passes* project that I regained my driving licence and welcome independence. It was such a joy and relief to be able to set off on a 'spur of the moment' photographic mission and not have to plan every trip down to the last detail before venturing out of the door. With that new-found freedom I travelled over to the Lakes far more frequently, but greater *ad hoc* mobility did not lessen the logistical problems involved in photographing the remainder of the mountain passes. In an attempt to sustain my

> The routes specifically established to transport coffins became known as 'corpse roads'

Below: the pack-horse bridge and old mill at Boot marked the end of Burnmoor Corpse Road from Wasdale Head.

Opposite: the Mardale Corpse Road was obliged to follow a steep, tortuous route to climb up and out of the valley on its way over the Shap Fells.

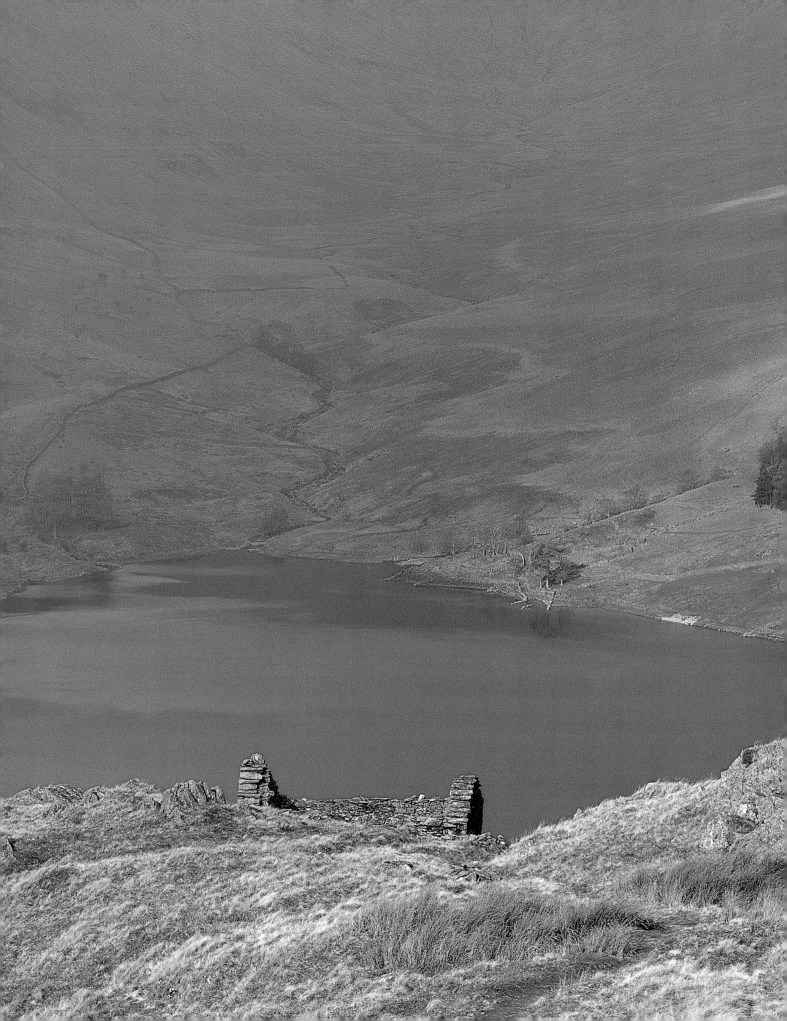

avowed policy of maintaining climatic continuity for each chapter, I splashed out on a mountain bike in the hopes that it might speed my daily progress. I also deduced that when roads ran roughly parallel with some of the paths and bridleways it would provide a convenient mode of conveyance back to wherever I had left the car.

The theory was sound but, in practice, the bicycle became more of a liability than an ally, ultimately forcing me to acknowledge that there was no realistic substitute for two legs. The machine I opted for was made by Peugeot, had lots of gears and a saddle-rack on which I intended to strap my heavy-duty tripod to ease the weight off my back. But in the mid-eighties mountain biking was not the universally accepted pastime that it is now, and the technical shortcomings of my bike became apparent from day one. It was far too heavy to lift easily over stiles and gates, its gears were prone to slipping at crucial moments, and I was unable to secure the tripod in place satisfactorily so it kept slipping whenever I negotiated a bumpy section of terrain.

Kirkstone Pass was its inaugural outing: I planned to cycle along the old farm track that AW indicated should be followed from Ambleside to its emergence just below the Kirkstone Pass Inn at Petts Bridge. I thought I would then be able to push it up the last steep section of road, photograph the pass looking down towards Patterdale and then experience an exhilarating free-wheel dash back down the pass to Ambleside, strap the cycle on the roof rack and, hey presto, the job's a good 'un.

I set off on a bright spring morning, with snow lingering in crevices up on the distant fell tops, and puffed my way up the Stock Ghyll Force road out of Ambleside, receiving painful reminders at an early stage that pedalling uses different muscle groupings from walking. Having made a detour on foot to take a picture of the impressive falls, I pressed on along the narrow lane that eventually petered out in the vicinity of Low Grove Farm. I dismounted, and was about to pass through a gate leading on to the road's continuation as a rough bridle track when a loud voice shouted, 'Oi, where do you think you're goin' with that?' I had been unaware of anybody else, but the farmer had obviously been watching my approach and pounced from behind

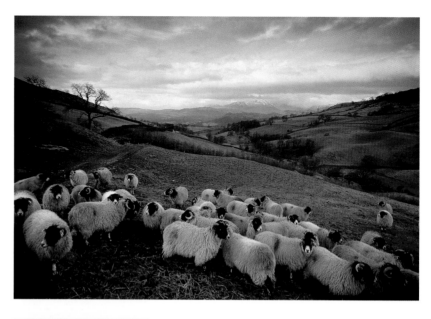

Top: despite poor light conditions, I was able to filter a bit of character into the sky, and the textured fleeces of the sheep also helped to give greater weight to the image.

Above: the Kirk Stone, after which the pass was named, is thought to resemble a church when seen from certain angles.

Opposite: the summit of Kirkstone Pass and the huddle of buildings that form the old coaching inn.

a nearby stone wall. I explained what I was doing and, in response, he jabbed a finger towards a handwritten notice pinned to the gate that said 'No Cycling'.

Having got that far I was reluctant to retreat, and so I promised faithfully that I would only be pushing the bike and it would not be ridden until I reached the tarmac road at the other end. I must have done a good job of convincing him as he allowed me to pass through, although I suspected that he might be monitoring my onward progress from his Land Rover; I wondered what inconsiderate behaviour by others in the past had left him with such a vehement dislike of cyclists. Once well out of sight, of course, I remounted and started to make good progress until ambushed by a menacing-looking flock of sheep, obviously acting on instructions from the farmer and determined to 'baa' my passage. I soon discovered that off-road biking with a heavy load on a muddy rutted track was far from easy; even if I had opted to disregard the embargo, my journey time would not have been any shorter. However, the return ride was uneventful, despite a panic that my brake blocks would not withstand the pressure of hurtling back down to the car – and the transportation drawing board. Mountain biking is now big business and extremely popular, and rapid advances in manufacturing have transformed bicycles into feather-light hi-tech machines. I shudder to think what AW

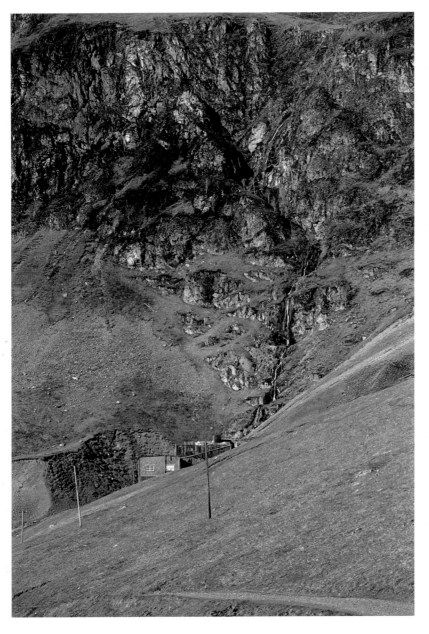

The adverse camber of the fells surrounding the ruined Coledale mine and associated workings renders it quite difficult to photograph. By using a vertical framing, I was able to feature the road, mine buildings and the hostile-looking rock face that formed an appropriately stark background.

would have made of the new phenomenon; it is perhaps safe to assume that he would not have taken kindly to being confronted by a cyclist clad in garish, skin-tight Lycra wearing a helmet plucked direct from the pages of a sci-fi comic.

The bicycle did prove useful on less taxing expeditions, such as the long mine road leading up to Force Crag and Coledale Hause from Braithwaite. The dilapidated remains of the mill of the Force Crag mine are one of my favourite industrial relics in the district. The corrugated iron buildings are somehow reminiscent of those often featured in Western movies; after a long ride, I was rather hoping to get out of the saddle and into the saloon bar for a shot of whiskey and a hand of poker. Sadly, there were only ruins to photograph, but at least the scattered pieces of tangled machinery provided a secure anchorage for the bike while I climbed up to the summit of the pass. That particular chapter slipped through the continuity net, as I opted to complete the end section near Buttermere on my next visit. I then got sidetracked into other things, and by the time I got back on course autumn had arrived to turn the green bracken-clad fells brown, which introduced a jarring note to one of the double-page spreads.

A couple of the other passes around Patterdale were also photographed in two separate halves of even greater contrast than Coledale. I had been anxious to make sure I got at least some snow pictures in the book, even if they only portrayed the landscape in the aftermath of winter. The Scandale Pass chapter from Ambleside to Patterdale comprises two pictures with bright green vegetation and clear blue skies, and two contrasting efforts depicting patchy snow and a golden foreground of faded grass. Conversely, Hart Crag Col was reversed in its seasonal presentation, having a snow-clad opening and a fresh summer conclusion. The dramatic photograph of Deepdale from the col is actually one of the best in the book, containing all the right ingredients: clear visibility, a high vantage point, the interplay of sun and shadow, and a sky full of interestingly textured clouds.

At one stage when progress seemed to have ground to a halt through lack of impetus on my part, I resolved to remedy the situation by

This simplest of compositions, featuring a 'hanging on by the fingernails' overhead shot of the Black Sail youth hostel, really works for me because of the intense cloud shadows that play across the top part of the frame.

launching a major offensive to get the book back on track. Summer had made me feel lethargic and I was probably suffering from the effects of too many wasted journeys over to Cumbria. I decided that an appropriately severe punishment had to be administered in retribution and so set off for Wasdale Head armed with AW's text from every chapter vaguely related to that area. Because several of the passes were almost interlinked, I reasoned that with careful planning and a slice of luck, I could complete at least one chapter and make serious inroads into others.

My day of penance began with the Black Sail Pass from Wasdale over to Ennerdale which, by a stroke of good fortune, did not require any photographs after the path had crossed the River Liza. That left me free to continue on to the Loft Beck Crossing and almost as far as Honister, prior to retracing my steps back to the luxurious Black Sail Youth Hostel and then slogging up Stone Cove to Windy Gap. Although far from spectacular and often cloudy, the light had remained fairly constant and I had not been obliged to waste precious time by hanging around too long for each shot. Stone

A view of Aaron Slack from the slopes of Great End. Whichever side of Windy Gap is ascended, it is a route of fairly unrelenting tedium. Having reached the summit, one rapidly discovers that there are few more accurately named features in the Lake District.

As I struggled up the rocky path, the distinctive nick of Windy Gap never seemed to get any closer

Cove is a heartless place, offering no diversionary scenic delights; as I struggled up the rocky path, the distinctive nick of Windy Gap linking Green and Great Gables never seemed to get any closer.

I photographed the pass, took views in the direction of Sty Head looking down the equally uninviting slope of Aaron Slack and, despite starting to feel ever so slightly knackered, I rested up to consult the Wainwright oracle to see what else might be achieved on that mission. It then dawned on me that I still had to get back to Wasdale; to do so meant either going back down the way I had just struggled up or reassessing my feelings towards Aaron and getting home down Styhead Pass instead. I opted for the latter, got a few more half-decent shots on the way and ended up back at my starting point with energy levels running on empty. Driving away to find a welcome bed for that night, I was able to conclude that, although I had to await the tangible evidence of the photographs, the day had nevertheless been an unqualified success due to good fortune with the weather and a hefty bit of resolve on my part.

Lakeland Mountain Passes was a fascinating exercise: not only did it broaden my own knowledge of the region's history and landscape, it also provided me with invaluable experience of some of the wilder places in the Lake District. With the fells, familiarity does not breed contempt – it raises awareness. When it came to photographing the next Wainwright, I was grateful for every additional scrap of knowledge I had managed to accumulate.

The diminutive and wonderfully atmospheric Wasdale Church is almost completely hemmed in by dense yew tress, thereby rendering it virtually impossible to photograph in consistent light.

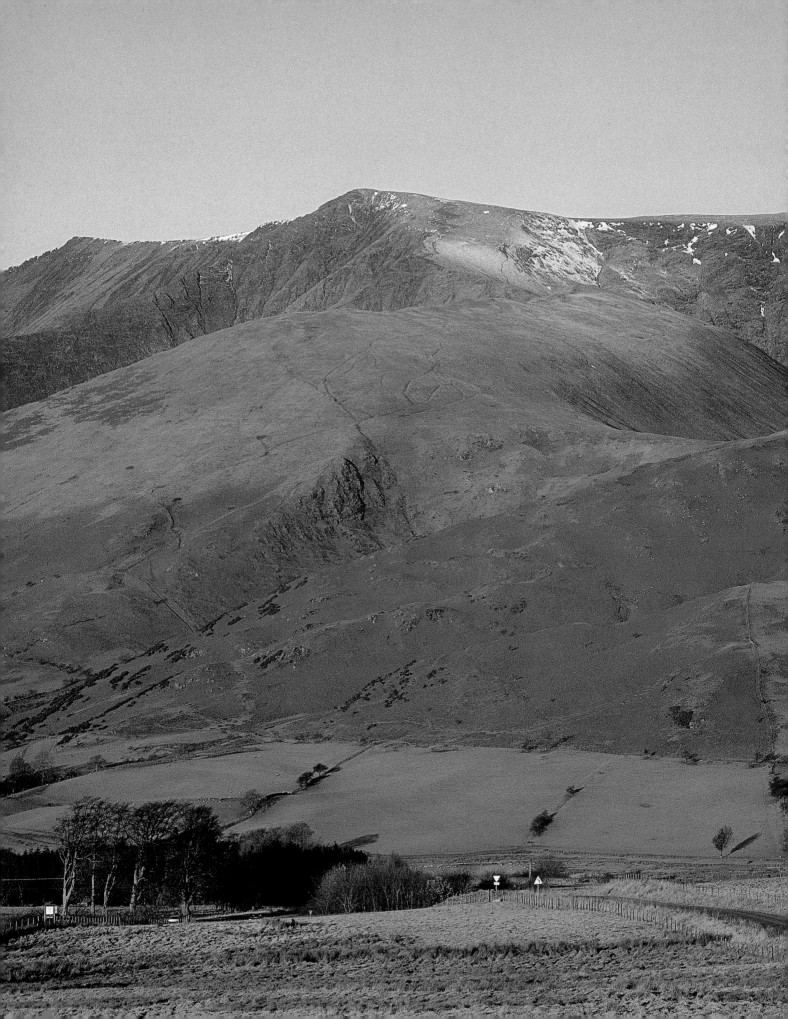

First sighting of the enemy. Blencathra's distinctive saddleback makes a prominent landmark on the approach from Penrith. An early morning shot is essential to catch it in the best light.

Chapter Eight

MOUNTAIN WARFARE

After *Wainwright on the Lakeland Mountain Passes* I became involved with a couple of extremely time-consuming publishing projects away from the fells; reluctantly, I had to decline the offer of collaborating on the next Wainwright, featuring the limestone dales of Yorkshire. I was devastated at having to break the continuity of our successful partnership, but although I lived virtually on the region's doorstep there was no realistic prospect that I could satisfactorily undertake all the pictures, and so that particular book was beautifully illustrated by 'super-sub' Ed Geldard.

AW's output was prodigious during 1989 and 1990; his typing fingers must have been severely stunted by constantly bashing away at the keys of his old machine. *Limestone Dales*, *Favourite Mountains* and *Valleys of Lakeland* were all in various stages of production during that time. Perhaps he feared that his gradually failing health might intervene and prevent him from accomplishing all the tasks he wanted to achieve.

Having eventually freed myself from other obligations, I was able to give my undivided attention to *Wainwright's Favourite Lakeland Mountains*, and I vowed from the outset that I would strive to produce as perfect a portrait as possible of every one of the twenty mountains AW chose to feature in the book. I still retained my intense fear of heights, but reasoned that as I had survived thus far without life-threatening mishap the chances

were that by continuing to employ a modicum of common sense I might complete yet another book and live to tell the tale.

I did not take for granted my good fortune in having a job that offered so much freedom, but it was never just a matter of a leisurely saunter over the fells while other poor sods were stuck in offices and factories. It was a war of attrition between myself and the elements – a conflict I was determined to win. The mountains were my place of work. They formed a vast outdoor studio and so, unlike the majority of visitors, I seldom travelled to the Lakes purely for fresh air and recreation; it was always business and the hours were significantly longer than nine to five.

When devising a shooting plan for the book, I spent a long time looking through my previous efforts, analysing what needed to be done differently to make the photographs really stand out as individual images. As I turned page after page of *Fellwalking* and our other titles featuring the Lake District, I came to an inescapable conclusion: they featured too many summery green pictures, and an unacceptably high percentage were also marred by poor visibility. For this book, by the time I was ready to start work Wainwright had completed a large chunk of the manuscript and accompanying illustration guidelines, ensuring that I had *carte blanche* to balance the chapters seasonally at my discretion. There would obviously need to be a hint of summer, but I decided the book was going to be a study of the fells and mountains clad in the gold, brown and ochre of autumn and the stark white of deepest winter. Up to this moment I have never done an image tally for the book looking for seasonal bias alone, but I have now gone through every chapter of *Wainwright's Favourite Lakeland Mountains* and, out of a total of 220 photographs, fewer than two dozen are either predominantly green or tarnished by atmospheric haze.

I resolved that there would be no compromises. I would not make do with sub-standard pictures; no matter how many journeys it might entail, if conditions were not right for photography I would either go straight home or stay over and wait for an improvement. The quality of the light falling upon any subject is paramount in creating a good picture, and the two hours after sunrise or preceding sunset are the most valuable from a landscape photographer's point of view. At the beginning and end of the day the sun's naturally warm tones are exaggerated in the camera, because slide film emulsion is chemically balanced to reproduce colours accurately under midday sunlight. The pleasingly mellow bias one achieves after sunrise is gradually replaced by a more unsightly blue cast as the day wears on and the colour temperature rises, rendering good landscape photography virtually impossible.

Some professionals use a range of colour correction filters to counteract such imbalances but, even with those aids, essential shadows and textures are absent. I prefer to harness the light in its natural state, with little or no recourse to filtration. My camera bag only ever contains two kinds of filter, neither of which artificially alters the picture's colour, but merely serves as an aid to enhance what exists naturally. A graduated neutral density filter is invaluable to create closer parity between land and sky, because the contrast between those two elements is too great to be reproduced with the same exposure. A polarising filter enriches the photograph in a different way; under the right conditions, it transforms a normal blue sky into a dark rich ultramarine, against which any clouds are hurled forward into visual prominence in an almost 3D-like effect. Polarising filters also cut out unwanted reflection; when used correctly, they can radically increase the colour saturation of a landscape picture. Every leaf and blade of grass acts as a reflective surface, making a particular scene appear less vibrant than it might be; under polarisation, all reflection is removed, allowing the countryside to be photographed in far richer tones.

Having to become as one with nature and literally 'rise with the lark' can become wearing if one is working solidly for two or three consecutive days in mid-June, when sunrise is somewhere around the ludicrously anti-social hour of 4 a.m. and sunset not until some eighteen hours later. Fine summer days on the fells consequently pose the difficult conundrum of how to make the best possible use of those precious few hours of morning and evening light, but also how and where to spend the intervening chasm of time.

The mountains were my place of work. They formed a vast outdoor studio

Opposite, above: Harrsion Stickle on the Langdale Pikes, photographed with a telephoto lens in the warm light of sunrise. Cloud shadows contributed to the picture's atmosphere by breaking up what would otherwise have been a more solid block of colour.

Opposite: Fleetwith Pike at the head of Buttermere in the late afternoon. The mountain's natural colour and the vivid blue sky were enriched by the use of a polarising filter, but the image was marred by a rapidly advancing dense shadow cast by High Stile.

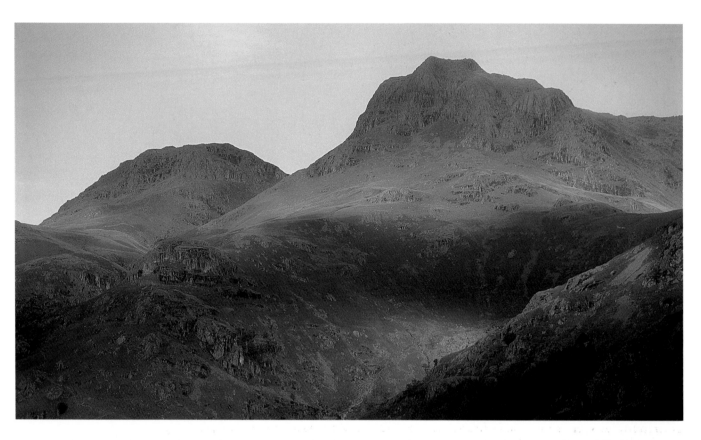

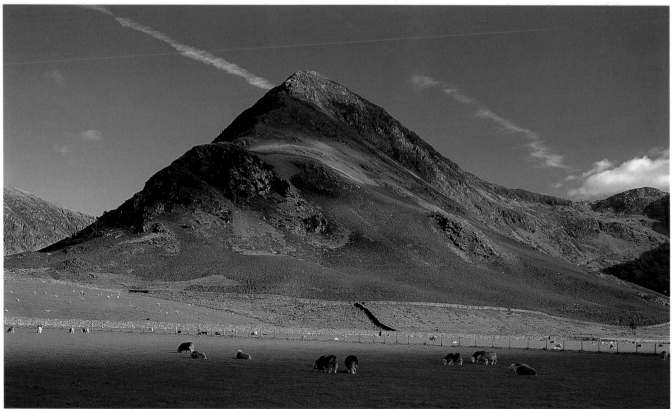

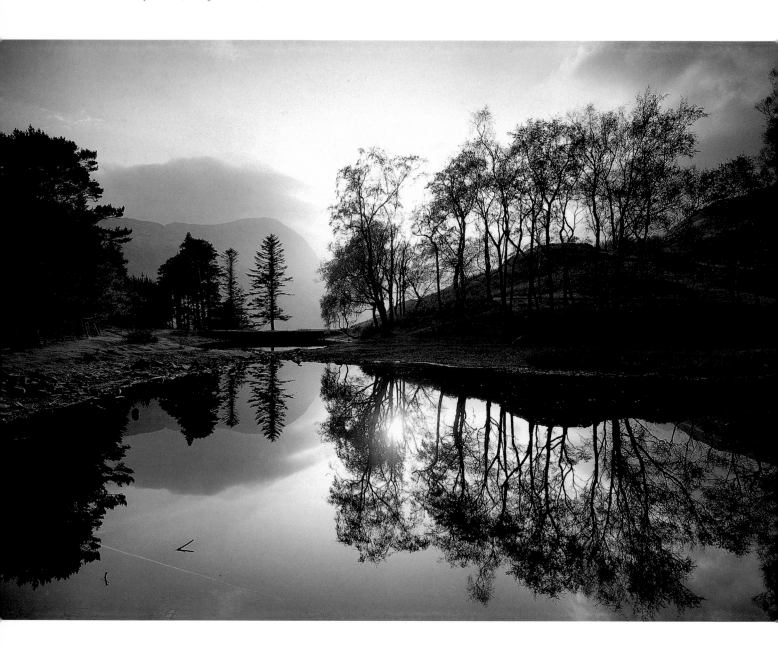

Lanty's Tarn in Patterdale,
showing how a bright sky and
low, swirling mist and cloud
were harnessed by the use of
a neutral density graduated
filter to cut exposure to the
upper part of the frame.

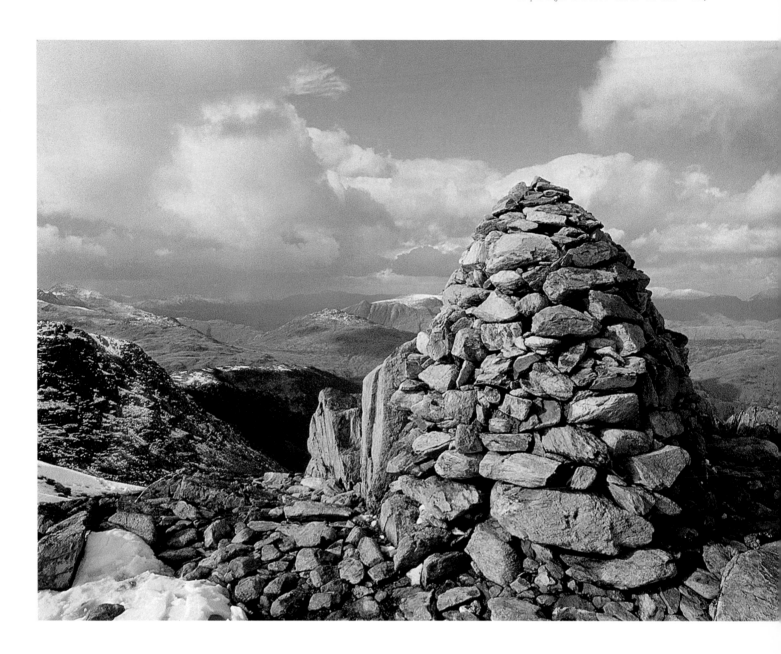

An equally effective but completely different treatment of sky and clouds was used for this shot of the summit cairn on Swirl How near Coniston. Polarising filters operate to their maximum potential when the sun is almost at right angles to the subject. On this occasion, the clouds seemed to leap out of the blue sky when seen through the filter.

Experience had taught me that not every day that starts perfectly remains clear; clouds commonly begin to bubble up and by mid-morning the fells have lost their earlier sparkle and rich colours. I consequently regarded the early sessions as the key to a successful day's work, not least because so many of my intended locations faced either east or south-east and would be correctly lit only during the first part of the day. However, it was always intensely frustrating to be in the perfect place as the sun rose, but then to realise another hour would need to pass for it to rise sufficiently high above any intervening hills and penetrate down into the darkly shadowed valley floors. With every passing minute, I could see the sun's effect upon the landscape waning as the light changed from an intense golden glow to a more pallid overall yellow.

In order to gain greater freedom of movement at any time of day or night as required, I abandoned guest houses, hotels and B & Bs in favour of tented accommodation; I joined the ever-increasing number of campers who now flock to the Lake District. It seemed a pointless and expensive exercise (especially to a Yorkshireman) to be constantly shelling out hard-earned money for a bed that would scarcely be slept in or, indeed, paying for a breakfast that would never be eaten (I have yet to meet a proprietor who could be persuaded to knock a bit off the bill in compensation for unconsumed bacon, eggs and toast). I always got worried looks when checking in anywhere as my first question would invariably be: 'Can I get out easily at 3.30 in the morning without setting off alarm bells or having my ankles savaged by a lurking guard dog?' Despite offering to pay up front for a night's accommodation, such an enquiry generated worried frowns; on more than one occasion, I was told there had been a mistake and they were actually fully booked that night.

Although some childhood family holidays to France had been spent in a large frame tent, I had never been in the Scouts or participated in school outdoor adventure activities, and camping alone was a new experience. I soon discovered where the best sites were, although those with the best facilities were not always the ones located in the very heart of the mountains. Many campsites have been

Seasoned campaigners had their tents up and stoves burning within a matter of minutes

Camping is increasingly popular throughout the Lakes, and sausage sales soar to record heights during the summer months!

substantially upgraded during the intervening fifteen years but, even so, there still appears to be a demarcation line between those catering for serious walkers and others that are geared more to the general tourist trade. The closer one gets to the heart of the fells, the more rudimentary the facilities tend to be; I have encountered shower blocks in which one would not wish to linger longer than the minimum time required to fulfil the basic necessities of hygiene.

Apart from being ultra-convenient in terms of providing easy access to my outdoor office, campsites are wonderful microcosms of society, although many of the behavioural traits exhibited there did raise both my eyebrows and hackles in fairly equal measure. Regardless of location within the National Park, I discovered that camping out on a Friday night was a non-starter in terms of getting any peaceful sleep, especially when a fine weekend was forecast. It was as though the Lake District was transformed into a shrine, a place of pilgrimage to which people from far and wide journeyed to observe the miracle at first hand; the dazzling beams of their car headlights pierced the campsite until well into the night.

Some religious pilgrims fast as a token of devotion, but most fell worshippers engage in ritual feasting to appease the mountain gods, countless sacrificial sausages being martyred upon charcoal-burning altars known as barbecues. Tradition also demands that copious quantities of alcohol be consumed and, as the liquid goes down, the volume of noise rises. With tongues loosened, travellers relate tales of past journeys and exploits, the details of which would certainly make Chaucer's eyes water. Seasoned campaigners had their tents up and stoves burning within a matter of minutes, but there was always somebody who had decided to impress his girlfriend by bringing a newly purchased tent up to the Lakes for their romantic weekend, without the benefit of a dry run in a park or garden. It made great theatre, observing the man struggling to decipher the manufacturer's instructions while his increasingly disenchanted partner wondered just how long it would take him to crack the code to enable that tangle of alloy poles and garishly coloured fabric to be transformed into a shelter. As the minutes rolled by and the car head-

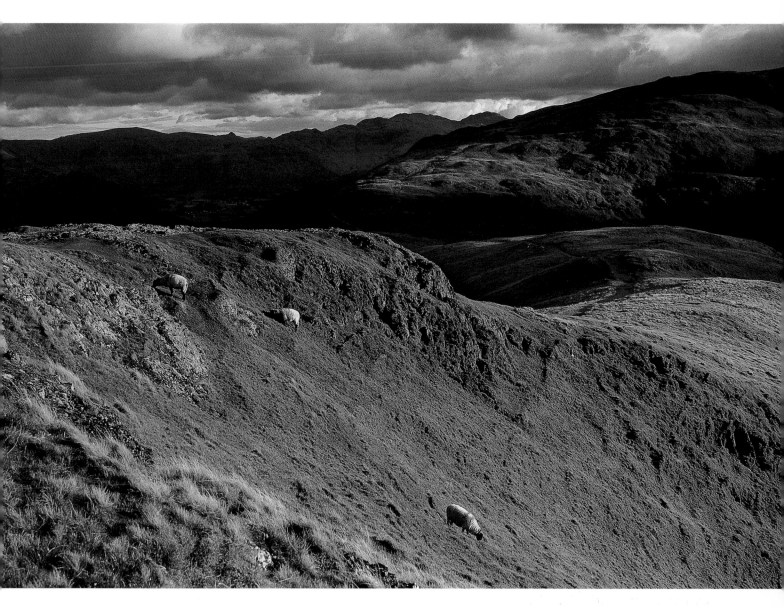

Low-angled light that creates plenty of shadows and textures can transform the simplest of scenes into a study of mood and atmosphere. Although not particularly prominent in the frame, the three sheep make a significant contribution to the picture's composition. (I have found that carrying several inflatable specimens around with me is of enormous benefit!)

lights began to dim through loss of battery power, her body language would reveal that getting the tent up might be his only successful erection that weekend.

Some of the better-managed campsites had entry barriers to regulate disruptive vehicle movements late at night or very early in the morning, and I vividly recall my first visit to one in Keswick where I had overlooked those restrictions. My alarm clock had been set for 5 a.m. and, having peeked out through the tent flap to confirm that the day was about to dawn clear and sunny, I brewed up coffee and wolfed down my customary breakfast of yoghurt and bananas before starting

work. Some twenty minutes later I was all set for action and seeing Skiddaw's rolling summits perfectly silhouetted against the pre-sunrise glow heightened my sense of anticipation. I started the car and moved off as quietly as possible towards the exit, where I encountered the lowered barrier and an adjacent sign reminding guests that it would not be raised until 7 a.m. I watched in frustration and a darkening mood of self-recrimination as the sun popped up over the horizon and accelerated mockingly into the sky, completely ruining my carefully planned schedule for a priceless couple of hours' atmospheric photography. When I stayed there again, I always ensured that I

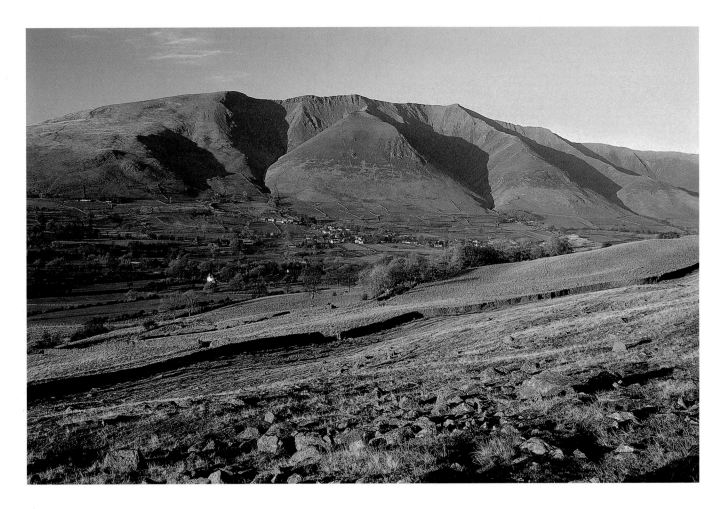

removed my car to the other side of the barrier before retiring for the night!

Although *Wainwright's Favourite Lakeland Mountains* revisited most of those I had already encountered during *Fellwalking*, AW's approach to the latest work was more in keeping with his original *Pictorial Guides*, with each peak being portrayed in greater detail rather than simply being the highpoint of a circular route. The mountains were featured in alphabetical order, and I thought it highly appropriate that Blencathra should open the book: its distinctive saddleback-shaped summit was always the first prominent landmark that greeted me after leaving Penrith on the westbound A66. There were times when I caught a glimpse of it in the distance descending from the Stainmore Pass over the Pennines, but I discovered those occasional sightings fell into the same category as the legend surrounding weather forecasting for cricket test matches at Old Trafford: 'If you can see the Pen-

nines from the ground it will soon be raining, and if you can't, then it already is.'

Blencathra is one of the few mountains in the Lakes standing alone as a separate entity; it can be photographed from several angles, clearly portraying its different facets. The saddleback, from which the mountain derives its alternative name, is apparent only from the east, but the most dramatic views are undoubtedly those incorporating the five distinct buttresses that combine to create its massive southern façade. The rising slopes of Threlkeld Common provide a perfect platform from which to take several different studies of the mountain in its entirety and telephoto shots of individual features. The most dominant of those is Hall's Fell, appearing from a distance as a vast pyramid towering over Threlkeld whose tapering apex leads on to a narrow ridge and thereafter directly to Blencathra's summit, marked by a disappointingly ramshackle pile of stones. I was hugely

Blencathra is one of the few mountains in the Lakes standing alone as a separate entity

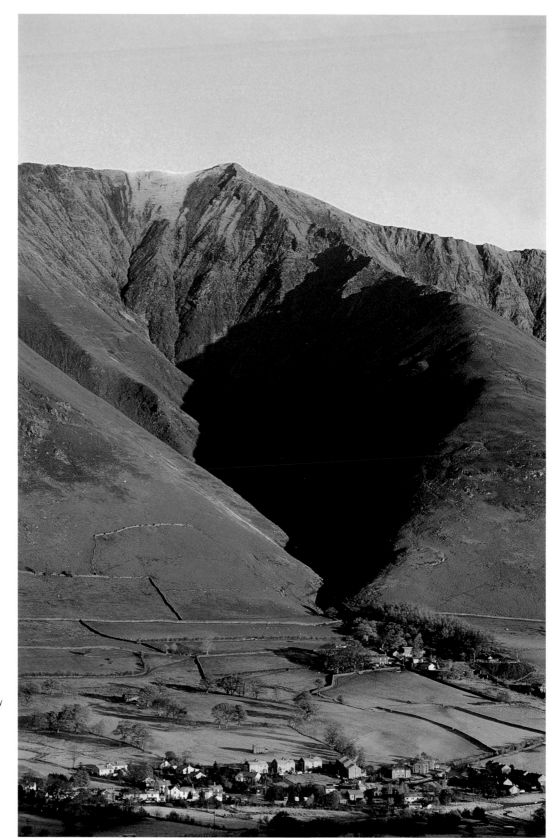

A wide-angle sunset shot of Blencathra from Threlkeld Common (opposite), in which the foreground is broken up by rich textures and a diagonal stone wall, contrasts with a telephoto version taken from the same spot in the early morning (right). The frost coating the fields created additional atmosphere, but disappeared rapidly once warmed by the rising sun.

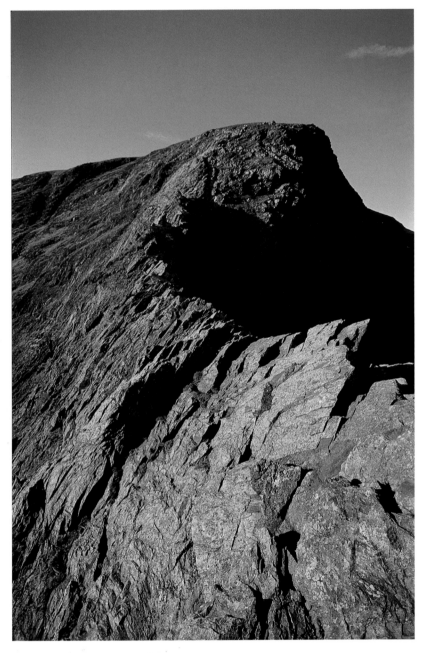

Sharp Edge on Blencathra was an even more daunting challenge than Striding Edge on Helvellyn. Although I had bright sunshine and a blue sky, the wind was so ferocious that I could barely stand upright; I had to shoot with a fast shutter speed and minimal depth of field to avoid camera-shake. That resulted in the background being slightly out of focus – but it was more important to concentrate on the sharp rocks nearest the camera.

relieved to note that AW had not included that route of ascent on his picture guidelines; I had already slogged up the fell's near-vertical face for *Fellwalking*, and once was more than enough. Blencathra's most difficult challenge, Sharp Edge, is less heralded than its Striding counterpart on Helvellyn, but in some respects it is even more daunting. At one point there is no alternative but to negotiate a path that suddenly narrows down to a razor-sharp ridge, requiring considerable caution. If you are descending rather than climbing, prudent use of your backside as a temporary secure mode of transport should not be discounted.

One of the problems faced when taking comprehensive wide-angle pictures of a mountain such as Blencathra is how adequately to fill the increased foreground area. When a photograph requires great width, there is nothing worse than a boring, featureless foreground. After several disappointing efforts, I was able to get the shot I wanted late one afternoon by utilising the combination of a stone wall and low-angled sunlight to transform an otherwise bland foreground into an area filled with complex colours and textures.

Blencathra was largely photographed in rich winter sunshine and so, by way of contrast, four of the following five chapters were mostly captured in late summer and appeared much greener. Bowfell, Crinkle Crags, Dale Head and Eel Crag were all shot before the bracken began to die down and transform the overall colour of many fells to russet brown. In a moment of madness, disguised as striving for artistic perfection, I decided to elevate the camping ethos to another level – to be precise, 2,816 feet up around the top of Crinkle Crags. It seemed like a good idea at the time. I had equipped myself with a very small, lightweight, bivouac tent, and I thought I could cope with the additional burden of a camping mat, a couple of sandwiches, water, a torch and a bottle of Dutch Courage to embolden me if confronted by gremlins, ghosts or unruly sheep with ideas above their station.

I would like to say that the experiment was an outstanding success, but the evening session produced only a close-up shot of the tarn on Shelter Crags and a vivid sunset behind the Scafell range. Being totally alone up there was quite the most

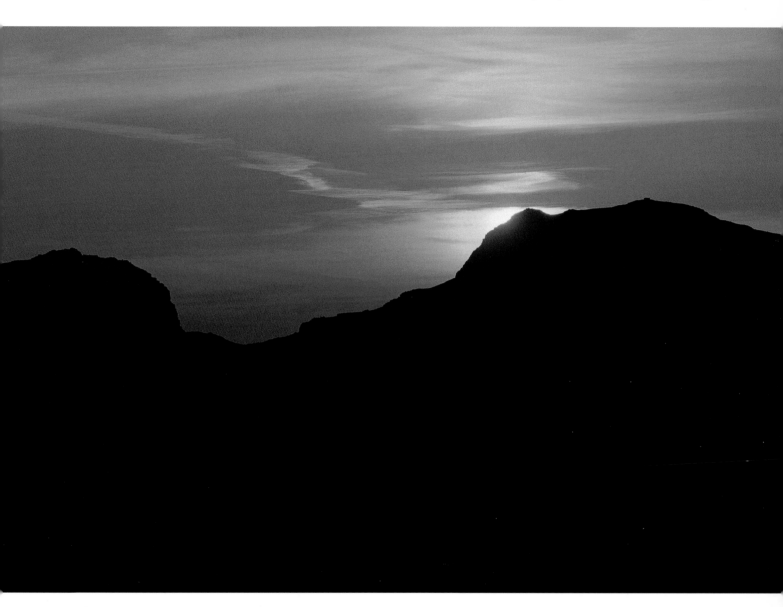

My one and only mountain-top camping experience produced this vivid photograph of the Scafells at sunset taken from Crinkle Crags. Had I waited to take that shot before making my way back down off the fells, the latter part of the descent would have been in almost total darkness.

eerie experience of my life, especially since I was blessed with a clear evening and I saw the stars gradually brighten in intensity as darkness finally banished all traces of daylight. It is not until one is totally away from any traces of habitation that the reality of light pollution in modern society can be fully appreciated; in fewer and fewer places in the country can the night sky be viewed in its untainted glory. We have become accustomed to seeing only the principal constellations but, as I sat there on my rocky observatory, the heavens were alive with individual stars and the pale creamy brush-strokes of seldom-seen galaxies. Such examples of nature's unfathomable power put the status

of human beings into a different perspective – being alone in the dark, I felt increasingly vulnerable. However, I reasoned that no harm could possibly come my way: Crinkle Crags were not renowned for venomous snakes, poisonous spiders, hungry wild cats, enraged rhinos or peckish polar bears, and the chances of being mugged for my cameras were also fairly slim.

When I awoke the following morning and peeped out of my claustrophobic refuge it was already light, but the Crags were fogbound and I was in a swirling sea of cotton wool. For a split second I thought maybe I had been taken in the night and that an angel might flit by at any second,

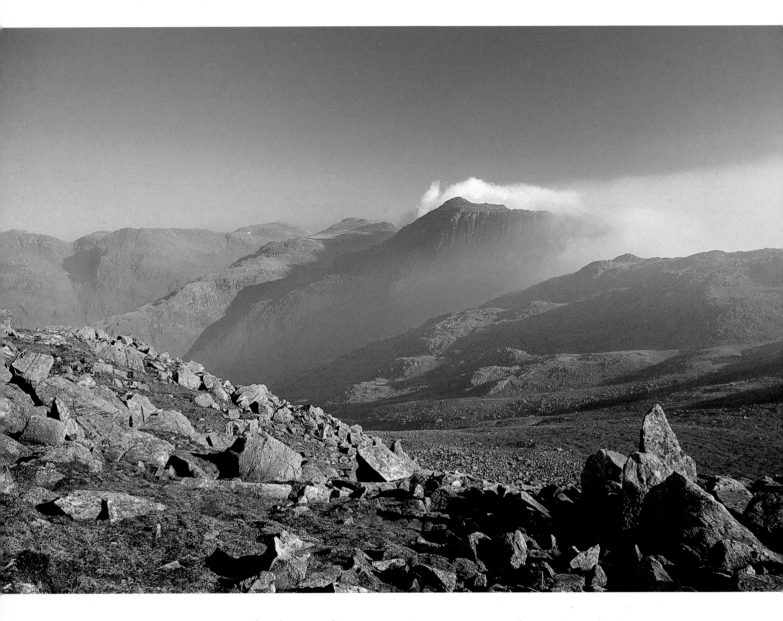

but the moment of madness quickly passed and common sense prevailed. If I had indeed expired, I would scarcely be regarded as cherubim material and would probably be confined to a much darker aspect of eternity than the whiteness that then surrounded me. Confirmation of continuing life came shortly after, when the mist started to thin and patches of blue sky and sunshine began to appear above the eddies. It was not the kind of start to the day I had hoped for, but I was grateful that the prospects for photography were not as bleak as they might have been and I was in situ on top of a mountain without having broken sweat.

I started to work through my scheduled list of pictures for that day, pleased that several were simply details of rocky features not requiring long-distance clarity as quite a haze lingered in the aftermath of the heavy morning mist. I did manage one really good view looking across towards Bowfell as the clouds were being blown from its summit by a freshening breeze. For a moment I actually felt quite smug, as I could see that Langdale and Mickleden were still totally enveloped in fog and anyone walking upwards through it in my direction would be feeling very clammy and uncomfortable. Although the light had not materialised in the way I had hoped, some of the results were excellent. But, on balance, I decided that the hassle

Although Bowfell was partially shrouded in early morning mist, a polarising filter cut through the worst of the haze. By darkening the sky, it made the swirling white plumes stand out even more than when viewed with the naked eye.

of humping several more kilos around the fells and the stress of isolation probably outweighed the benefits; consequently, Crinkle Crags would probably be my first and last camping foray up a mountain.

During the summer months, in particular, I frequently happened on small groups of tents in easily accessible locations such as Styhead Tarn, but I worried about how disciplined their occupants might be in terms of dealing with human waste. I recently read a chilling scientific report on the testing of water sources within the Lake District National Park. Never having been too pernickety in the past about replenishing water supplies on the hoof, I have now taken to carrying extra water with me, despite the unwelcome extra weight. A large nomadic sheep population obviously contributes to the pollution of watersheds, but some of the bacterial and faecal matter readings were disturbingly high, with Styhead Gill figuring high on the list. Trekkers in Nepal are constantly warned not to touch water from mountain streams, no matter how cold or fast-flowing they might be, as round the next bend there could well be a village for which the river acts as a public convenience. Although that could never be true in the Lakes, just thinking of how many people a week are up there for hours at a time makes it probable that it is not just rainfall permeating through the peat to create the springs and streams that ultimately cascade down the fells.

With the invaluable benefit of hindsight, I regret not having made a better effort over the photography of Haystacks, which I have always found difficult to catch in the right light due to its north-facing aspect. But I was happy to have produced an appropriately atmospheric picture of AW's final resting place, Innominate Tarn. When I was busily progressing through the shooting of *Lakeland Mountains*, I had no inkling that from 20 January 1991 the book would become transformed into far more than just another title in the series; ultimately it became my personal epitaph to AW. His untimely death came as a great shock. I was aware of his declining health through my regular visits to Kendal Green, but the news that he had been taken to hospital and died just two weeks later was a terrible blow.

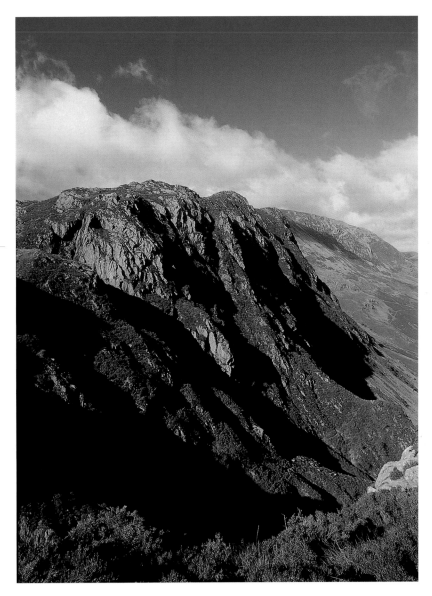

'A picture speaks a thousand words.' I redoubled my efforts to ensure that the photographs in *Wainwright's Favourite Lakeland Mountains* paid their own voluble tribute to the man who had devoted most of his life to creating so much enjoyment for others. Although it could hardly be said that the production of his *Pictorial Guides* was a work of pure altruism, his compulsive enjoyment of the fells and mountains was infectiously transmitted from every page, and countless numbers thereafter succumbed to the fell walking bug.

AW's personal affinity with the mountains is particularly well highlighted in his numerous lamentations on the fate that has befallen Coniston

Haystacks faces almost due north and is consequently difficult to shoot correctly. Despite heavy shadows, however, enough of it was still lit well enough to make the shot worthwhile.

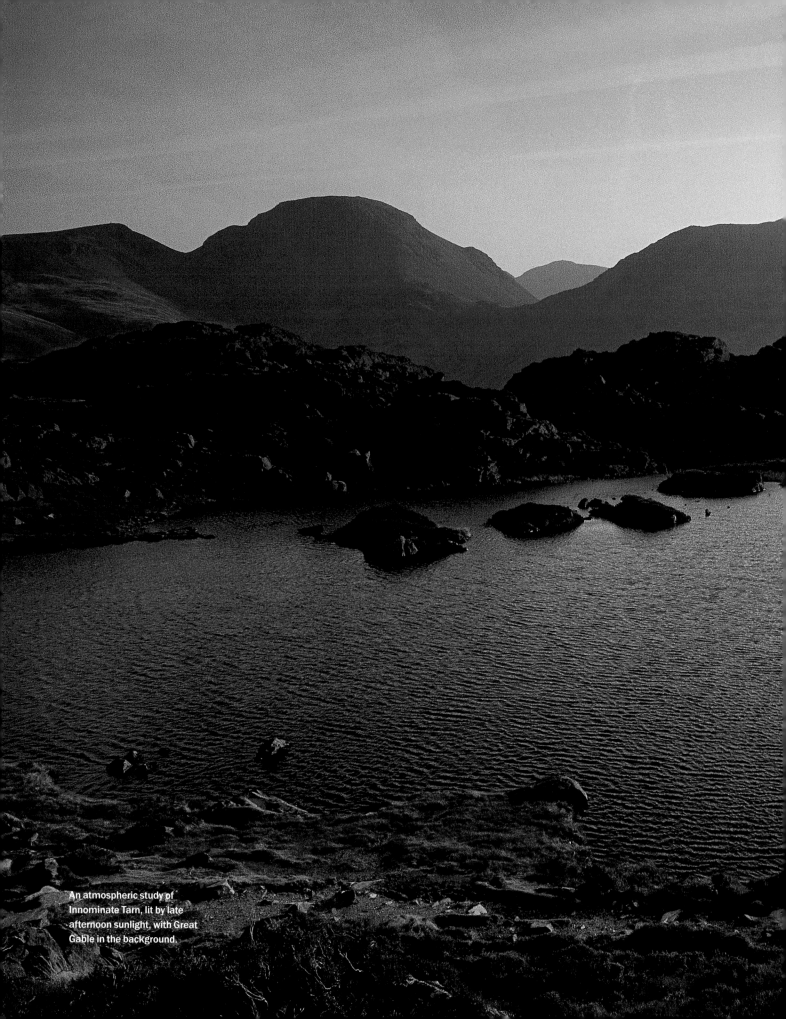

An atmospheric study of Innominate Tarn, lit by late afternoon sunlight, with Great Gable in the background.

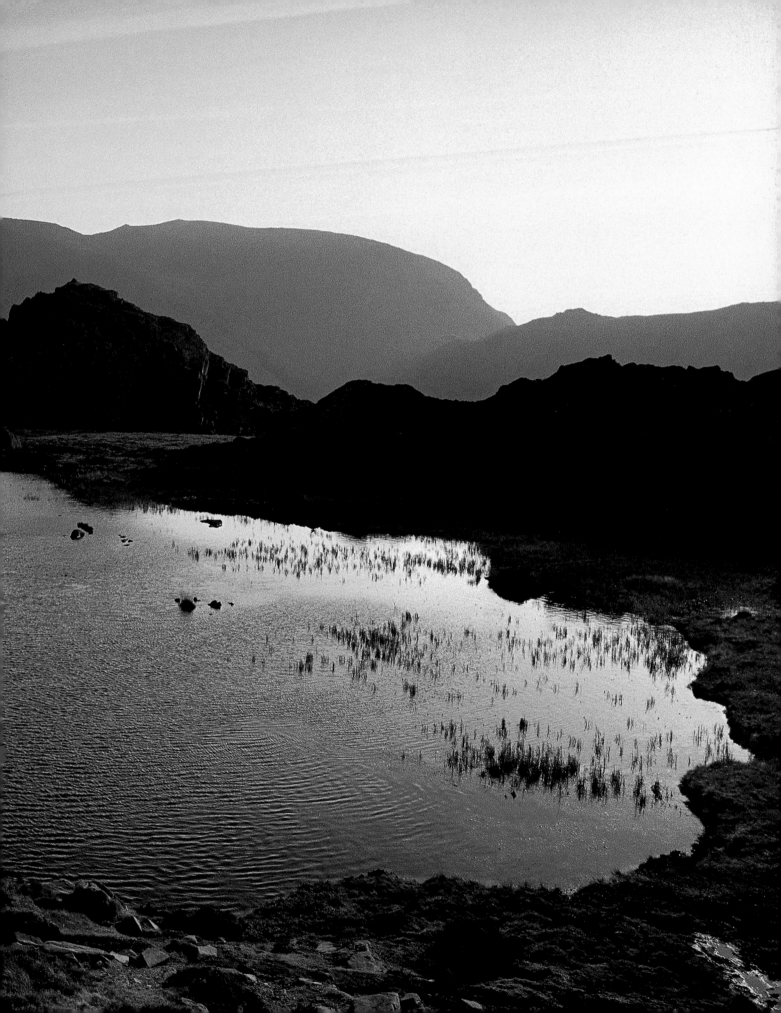

Old Man after years of slate and mineral extraction. I always wondered whether he would have adopted a more impersonal tone had the mountain looming over the mining village and lake of Coniston been called something other than a name bearing human connotations. In most of his works, AW writes about the mountain using the second-person form to describe how 'he has been more cruelly exploited than other mountains' and 'he would really prefer to be left in peace to lick his wounds'. Wainwright also confessed to having had 'a spasm of exuberance' when he suggested that the Old Man is to Coniston what the Matterhorn is to Zermatt. This was more a flight of fancy than anything else, and if there happen to be any Wainwright readers in that Swiss village they could well have a case for defamation of character – it is true that both places have a notable mountain on their doorstep, but there the similarity ends.

The flanks of Coniston Old Man have certainly been ravaged by industry, but dating back to a time when no environmental responsibility was attached to such activity. One imagines that, if the mountain's mineral wealth were to be exploited today, licences would be granted only on condition that everything was restored to its original state after an agreed period. Although the relics of that bygone age are certainly not a pretty sight, I really enjoyed pottering around among them; the rusting remains do have a certain aesthetic appeal to artists or photographers. My trip up to the summit cairn was made on a blissfully clear winter's day when the setting sun's rays appeared to transform the rocks into burnished sheets of the copper once mined there.

But my timing was very close to being awry; I only just made it to the top as the sun was about to be swallowed up in a bank of low cloud running along the horizon. The last few hundred metres were walked at a very fast pace; although I could sense I was on the brink of disaster, I was in deep shadow and had no idea exactly how low the sun had sunk. When I finally made it up on to the summit plateau, I estimated that I had less than a minute to get my shots taken. I had just extended the third tripod leg when a red anorak-clad figure popped out from behind the huge cairn and wind shelter, completely destroying my picture's com-

position and colour balance. He remained impervious to my desperate pleas for him to hide for a moment and then, just as he vacated the cairn, the sun disappeared. Murder was nearly committed that day, and had I been hauled up in court I am quite confident I would have got away with a verdict of justifiable homicide.

Despite the sun's disappearance, however, I sensed that the fat lady of dusk had not yet begun

her aria and so patiently hung around just in case I got lucky. My virtue was rewarded some five minutes later when the sun briefly emerged from behind its cloud for a matter of seconds. By that time it was even better as the earlier clouds had almost disappeared and those that remained were tinged with pink. With my camera already set up on the tripod, I had time enough to take a variety of exposures to make doubly sure I had it in the bag. I thanked the old chap for his hospitality and fumbled my way back down in rapidly approaching darkness, ecstatic at such a brilliant result – such magical moments were always far outnumbered by near-misses or occasional total disasters.

By February 1991 winter had kicked in with a vengeance, but although light snow had fallen on the mountain summits, their lower slopes and surrounding valleys were still clear. I telephoned the Lake District National Park weather line every afternoon at 4 p.m., hoping for news of a clear

Substantial remains of mining operations make photogenic subjects (opposite), but I was more concerned with getting a great shot of the summit cairn on Coniston Old Man. I thought my only opportunity would be ruined by the red anorak (opposite, above) but, within ten minutes, conditions had improved even further and I got my shot (above). Patience was ultimately rewarded.

forecast for the following day; my walking and camera equipment were permanently parked by our front door, ready for action. Several tempting outlooks resulted in fruitless journeys, but I dared not take a chance on missing even half a day's decent light. Then, finally, one freezing cold Monday, it all slotted perfectly into place. I rang the Sunday afternoon bulletin and every phrase was audio manna from heaven: 'unbroken sunshine, scattered cloud above 3,000 feet, visibility excellent'; before the man could finish telling me just how cold it was going to be, I was off to find a bed for the night and plan the next day's campaign.

Deciding which location to select was always a nerve-racking affair: if I inadvertently made the wrong choice and conditions were not as predicted, precious hours would be wasted while I reverted to Plan B (assuming there was one) and the best light would have been lost anyway. Having flicked through AW's carbon-copied chapters yet

again, I elected to launch a double-headed assault on Fairfield and Helvellyn, reasoning that if the day was going to be as good as promised I should have ample time to work on both chapters, and such opportunities were likely to be few and far between.

Although I was primarily interested in photographs of Fairfield's summit and the surrounding area, AW had included in the chapter a shortened description of the famous Horseshoe walk for which new pictures were also required. I knew from bitter experience that trying to cram too many shots into a day was a guaranteed recipe for disaster, and I therefore concentrated on reaching the highest and most distant points, leaving the nearer locations to be easily picked off at another time.

I opted for the fastest access route up to Fairfield via Sweden Bridge Lane and the Scandale Pass, setting off in the half-light of dawn and sensing

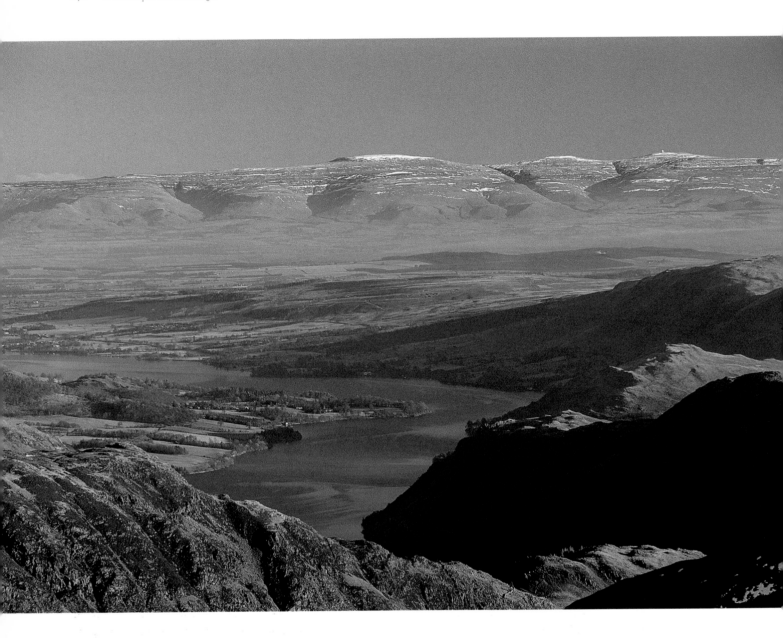

An early morning expedition
to Fairfield and Helvellyn
produced unexpected
results of startling clarity. A
combination of atmospheric
conditions and a polarising
filter contrived to bring Cross
Fell and the Pennines to within
almost touching distance.

that I was on the verge of the best day's photography of the project thus far. It really was bitingly cold and, despite the eventual sunshine, a strong breeze kept the wind-chill factor fairly high throughout the day. Keeping my hands sufficiently warm to operate the camera fluently and change lenses was a problem on perishing winter days, so I used a combination of fingerless gloves and heavily insulated loose-fitting mittens. Cold, fumbling fingers are no use to a photographer in a hurry – vital pieces of equipment end up being dropped and if hands are rapidly warmed by blowing on them the chances are that the moisture from one's breath will cause the lens or viewfinder to mist over.

When I eventually reached the top of Scandale and headed off towards Dove Crag and Fairfield itself, I remember laughing out loud in sheer disbelief that anywhere in the Lakes could look so fabulous. The sun was still low, its light strong and directional, and I could also see intermittent banks of fog swirling over Ullswater and other low-lying land away to the east. Conditions were perfect for using the polarising filter and it was quite extraordinary to see how it transformed the scene's colour, tone and texture, but the most startling results were achieved when I took some long-distance views across to the Pennines. Due to a combination of the day's strange atmospherics and the filter's propensity for cutting through haze, Cross Fell appeared abnormally magnified in the viewfinder as though the Pennine Way had been re-routed to pass just to the east of Penrith.

I knew that trying to cut all the way across to Helvellyn would prove fruitless within the remaining hours of workable light, but I did manage a compromise by taking the Cofa Pike route over to the excellent viewpoint of St Sunday Crag and captured several useful images to complement those of Fairfield already taken. Clouds started to play havoc with the sun as the day progressed, but by that time I was already on my way home with every item on my photographic shopping list for the day marked by an emphatic tick.

It is such a shame that during the great geological upheavals that created the Lake District, nature could not have contrived to push Great Gable up a

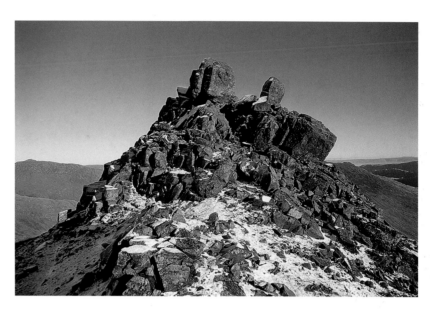

I remember laughing out loud in sheer disbelief that anywhere in the Lakes could look so fabulous

Although physically overshadowed by its more illustrious neighbours, Fairfield and Helvellyn, the chunky spur of Cofa Pike makes an excellent vantage point.

few extra feet into the air: just another 261 feet and a few inches would have promoted it above the boring, desolate pile of rocks currently afforded the status of England's highest mountain. Scafell Pike may have the height but is distinctly lacking in the personality department, an attribute Great Gable has in abundance. One could equate the Pike v Gable contest with the Himalayan equivalent of Everest v K2 (Mount Godwin-Austen): the former simply happens to be the highest part of a range, while the latter stands alone in aesthetic perfection, but without the vital several hundred feet to surpass Everest. It would be more appropriate for K2's almost perfectly formed inverted cone to be the top of the world and, similarly, in the Lakes there is arguably no finer sight than Great Gable towering over the head of Wastwater. I have never really enjoyed the physical process of climbing the mountain because its rugged conformation has restricted summit access to a mere handful of paths, most of which are now so badly battered and eroded that they offer scant walking pleasure. Fortunately, a programme of restoration has been recently undertaken, especially on the Breast Route from Sty Head, but as Great Gable is one of the 'must do' peaks damage limitation is always going to be a struggle.

One of Gable's main attractions for me is the way its physical appearance changes completely from different angles; I found it hard to believe that so many varying aspects belonged to the same

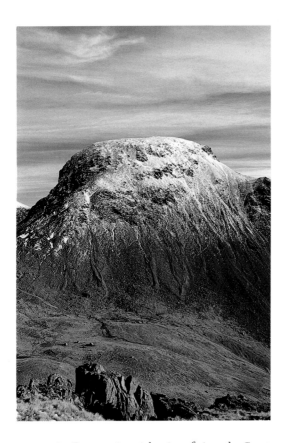

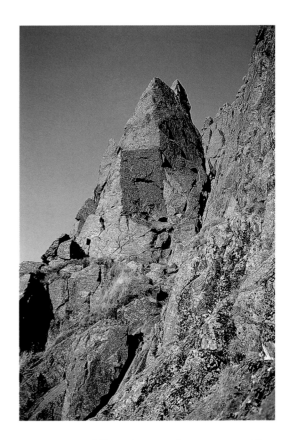

mountain. From a pictorial point of view, the Great Gable chapter unintentionally turned into a contrasting hotchpotch of colours: nine of the seventeen photographs had a wintry feel, but a majority of the remainder were of brightly lit rock under Mediterranean-type blue skies. In addition to detailing the various routes of ascent, AW devoted four pages to the Gable Girdle, a high-contour circumnavigation incorporating the cliffs, crags and pinnacles that so distinguish the mountain. It was those pictures that caused the jarring note, as they had been taken on an untypical, blazing hot, autumnal day that became so hazy that conditions were suitable only for close-up work.

Wainwright suggested that the route should be followed in a clockwise direction from where the path branches off from the Breast Route, so I duly slithered off along the scree slopes leading to several renowned rock climbs around the Great Napes, Tophet Bastion and Kern Knotts. I was amused to read that back in the days when the path was used exclusively by rock climbers, the first twenty yards were deliberately left untrodden in order to prevent confusion among those

Above, left: the rounded summit of Great Gable when viewed from Black Sail contrasts sharply with its more triangular appearance from other angles.

Above, right: the rock climber's paradise of Napes Needle on the Gable girdle.

attempting to follow the normal tourist route. This conjured up a wonderful mental picture of burly men in tweed suits and hobnailed boots, adorned with ropes, tiptoeing gently across the slopes of Great Gable to avoid leaving any trace of their passing.

I was not in the slightest bit tempted to venture further from the track than was necessary to get my photographs, having always maintained that if man was intended to climb vertical rock faces he would have evolved with suckers on his hands and feet in the manner of a certain comic-book hero. Some of the sheer faces, crags and pinnacles I encountered along the Girdle might not have stretched Spiderman's capabilities, but I would have welcomed the opportunity to observe just how mere mortals tackled some of the more complex-looking tests – but I had the place to myself, so the rock climbing demo would have to wait until another day.

Regardless of whether I am photographing in the Lake District, I always try to make it over there on Remembrance Sunday for the informal service held at the bronze war memorial tablet on Gable's summit. I attended it for the first time while photo-

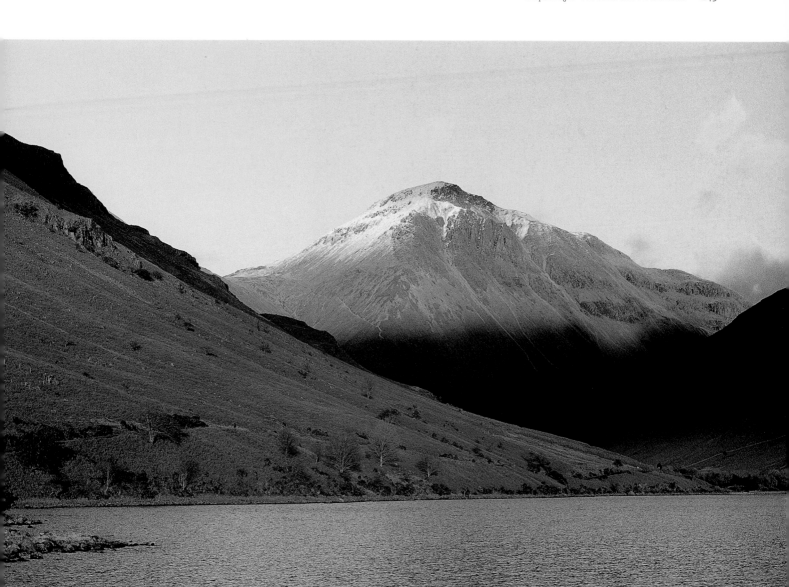

Although a disconcertingly solid band of shadow was creeping up from Wasdale Head, there was enough light on both the bracken-clad foreground and Great Gable itself to make this shot viable.

graphing *Favourite Lakeland Mountains* in 1989, and it is one of the most moving events I have ever witnessed. In the moments just before 11 a.m., a short address is delivered by a representative of the Fell and Rock Climbing Club, reminding those present that their freedom to roam over the mountains can be attributed to the club's far-sighted purchase of over 3,000 acres of the highest fells and crags, the title deeds for which were handed over to the National Trust in 1923. The war memorial bearing the names of twenty members of the FRCC who died in the Great War was dedicated a year later in 1924; for me, one particular paragraph of the eulogy from that service perfectly encapsu-

lates the ideals that led to the ultimate price paid by so many to uphold them:

> Upon this rock are set the names of men – our brothers, and our comrades upon these cliffs – who held, with us, that there is no freedom of the soil where the spirit of man is in bondage; and who surrendered their part in the fellowship of hill and wind, and sunshine, that the freedom of this land, the freedom of our spirit, should endure.

Apart from the short speech of introduction, no other words are spoken and then, just as at the Cenotaph in London and towns and villages

throughout the land, a silent tribute to those killed in all conflicts since 1914 is respectfully observed. The numerous wreaths, crosses and poppies that have been carried to the summit are then either tied to surrounding boulders or wedged into cracks in the rock to prevent them from blowing away.

I made that same pilgrimage again on 14 November 2004, hoping to re-photograph the ceremony for this book. Although the majority of England enjoyed a crisp, bright day, the Lake District once again proved its meteorological independence by producing the foulest of conditions. The cloud base was actually below the top of Honister Crag and turbo-charged rain was driven across the fells by a fierce wind. The prospects for photography were as bleak as the conditions but, nevertheless, I joined countless others in the long, uncomfortable trek. Visibility was down to little more than 30 metres but I wanted to be there anyway, to remember those who fought and died amid horrors beyond any sane person's comprehension. This gathering had an added poignancy because, even as we stood there in the lashing rain, British and Scottish soldiers were engaged upon active duty in Iraq; regardless of the political rights and wrongs of that campaign, men were continuing to die in the service of their country. As we stood with heads bowed, the only sounds were the wind howling across the mountain's summit and the staccato beat of raindrops hitting hundreds of brightly coloured waterproof garments. I was relieved that my 86-year-old father, himself a holder of the Military Cross for gallantry, would

The only sounds were the wind howling across the mountain's summit and the staccato beat of raindrops

Remembrance Day on Great Gable in 2004 was a nightmare, especially as my elevated vantage point meant that I was more exposed to the elements than those huddled together in the crowd. Keeping the camera and lenses dry was impossible; conditions that day were the worst I have ever had to work in, but I still managed to get the two pictures I wanted – a general scene (above, left) and a detail of the many tributes of remembrance (above, right).

be enjoying better weather at his own village's wreath-laying ceremony. For those of us who had travelled to the Lakes from far and wide, Great Gable in one of its more aggressive moods was no place to linger. Within thirty minutes, the summit was almost deserted as people drifted off into the mist, leaving behind their vibrant red poppies as a tangible reminder of the phrase that will be forever associated with Remembrance Day: 'Lest we forget.'

I was determined to photograph at least a couple of chapters in the aftermath of a substantial snowfall, wanting winter on the fells to be represented by more than a sparse coating of white on mountains exceeding 2,500 feet. This was obviously something over which I had no control: the weather would either cooperate or decide to be its usual unpredictable, obnoxious self and just rain instead. For a couple of weeks in succession, there were sufficiently photogenic deposits of snow at higher levels to make the tedious drive all the way round to Wasdale Head more than worthwhile.

Despite the fact that I was working in the depths of winter, at times finding a bed for the night in that vicinity became almost impossible due to the large numbers of freelance contractors and visiting executives involved with the nearby nuclear plant at Sellafield. Some places were permanently block-booked by companies from Monday to Thursday, and as it was difficult to predict in advance just when I might be over there I had to take pot luck. After one particularly taxing day's work, I spent a fruitless hour driving around, and contemplated trying Wainwright's old trick of simply knocking on a door at random and asking if they had a bed for the night. Prudence and a low pain threshold prevailed – society's attitudes have changed somewhat since AW's younger days, and I stood more chance of being head-butted or arrested than willingly invited in to sit before a blazing log fire. I was on the verge of giving up the local search and driving away to either Keswick or Kendal when I struck lucky at a large pub and restaurant that also did accommodation; someone had just telephoned to cancel their reservation for what appeared to be the only vacant room in the whole of West Cumbria. The landlady quoted an outrageously high room rate, informing me that it

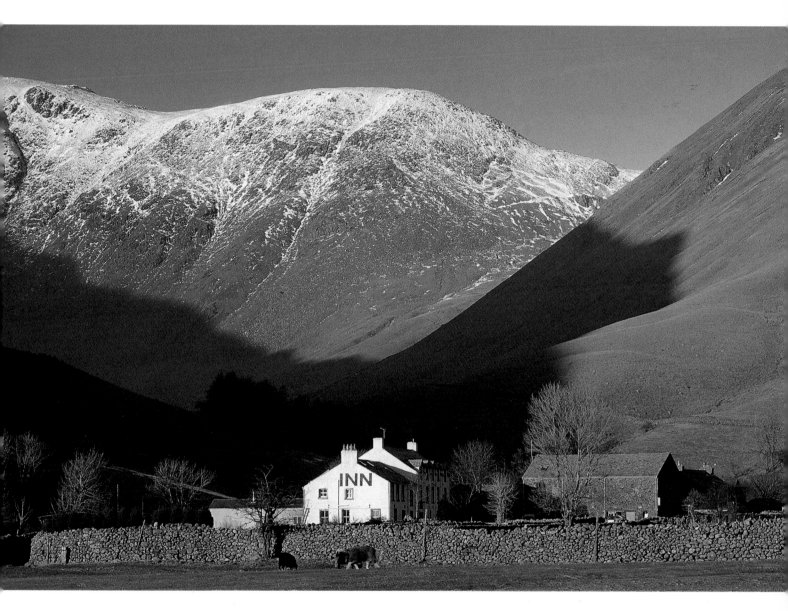

A tightly framed telephoto shot of the Wasdale Head Inn with Pillar under snow in the background. Early-morning shadow cast by the surrounding fells lingered behind the buildings to give them greater prominence.

was the bridal suite with a four-poster bed and the cost was non-negotiable: 'Take it or leave it, love, it's all the same to me.'

I couldn't write the cheque out fast enough and be on my way upstairs for a long overdue soak in a very hot bath. As I climbed the creaking stairs between dark-panelled walls, I wondered how much wedding trade there really was and whether the room saw more action as a midweek managerial entertainment venue. My suspicions were not ill-founded: in addition to the four-poster, there was a large, circular, chocolate-brown bath on a raised carpeted dais in the centre of the room. I looked up at the beamed ceiling and wondered

what extraordinary tales the spiders might be able to relate from their finely spun lookouts. I turned on the hot tap in blissful anticipation of a lengthy wallow, but for a moment nothing happened. Then, with an almost apologetic sigh, a thin trickle of water sidled out into the dark reservoir. I calculated that at such a slow rate of flow it could take at least three days for me to become fully immersed, and I would probably die of hypothermia or boredom while waiting. Complaining got me nowhere: I was brusquely informed that due to the room's top-floor location water pressure did fluctuate but that nobody else had experienced similar problems.

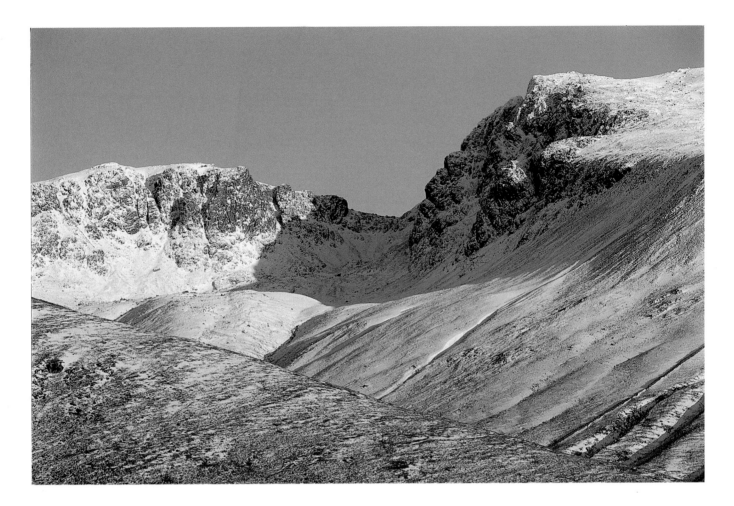

The only point in favour of my overpriced lodgings was that breakfast was served early to cater for the site workers and I was therefore able to set off for another day's work with a decent hot meal inside me, even if the exterior remained unwashed. High-pressure weather dominated the region, and I drove back to Wasdale in the company of an ever-lightening blue sky and the prospect of a fine day to assist in my photography of the Scafells. I was hoping to have a prolific day's shooting, knowing that a thaw could sweep in at any time to rob me of the glorious snow cover. In the two adjacent chapters covering Scafell and Scafell Pike, AW had listed a total of 32 separate pictures, and my intention on that day was to isolate those relating specifically to Scafell's principal features.

My greatest concern was getting a shot of the awesome face of Scafell Crag from the amphitheatre of Hollow Stones before the sun rose high enough

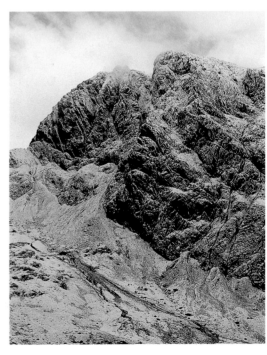

These two views of Scafell illustrate how the sun's low arc in winter can make it difficult to get light on to certain subjects. The wider version (above) is nicely sunlit but with the all-important crag itself in shadow. To convey information about the configuration of the rock face more fully, I had to shoot it in the unlit consistency of early morning (right).

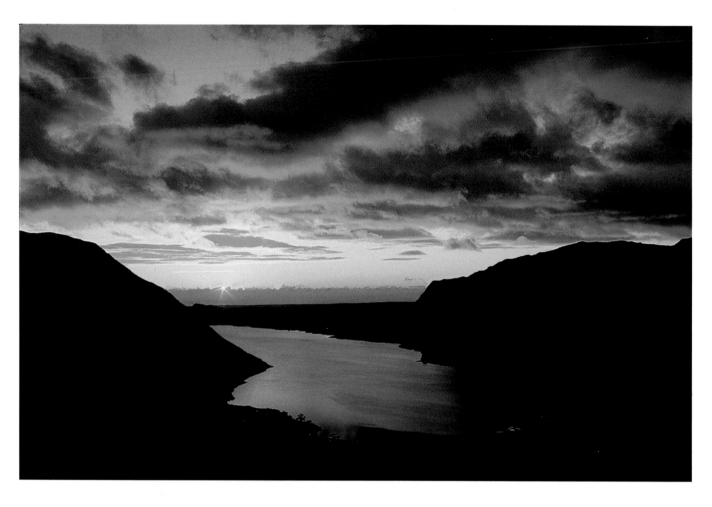

I have yet to better this sunset over Wastwater and possibly never will. Nature seldom pulls out all the colour stops on demand but, on that evening, I was in the right place at the right time. Exposure calculation was difficult because the sun was still shining straight into the lens and so I had to take my readings well to one side of the frame.

to kiss its upper reaches – as soon as that happened the photograph would be impossible because of overwhelming contrast between glaring white snow and unlit rock. Having successfully got that one locked away in the camera, I noted that AW's text once again enthused about the joy and exhilaration of ascending the narrow confines of Lord's Rake, but I was equally adamant that I could cope without such pleasures, a climb up the icy scree slope to Mickledore promising excitement enough. The Rake was deleted from my list with no twinge of remorse, and an alternative view substituted in its place. Having made that amendment, I remembered sadly that I would not be facing a mock inquisition from the author as to why I had not followed his script to the letter – that brief moment brought home just how much I missed AW and the genial banter of our picture editing sessions.

Fine days always seem disproportionately shorter than useless cloudy ones. I walked as fast as

I could from location to location, but the sun soon slipped too low to illuminate adequately any more of my designated targets. However, I was still more than satisfied with my haul of over a dozen photographs. There was nothing more I could achieve on Scafell, but I noted that conditions augured well for a good sunset and so I descended part of the way back down towards Wasdale Head until I found a suitable place from which to get an atmospheric picture of Wastwater. My intuition was rewarded by an unexpectedly spectacular result. Until it actually happens, it is virtually impossible to predict whether a sunset will produce a sky full of vibrant colour or a half-hearted flicker of pink before the sun flops exhaustedly below the horizon.

I had not made it up the summit of Scafell Pike during that expedition but was able to tackle it just a couple of days later via the Corridor Route from Styhead. Having photographed the Pike's Ordnance Survey column and stone shelter against a back-

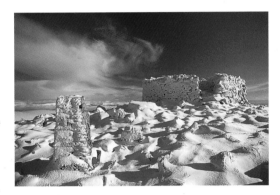

drop of blue sky and creatively airbrushed clouds, I then watched in concern as a rolling bank of cloud headed up from Borrowdale to obliterate completely the tiny distant puddle of Styhead Tarn before doing the same to me.

The last few photographs I took while that cold spell persisted featured the ascent of Pillar from Ennerdale. I knew that when AW highlighted a particular route of ascent as 'the best approach of all' it was likely to be hard work, and the Wind Gap approach proved no exception. Extensive snow cover had deprived the firebreak in Ennerdale forest of any discernible features and logical path-finding was out of the question. I just had to pick my way over the sodden, squelching terrain as best I could. Constantly sinking into peat and mud became very energy-sapping, and because the cove was in the lee of the strong prevailing wind I also got overheated, but had neither time nor inclination to start shedding layers of clothing. As I climbed up closer to Wind Gap's summit, I could see just how fierce the wind actually was: fine plumes of snow were being driven vertically from the deceptively solid-looking cornices that had built up along the ridge.

Visibility that day was crystal clear: having attained the flat expanse of Pillar, I was astounded at just how far I could see. Every mountain was more clearly defined and readily identifiable under snow cover; it almost felt as though I could reach out and touch Helvellyn and the serrated line of north-eastern fells filling the horizon. Mesmerising it certainly was, but preventing my fully extended tripod from blowing over in the gale was proving difficult – having got that far, the last thing I needed was a concussed camera. I took as many photographs as I could, but although the light was

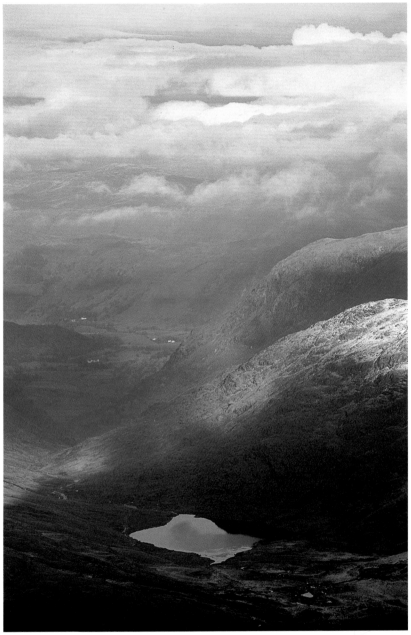

After overcoming a difficult ascent to the deserted summit cairn on Scafell Pike, I was rewarded by clear conditions and wispy clouds that were perfect for polarising. The sense of euphoria was shortlived: by the time I had taken a few long-distance views of Styhead Tarn and Borrowdale, the clouds that nicely framed the top half of the picture were accelerating rapidly in my direction.

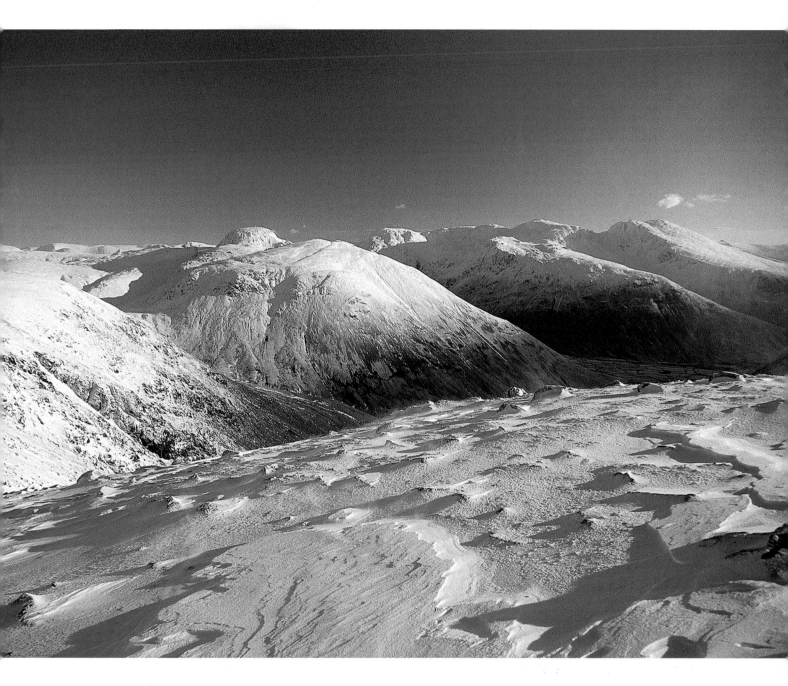

This panoramic view of other Lakeland mountains from Pillar contains more foreground than I would usually opt for, but the textures of the ice-crusted snow were so strong that I thought they added to, rather than detracted from, the atmosphere of the photograph.

fantastic conditions were debilitating, and I still had to make it all the way back down Wind Gap Cove and across the Ennerdale bog. From some angles, my surroundings appeared more like the bleak, snow-blown wastes of the Russian steppes – on that day, Pillar could have featured in a scene from the film of *Dr Zhivago*. I cast a few hopeful glances around, but reluctantly accepted that a ride back to my car in a troika driven by a fur-clad Julie Christie was unlikely, so I trudged off back on foot.

It was not physically possible to re-shoot every photograph that had not met my exacting standards, but when the entire portfolio was assembled and printed I knew that, had he been there in body rather than spirit, Wainwright would have been pleased with the outcome. I had pushed my physical and mental boundaries far beyond those I had believed myself capable of, and I felt I had more than done justice to my avowed task of honouring AW's memory through my work.

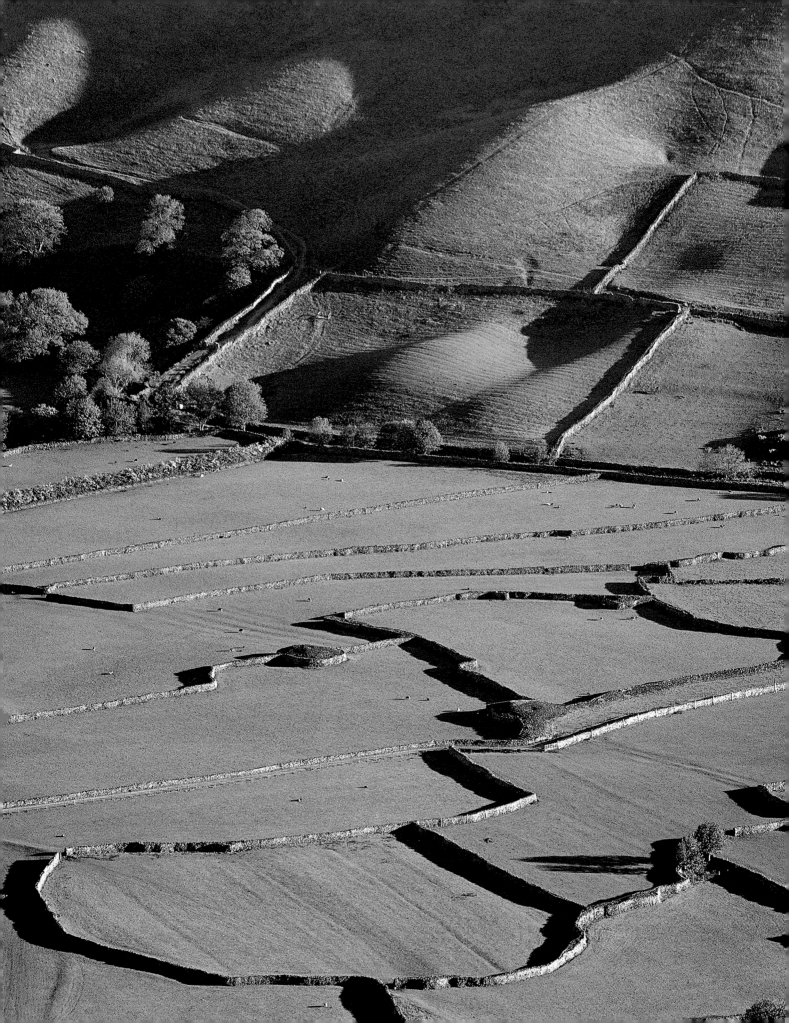

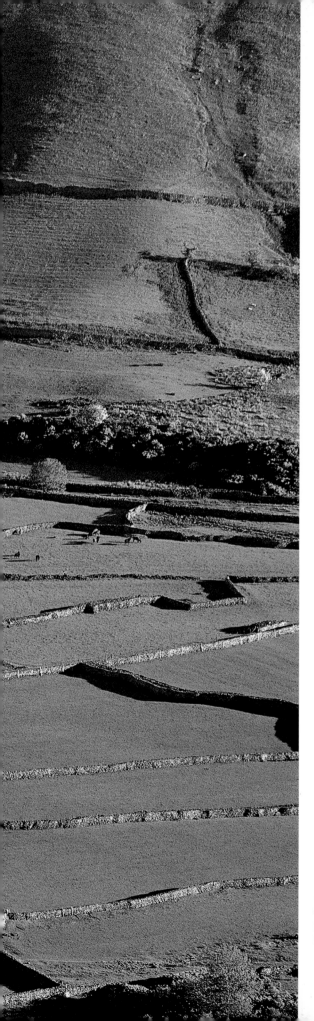

Looking down on Wasdale Head, with the inexplicably shaped complex of walls picked out with stunning clarity by the early morning sun.

Chapter Nine

LAKELAND VALLEYS

I cannot remember being aware of a further AW manuscript when I was working on *Mountains*, but I certainly experienced misgivings about photographing what would, in effect, be a second posthumous Wainwright publication. I now realise that my emotions were somewhat irrational, but my inescapable feeling was that I was somehow sneaking behind his back. After a period of reflection, I acknowledged that I was still really missing AW. Despite the fact that almost half the previous book had been undertaken without his input, I nevertheless felt his presence with me up on the mountains, offering encouragement on good days or chastising me for being faint-hearted when things got tough. On numerous occasions I had to retort: 'They might be friends of yours, AW, but certainly not mine.'

It was not until much later that I discovered just what a hard-fought struggle it had been for him to complete the text and compile appropriate illustrations to accompany the *Valleys* manuscript. By the second half of 1990 and the last few months of his life, AW's eyesight had failed to such a degree that he was navigating the keyboard of his old typewriter virtually from memory. He was totally reliant on Betty's help with *Valleys* during those last few defiant months; there were many mistakes through wrongly hit keys and she had to proofread everything aloud to him as he was unable to see his

own words. The fact that the book was completed at all in the face of such adverse circumstances bears testimony to Wainwright's single-minded determination, a trait his detractors might have perceived as 'sheer stubborn bloody-mindedness'. Looking back over his achievements, it is difficult for most mere mortals even to contemplate producing a similar volume of published work in a lifetime, let alone one requiring so much physical endeavour before pen came remotely close to paper.

When planning the final book, AW opted for a structural approach similar to that employed in his *Pictorial Guides*, in which the fells were grouped together on a geographical basis and then sub-divided into more detailed segments within each category. Rather than listing a number of different chapters, the contents page of *Wainwright in the Valleys of Lakeland* identified the book as comprising five parts covering the eastern, southern, western, northern and central valleys. Those principal arteries of each region were then dissected to include their offshoots or tributaries. If one interpreted it graphically, it would probably have ended up resembling an early pioneering anatomical drawing attempting to show every blood vessel in the human body.

When my copy of the manuscript and accompanying picture notes arrived, I was heartened to note that, although I was destined for a lot of walking, not too many of the valleys required photographing from excessively elevated viewpoints. In some respects I was surprised that AW had not included more bird's eye views because, in much the same way that one needed to be high above a pass to appreciate it in context, I assumed the same theory would apply to the valleys. Having only just finished my prolonged duel with the mountains, I cannot pretend that I was anything other than delighted not to be scaling too many heights again. That sentiment was not directly related to my tolerated, but never conquered, fear of heights; it was generated more by an awareness that I did not want to try to better something I had just accomplished to the very best of my ability. As it was, I discovered that although numerous shots were to be taken from high above, Wainwright had adopted a more pastoral tone, taking his readers in

among the valleys, their villages and communities and also featuring significantly more of the region's architecture.

Photographing the valleys consequently became a voyage of discovery, an opportunity to widen my own knowledge outwards from the heart of the fells and mountains. I was so enthralled and intrigued by many of the places on that new itinerary that working through the book served as a catalyst for me to undertake further exploration on my own behalf, even though many of the locations I subsequently discovered could not be incorporated into AW's narrative. Largely due to the constraints of time during earlier projects, my attentions had been focused almost exclusively on those areas encased within the Lake District National Park. I remained ignorant of the wealth of history, heritage and more varied landscapes on its doorstep.

If you study Cumbria in context on the map of England, the most striking aspect is the way it appears to be almost a peninsula incised by the Solway Firth to the north and Morecambe Bay to the south. That impression of isolation by water is further enhanced in purely cartographic terms by the portrayal of the M6 motorway as a broad ribbon of blue creating an eastern boundary. For several enjoyable months, I got to know just about every secluded corner of the county. By following the natural progression of some valleys, AW

Almost a hundred defensive pele towers were built in and around Cumbria

The memorial commemorating the death of Edward I has little visual appeal in itself, and so I was grateful for the briefest of appearances by a watery sun. I was then able to add to the site's poignancy by making it an atmospheric silhouette, rather than a straight record photograph.

The fortified pele tower of Kentmere Hall survives as a graphic reminder of the border region's turbulent past.

ventured as far as the south and west coasts, but sadly his coverage stopped well short of the desolate, atmospheric shore of the Solway. I readily appreciated the fact that those northern extremities of Cumbria could not realistically fall under the Lakeland valleys umbrella, but from both a historic and photographic point of view, I deemed them worthy of inclusion.

Sadly, I had no author with whom to plead my case, and so had to confine such unscheduled pictures to my personal collection, especially the Victorian memorial on Burgh Marsh erected to the memory of Edward I, who died of dysentery while camped there in July 1307. The ageing monarch had been intent on waging another campaign against the Scots, but was defeated by nature rather than by his intended adversary, Robert Bruce. It is easy to forget just how turbulent and lawless that region was, especially as the line of the border between England and Scotland frequently depen-

ded on which nation's forces were in the ascendancy at any given time. Cross-border incursions by large armies or smaller bands of raiders were commonplace; many Lake District settlements built fortified churches and pele towers to safeguard the population against the marauding Scots.

It is estimated that almost a hundred defensive pele towers were built in and around Cumbria, mostly following a similar pattern of construction on three or four floors. Ground level was usually a simple space for the storage of essential supplies or to keep precious animals out of harm's way, with the upper storeys reserved for cooking and living spaces. Most towers also had a battlemented flat roof, from which either missiles or insults could be rained down on attackers. Although many pele towers have disappeared, the best examples of those that remain intact tend to have been integrated into the farms or manor houses they were originally built to serve. A fine fourteenth-century

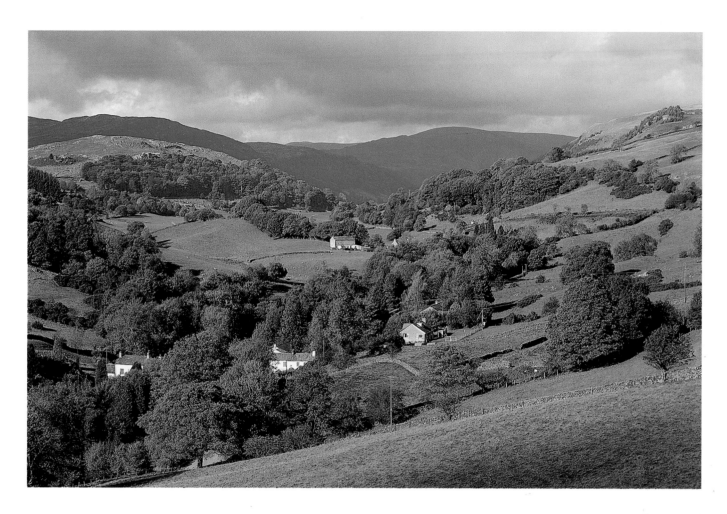

Opposite: the plain rendered exterior of St Cuthbert's parish church in Kentmere may not exude antiquity, but the bright facade nevertheless makes a useful focal point for photographs of the valley. The church appears elevated on its own natural pulpit, gracefully dominating the scattered dwellings in its immediate vicinity.

Above: valleys such as Longsleddale are difficult to encompass in one image, but by using a telephoto lens from a distance I was able to include both its pastoral aspect and just give a hint of the shadowed fells beyond.

example of this architectural genre, peculiar to the north of England, still forms part of Kentmere Hall, situated at the head of the valley from which its name is derived. The hall, originally the seat of the Gilpin family, still dominates a cluster of farm buildings. Kentmere was one of several eastern valleys that featured in the book; although now sparsely settled, it was once a thriving industrial centre where mills drew their power from the fast-flowing waters of the river Kent. The valley certainly contains evidence of Neolithic, Celtic and Norse settlements; before the building of modern roads it was a communication hub on the crossing of two important pack-horse routes over the Garburn and Nan Bield passes.

Kentmere is now anything but a transportation hotspot. Parking space for visitors to the valley is at a premium, because no concessions whatsoever have been made to modern car-borne tourism. I have had to abandon intended photographic missions because I simply could not safely leave my car anywhere for an hour or so. It was not pique that made me drive away, simply the practicalities of time and light – by the time I had parked two miles away and walked back into the very heart of the valley precious light that could be used to better effect elsewhere would have been wasted. In some respects it was quite refreshing to see somewhere so close to Kendal and Windermere so inaccessible to casual visitors, but those were not my sentiments after two frustrating circuits of the narrow, single-track roads on which every available square inch of spare grass verge had already been commandeered.

I subsequently discovered that nightmare parking scenarios were equally commonplace in Longsleddale, a valley running almost exactly parallel to Kentmere, whose only vehicle access is via the main A6 Kendal–Penrith road. As Longsleddale eventually leads up to the Gatescarth Pass and

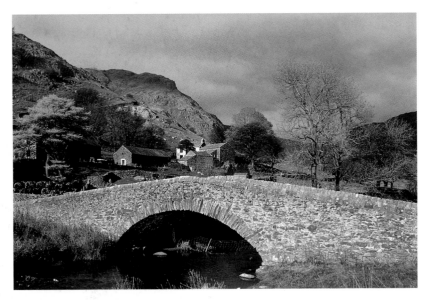

on to Mardale and Haweswater, I had been there before on an out-of-season weekday, but unfortunately my return visit was during a fine weekend when, in desperate pursuit of some decent light, I had broken my house rule of 'never on a Sunday'. The problem with Longsleddale as far as motorists are concerned is that the valley road terminates abruptly at the hamlet of Sadgill, where cars have to be abandoned and journeys continued on foot. It is quite extraordinary how normally rational people abandon all vestiges of common sense or consideration when driving; despite being about to embark on a six-mile walk, they will seemingly do anything to ensure their car is as close as possible to the departure point, regardless of what chaos is left in their wake. There is a very elegant stone bridge over the river Sprint at Sadgill which, although photogenic, also fulfils the more practical purpose of providing access to locals living across the river. Having safely parked my own car on a wide verge about half a mile back from Sadgill and then strolled back along the river bank, I was horrified and embarrassed at the selfish antics employed by some drivers intent on getting pole position on the parking grid. Their vehicles were left in a haphazard fashion with absolutely no thought for others; I watched a resident taking more than five minutes to do a twenty-point turn because the bridge's exit had been partially blocked.

Isolated communities and inaccessibility are very much the pattern of the other valleys on

I felt as if I had stepped through the wardrobe into C. S. Lewis's mythical Narnia

Above: in the heart of Longsleddale, the buildings of Sadgill and its bridge make an attractive grouping. I waited until the bridge was fully lit and other parts in shadow to increase the image's depth.

Opposite: I photographed the winding farm track leading up towards Bannisdale Head from a high vantage point so that its course through the valley could be clearly seen.

the eastern fringes of the National Park, much of whose perimeter shadows the route of the A6 which, before it was superseded by the M6 motorway, formed the main western road link between England and Scotland. Unlike the road to Longsleddale, access roads to some of the Shap Fells' lesser valleys are so well concealed and confusingly signposted that it frequently took me several attempts to locate them, especially since whenever I was trying to reduce speed to avoid missing a turning a lorry always seemed to be just six inches away from my car's rear bumper. Under those circumstances, the chances of braking suddenly and staying alive seemed slender so I had to overshoot, find a safe turning area and start the whole process again from the opposite direction, always keeping a weather eye on the rear-view mirror.

Perhaps the most awkward of those hidden valleys to locate was Bannisdale, unsurprisingly referred to by Wainwright as 'the shyest of valleys'. Never was a truer word spoken: once within its confines I felt as if I had stepped through the wardrobe into C. S. Lewis's mythical Narnia. The landscape was not especially spectacular, but the valley's narrow entry road suddenly plunges down through a steep-sided cutting, creating the sensation of leaving one world behind and entering another entirely strange and new. It felt a very long three miles from the A6 to the valley's end at Bannisdale Head, because well over half the distance required driving over a rough unmade farm track that noisily gouged away at my tyres' rubber through the medium of strategically placed razor-sharp stones. Just as I turned the steering wheel to avoid one hazard, another two sprang up to replace it. I wholeheartedly empathised with Heracles and his Hydra difficulties.

Rejoining the main road with car wheels and suspension just about intact, I drove on towards Borrowdale and Wasdale Head. Blessed with names identical to two of the jewels in the Lake District's crown, these would be rumbled as paste at first sighting. I had no idea that the names had been duplicated. The Westmorland version of Borrowdale is a pleasant, if unspectacular, valley; but the desolate ruined farm of Wasdale Head Mark II could not even be enhanced by the Scafells or Great

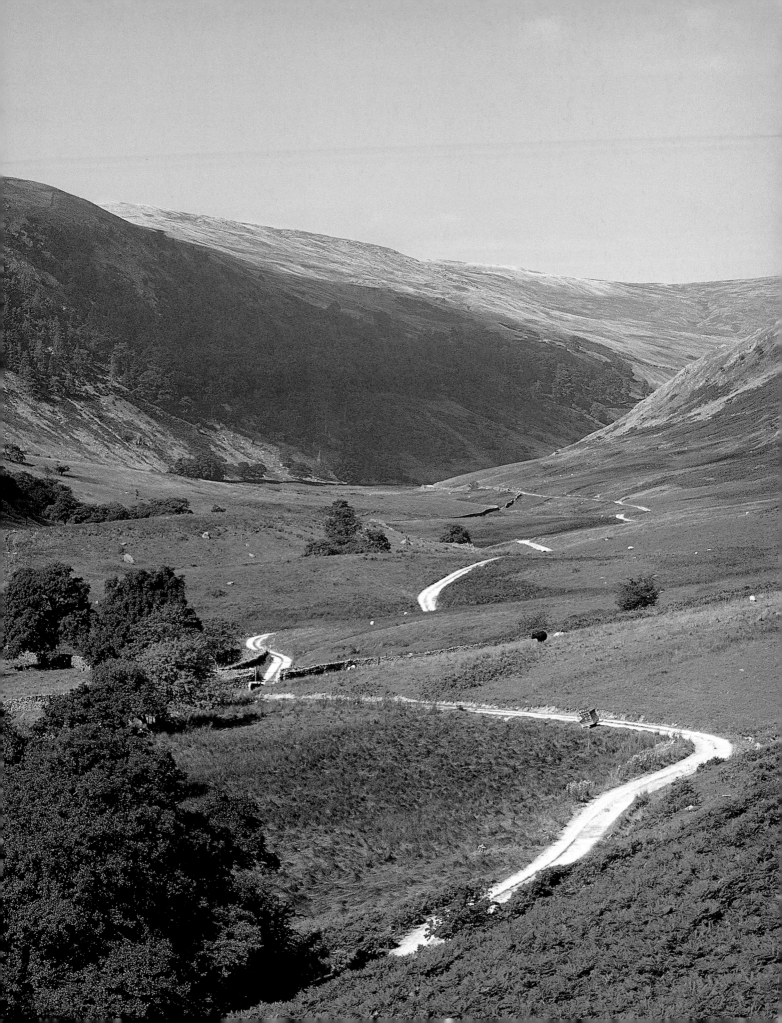

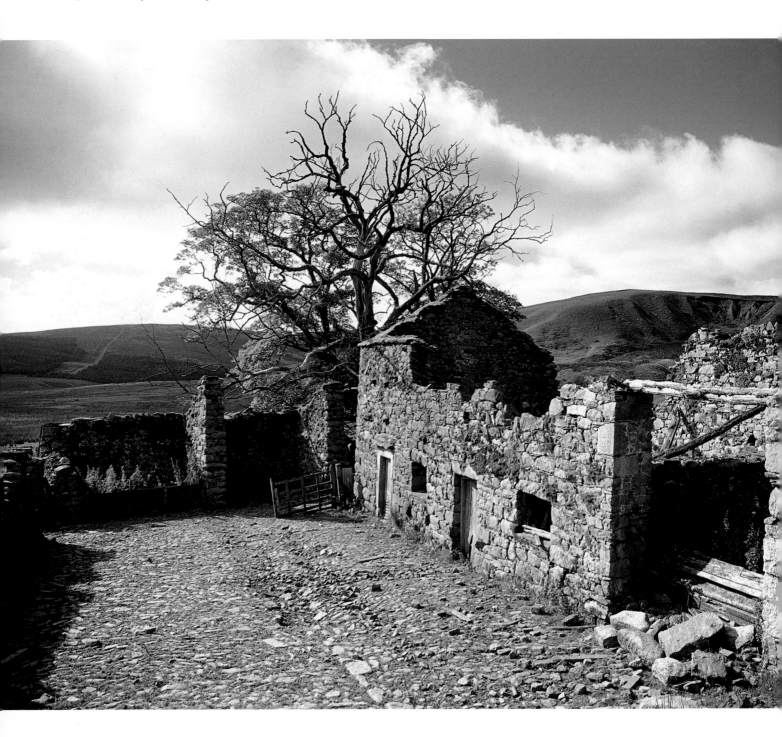

The ruins of Wasdale Head,
Westmorland. Trees growing
out of buildings are always a
good indicator of dereliction.
Although the mood might
have been enhanced by less
sunshine, on that occasion
the light was eager to please
and remained constant.

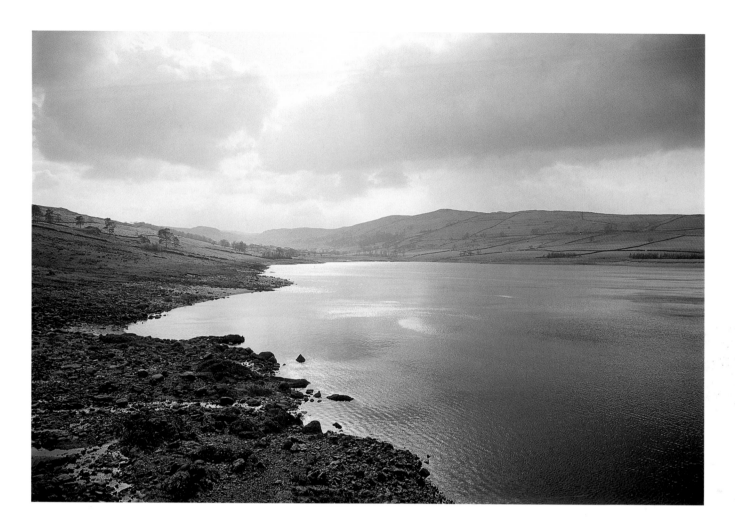

'The silence is not of peace, but of death'

Wet Sleddale was neither visually appealing nor particularly photogenic. Fortunately, I was able to shoot into the light and use my graduated filter to enhance the clouds and create a bit more atmosphere and depth.

Gable appearing miraculously in the background. Although perhaps not over-endowed with natural charms, these valleys of the Shap Fells perform their function as watersheds very well, and none more so than the perfectly named Wet Sleddale, transformed from a dry(ish) valley into another of Manchester's long-distance reservoirs. As with the 'rape of Mardale', any similarly perceived act of pastoral desecration had AW reaching for his Thesaurus of doom; in the case of Wet Sleddale, he opted for: 'The silence is not of peace, but of death.' Despite having the benefit of being well off the beaten track and consequently able to roam undisturbed, I found that particular valley scarcely worthy of quite such an impassioned outburst.

Towards the latter stages of its journey from Shap and Penrith, the A6 runs into a more ordered landscape dotted by farms and the castles, mansions and manors of the dynastic families whose influence shaped the land and the lives of those who lived and worked upon it. Just a few miles to the south of Penrith are the contrasting examples of Lowther Castle and Clifton Hall; although Wainwright had included only the former in his book, I was equally intrigued by the history of the latter and decided to investigate further under my own steam. Such instances emphasised what a void had been created by AW's death, since there was not the remotest possibility that I could further the cause of any such omissions, no matter how worthy. The text had been written and laid out with appropriate illustrations, and it was beholden upon all of us to adhere to his stipulations. In some of our previous collaborations I had been able to persuade him to make slight changes in order that a particularly good photograph could be included on merit, but *Wainwright in the Valleys of Lakeland* had to remain exactly as visualised by its creator.

The surviving pele tower of Clifton Hall (left), a commemorative plaque in the parish church (below) and the gaunt empty shell of Lowther Castle (bottom).

Wᵐ de Wybergh married Elianor yᵉ only Daughter & Sole Heir of Gilbert de Engayne of Clifton in yᵉ County of Weſtmor in yᵉ 38 of K.Edw yᵉ 3 By wᶜʰ Elianor came yᵉ Manor of Clifton to yᵉ Wyberghs.

Clifton Hall now stands alone in the midst of a working farm. Originally it was a sturdy pele tower in the ownership of the Enguyne family and later, through marriage, of William de Wyburgh and his descendants. The union of the two families is marked by a plaque and coat of arms in the parish church that looks as though its creator had underestimated the size of stone required and been obliged to use several abbreviations to accommodate the full text.

On a significantly grander scale than Clifton, Lowther's vast roofless shell is all that now remains of a gothic revival fantasy built during the first decade of the nineteenth century by William, Earl of Lonsdale, at a time when the Romantic Movement was very much in vogue. The Lowther family history can be traced back to the reign of Henry II when its name appears against substantial grants of land; centuries later, Sir John Lowther was created 1st Earl of Lonsdale in recognition of his support for William III and the Glorious Revolution. The castle's heyday as a focal point of society and a place of lavish entertaining came under the

An early morning photograph of Askham's daffodils. Clumps of flowers are often best photographed with a telephoto lens to compress the blooms visually into a more solid bank of colour, but as these were so profuse I was able to get in close with a wide angle.

auspices of Hugh, 5th Earl of Lonsdale, but his extravagant lifestyle and poor business acumen led to a severe downturn in the family's fortune. Hugh was a keen patron of many sports: I had not realised that it was he who instigated the Lonsdale belts that are still awarded to the winners of British boxing title championships.

Driving westwards through the beautifully landscaped 3,000-acre estate takes one on to the extremely photogenic village of Askham which, when adorned by spring daffodils, is arguably transformed into the most beautiful within the Lake District. From an artistic point of view, Askham works really well: its wide main street is structured on two levels and the steep grassy bank linking one with the other is carpeted in flowers. I was actually on a dawn mission to Haweswater and had almost driven past the village one very cold morning when I noticed that the daffodils were in bloom and the sun was almost high enough over

the surrounding trees and rooftops to throw some light on to the scene. The practicalities of taking the picture were more difficult to overcome than I had anticipated; the sun was positioned in just about the worst possible place and at the best viewpoint was flaring straight into the lens. I spent a good fifteen minutes trying to create an acceptable compromise and, because there had been a heavy overnight dew, I had to be very careful not to walk over bits that might eventually be included in the picture – there is nothing worse than a pristine foreground being tainted by unsightly footprints.

In terms of historical detail, it would have been nice if AW could have extended the book's boundary just a little further east to include Penrith, or at least the atmospheric ruins of its red sandstone castle – I regard such structures as an integral part of the landscape, whether in a rural or urban setting. The ruins are far from substantial, but the surviving stones have an intriguing history dating

back to 1399. William Strickland, later Bishop of Carlisle and subsequently Archbishop of Canterbury, added defensive walls to an existing pele tower as increased protection against the all too-frequent Scottish raids. Those relatively basic amendments were enhanced over a further seventy years until ultimately Penrith became one of several northern strongholds used by Richard, Duke of Gloucester, prior to his dubious accession to the throne as Richard III.

I have lost count of the number of times I passed Penrith on my way to the Lake District. Probably in common with most other visitors bound for the fells, I paid little heed to the villages and countryside either adjacent to the A66, or further beyond Blencathra's more benign northern slopes. After exploring the arc of the Caldbeck fells that sweeps round to Bassenthwaite, I sided with AW's observation that 'the fells are bare and austere, the valleys sterile'; yet even within those unfamiliar and singularly uninviting surroundings lay one or two places that merited more detailed investigation.

Caldbeck is a pleasant village of substance endowed with a handsome parish church, with the additional bonus of having the legendary huntsman John Peel as a long-term resident in the churchyard. I have not visited Caldbeck since the

The Ulldale fells photographed late in the day when I was able to maximise the effect of long shadows and the additional textures created in the landscape by a low-angled sun.

ban on hunting with hounds was made law, but I suspect that there might now be quite a lot of subterranean upheaval in the vicinity of John's headstone.

I was more intrigued by the neighbouring village of Hesket Newmarket. Isolated on a fell side, its wide central village green and covered market cross imply that the place perhaps once played a more prominent role in the district. The village was listed on my photography schedule, but Wainwright had rather dismissed it as little more than a place one passed through on the way to somewhere else. Prior to the eighteenth century Hesket was little more than a small cluster of farms and buildings; then it was granted a market charter and by 1751 was being referred to as Hesket Newmarket. However, by 1829 a local chronicle described the place as 'a small neat and compact town, the market held on Friday is only of trifling consequence, but several good fairs are held annu-

Penrith castle (above) and Caldbeck church (right) were both photographed immediately prior to sunset, when the quality of the light is perfect for such architectural subjects. However, it can also be quite difficult at that time of day to avoid the intrusive shadows cast by trees or buildings.

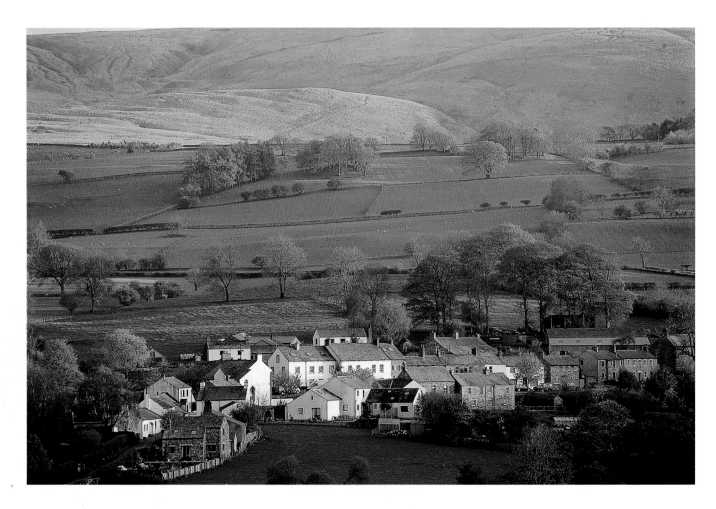

ally'. Towards the end of that century the weekly markets ceased altogether, with cattle fairs held just twice a year in May and October. But although formal markets and trading are now things of the past, the flame of enterprise has been rekindled. What originally began as a cottage brewing industry in a converted barn behind the Old Crown pub is now a thriving co-operative: the Hesket Newmarket brewery's expanding range of beers is attracting rave reviews from aficionados of real ale.

The one other place of that northern loop that I just had to visit also required a bit of moonlighting since AW's index went directly from Greta to Grisedale without making room for an entry under Greystoke. I suspect that my interest was initially sparked off by subliminal word association: the 1980s film *Greystoke: The Legend of Tarzan, Lord of the Apes* had probably been kicking around on video or been shown on television. It only took one

sighting of the road sign to divert me off to find what literary or cinematic inspiration lurked less than five miles from Penrith. The answer, of course, was absolutely none – but I did get a clue as to why the place might possibly have been shunned by AW, and I was also rewarded by discovering a magnificent collegiate church.

The present church was financed by William, 14th Baron of Greystoke Castle, and completed over a number of years between 1382 and the fifteenth century. No memorials bear a recumbent figure clad only in a leopard-skin loincloth, but two glorious alabaster figures occupy a niche near the chancel, one of which is the 14th Baron, resplendent in a suit of armour similar to that depicted on the tomb of Edward the Black Prince in Canterbury Cathedral. Next to William lies John, the 16th Baron, who is reputed to have bequeathed all his armour and horse to the church. In the light of present-day values, a few bits of beaten metal

Opposite: the village of Hesket Newmarket (above), Greystoke village cross and castle lodge (centre) and knight effigies in Greystoke church (below).

Below: Glenderaterra Beck and its steep-sided valley.

might seem a trivial bequest, but craftsman-made armour, the finest of which emanated from Italy, was a highly prized commodity.

Greystoke Castle's history pre-dates the church; the first stone structure on the site was erected in 1129. In the mid 1500s, Thomas Howard, 4th Duke of Norfolk and Earl Marshall of England, acquired the castle by marriage to the widow of Lord Dacre from Naworth Castle near Brampton. The Howards were Catholics and staunch Royalists, a fact that did not escape the attention of Oliver Cromwell, who ordered Greystoke to be destroyed. Although it was eventually restored, it suffered a disastrous fire in 1868. The present castle is a

magnificent Victorian structure which, although not open to the public, is used for civil weddings, corporate entertaining and adventure activities. I wonder if AW ostracised Greystoke because the castle stands in about 6,000 acres, making it one of the largest enclosures in England without a road or right of way running through it. Possibly, from Wainwright's perspective, if somewhere could not be walked upon, in his eyes it did not exist!

As the main road draws closer to Keswick, Derwentwater and Bassenthwaite, the surrounding valleys broaden and flatten but AW still found more secluded places for me to photograph, none more so than the steep-sided valley of Glenderaterra

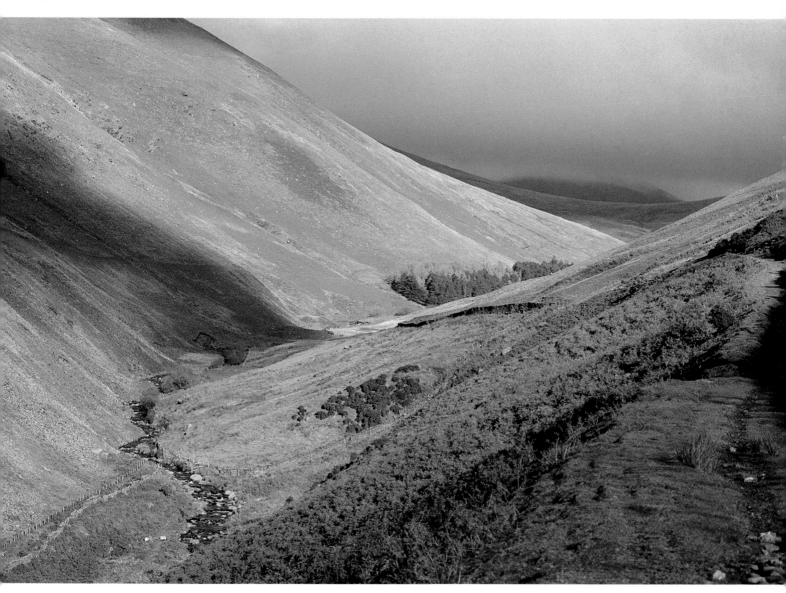

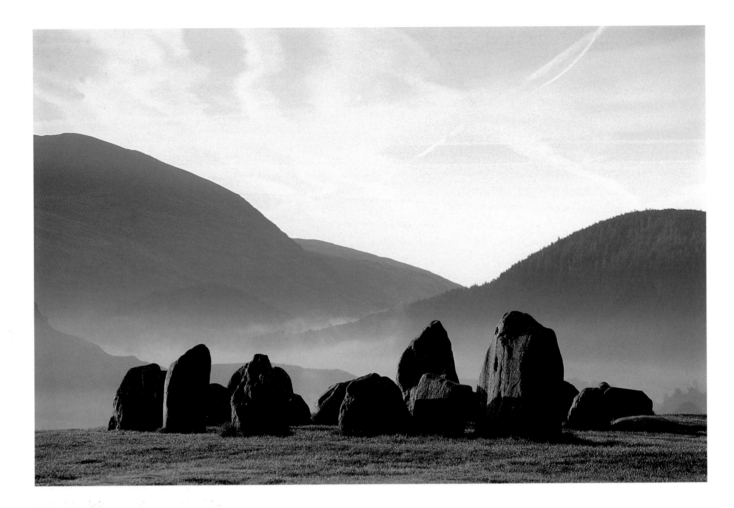

Beck that divides Blease and Lonscale Fells on the flanks of Blencathra and Skiddaw respectively. It provides great walking on a sound bridle track which leads right into the wilder recesses of Skiddaw Forest and is easily accessed by a narrow road from the mining community of Threlkeld. At the very end of that lane is a rather institutional-looking cluster of buildings whose function I had always wondered about; at the time I was working on *Valleys* I had no inkling that I would shortly be gaining first-hand knowledge of the Field Studies Council's Blencathra Centre. The early twentieth-century structure was originally a sanatorium for the treatment of tuberculosis, providing patients with ample supplies of the invigorating fresh air deemed an essential part of their treatment. The Field Studies Council is an educational charity committed to widening environmental under-standing through the running of both academic and leisure courses.

I suggested that the Blencathra Centre would make an ideal base from which to run landscape photography workshops, offering myself as a guest tutor. It seemed like a good idea at the time, as I wanted to share my photographic knowledge and accumulated expertise of the Lake District, but I did not fully appreciate just how taxing it would be to keep a dozen or so keen amateur photographers entertained for days on end in bad light or pouring rain. The problem was that I took it all far too personally: I felt responsible for the adverse weather and was overwhelmed by guilt that my charges had paid for a week's photography and I was not delivering the goods. There was a limit to how many slide shows or technical discussions I could provide, but I discovered that keen amateurs are a hardy bunch – when conditions were foul, we tramped off into the woods to find photogenic lichen and fungi. I had never really considered myself to be a 'nature' photographer but I became

Castlerigg stone circle near Keswick can probably be photographed at any time of day and in any month, but shortly after sunrise in late autumn or winter can be especially rewarding. Above: the stones as a huddled group, seen with mist lingering in the background. Opposite: the reverse angle, looking towards Blencathra after a heavy overnight frost.

fascinated by the vast range of colours and textures – even now, I find myself temporarily moving into 'macro' mode if something interesting catches my eye.

It was an exciting challenge and we roamed far and wide in search of decent light, but I was also extremely fortunate to have one of the country's most photogenic ancient monuments less than a ten-minute drive away. The Castlerigg Stone Circle may not be as spectacular as Stonehenge in terms of sheer size, but it knocks spots off its Wiltshire counterpart in respect of sheer atmosphere. Although some of my repeat guests groaned at the very mention of it, Castlerigg was nevertheless a perfect location for demonstrating the importance of the quality and direction of light to the creation

Castlerigg was a perfect location for demonstrating the importance of the quality and direction of light

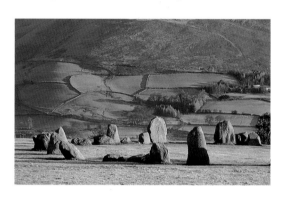

of a good photograph. The stones also present an exacting exercise in composition through careful positioning of the camera and appropriate selection of the lens. I led many dawn raids to Castlerigg; in much the same way that sleeping mill workers in Wainwright's Blackburn were raised by a 'knocker-up', I crept along the hostel's corridor tapping on doors to make sure my team was awake and ready for action. One course co-incided with the summer solstice, when sunrise was at a disgustingly anti-social hour, but we nevertheless sallied forth in anticipation of a glorious morning. The brightening sky was absolutely clear and it promised to be one of the best sessions I had conducted there, until I noticed the battered camper van parked opposite the site. My worst fears were confirmed as we walked up to the circle – it contained a motley collection of bodies in garishly coloured sleeping bags. The whole shoot was utterly ruined. Some people

managed one or two excellent candid pictures of the 'travellers', who had been rudely awoken by my even ruder language, but it was a frustrating waste of a precious opportunity; I knew full well that fine days in the Lakes cannot be conjured up on a whim.

Wainwright spent an entire paragraph decrying the changes to Keswick brought about by post-war mass tourism, but if he had still been around to experience a twenty-first century August weekend it might have taken more than a few lines for his feelings to be adequately expressed. The town sometimes seems to be on the verge of sinking under the sheer weight of bodies. On recent occasions when I have been obliged to stay there during the busiest summer months I have found the experience quite disconcerting. It is now over twenty years since my first expedition and even during those two decades I have noticed a dramatic increase in visitor numbers. A strange new sound can now be heard echoing around the streets of Keswick – the constant click-clack of walking poles on pavements. It doesn't matter how level the surface, people seem to return after a day on the fells reluctant to abandon their newly found aids for fear of capsizing outside Woolworth's. I realise that this innovation has enabled less mobile walkers to be more confident of tackling routes they might previously have rejected as too difficult, but one now sees young, fit people poling their way over Catbells as though training for the Winter Olympics cross-country events. Poles certainly aid people's progress over rough or uphill paths, but I do worry about safety aspects – it only takes one carelessly planted pole to cause a severe shift of balance and a potentially harmful fall. However, I am sure the benefits probably far outweigh any disadvantages – in any case, it is amusing to watch people ski-lessly langlaufing around Keswick market place with not a flake of snow in sight.

Although Derwentwater had been featured in most of our collaborations, prior to tackling the photography for that last book I had never noticed the memorial stone on Friar's Crag to John Ruskin (1819–1900), being usually been more intent on capturing views looking out across the lake. The slate obelisk bears an exquisitely carved cameo of Ruskin in profile; on the day I was there to photo-

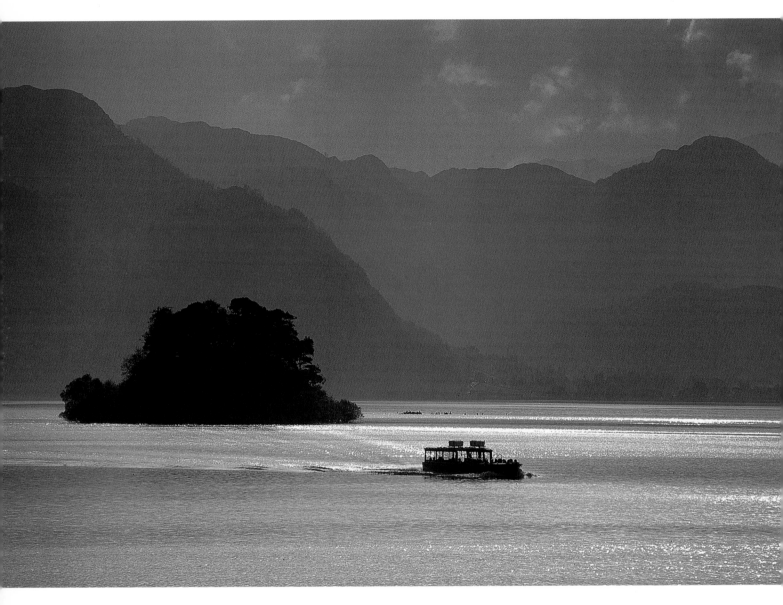

graph it, rays of dappled sunlight fell perfectly upon his face. Ruskin's *curriculum vitae* would eclipse that of many modern academics – he was an artist, scientist, poet, environmentalist, philosopher and, perhaps most importantly, the pre-eminent art critic of his time. He was largely responsible for elevating the much-derided Pre-Raphaelite movement to prominence and respectability, praising their naturalism and truth to nature in an era that was dominated by staid and formulaic Victorian art.

One of Ruskin's criticisms as pertinent today as when he made it over a century ago was targeted at those tourists who travelled for the sake of it and, in doing so, really saw nothing of their newly discovered surroundings. I fully accept that my own eye is often firmly clamped to a viewfinder, but only after first appreciating with the naked eye that there is something of interest or beauty to photograph. I despair of those visitors to the Lake District, or anywhere else for that matter, whose sole intention is to capture as much as possible on film, disk or video tape but who, in doing so, are depriving themselves of truly savouring a particular experience. Obviously we should make a visual record of holidays as a memento or *aide-memoire*, but few family outings require a feature-length documentary to do them justice.

The eyes are only one of our senses; I fear that reliance on the single dimension of a flat viewing screen will rapidly degrade our powers of observation and the wider appreciation of the natural world that we so often take for granted. On numerous occasions, photographs that I had anticipated would be good proved singularly disappointing when inspected more closely. When analysing why they had not met my expectations, I realised that it was because the image itself had been but one element of a particular scene perhaps made special by other ingredients – such as the sound of birds and insects, of rushing water or maybe the scent of newly mown hay. When those ingredients were removed, the picture appeared dull and lifeless.

If forced to choose my favourite of all the Lakeland valleys featured in the book, I would unhesitatingly opt for Newlands. I have photographed many aspects of it since my involvement with AW, but every visit seems to reveal a new insight that had hitherto been obscured. Newlands is so appealing because encompassed within its length are so many contrasting characteristics; the manner in which it has been sculpted out from the landscape renders it a perfect subject for the camera at most times of the day. Many locations demand a certain light, but even when conditions are far from favourable there will nearly always be something to photograph at Newlands, even if only the fragmented remains of old mine workings. My opinion regarding the best way to approach it fluctuates: both have their merits. When driving up from Buttermere and breasting the rise of Newlands Hause, there is the marvellous sweep of the valley falling away into the distance, with Skiddaw making a perfect backdrop. But, on balance, I prefer the winding climb up from Braithwaite as that affords a more leisurely opportunity to enjoy the gradually unfolding panorama. Despite the far-reaching views available to walkers and motorists, it is the detail encompassed within Newlands that appeals most, from the sublime whitewashed church at Littletown to the ridiculous, but nevertheless endearing, purple timber-clad house one suddenly encounters after rounding a tight bend by Rigg Beck. It comes as a shock to the system amid so much greenery, but sadly the place now seems forlorn and deserted,

Opposite: Derwentwater from Friar's Crag (above) and the memorial to John Ruskin (below).

Below: the curious purple house.
Right: spoil heaps from the Goldscope mine in the Newlands valley.
Bottom: Newlands church.

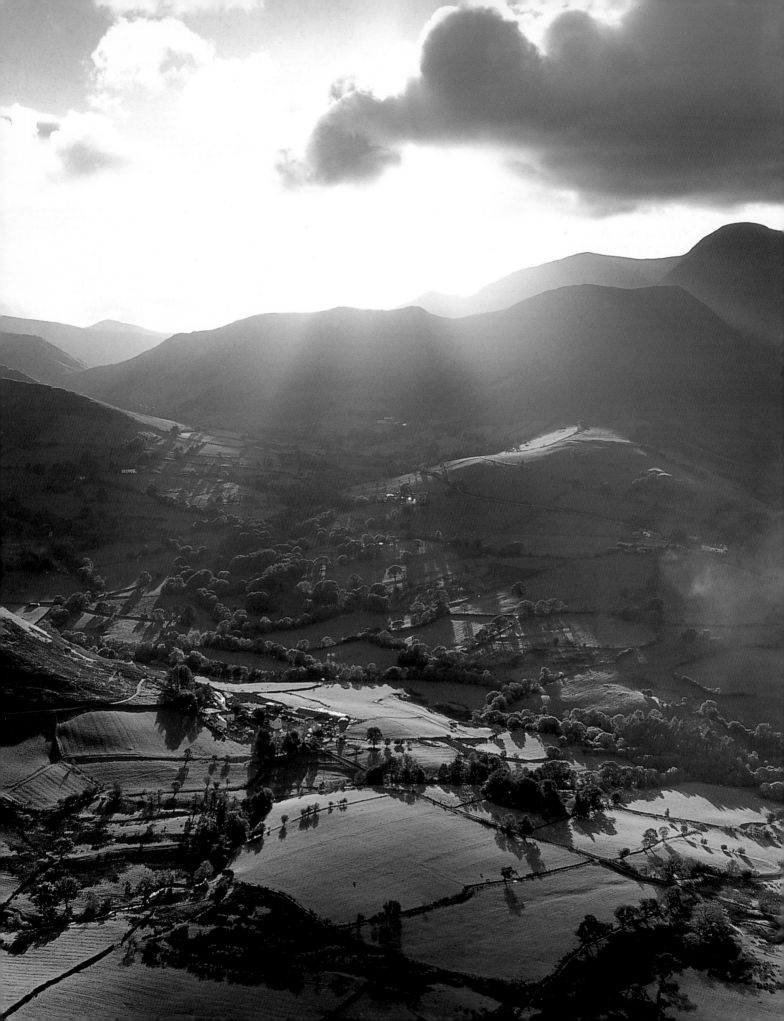

with tattered net curtains draped over the windows – I wonder what plans there might be for its future?

Buttermere also takes high rank among the central valleys. It is now forever linked to Wainwright's memory, but like him I prefer the solitude afforded by those places not so heavily frequented by crawling lines of cars and coaches. A memorial to AW is set into a window of Buttermere's tiny parish church: upon it is inscribed the invitation, 'Lift your eyes to Haystacks, his favourite place.' Despite the presence of so many more dominating peaks, the unassuming outline of Haystacks is so much in keeping with the man and the way he conducted his life.

I always try to set aside time whenever I am in the Lakes to walk up to Innominate Tarn for a moment of quiet reflection and a few words with 'himself'. As I meandered along the shore during my most recent outing, I observed a brilliantly coloured dragonfly playing among the reeds and grasses that flank the water's edge, its vibrating wings glinting in the late autumn sun. I suspect AW might have had typically forthright views on the possibilities of reincarnation, but the creature appeared so happy in its domain that I hoped AW's spirit was being carried along with it on the gentle breeze.

On my way back down towards Warnscale Bottom and Gatesgarth, I was just approaching the point where the Haystacks path meets up with the one that winds down from Honister through piles of slate debris when I was accosted by a couple asking for help with route-finding. They were Americans on vacation and although not equipped with an Ordance Survey map they did have a poor-quality photocopy of a Wainwright walk. The only problem was that they were intending to climb Great Gable via Grey Knotts and Brandreth, but instead of turning left after the climb up from Honister Pass car park had carried straight on. Reluctantly, I was obliged to turn them around and I pointed to the distant skyline from where they had just walked – without a map, I felt they were safer sticking to well-blazed trails rather than attempting to cut across open country to regain their route. We chatted for a good ten minutes about Wainwright and the other mountains they

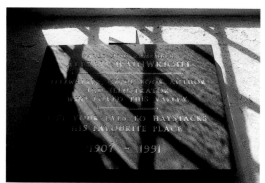

Opposite: this late afternoon photograph of the Newlands valley from Catbells took ages to accomplish as, for once, the sun seemed reluctant to become obscured by clouds. I needed it to be partially covered to reduce the risk of flare in the lens; at the same time, I was mindful of having to avoid getting too much heavy shadow in the main body of the photograph.

Above: Buttermere church (left) and the memorial stone to Wainwright set into one of the window recesses (right).

Right: Wordsworth's birthplace in Cockermouth, photographed prior to recent renovations.

were hoping to explore; as we parted, I suggested that a few pounds expended on a proper map would be money well spent, despite the prevailing adverse exchange rate.

Many of those who visit the Lake District have little or no interest in taking to the fells, their sole purpose being to imbibe the atmosphere conveyed by William Wordsworth in many of his poems. In much the same way that religious pilgrims make obligatory visits to other holy places *en route* to a shrine, Wordsworth devotees also tend to follow a fixed itinerary that logically begins at the poet's birthplace in Cockermouth. It is perhaps fortunate that when he was born in 1770 it was into relatively affluent surroundings – his father was the personal attorney to Sir James Lowther, Earl of Lonsdale – and his formative years were therefore spent in the elegant Georgian town house now in the care of the National Trust. No blue plaque on a red brick terrace for William – which is perhaps as well, because controlling visitor numbers could

I was able to get an atmospheric shot of the parish church just seconds before being drenched by torrential rain

Abaove: Hawkshead parish church against black storm clouds. It is obviously difficult to orchestrate this type of photograph but, when the weather is being fickle, patience and being prepared to risk a soaking are potentially rewarding.

Left: the light was very flat for this detail of the Hawkshead grammar school door, but although the colours are muted no detail has been lost, and any sunlight might have cast deep shadows to obscure the elegant wrought iron work.

become quite tricky in a working-class two-up two-down. I tried to re-photograph the house but, with my customary bad luck, found it under renovation and encased in scaffolding. I was more fortunate with Hawkshead Grammar School where Wordsworth received most of his formal education. The building has one of the finest doors I have encountered, and I was also able to get an atmospheric shot of the adjacent parish church just seconds before being drenched by torrential rain. Gaining access to the best vantage point in the churchyard requires a short, but very steep, climb to an upper tier – with just about twenty seconds of sun left before the storm, this was a potentially coronary-inducing dash with tripod and camera under one arm and gadget-bag flapping open on the other.

Grasmere represents the very essence of Wordsworth's Lake District; it is thought that much of his best work was written during his eight years at Dove Cottage and one can readily appreciate how such a glorious environment acted as a creative catalyst. One of the most perfectly structured panoramas in the Lake District is one that Wordsworth must have gazed at on many occasions; although difficult to get it correctly lit from front to back, the view over Grasmere from Loughrigg Terrace must surely inspire all but the most hardened philistine. The colours of the landscape are appealing at most times of the year, but with such extensive tree cover the predominantly brown shades of autumn reflect it in the most favourable light. An added bonus that comes with a trip to Loughrigg is an equally delightful view down over the adjacent Rydal Water, just a stone's throw away from Rydal Hall, Wordsworth's home after leaving Dove Cottage. The Terrace must have presented a marvellous sight in Victorian times as formally dressed couples promenaded along the wide footpath – on a clear day they might have just been able to make out the waggoners urging their teams of horses up the long drag towards Dunmail Raise.

From a photographer's point of view, Loughrigg Fell is an extremely versatile place: its northern tip provides views over Grasmere, and the southern extremity near Ambleside does the same for Windermere. It is quite difficult to get a clear overview of the National Park's most southerly expanse of

A major problem when photographing Dove Cottage in Grasmere is trying to get a clean shot without visitors appearing in the viewfinder. It is also quite tricky to capture the entire building: it has quite a claustrophobic setting and, as you move further away, the bland end of the building starts to be excessively dominant in the frame .

Two contrasting views of adjacent lakes taken from Loughrigg Fell. I accentuated the intimacy of Rydal Water (left) by isolating one segment with a telephoto lens, but used a wider angle to convey the vastness of Windermere (opposite). A graduated filter enhanced the already dramatic cloud formations and exposing it as a silhouette focused attention on the lake's contours and dimensions.

There is much beauty around Windermere but, due to its length, you have to work significantly harder to find the right places

water; elevated vantage points are rare as the terrain mellows and the fells are replaced by fields and a heavily wooded shoreline. There is much beauty around Windermere but, due to its length, you have to work significantly harder to find the right places that show enough of the lake and its natural surroundings. It is becoming ever more difficult to exclude the burgeoning armadas of small craft now moored around every accessible inlet.

The Coniston valley runs virtually parallel to Windermere; due to its protected and sheltered setting, Coniston Water has provided some of my best atmospheric pictures. In late autumn and winter, the sun sets in the perfect position in rela-

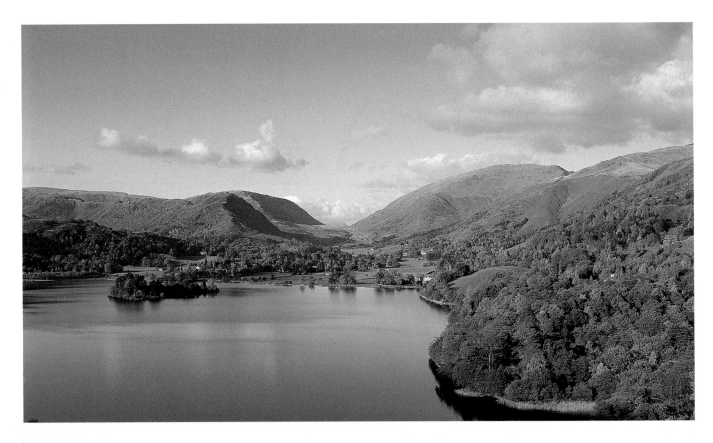

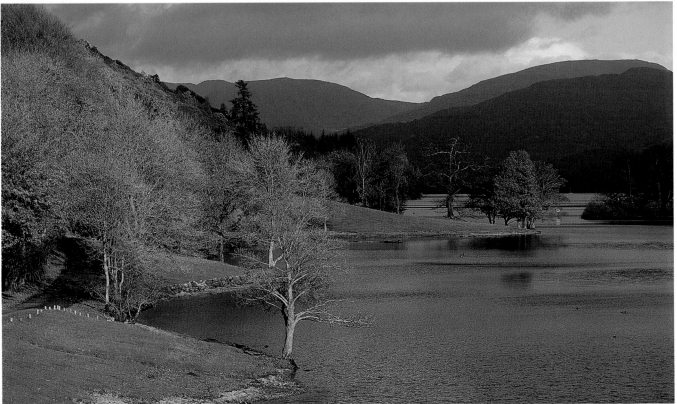

Opposite, above: the popular viewpoint of Loughrigg Terrace is perfect for capturing the serene beauty of Grasmere.

Opposite, below: this detail of Windermere's indented shoreline gains emphasis from the absence of sunlight on the backdrop of rising fells.

Above: an atmospheric post-sunset shot of Coniston Water in which the tranquil surface perfectly mirrors the sky's rich colours.

tion to the lake and adjacent hills – and because the water's surface is so frequently unruffled, an almost perfect mirror reflection of the evening sky can be captured. It is impossible to gaze out over that tranquil expanse of water without remembering the death of Donald Campbell in 1967 during an attempt to raise his own world water-speed record in the turbojet hydroplane *Bluebird*. I vividly recall watching the grainy black-and-white news coverage of the event and that awful moment when his craft left the water, somersaulted and disintegrated. One gets the impression that Campbell and Wainwright were not too dissimilar in some respects: both were totally focused and single-minded to the exclusion of almost all else in pursuit of their avowed goals.

I was delighted to note that AW had included a monastic ruin other than Shap on my list of locations, especially as I was then unfamiliar with the origins and history of Calder Abbey and anxious to discover more. That enthusiasm was subsequently tempered when I realised that the abbey's remains were in private ownership, not open to the public, and viewable only from a nearby public footpath. Although I could get close enough to take the photograph I needed, it would have been so much more enjoyable to be able to inspect the buildings in closer detail. Unlike some ancient monuments

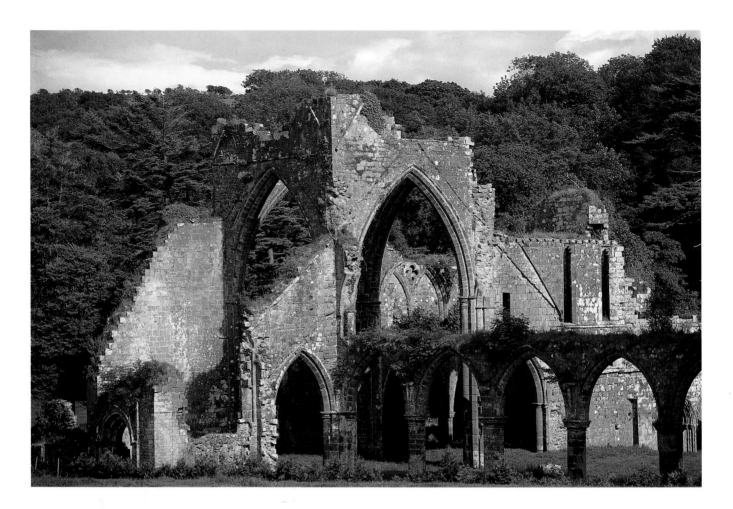

that are presented in pristine condition, Calder is endowed with a slightly unkempt but nevertheless endearing atmosphere by the gradual intrusion of nature.

Calder was founded as a daughter house of the richly endowed Furness Abbey and therefore, in the interests of continuity, I have taken the liberty of extending AW's original parameters by adding ten miles down to the Valley of Nightshade on the outskirts of Barrow-in-Furness. Furness Abbey was founded by the Savignacs in the early 1130s, an order that later amalgamated with the Cistercians, known as the 'white monks' because their habits were made from coarse, undyed wool. Several of northern England's Cistercian abbeys, including Fountains, Rieveaulx and Byland, are notable for the sheer size, grandeur and architectural perfection of their churches and monastic ranges. These qualities are exemplified at Furness by the stunningly beautiful row of five decorated arches that

grace the east range, the central one being the entrance to the chapter house. The great wealth accumulated by those Cistercian foundations stemmed largely from their vast sheep-farming concerns. Furness was no exception, owning and managing enterprises as far away as the Yorkshire Pennines. Monastic farms were called granges and that original connection survives in the name of several well-known Cumbrian villages such as Grange-in-Borrowdale and Grange-over-Sands.

Whether controlled by providence or simply the forces of nature, rainbows are persistently aggravating in their refusal to appear anywhere useful . In my case, they usually reserve their best displays for when I am in the outside lane of a motorway or when access to a camera is impossible. Those frustrations were finally put to rest in no uncertain manner near Santon Bridge on the approach to Wasdale. The weather appeared uncompromisingly bad and I had been undecided

Above: Calder Abbey is on private land, but was perfectly accessible via a zoom lens from the nearest public footpath. It took two visits to get this shot as the sun was in the wrong place on my first attempt.

Opposite: a steep hill fortuitously overlooks Furness Abbey, so I was able to get an establishing shot (above) to show the sheer scale of the site and put the ruined buildings in the context of their surroundings. I then took details within the monastic complex to convey the sheer grandeur of the architecture, such as the chapter house entrance arch (below).

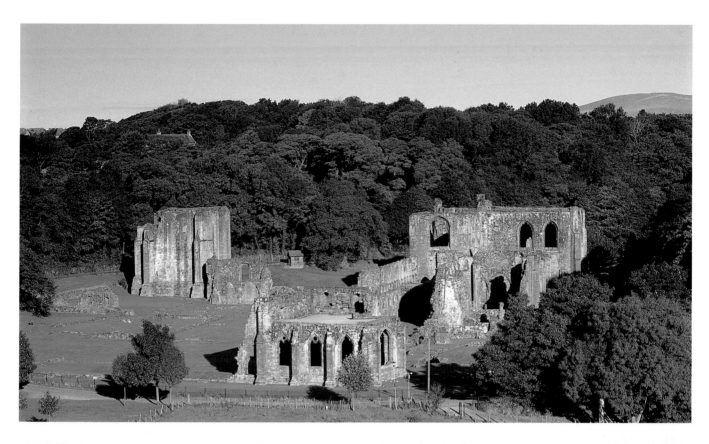

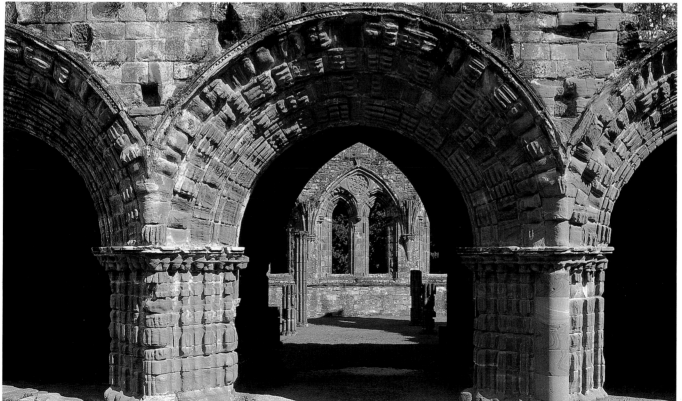

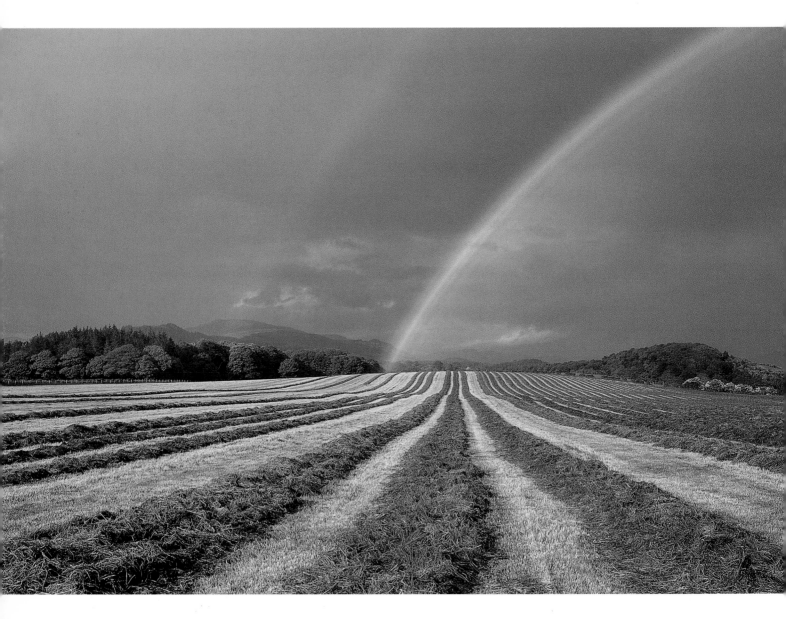

whether to persevere with the trip at all, but landscape photographers have to be naturally imbued with a greater sense of optimism than other mortals, so I elected to persevere for a while longer. Optimism was required in large doses on that day, but despite almost jet-black skies and torrential rain, I must have had an intuitive sense that something would happen – other than the car being washed away. I had turned off the main coastal road to cut across towards Wasdale when an unseen hand powered up a giant projector and blasted two rainbows on to the dark background. Never have I seen such intensity of colour. I was convinced the phenomenon would disappear before I could find

a gap in the hedgerows, but eventually I happened on a gateway. An added bonus was the fact that I had stopped by a field of cut hay so I was able to use the geometric lines to fill the foreground creatively. Despite the rainbow's brightness it was still raining hard, so I had great difficulty keeping water off the lens. I had not dared to pause long enough to don boots so was in the process of ruining a pair of shoes in sodden grass, but at that moment I could not have cared less – I would have walked up Gable in bare feet if necessary. I had finally nailed a perfect rainbow!

As I sat in the car and dried off my cameras, I noticed that patches of blue were beginning to

Despite the rainbow's brightness it was still raining hard, so I had great difficulty keeping water off the lens

Opposite: natural and man-made symmetry united for this photograph of a double rainbow near Wasdale. The rainbow would probably have made a good photograph anyway, but the graphic lines of newly mown grass leading away from the camera were an unexpected bonus.

Below: Wastwater screes are best photographed in the late afternoon when the textures are really etched out by a descending sun.

establish themselves amid the glowering black clouds and I pressed on to Wastwater where I was rewarded by some wonderfully soft sunlight falling on the famous Wasdale screes. As the weather had improved immeasurably in such a short space of time, I gambled on the following day maintaining that trend, and camped overnight on the National Trust site at the head of Wastwater. Even though the following day was a Sunday and the fells would be liberally coated with a seething mass of bodies by noon, I could be several hours ahead of them and have my work done and dusted while their breakfast bacon was still cooking.

The great thing about that particular campsite is that you can literally walk up on to the fells without having to drive anywhere first. I was up and away just before sunrise, serenaded on my way up Lingmell by a bizarre symphony of birdsong and snoring from the surrounding tents. It was not much later than 5.30 a.m. but even by that time it

had become the most glorious early summer's day and the sun was beginning to reach down into the recesses of Wasdale Head. Of all the Lake District valleys, Wasdale is the one most effectively portrayed from above to highlight the intriguing geometric shapes created by the stone-walled fields in the vicinity of the Wasdale Head Inn – it seems quite extraordinary that there should be such a complexity of shapes and sizes of enclosure within that small area. My plan for the morning was to press on to the summit of Lingmell and then cross over to Scafell Pike for a few more shots before the sun got too high and other walkers started to arrive. I knew that when things started going too well, a gremlin was always likely to be lurking to spoil things; on that perfect Sunday morning, he manifested himself in the guise of the Three Peaks Challenge. I know that such events raise invaluable funds for charity, but – just as with the Lyke Wake Walk over the North Yorkshire Moors – such mass

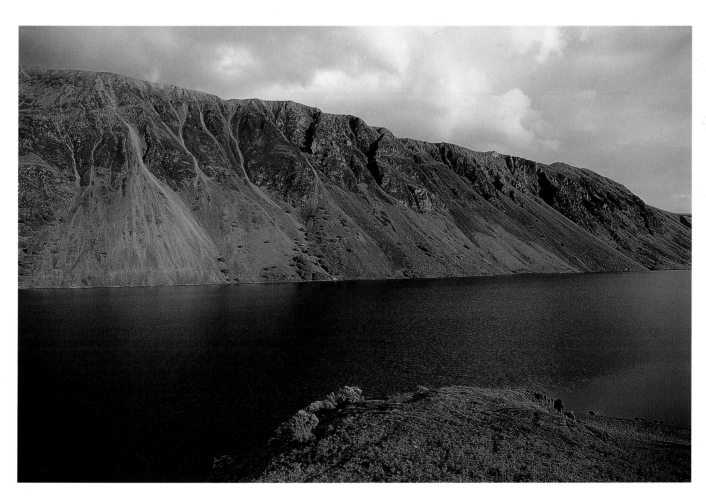

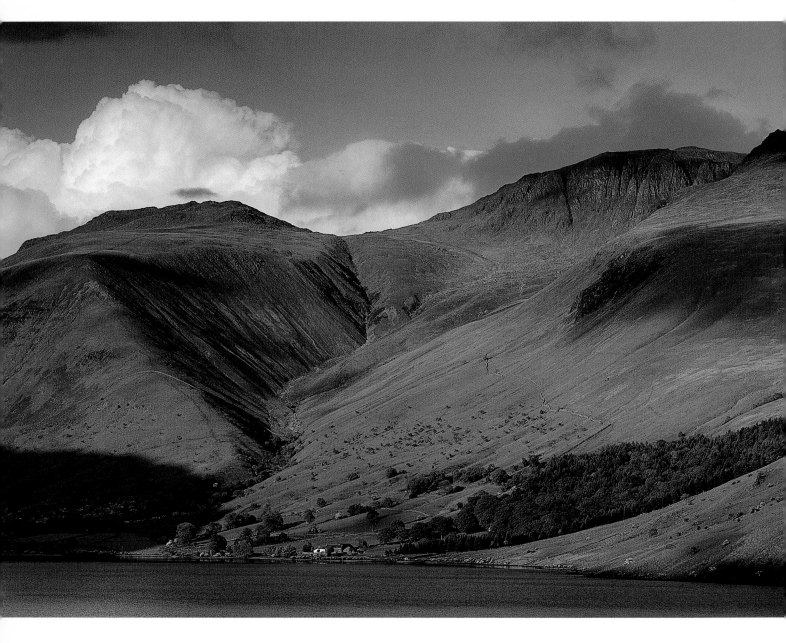

assaults are knackering our environment. The 'challenge' is to climb Ben Nevis, Snowdon and Scafell Pike within a 24-hour period, and participants are ferried the hundreds of miles from peak to peak in fleets of fume-belching minibuses.

They started arriving as I was half-way to Lingmell's cairn and, for the next few hours, I watched as groups of walkers made their way up to the Pike to have themselves checked off by a squad of clipboard-toting, luminous-orange-clad officials. As people descended from the summit, it was like watching a defeated army in retreat, their uniforms

discarded and the wounded leaning on able-bodied comrades for support. I did not persevere with my intended objective, and was well on my way home via Kendal before lunchtime.

I got to know Kendal reasonably well during my years of working in the Lakes. Unless I was in a desperate hurry, I preferred to drive through the centre and past AW's old office in the Town Hall rather than use the soulless by-pass. Victorian civic buildings are in a class of their own and Kendal's is a typical example, with its tall clock tower dominating the high street. The moment you step

This picture of Wasdale Head was taken an hour after the rainbow photograph (page 280) and proves just how rapidly weather and lighting conditions can change within the Lake District.

through the front door, there is that unmistakable lingering smell of floor polish. It must have been an austere place to work during Wainwright's regime as Borough Treasurer; I felt sorry for any employees or member of the public who got on his wrong side, as AW could be quite brusque.

Wainwright's employment record is well documented, but far fewer people are aware of just how much of his spare time was devoted to helping at the Kendal museum. From 1945 to 1974 he was honorary clerk and a voluntary curator, helping with many geological and other collections for no reward other than the sheer pleasure of being utterly engrossed in something that interested him or was of benefit to others. It is absolutely appropriate that there is now a Wainwright section in the museum, exhibiting many of his original pen-and-ink drawings and personal items including his walking jacket, spectacles, rucksack, heavily darned socks and, it goes without saying, a smoke-blackened pipe!

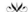

Despite AW's reluctance to have any kind of attention focused upon him, I think he would have been quietly proud of that tribute; to note how much he was loved and respected by those with whom he worked and the countless thousands of others whose time on the fells and mountains of Cumbria has been enriched by having AW as a companion, albeit if only in print.

Tangible memorials to AW are few and far between, but maybe that is the way it should be, as countless 'Wainwright Stood Here'-type signs would serve little useful purpose. His *Pictorial Guides to the Lakeland Fells* and the mountains themselves are surely reminders enough of a truly extraordinary person. I feel privileged to have been involved with someone who has given so much for the benefit of others, but with no thought of personal reward, save for the pleasure of accomplishing the task.

I had never imagined that I would be spending the best part of a decade working with one particular author on producing a succession of books that would scare me silly, but am so pleased that I did. Being invited to follow in Wainwright's footprints was a great honour, even if it often felt more like purgatory at the time!

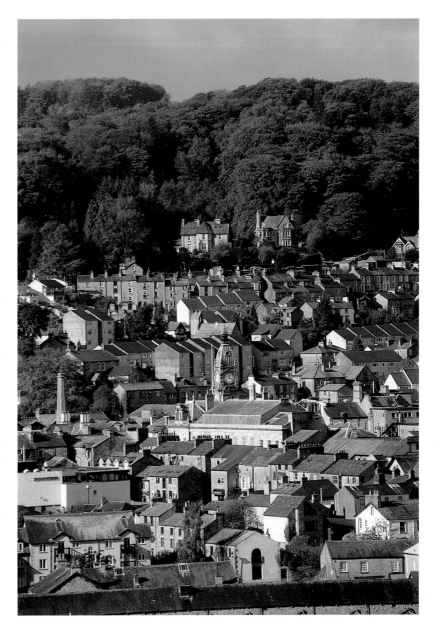

Tangible memorials to Wainwright are few and far between, but maybe that is the way it should be

Kendal town centre from Castle Hill, with the distinctive landmark of the town hall clock tower (containing Wainwright's old office somewhere beneath it) in the middle of the frame.

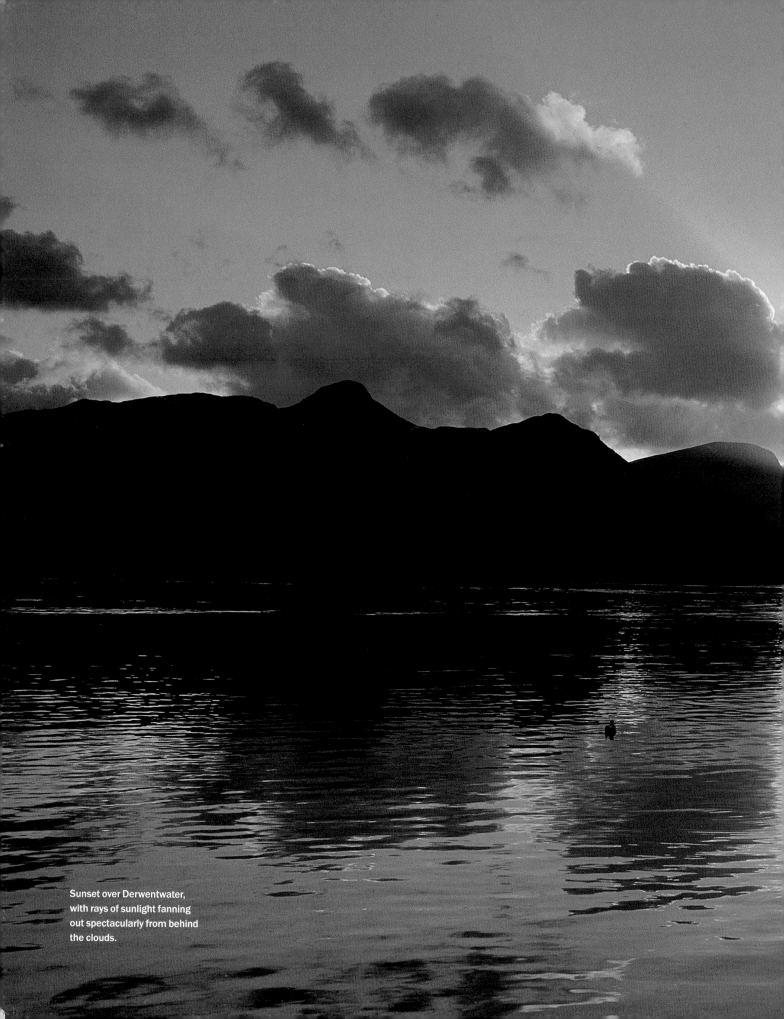

Sunset over Derwentwater, with rays of sunlight fanning out spectacularly from behind the clouds.

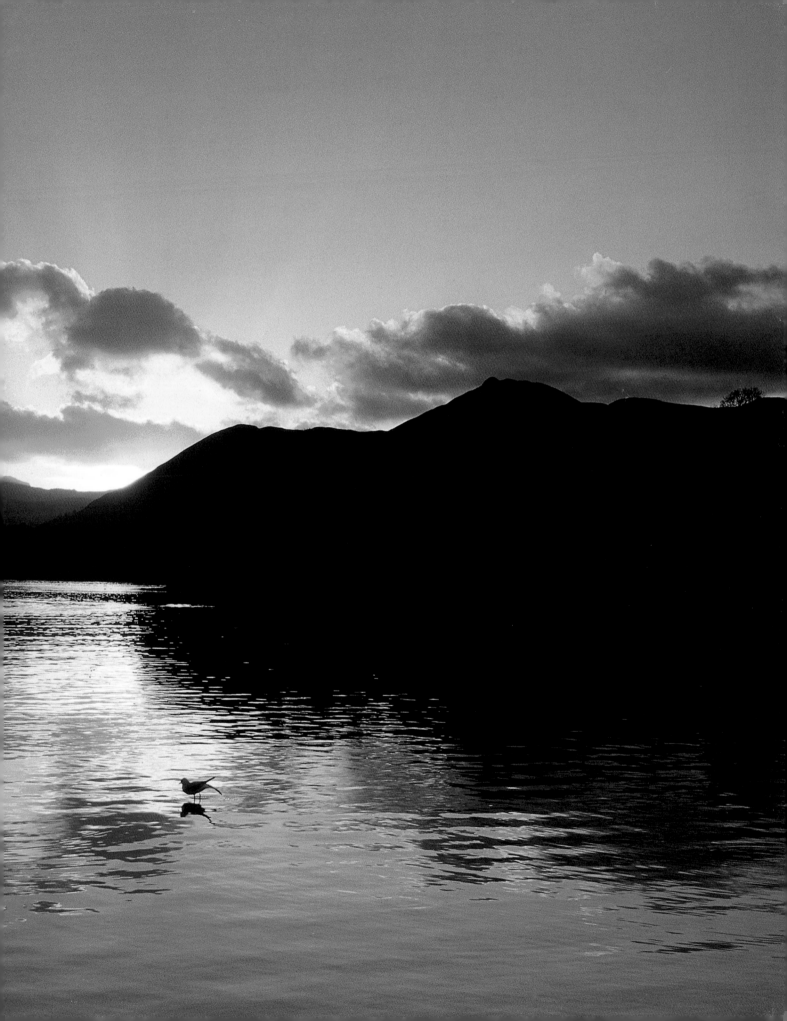

INDEX